Handbook for Contemporary Photography

4th edition

Handbook for Contemporary Photography Arnold Gassan

light Impressions
rochester, new york

Published by Light Impressions Corporation
Box 3012, Rochester, New York 14614

Cover design by Bill Buckett Associates
Book design by Laurence E. Keefe
Manuscript illustration by
Paul E. Gillmeister
Printed by Mohawk Press in Rochester, New York

10 / 9 / 8 / 7 / 6 / 5 / 4 / 3 / 2 / 1

Library of Congress Cataloging in Publication Data

Gassan, Arnold
 Handbook for contemporary photography.

 1. Photography — Printing Processes. I. Title
TR330.G38 1977 770'.28 77-14576
ISBN 0-87992-009-2
ISBN 0-87992-008-4 pbk.

for Laird

TABLE OF CONTENTS

CHAPTER FIVE
SPECIAL PROCESSES

CHAPTER SIX
ALTERNATE PHOTOGRAPHIC PROCESSES

CHAPTER SEVEN
HALFTONE PROCESS

CHAPTER EIGHT
COLOR NOTES

Introduction

It was near the end of the first year I taught photography at Ohio University that I typed out a set of process and procedure notes and had them mimeographed for use by students. These notes were needed because of problems which I now realize are common in photography—students develop interesting but unreal myths about photographic facts, and pass them on innocently, and every teacher forgets to tell each new incoming class **all** the facts they should know. When I heard myself saying "but I told you that," and receiving a hurt and distrustful look in return, I knew it was time to organize things.

The intention of those notes was explored further in a trial publication printed by friends in Aspen, Colorado; it was titled "A Handbook for Basic Photography." A study of the text revealed it was not **basic** photography with which I was concerned. This was in the late 1960's and new attitudes toward photographic printmaking were appearing and old attitudes derived new energy from an ongoing dialogue between artists and their materials. Nineteenth century processes that had fallen away from popularity were being revived, but references then available were written with antique measurements, names and language, citing obsolete producers and equipment. They had to be interpreted and restated in contemporary terms, after being verified by test. And there was a desire to produce a useful workbook that did not merely duplicate excellent theoretical source books on the optics, chemistry and physics of photography. Better, I felt, to produce an elegant cookbook; set theory to one side, and offer information that was of immediate practicability yet which did not dictate an aesthetic derived only from the craft.

There are implicit biases in any text; my own thoughts about the photographer and his camera (and his craft) are reflected here: "There is no more important quality than ease in mechanical working. The adjustments ought to be so simple that the operator may be able to bring [the camera] from his satchel to get it in order for making an exposure without a conscious thought. Each worker will have his own idea as to which style of camera comes nearest to perfection in this respect, and having made his choice he should study to become so intimate with it that it will become a second nature with his hands to prepare the camera while his mind and eyes are fully occupied with the subject before him." The musician practices each day to retain his skills; the artist draws or paints as many hours, building and developing mechanical and perceptual talents; the photographer can do no less.

My first experiences as an independent teacher taught me that craft and chemistry must work in close harness with insight and aesthetics. If not, the results are on the one hand that terrible barrenness of the phototechnician who judges every print by holding it to the tip of his nose while he studies the grain, and on the other hand the languid posture of the aesthetic dreamer who insists on the esoteric intention of his silvery splotches.

The Fourth Edition of this Handbook introduces beginning photography as well as completely revised information about advanced controls, and significant clarifications of process information on alternate printing processes for the advanced photographer and photo-printmaker.

+ J. Craig Annan, on "The Hand Camera," from W. Lincoln Adams, *Sunlight and Shadow,* Baker and Taylor, New York, 1897, pp. 72

CHAPTER ONE
Beginnings

First Steps

Beginning photography is like riding a bicycle. Once learned, it is simple, but at the start it looks hard.

First, borrow or buy a simple camera. Then expose some pictures. Photograph whatever pleases you. The camera and film will change the way things look. There is no way to know how these changes will look until you experiment. Then, if you really want to learn all the possibilities, develop the film yourself and make your own prints. When photographing in black and white this is better than sending the film off to your drugstore because, after a few tries, you can do the job better yourself.

A simple camera is one that has few controls for you to worry about. Some very expensive modern cameras are also "simple" because the camera takes care of the controls for you by means of electronic circuitry. Simple means more than "simple to use." It used to mean a "box" camera, because it resembled a plain black cardboard box. In fact, many of the old box cameras still work well.

A camera is a light tight box with a lens on one side, a light sensitive film on the opposite side, and a shutter in between. This is all it **has** to have. Modern cameras have a viewing device so that you can see approximately what the film will see. They also have ways of changing the amount of light that will come through the lens: a diaphragm that can be made smaller or larger to control the quantity of light and a series of shutter speeds that change the length of time the light can enter. (Figure 1-1)

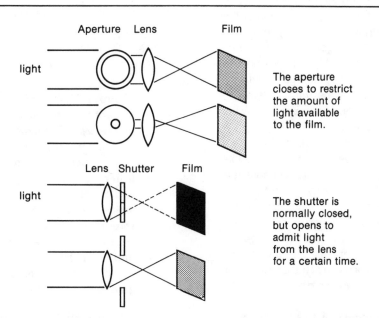

Aperture Lens Film

light

The aperture
closes to restrict
the amount of
light available
to the film.

Lens Shutter Film

light

The shutter is
normally closed,
but opens to
admit light
from the lens
for a certain time.

Figure 1-1: **Schematic of diaphragm and shutter controls. The iris of the diaphragm controls the amount of light that can pass through the lens, and the shutter controls the time.**

The lens organizes light; it makes an image on the film of the world in front of the camera. A shutter turns the light on and off. Modern cameras also have focusing devices that change the distance between the lens and the film so different parts of the scene being photographed are in focus when the shutter opens.

Figure 1-2 shows a simple camera. It has everything listed that a camera needs, including a way of knowing how much film has been exposed, so that when the film is all gone the camera can be opened and loaded with new film. The only difference between this camera and more sophisticated modern cameras is that the more expensive machines have more precision of manufacture and quality of materials.

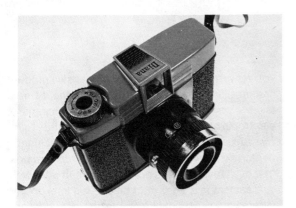

Figure 1-2: **A simple camera that has all the basic elements of a camera: light-tight compartment for the film, method of advancing film between exposures, viewing device, shutter and diaphragm for controlling the exposure.**

Load a simple camera with what is called a "high speed" film, Kodak Tri-X. Go outside and make some pictures. That's really all there is to it. Point the camera at what interests you and push the shutter button. A simple camera lets you do this without a lot of planning. A complicated camera requires you to focus, adjust for the light, and do other technical planning. Beginnings should involve you with the picture alone, with the event in front of the camera and your discovery of how the camera changes that event.

The first problem of the photographer is to learn to see what the camera sees. It does not see like you see. It sees both less and more; because it is rigid and mechanical it changes things, relative to what we see. It makes color into black, grey, white. And all the other things, light, textures, emotions, speed, hopes, excitements...all the things you see and state as feelings are changed by the camera into patterns of silver on a piece of transparent film. These can then be changed into grey tones on the print.

The eye is often compared with a camera but it shouldn't be. In fact, the eye should be thought of as two systems working together. One is the soft globe at the front of the head, with a lens; the other is the strange electro-chemical machinery that is the optic nerve and the brain itself.

Figure 1-3 is a very simple schematic of how we see. Light from the outside world passes through the cornea into the eye and affects the retinal sensing devices called rods and cones. These are in constant motion, always being presented to new areas of the image formed by the cornea. And the eye itself constantly moves in rhythmic pulses from side-to-side in what is called the **sacadic** rhythm. This complex motion is necessary because for each area of the retina there is a threshold of light intensity which will cause that tiny part of the eye to generate an electrical signal. These signals are counted, accumulated and passed through the optic nerves to the brain. Within the brain itself the electrical signals are integrated and **understood.** The process of seeing can poetically be referenced to the "mechanical" eye with the lens and to the "thinking" eye in the brain. What we "see" is discovered by means of the mechanical eye, but perception and understanding is in the thinking eye. The camera has only a mechanical eye.

Right & left brain images reconstituted from electro-chemical pulses and memory associations

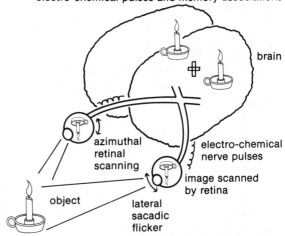

Figure 1-3: **This simplified drawing shows the subject reflecting light toward the cornea, or lens of the eye. The lens forms an image which is scanned by the retina. Both the lens and the retina are in constant motion—the image is not static as it is in a camera. The light impinging on retinal rods and cones generates electro-chemical discharges which are summed up and transmitted to the brain through the optic nerves. Various parts of the brain work together to restructure these electrical pulses and by pulse-time scanning generate what we "see." This final image is modified by memory, emotions, and other brain functions.**

Make your first pictures without any concern for what is "good" or "bad" or "wrong" or "right." Simply try photographing. Don't ask if the pictures should "come out" a certain way. You won't know how they can look until you try.

When you have exposed a roll of film, carefully take it out of the camera and seal the protective wrapping with the gummed strip. (Figure 1-4).

Take that film to a photographic darkroom; prepare to develop it.

A photographic darkroom is simply a space which can be conveniently made light-tight. It may be a closet or it may be a fancy room with stainless steel sinks, fancy plumbing, and complicated electrical circuits. A closet works fine if you have nowhere else. A bathroom often is adaptable. The first problem is always light control. A darkroom must be dark.

A bathroom can be made dark by taping black plastic sheets over the window. If you are going to use it as a bathroom as well, the plastic can be fitted neatly over the glass alone; then the window can be opened for light and ventilation. Or a piece of the fiber board used to sheath buildings, available at lumber yards, can be cut to fit just inside the window casing; this can be removed when darkness is no longer needed.

You will have to have certain photographic chemicals. First needed are Kodak *Dektol* developer (this is a powder, to be dissolved in water), Kodak *Rapid Fix*, and Kodak *Hypo Clearing Solution.* The second is liquid and is in two concentrated solutions. Mix according to directions on the package. Mix chemicals the day before you use them; this allows them time to dissolve completely. It's best, for safety reasons, to mix and store them in plastic bottles that can't be broken. One gallon milk jugs are fine. Store chemicals in the dark (e.g. a closet) and where it's cool. Developer and fixer both last a much longer time when the temperature is between 55 and 65 degrees. Above 80 degrees all photographic chemical mixtures will decay rapidly.

Before you try to develop the roll you exposed in the camera, take a second roll of film, one that's never been through a camera. Open it. Just take it out in the light and examine the film itself. (Figure 1-5) It has a light grey side and a dark side. The color of the dark side may be purple or dark green; a few special films are a deep brown. The colored side is the back of the film. The color is there to absorb any light that goes all the way through the film, that isn't used in making the picture on the silver emulsion. It's called the anti-halation backing.

The light grey side is the *emulsion.* The emulsion is in two parts: a thin coating of gelatin, and the silver salts. These are distributed evenly through the gelatin. It is the silver salts that actually make the visible image.

Cut off a piece of this raw film. Put the piece halfway into some fresh developer. (Figure 1-6) Hold it in; stir it around. Watch the silver turn dark as the developer interacts with the silver—silver that you have exposed to the light merely by removing the backing paper. Exposing it to unfocused light is called fogging the film. Notice how

Figure 1-4: **When the camera has been used, and the film has been wound through, open the back and remove the exposed film. The sealing tab can be easily opened in the darkroom *if* the end of the protective paper has been folded under before the tab is moistened.**

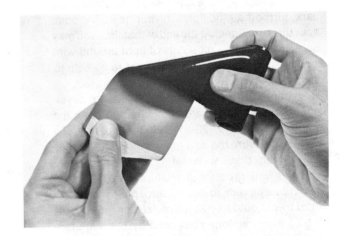

Figure 1-5: **The light grey side is the photosensitive emulsion. The back side is dark, because of the anti-halation dye which absorbs the light passing through the film.**

]4[

the dark color on the back dissolves into the developer, staining it.

Cut off another piece of film. Place this fogged piece directly in fresh Fixer. (Figure 1-7). Watch how the grey silver in the emulsion is quickly dissolved. This fixing is a removing of the undeveloped silver and is also called "clearing." Doing this in the light will show you quickly and definitely what **development** and **fixing** is. Developer changes the invisible image of light into dark silver. Fixer dissolves away silver that wasn't used during development to make a visible image.

Use the rest of the roll of film to practice developing in a tray. Unroll the film. Take it off the spool. See how it is attached with tape and how you separate it from the paper. (Figure 1-8). This is a rehearsal for what you will do in the dark: close your eyes and let your fingers see for you.

Developing film requires very little equipment. You can use the same trays and darkroom you will use to print. There are many special tanks made so that film can be developed in white light. But tray processing is inexpensive, simple, and in many ways still the best way.

You need a place to work. The bathroom or a large closet can be used; a basement room where the light can easily be excluded is often available.

The minimum equipment needed is a darkroom with a counter or table that is waterproof, a one-liter graduate or measuring cup, three 8 x 10 inch photo trays, a photographic thermometer, standard photographic printing chemicals (developer and fix), a clean sponge, and a timer that either has luminous hands or else counts down a preset interval and has an audible alarm. The counter can be a piece of ¾ inch plywood, covered with a sheet of clear or black polyethylene. (Figure 1-9).

When all this is ready, use the roll of practice film and rehearse in the light what you will have to do in **total darkness.** If there is a question of how dark is dark, turn off all the lights in your new darkroom. Wait three minutes. At the end of that time you may be able to see tiny pinpoints of light around windows and doors, but you ought not to be able to distinguish **any shapes** within the room itself.

Prepare your trays by putting 500 ml of developer and 500 ml of water, combined to bring the solution to 68-70° F (20-21° C) in the first tray. (To do this, measure the developer temperature. If it is 23° C, then draw water at 17° C. Adding equal volumes will produce a mixture of 20° C.) The second tray needs to be half full of plain water. The third tray should be half full of fixer, mixed according to the directions suggested by the manufacturer.

Identify the tray used for developer with a permanent felt-tip marking pencil and use it **only** for developer. The developing solution is basic (ph is

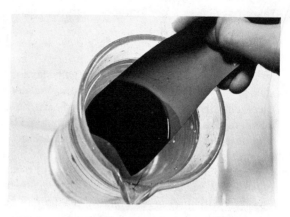

Figure 1-6: **Immersing a piece of film directly into the developer: the chemicals interact with the silver salts in the emulsion and produce black metallic silver.**

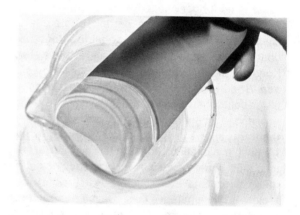

Figure 1-7: **Dipping a piece of undeveloped film directly in fixer, or hypo, the silver salts are dissolved and the film "clears." This is what happens when you have finished development, and put the film (or paper) into the fixing bath to remove unused silver.**

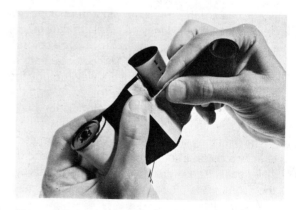

Figure 1-8: **In the dark, after you have prepared to develop the film, break the sealing tab and unroll the film, separating the paper protective backing. The film will curl up in one hand, as shown. The tape that holds the film to the paper must be carefully torn away. Then the film may be developed.**

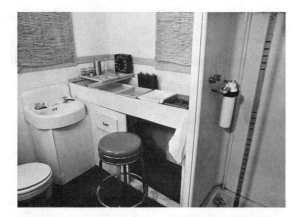

Figure 1-9: **A student darkroom. Elegant controls, stainless steel sinks, meters and water temperature controls may be pleasant, but they are not essential to productive work in photography.**

greater than 7); all the other photographic solutions are acid. Putting developer into a tray commonly used for a strongly acid solution will rapidly diminish its effectiveness.

When you have the darkroom ready, take the test roll of film and hold the spool of tightly curled dry film in your right hand. Practice developing with the lights on. Pull out six or eight inches and press that down into the developer. (Figure 1-10). Let the newly wetted film curl up by moving your left hand toward your right. (Figure 1-11). *Don't* let the spool of film in your right hand get wet all at once! the gelatin emulsion swells as it is wetted, and it will all stick together in a tight roll.

When all the film is wet, begin to pull the film back out to the right; allow it to curl up in a roll again in your right hand. As the film wets, it will lose its curl; when this happens lift one end of the film from the developer until the film is hanging straight, then take the lower end in your other hand and begin to see-saw the film in and out of the developer. (Figure 1-12). This provides even *agitation,* which describes the replacement of developer in all parts of the film.

As you develop the film you will make it darker in *some* areas, but increasing the time will not make it darker overall; shadows will stay light and increasing developing time will only increase the *contrast*. A certain time is correct. Start by developing for the time suggested by the manufacturer of the film. This is listed on the data sheet that comes with each roll.

After you have finished developing your first roll of film, you have to stop the developing action and then "fix" the film. When the developing time is up, lift the film and move to the second tray. It has plain water. See-saw the film through the water for about 30 seconds. The time isn't critical; the purpose of the second bath is to wash off the developer before you put the film in the third tray which has the fixer.

The fixer will remove the *unused* silver. After you have agitated the film in the fixer about a minute, turn on the lights. Your film should have been developed in the first bath and be fixed in the third and appear *clear.* Clearing the film means removing the unused silver; the film will be dark with

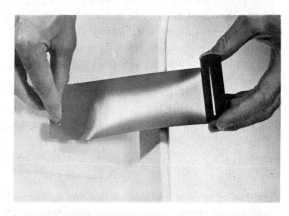

Figure 1-10: **Starting tray development of roll film. Pull out a few inches of film and wet it in developer, keeping the rest of the film dry.**

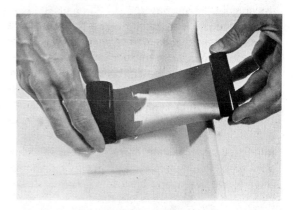

Figure 1-11: **As the film enters the developer it will still tend to curl, let it roll up as shown. After one or two passes through the liquid it will become limp.**

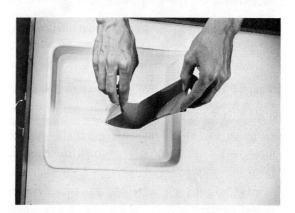

Figure 1-12: **When the film is wet and soft, it may be agitated by see-sawing it up and down in the tray. The developer offers some resistance to the film and you quickly learn to feel when it is wet, even in total darkness.**

transparent patches. There will also be a pink or purple color to it; this is from left over dyes used in making the anti-halation layer on the back of the film. These will not affect the negative and can be ignored.

After twice the time it takes to make the film fully clear (and the time for this will be different for each fixing solution), empty the second tray. Lay the film in it and then put the tray under a cold water tap. Allow cold water to run for five minutes; the excess will flow out over the sides. This is called washing the film; it will remove most of the fixer. It won't remove all of it; complete chemical removal of the fixer will be described later.

Turn off the water; remove the film and hang it up to dry in a quiet, dust-free place. The water will not want to run off completely when you hang it up. Droplets will remain. A softened clean sponge should be used to remove the excess water. (Figure 1-13). Wipe each side of the film firmly and gently, in a single continuous motion from top to bottom. Use one side of the sponge for the emulsion and the other for the base of the film. When you finish, almost all the water will be gone. Rinse the sponge thoroughly and put it in a plastic bag, safe from dirt. When the film is dry, take it down. If this were film exposed in the camera and not a test roll, you would cut it into strips of three or four frames. Repeat all this with an exposed roll. Develop in TOTAL DARKNESS. Finish the film and dry it. Your film is ready to print.

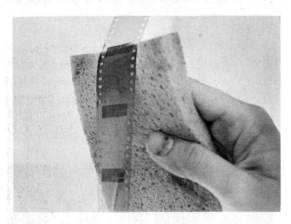

Figure 1-13: **After the film has been fixed, washed, and is ready to be dried it may be wetted with a wetting agent and hung to dry. But if the water you are using has any sediment it is best to also sponge it carefully, drawing the sponge down from the top. Make one slow passage down each side.**

There are two ways to print negatives. One is called *contact* printing and the other *enlarging*. Contact printing means laying the negative onto a piece of photographic print paper, covering the negatives and paper with a piece of glass to hold them together and then allowing white light to penetrate the negative. This creates an invisible but real image on the photographic print paper just as the light coming through the camera lens made a real but invisible image on the film. Enlarging is similar, but there the negative and the print paper are separated by an optical system which is like a camera used backwards. Enlarging permits making a print larger than the size of the negative.

Contact printing should always be the first step in photographic printmaking. The contact print lets you see what you have made; it also tells you about negative contrast and comparative exposures, and it permits you to make a first evaluation of your pictures. The contact print also changes the **negative** image to a **positive** image. This change affects our response to the picture. A good-looking negative often makes a dull print, and the other way around!

Contact printing needs little special equipment. The trays you used to develop the film, a smooth dry surface on which to work, and a piece of double-strength window glass (have the edges "dry wiped" at the glass shop to remove their dangerous corners or tape them with masking tape) and an electric light over the printing area are all you need. The light used to expose the paper can be the regular room light if necessary. Fluorescent lights are not good, however, because they turn on and off slowly and are hard to control for accurate timing.

There are many kinds of photographic printing paper. Buy a standard paper with a normal contrast, for example Kodak Kodabromide F-2. Do not start with the variable contrast papers. You may wish to use the resin coated (Kodak RC or Ilford Ilfospeed) paper because they require little washing time and are easy to dry. Buy only 25 sheets the first time because, at first, there are many ways to make silly mistakes that would ruin more paper if you had it on hand.

When you are ready to print, pour 500 ml of developer and 1000 ml of water into the first tray; fill the second tray about half full and add Kodak Indicating Stop Bath, as indicated on the bottle. This is a mild acid and is not dangerous unless splashed into the eyes. In the third tray put the same fixer you used for the film. (Later, you will want to use separate solutions for papers and films but you can start this way.)

If you do not have a "safelight", you can print in total darkness, just as you did when developing the film. A safelight is a lamp with a filter that offers only colored light to which a photographic emulsion is relatively insensitive. There are no perfectly safe safelights. All safelights will eventually produce some fogging of the emulsion if improperly used.

First, a safelight must be of the correct color for the emulsion being handled. Paper and film require different colors. A yellow safelight suitable

for most photographic papers is called an "OC" safelight. Red safelights are not suitable for modern enlarging papers.

Figure 1-14 shows a Kodak Darkroom Lamp. This is a sturdy, dependable unit with interchangeable filters so the color of light can be adapted to the emulsion used. To enlarge its adaptability, a small SCR dimmer has been added by the photographer to the circuit so the light may be made very dim when a sensitive emulsion is used.

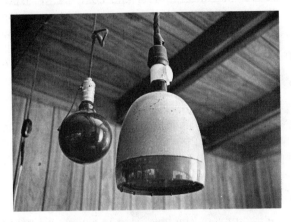

Figure 1-14: **A Kodak safelight with a commercial SCR dimmer attached. The dimmer isn't required, but it permits the use of a larger bulb in the safelight for general preparatory work in the darkroom, and then a dim, very safe light during printing.**

If you have to work without a safelight, you will find it hard to lay out the negatives evenly on the photographic print paper in total darkness. A way around this is to carefully tape the negatives to the cover glass before turning out the lights. Then you can just tip the glass over onto the print paper in the dark (Figure 1-15) and keep everything in alignment.

Use 3M Magic Mending Tape to hold the negatives neatly on clean glass. Lay the film on the glass emulsion side up (which is the lightly frosted side

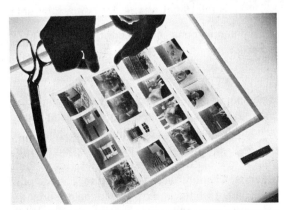

Figure 1-15: **For simple contact proof printing, tape the negatives emulsion (dull side) up to a piece of clean glass.**

of the film) and hold it in place with a small piece of tape.

Turn out the lights and open the paper package. Remove a sheet of paper and lay it, emulsion side up, on the dry work surface. It helps to have an inch-thick pad of sponge (polyfoam).

Put down the glass with the negatives on top of the paper so the negatives are held in intimate contact with the paper. Turn on the lights. If the room light is a 75 or 100 watt bulb, try turning on the lights for 10 seconds. You can count seconds easily, saying smoothly "one-thousand-one, one-thousand-two, one-thousand-three," etc.

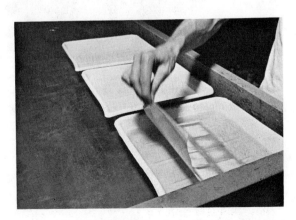

Figure 1-16: **Alternatively, the negatives can be stored in clear plastic sleeves which hold them in correct position for contact proofing. They need not be removed from the sleeves until you are ready to enlarge them.**

Turn off the lights. Place the glass and negatives safely to one side where they won't get splashed. Put the paper into the developer by laying it face down and then lifting it immediately and placing it face up. This will wet both sides. Agitate the print; lift it by one corner, then lay it down. (Figure 1-17).

Figure 1-17: **Lift the print from the developer to provide agitation. This breaks the film of liquid and when the print is laid back in the tray it rewets completely.**

This is the most even agitation you can offer the paper. It is *not* good agitation to slip the paper into the tray and gently rock the tray. The developer will slosh back and forth, but this will not be effective agitation. Lifting the print and *laying* it (not pushing it) down will provide complete removal and replacement of the developer. Do this four or five times a minute.

After two minutes, lift and drain the print. This means letting the developer run off until it stops making a stream but begins to fall in drops; almost all the free liquid has been removed and draining it longer is ineffective. Place it face down in the acid stop bath. Lift and replace three times. Drain. Place in the fixer. Lift and replace for two minutes. Turn on white lights.

Since this is a first trial print, it is not necessary to process it completely. A well-made contact proof should be processed completely; it then becomes a permanent record and a future guide to your

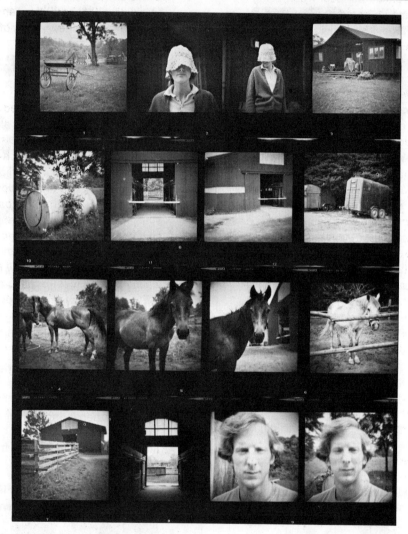

Figure 1-18: Contact proof sheet from negatives exposed with a simple camera. The contact proof sheet is both a record of what is on the negatives and also an exposure guide for printing, if it is properly exposed itself.

negatives. Right now you want just a proof to study.

After one minute, the fixer has removed enough of the unused silver so it is safe to be examined under white light. The fixer can stain garments because of the silver dissolved in it; carefully take the print from the fixer and wash it under running water for a minute. Now it can be examined.

The print will always "dry down." This means the gelatin emulsion in which the light sensitive silver is suspended will shrink as it dries, and this changes the way the picture looks. A print will be noticeably *darker*—especially in the highlights (the light grey areas)—and *flatter* when it is dry than when it is wet. Flatness is a term describing the sense of brightness of the picture. The wet print has brilliant whites and blacks; in the dry print the blacks become somewhat dull, the whites a little grey.

Because of drying down, it is desirable to dry one

print before going on with another print; when you have more experience, you will learn to estimate the effect of this.

Drain the print, wash it with tap water for a minute. Gently wipe it dry. If it is resin coated paper, hang it up with a clothespin to dry. If it is a gelatin paper, lay it emulsion side down on a clean dry towel. When it is dry, examine the print. This will permit you to see what you have on the negatives.

At first, the proof sheet will seem confusing. (Figure 1-18). It seems cluttered and it's hard to look at any single image. The individual pictures are surrounded with black. If you were not tidy when you laid out the negatives, some of the pictures go one way and some another way.

Frequently it is desirable to make two proof sheets from the same negatives. One sheet is kept with the negatives; it offers a technical information record about the negatives—their relative exposures, the sequence in which images were made, and problems of contrast. The other sheet can be cut up into little separate prints, trimmed out and glued onto file cards; these become miniatures, study prints that permit you to see what each picture looks like without the visual noise caused by the black borders and the neighboring pictures that push at your attention.

When you have made the proof print, you have completed the photographic cycle for the first time. The camera has gone out into the world and taken a picture of something that interested you; the film has been developed; a print has been made. Now, you can begin to see how the camera and film and paper **change what you saw into a photograph.** The photograph rarely resembles the vision your eye saw! Through the camera, things change; the creative photographer discovers how these changes relate to his vision. He and the camera become partners in the act of making pictures.

After you have studied your contact proof sheet, go out and expose another roll of pictures. Use the knowledge gained. See what subjects made pictures pleasing to you.

Study the following things when you examine the contact proof:

1. The subject: what kind of subject, how close they were, what angle they were seen at, and the kind of movements they showed.
2. The composition: whether the pictures that pleased you were of things seen in the center of the frame or shapes distributed over the whole area of the picture.
3. The light: direction and quality (hard, soft, from above, below, to one side).
4. The contrast: how black the shadows are in relation to the white areas of the pictures.

There are other possibilities. Find what visually excites you and then return to this with the camera. Don't try to make a picture just because it is like a "good" picture you have recently seen. The best pictures are those which are most like yourself; this discovery is lost easily if you begin to copy other photographers' work. Working "in the manner of" a famous photographer is a healthy exercise, but it is best done after an initial sense of the meaning of the medium of photography has been developed by personal trial and with the assistance of a perceptive teacher who can frequently redirect you to help you keep sight of your own vision.

Development and Printing

Film Development

A simple camera has limited control of exposure. Frequently it has only one shutter speed (about 1/30th of a second), but sometimes it does have an aperture or diaphragm which can be changed for "bright," "cloudy" or "dull" light.

Exposure is therefore approximate. But even with a simple camera the most basic rule of silver emulsions can be demonstrated. This is that **exposure controls the silver image density in the areas where there is little light,** and **development controls how dark the silver will become** in the areas where there is great exposure.

The meaning of this is important to understand. A simple experiment will reveal quickly how changing the developing time will change the silver density in the negative, while exposure is held constant.

Expose an entire roll of film on an ordinary landscape or on a simple view of the street on which you live. Make notes on the kind of light, time of day, and the season (for example—flat light, winter, noon). **Expose the entire roll of film all on the same picture.** Take this film to the darkroom and prepare to develop it.

In the dark, cut the film into four pieces. The exact length is not important. What you want is four pieces, each with one or two complete pictures. Put these pieces in a light-tight box.

Develop the film as follows:

Part 1: immerse in the developer in the tray (Dektol diluted 1:1 at 20-21°C) for 30 seconds. Agitate it constantly by moving it back and forth in the tray. Then put it into a stop bath, then into the fixing bath.

Part 2: develop it for 1 minute with constant agitation, stop and fix.

Part 3: develop it for 3 minutes with constant agitation, stop and fix.

Part 4: develop it for 6 minutes with constant agitation, stop and fix.

After they are washed, dry all the pieces and tape

them to a piece of glass so you can comfortably compare them by looking **at** them, or **through** them.

Look at the shadows: these are areas under bushes or trees, under cars, in the porches of houses, in the entrances to apartments. Look at how little change there is from the 1 minute to the 6 minute development. Figure 1-19 shows the effects of this test.

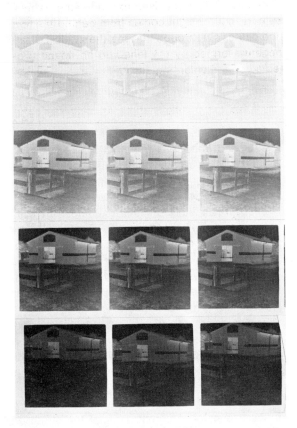

Figure 1-19: The negatives produced by exposing a roll of film on one subject, cutting it into four pieces, and developing for 30", 1', 3' and 6'. Note the way the shadow details change relative to the density in the highlights with the increasing development time.

Look at the highlights: these are areas where there was a lot of light and very reflective objects in the sunlight—white shirts, concrete, light colored brick, light colored walls, brightly colored automobiles. See how rapidly the silver in these areas becomes dark and how the longer you develop, the darker these become.

From a careful study of these four negative strips you can also begin to learn how to gauge "good" development. A negative which lets the text of a printed page be **just visible** when you hold the negative between you and the book, much as you would hold a magnifying glass, is correctly developed. (Figure 1-20). An underdeveloped negative is very transparent, the type is too easily read. An overdeveloped negative is too dark for type to be

read through the silver densities that represent the light greys and white places in the subject.

Figure 1-20: Correct exposure and development produce a negative which is "filmy" and through which one can read print, even in the highlights.

A correctly exposed negative also has faint but definite detail in those transparent areas that represent the shadows of shrubs, pavement under cars, or dark shadows inside open doors. If these do not exist, the negative is probably underexposed. (Figure 1-21). But, where these are too clearly stated, the negative is overexposed. (Figure 1-22).

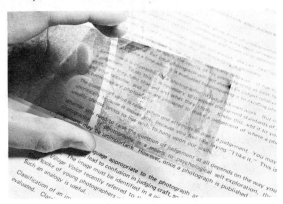

Figure 1-21: An underexposed negative has a sense of being thin, and is translucent in all parts.

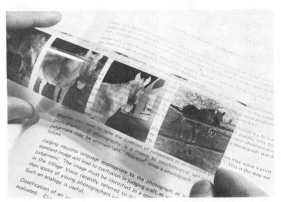

Figure 1-22: An overexposed negative is not only too dense to see through in the highlights but it also has excess opacity that isn't useful in the shadow areas.

Underexposed shadows will always produce a print that has large black areas without any detail. The effect is a graphic, melodramatic quality in the print. Overdeveloped small camera negatives will always be grainy. Then the result is a sandy texture in the grey and light parts of the print. Large amounts of overexposure will actually cause light grey areas to lose all sense of the subject's surface and texture, to become coarse and lose roundness, to look as though they were seen through a screen.

Enlarged Prints

The first print you should make is a contact proof print. Subsequent prints may also be contact prints; but in our time these are rare because the small camera negative makes a small print. Most of the time we desire a silver print larger than the negative. When the picture is a reproduction in a book, we easily accept this size of print, but then the scale of the image is controlled by the context of the book itself. Prints seen for themselves are usually larger.

An enlarged print requires an enlarger. These are, in effect, reversed cameras. (Figure 1-23). The geometry of film and lens are the same as in a camera, but the light comes from behind the film and passes out through the lens; the shadow of the negative formed by the lens into an image projected on the enlarging easel.

The Camera and the Enlarger

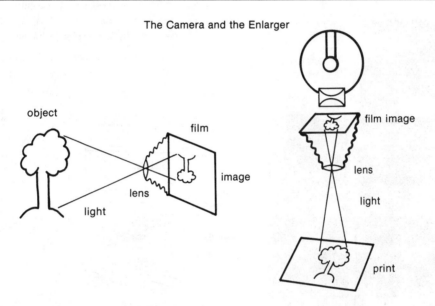

Figure 1-23: **The camera and the enlarger are quite similar. The camera takes in light to form an image. The enlarger projects the light out through a negative, forming an image. Cameras used to be made which were convertible into enlargers with the addition of an illuminating back.**

The price range of enlargers is as great as that of cameras. A cheap enlarger can be purchased for less than a hundred dollars; the best laboratory models (even for 35mm) cost several thousand dollars. The difference is in precision of the parts, the design of the lens used, the rigidity of the frame that holds the enlarger head, the accuracy with which the film is held parallel to the paper, and the evenness and type of lighting system, which ranges from point source to diffusion grid.

Precision and design makes it possible for a negative to be used in the enlarger, removed, and another placed there for printing—all without having to refocus. A high quality lens makes possible a print which is very sharp out to the corners, in black-and-white or color, with the same exposure at the corners and in the center of the paper. A rigid frame means the picture will be sharp, have proper contrast, and be in constant focus because there is no motion during the exposure. Accurate construction assures the film and the paper stay parallel so the print will be sharply in focus, even with the lens at maximum aperture (fully open).

A well-designed enlarger has an even field of illumination. Enlargers made before 1960 often had uneven fields; the negative was more brightly lighted in the center than at the edge. Even today, some cheap enlargers have "fall off" toward the corners. This is also true of lenses used for enlarging. Cheap enlarger lenses often transmit more light in the center of the field than at the corners and are less sharp at the edges than the center. The print has lighter corners (greyer) and is unsharp near the edges.

Preparing a Darkroom

The enlarger permits a small negative to produce a big print. The limits to size are both mechanical and aesthetic. Mechanical in that each enlarger-lens-film size combination have a maximum **and** minimum image size possible with normal equipment. For most enlargers these are about 1:1 and 15:1. This means the print can be from the same size to fifteen times the original size of the negative.

The enlarger (Figure 1-24) consists of a light source; a film stage, where the negative is supported in the light path; a focusing device; a lens; a vertical support that permits positioning the enlarger at various distances from the easel; a baseboard that is parallel to the film stage; and a switch to control the light. The quality of the parts largely determines price.

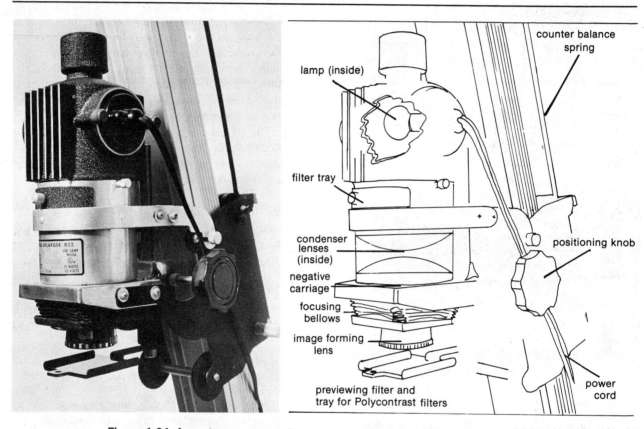

Figure 1-24: **A contemporary medium-price enlarger, and its component parts.**

The enlarger should be placed on a firm level support, with enough space around it to place negatives, printing paper and the other tools of photoprintmaking that are required.

Figure 1-25 shows an enlarger work area. Note that you are looking across the sink with photographic trays to the enlarger. The darkroom is divided into **wet** areas and **dry** areas. The enlarger is in a dry area, where chemicals are not going to spoil negatives or printing papers.

The darkroom need not be a bleak place. The serious photographer spends a lot of time there; it should be a pleasant place to work. Ways to guarantee that it stays pleasant are:

a) have good lighting—install safelights near the enlarger and over the sink so that you will not have to work in your own shadow;

b) separate wet and dry areas so the inevitable

splashes and spills will not damage precious materials;

c) make the darkroom so it can be kept neat, free from dust, dry, and at a comfortable temperature.

d) provide for ventilation—a stuffy darkroom will always limit your working ability;

e) be sure your counters and sink are at comfortable heights; avoid unnecessary fatigue.

If it has a concrete floor, buy a rubber mat to stand on. If it is in a basement and tends to be damp, use a dehumidifier. Your own physical comfort is usually provided for by the same conditions that are best for films and papers.

Fortunately for the amateur photographer, special darkroom equipment is now available at moderate cost. BURKE & JAMES (2434 West Sibley Blvd., Posen, Illinois 60469) sell the Porta Sink (60''x24''x6'') and the Porta Sink, Jr.

(47"x20½"x5"), plastic prefabricated sinks that are easy to install. They can be plumbed to drain into an existing sink or be installed permanently.

A sink can be used without running water, in which case it becomes simply a "wet" area, and all washing is done elsewhere. A bathroom can be used for washing; a piece of ¾ inch plywood placed across the bathtub can be made into a washing platform for a print tray.

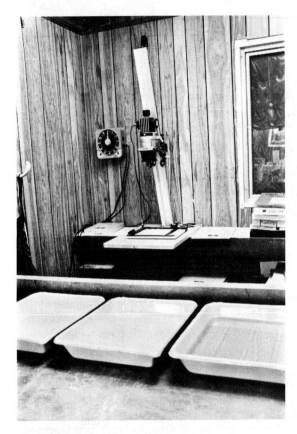

Figure 1-25: **A darkroom work area, looking across the sink to the enlarger. Darkrooms may be much more fancy, but all that is necessary is a light-tight room, with electricity, preferably with running water, and room to establish wet and dry work spaces.**

Basic equipment for the darkroom:
a) the enlarger, plus lens, film carriage and paper easel,
b) the sink and photographic trays,
c) safelights and timer (which can be simply a clock with a sweep second hand),
d) a light-tight space.

Some darkrooms are simply kitchens or bathrooms and can be used only at night. Sometimes little used spaces can be converted, for example a connecting hallway, or a large closet.

When you have created a trial darkroom (and you will find your definition of a "good" darkroom will change frequently), prepare it for printing. Mix all chemicals a day ahead of time, both so they can come to working temperature and so the chemicals are completely mixed. Set out trays in working order.

First tray: *Developer,* diluted 1:2 (one part developer stock, two parts water, all between 20-22° C).

Second tray: *Stop bath,* water with acetic acid (sometimes made with a ph indicator called Indicating Stop Bath by Kodak).

Third tray: *Fixer,* mixed to paper strength.
Fourth tray: *Water.*

The water tray is used to store the fixed prints for a few minutes after fixing. As each print is added, this solution becomes a weak fixing bath. While the fixer removes unused silver salts, it also unfortunately eventually etches away some of the dark silver image. About every half-hour the fourth tray should be emptied and the prints stored there moved into a print washer.

The simplest print washer is another tray. The Kodak Print Washing Siphon (Figure 1-26) is an effective and economical device which transforms a plain tray into an effective print washer. Hooked to a water tap, it allows water to flow vigorously into the tray and at the same time draws water from below the surface and pump-siphons it out. It will maintain a constant volume and circulate the prints in the water so they are well washed, provided there are not too many prints for the size of the tray. A rule of thumb is the washing tray should be at least the next larger size than the prints being washed. A tray for 8 x 10 inch prints should be at least an 11 x 14 inch tray.

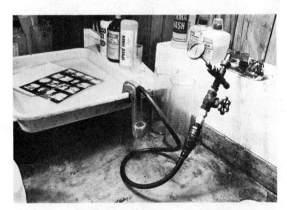

Figure 1-26: **The Kodak Print Washing Siphon is an economical way to wash a few prints at a time. The water flow must be vigorous, and the prints must stay in constant motion. Store extra prints in a tray of water until they can be washed. Don't put prints fresh from the fixer in with prints that are being washed.**

A hypo eliminating chemical should be used when all the day's prints are made. This may be the Kodak Hypo Clearing Solution, Heico's Perma Wash, Orbit Bath, Sprint Fixer Remover or some similar chemical solution.

The negative to be printed is placed in a **negative carrier** which is usually two metal plates (Figure 1-27) sandwiched together which hold the negative flat and still just below the light source of the enlarger. The emulsion side is normally **down** toward the baseboard of the enlarger. This way the light will pass through the negative and the lens and form an image on the paper with the same left-right relationships that existed in the original subject. Place the negative carrier in the enlarger, turn off the white lights, turn on the enlarger, and adjust the projected image on to the easel. Adjust the height of the enlarger to produce approximately the size of picture you want. Adjust the lens so it is fully open, and focus the lens to make a sharp picture on the easel.

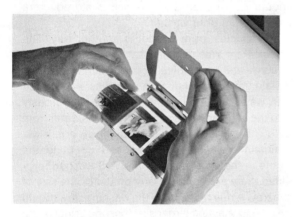

Figure 1-27: **Negative carrier for the enlarger illustrated in Figure 24. Similar carriers are used for other enlargers. It holds the negative flat, and locates it properly in the light-path for correct illumination and even focusing.**

When the lens is open, the picture on the easel is bright. Modern enlarging lenses are made so the "f numbers" are illuminated and easy to see in the darkroom. (Figure 1-28). As the lens setting is turned, the lens closes down, the projected picture

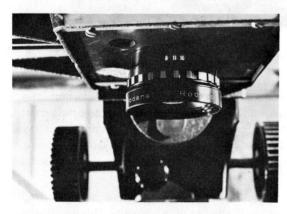

Figure 1-28: **Illuminated f-numbers on a contemporary enlarging lens. These make work in the darkroom easier, but like other luxuries, are not essential.**

grows dim, **and the numbers get larger.** The numbers used to indicate the lens opening (by a convention established years ago) are actually the denominator of a fraction: f=Focal length of lens.
diameter of lens

So as the effective diameter decreases in size, the f-number increases. Modern lenses have a diaphragm controlled by a ring of metal that has a tiny detent or click-stop; it can be felt when the control ring is moved from one f-number to the next. This is an exposure unit, which is defined as a 2:1 change in brightness. This change of brightness is a 2:1 change of area of the lens opening.

A change of 2:1 in brightness of the image passing through the lens is also called a "stop change." **Stopping down** describes a decrease in light. **Opening up** describes an increase in brightness of the image. Since each click stop is a 2:1 change of light, a useful relationship is possible between diaphragm and shutter speeds—which are also established as 2:1 changes.

This reciprocal relationship is very important because it is used in all photographic equipment design. If you wish to increase the time required to expose an image onto the paper, you can **stop down** the lens; each stop decrease in brightness will then require a **doubling** of the time. One stop =2x; two stops=4x; three stops=8x the original exposure. All of these are essentially the same total exposure. This leads to the rule that **Exposure=Intensity x Time.** If one doubles the time and halves the intensity, the exposure remains constant.

Knowing this, focus the enlarged image with the lens wide open. Then as a starting point, **stop down three stops.** Turn off the enlarger and the white lights, place fresh photographic paper face up on the easel. Expose it in sections, or strips, making the exposures start at five seconds and increase five seconds for each additional strip.

The problem arises, what kind of paper? Use a **normal contrast** grade, **smooth** surface paper. The contrast grade that is "normal" varies from one manufacturer to another, but you have to start somewhere. Try Kodak Kodabromide F-2 or Ilford Ilfobrome Glossy No. 2; after a few days you will have acquired some sense about the process and know if you want to stay with that paper or try another.

The paper should be exposed by covering all but a strip of projected image about 2 inches wide (Figure 1-29); at the end of five seconds, smartly uncover another 2 inches of image; after another five seconds uncover another 2 inches, and so forth till the entire print has been exposed in five second strips. Turn off the enlarger. This exposure will produce an invisible but real image in the silver salts on the paper; this image will be in strips having exposures of 5, 10, 15, 20 and perhaps 25 seconds.

Figure 1-29: **Exposing a test print in strips. A piece of cardboard is used to block light from the printing paper. It is moved at regular intervals to uncover more of the paper; this way a continuous exposure is made, and the test closely relates to actual printing conditions.**

Develop this print in the same way you developed the contact proof. Stop the development after 1½ minutes. Fix the print for at least a minute. Wash it with water to remove the excess hypo and examine it under white light. Do not drip on your clothes or on the floor, although the brief wash will minimize stains that result from the silver in the fixer turning dark brown. Silver stains usually do not appear until after clothes are washed and heat dried.

Figure 1-30 shows a typical proof print. The exposures used successfully **bracket** the desired exposure. At one side the print is too dark, at the other too light. One of the middle strips is very nearly right—for your first interpretation of the negative.

A negative is an image source, one which can be interpreted many ways. It may be used to produce

Figure 1-30: **An example of a strip proof print showing exposures that bracket a "correct" printing. Individual taste controls which exposure would actually be used.**

dark or light prints, or prints that are "flat" or "contrasty" depending on your taste, your understanding of the medium and the visual statement desired. Figure 1-31 offers four interpretations of the same negative, showing light and dark interpretations. Which is most right? It depends on your taste and on certain conventions of photographic printmaking. First prints made by a beginning photographer are frequently very contrasty and tend to be dark because contrast produces **graphic**

strength and because beginners can't estimate changes in the wet print as it **dries down,** loses brightness as it dries.

Examine the strip proof. Choose the time that seems closest to what you think a correctly made print should be. Return to the enlarger and make a new print. Use the exposure time chosen from the test for the whole print. Develop this print for 1½-2 minutes. During the last 30 seconds watch how the image becomes tonally rich. Don't pull the print

Figure 1-31: Four different versions of the same negative. A "correct" exposure is determined by personal taste. These prints range from light to dark, but any one of them is "usable."

from the developer because it looks too dark! The eye is often fooled by the safelight. Keep the print in the developer at least 1½ minutes before draining it and wetting it in the acid stop bath.

Examine the full-frame proof print you have just made. Wash it off, gently sponge the excess water off. If you have used a resin coated paper, hang it in a warm dry place to dry. When the surface is firm to the touch, examine it again. Attempt to see how much darker the subject's highlights (the light grey areas of the print) have become as the print dried and the emulsion dulls. The image loses brilliance as it dries: *the highlights grey down and the blacks become flat.* When you have seen this happen, return the print to the wash water and see how it lightens again and the blacks again become brilliant. Try to remember what this looked like; if you can, you will soon be able to estimate how much "too light" a wet print must look to dry down to the "right" tone for the print you want to make.

Printing Contrast and Local Controls

"Contrast" is a way of describing the relative tonal scale of the print. The print with a rich sense of overall detail, made from a properly exposed and conservatively developed negative, is usually printed on a "normal" contrast grade of paper. The same negative can be printed on other contrast grades. Figure 1-32 shows prints from the same negative made on high, normal and low contrast grades of paper. These have been exposed for similar highlight detail. They show the effect of the contrast characteristics built into the emulsion.

A high contrast paper emphasizes graphics; it tends to eliminate highlight or shadow detail, to accentuate shapes. A low contrast paper reinforces the tonal possibilities of the picture; it minimizes the sharp graphic elements of the picture. And a "normal" or medium contrast paper offers a rich tonal statement, a balance between the graphic and the linear elements of the photograph.

Contrast control can be viewed either as a means of bringing negatives of varying contrast to a normality, or as a way of printing negatives in more interesting ways. The first is a technician's attitude, the second is an artist's.

Contrast in photographic paper is controlled by the emulsion itself, and affected by the developing time, the composition of the developer, the agitation of the print during development and the temperature of the developer.

It is difficult to describe the results of changing contrast grades of paper in terms of right and wrong or good or bad results. The "correct" contrast grade is one which produces the visual effect desired. A beginner often strives for effect rather than attempting to achieve a balanced result. A

Figure 1-32: **A negative printed on three different contrast-grades of paper. The exposures were adjusted for nearly identical highlights (the detail in the white wall). The decisions as to which of these is "right" is a personal judgement.**

high contrast print is usually more graphic; often it has a greater initial impact than a tonally rich photograph. But, the ongoing vitality of a photographic print does not depend on immediacy so much as it depends on a richness of tone. Tonal quality often implies various kinds of meaning; the viewer returns to it many times and on each occasion discovers new visual statements.

PRINT CONTRAST CONTROL

	To increase contrast:	To decrease contrast:
Developer	Use full strength, or change formula*	Increase dilution, 1:2, 1:3, 1:4; change formula*
Agitation	Constant agitation	Very little agitation
Temp.	Increase temperature to 24-26°C	Decrease temperature to 18-20°C
Time	Increase to maximum of 5 minutes	Decrease to minimum of 1 minute
Paper	Use a higher contrast grade (#3, 4, 5, 6)	Use a lower contrast grade (#1, 0)

*The chemicals used to compound the developer will be explored in **Advanced Controls.**

When a picture has "punch," it often lacks staying power. Yet there are places where impact is obviously more important than detail which invites contemplation. Advertising and news photography are obvious examples of this. Because these are problems of interpretation, the first choice of contrast grade for a given negative will be defined here in terms of achieving a full tonal scale print.

To demonstrate this for yourself, study your contact proof sheets; take a negative that has interesting highlight **and** shadow details. Place it in the enlarger. Make a strip test print as described earlier. Develop 1½ minutes, stop, fix, and rinse. Under white light find the exposure strip which has **normal looking detail in the highlights.**

Highlight detail in the print corresponds to the densest (darkest) places in the negative. **The dense areas of the negative control the exposure of the print.**

Examine again the strip you feel has correct highlight densities. This time look at the shadows in that print. Decide which of these conditions they represent:

a) They are fully detailed, but grey.
b) They have a sense of full detail and in the darkest places seem black.
c) They have little or no detail and are mostly black.

Figure 1-32 shows reproductions of prints that are examples of these conditions. These reproductions cannot be exactly like the original silver prints—they are halftone reproductions and are offered only as guides to what you should find in your prints.

The first print in Figure 1-32, with grey shadows, needs more contrast, **not** more exposure. The second print is "correct" or "normal." The third is "too contrasty" and should either be printed on a lower contrast grade or developed less time, for less contrast.

Returning to your own photograph, examine your print's contrast. If the contrast seems wrong for the negative, you can change the contrast by changing paper from one contrast grade to another. If your test print is light grey in the shadows, make a new strip test print using the next higher contrast grade of paper. (If you use Kodak or Ilford paper, a normal grade is 2. If you use Agfa, #3 is normal. If you use Polycontrast, exposing with contrast control filter #2 is about a normal contrast.)

If the shadows are black when they should have detail in your photograph, make the next test print on a lower contrast grade. You will find as you make new strip test prints, higher contrast papers require longer exposures and lower contrast papers need shorter exposures to produce highlight details of similar tones. This is an extension of the idea already stated: print exposure controls highlight details. The contrast grade of the paper largely controls shadow detail.

Shadow detail is also controlled by print developing time, agitation during development, and temperature of the developer. Figure 1-33 compares prints made with vigorous agitation and with no agitation. Agitation increases separation of adjacent tones and permits the black areas of the print to be as dense as the paper itself permits.

Figure 1-34 shows how the maximum blacks and whites of a print are controlled by the paper itself. The whitest white a print can have is determined by the color and reflectivity of the paper supporting the gelatin emulsion. Light passes through the gelatin and reflects from the undercoating. If the emulsion is cloudy or discolored, the sense of whiteness is marred. Discoloring happens when developing and fixing chemicals are overworked; it also occurs when the print is not agitated in the stop and fixing solutions.

Agitation is necessary in all three baths. The quality of black is determined by the light ab-

Figure 1-33: **A print developed with no agitation, and a print from the same negative developed with regular agitation.**

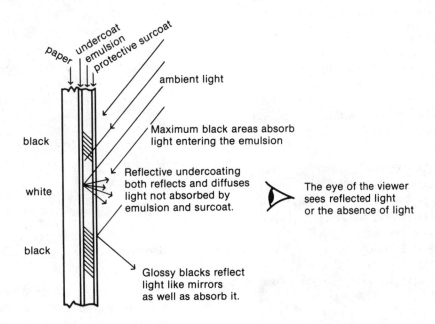

Figure 1-34 **The print emulsion reflects light in a complex way as shown in this cross-section drawing. The quality of the blacks and whites is determined by the way light is absorbed or reflected.**

sorbed, which is controlled by the characteristics of the paper. The blackest black is created by careful exposure and development. Curiously enough, silver emulsions can be *overexposed,* producing a less absorbent black than correct exposure. But, for a given exposure the quality of the black will vary with agitation, and also according to the developer and fixer used.

Leaving a print in the fixer longer than necessary will weaken blacks, will remove some of the silver of the image. This is called hypo bleaching; both the highlights and the shadows lose silver. The highlights become pale and the shadows lose crispness.

Sometimes changing contrast grades is not the right answer for a printing problem when there are dark areas of the picture which are of themselves normal in contrast, as are the light areas; but the overall density range is too great for a normal paper. In effect, one has a normal but thinly ex-

posed negative in the shadows and a normal but densely exposed negative in the highlights.

The solution to this kind of problem—and it occurs very frequently—is to mechanically vary the light from one part of the negative to another. Light may be held back from a part of the picture during the exposure. This is traditionally called **dodging.** Figure 1-35 shows dodging. A simple cardboard tool and the hand are used as very flexible dodging tools.

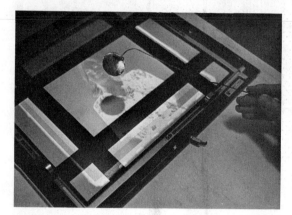

Figure 1-35: **"Dodging" a print during exposure to hold back light from shadow areas that otherwise would print too dark.**

Light can be added to a dense area after an overall exposure has been completed. This is called **burning in.** Figure 1-36 shows hands are used to make a flexible mask to add light to a small, dense area of the negative—without increasing overall exposure.

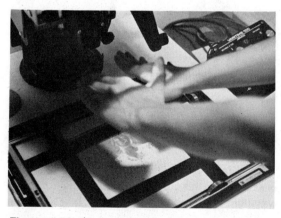

Figure 1-36: **"Burning in" part of a picture during exposure, which means adding light to some areas by masking out the rest of the print.**

Burning and dodging are ways to control locally irregular densities, ones not easily corrected by using different contrast grades of paper. Figure 1-37 shows a comparison of a "straight" print, one in which the exposure was made without local mechanical controls, and a print where dodging and burning were used locally to modify densities.

Figure 1-37: **A first print from a simple camera negative, made with no manipulations during the exposure.**

B: **A finished print from the same negative, with dodging and burning controls used to modify the tones of the print.**

Figure 1-37 also shows schematically what controls were used to achieve this result. Note the arrows which indicate movement of either the dodging tool or hole in the burning-in mask. Unless you want to see a sharp shadow line or a bright edge, never hold any controlling device still. Moving the mask smoothly and steadily will permit local density changes that are undetectable. Generally, any control that calls attention to itself in the finished product is considered undesirable.

Here is a demonstration of these controls you can do. Take the negative which you have proofed on a higher-than-normal contrast grade of paper and expose a print to produce correct highlight densities. The shadows will be too dark, lacking

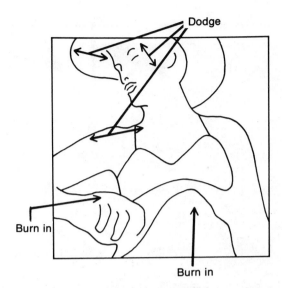

Dodge

Burn in

Burn in

C: **Sketch of the picture, showing the areas that were treated by burning and dodging, and the direction of the tools (dodging was done by using a cardboard circle taped to a piece of wire, burning in was done by using the hand to hold back light from the rest of the picture).**

detail. Make a straight print with no local controls, fix and rinse and lay it wet on a piece of glass or the bottom of a tray where it will be easy to study while printing but still be in the wet area of the darkroom. Examine the dark areas and imagine how you would move a dodging tool so as to evenly "paint" a shadow during exposure through those areas. This will lighten them without changing the highlights.

Turn on the enlarger without print paper on the easel. Take the dodging tool and practice moving it smoothly through the bright light, holding back light from what will be shadows in the print. Start just outside the picture at one edge and move the cardboard disc smoothly over all the shadow area, not stopping, not hesitating, always moving and always thinking how to paint with shadow *all areas equally, through time.* Having rehearsed the dodging pattern, put paper on the easel. Make an exposure for correct highlight detail. As soon as the exposure starts, repeat the dodging gestures you rehearsed. Continue these through the total exposure time. Develop the print, fix, rinse, and compare it to the wet straight print you made first.

It is possible you dodged, or held back too much light. The shadows may be thin. This is hard to predict without experience—trial and error. As a general practice, try to correct a printing problem by attempting to make the opposite error on the next print. If the first print is too dark, it is more economical to try to make the next print too light than to try to hit the *exact* exposure on the next try. Overcorrecting an error produces a print that is useful because then a third print can be made that

splits the difference and which should be very close to what you desire.

In the same way, don't make more than four prints from a negative in any printing session. The reasoning is this:

Print number 1: Strip test to locate exposure time for highlights and estimate contrast grade.
2: Overall view of negative to validate choices of time, contrast and development.
3: Trial dodging and burning to balance highlight and shadows.
4: Attempt at a finished print, incorporating 1-3.

Beyond this one tends to repeat and to make insignificant, tiny changes that will often not be visible when the prints have dried. Stop work on this negative and start again on another.

Papers are made in two ways. One type has fixed contrast grades. The other type is special paper that has two emulsions—intermingled, one high and the other low in contrast. These different emulsions are sensitive to different colors of light. Each manufacturer has a filter system suitable to their paper. If you use a variable contrast paper, use it with the correct filter system. Throughout all these demonstrations, the variable contrast papers can be substituted for numbered paper grades if the correct filter is used.

Film Exposure

Film exposure is controlled by the diaphragm and the shutter. These two mechanical controls affect the *amount* of light that can pass through the lens and the *length of time* light is allowed to affect the film. Even the simple camera has a shutter which opens for the light then turns it off again, and a diaphragm that limits the size of the lens opening.

Once you move from a simple camera to a more complicated one, more exposure decisions must be made. Since the exposure is the product of exposure time and the size of the lens opening, the exposure can be viewed as a technical problem. But, it is also always an aesthetic problem.

The size of the lens opening affects focus as well as exposure. The larger the diaphragm opening, the smaller the depth of field of focus. "Depth of field" is a technical term. In effect, it describes what appears to be acceptably sharp in the picture. Figure 1-38 shows a scene in which the foreground is not sharp. A large aperture was used (and a very short shutter time). The same scene was rephotographed in 1-39, but a small aperture was used (and a correspondingly longer shutter time). The result is the woman in the foreground is as much in

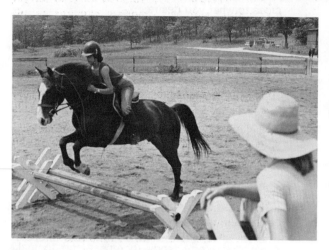

Figure 1-38: **A large aperture and short shutter speed produces a narrow depth-of-field. The horse is sharp, but the foreground isn't.**

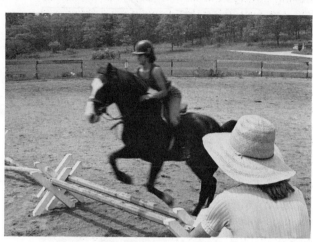

Figure 1-39: **A similar scene, with a small aperture and slow shutter speed. All parts of the picture are equally sharp, though the horse is now blurred because of the slow shutter speed.**

focus as the trees; the necessarily slow shutter required by the reduced aperture causes the moving horse to blur. Another way of looking at the same problem is to say that at a given lens opening one must choose what parts of the subject that will be in focus.

Obviously, exposure and focus are interlocked. Film exposure is a product of exposure time and the effective opening of the lens (also called the aperture, or the diaphragm setting). Depth of field, or how much of the picture appears to be sharp, is also controlled by the aperture. The smaller the aperture, the greater the depth of field. However, the smaller the aperture, the longer the shutter must remain open.

Obviously, exposure and focus are interlocked. Film exposure is a product of exposure time and the effective opening of the lens (also called the aperture, or the diaphragm setting). Depth of field, or how much of the picture appears to be sharp, is also controlled by the aperture. The smaller the aperture, the greater the depth of field. However, the smaller the aperture, the longer the shutter must remain open.

Modern cameras offer exact depth of field information. Look at the top of the lens on your camera (Figure 1-40) and you will find a mechanically coupled "depth of field scale." This consists of lines symmetrical about a center mark. This center mark points at the distance at which the lens is most sharply focused. When you set a "far" distance by an f-number to the left of center, you can immediately find a "near" distance by the same f-number to the right of the focusing mark.

For example—with the 35mm lens shown, the optical infinity mark (∞) is set against the f-16 mark. These marks are in fact color coded to match

the f numbers on the lens. The nearest distance that will be equal in sharpness to the farthest *and* in acceptably sharp focus will be about 4½ feet.

If the far distance is moved to the f/5.6 mark, the near distance of equal sharpness will move away from the camera to about 20 feet. The range of distances which will appear in equally sharp and acceptable focus will decrease.

Figure 1-40: **Illustration of depth-of-field scale on a 35mm lens.**

Look through the camera and focus on the nearest object that should be sharp. Now look at the top of the lens and move the focusing ring until the distance that had been at the point of sharp focus now lies by the f-16 mark. Look through the camera again, but now focus on a far object that must be sharp. Look at the top of the lens and note what that distance is. Now, reset the near object distance to the right hand f/16 line and then discover where the distance of the far object lies on the left hand scale. *If* the distance you measured by

looking through the camera lies on or inside the f/16 line, everything you want to have sharp will appear to be sharp in the picture if the exposure is made now, without refocusing the camera.

Look through the camera again. With the lens wide open, most of the picture will appear to be unsharp! But when you take the picture, a modern camera will automatically stop down to the aperture you have chosen — in this case f/16. The important objects will be equally sharp, because you have used the depth-of-field scale correctly, placing near and far subjects within the bracket of f-numbers being used.

But let's say that when you tried the far distance on the scale it was beyond the f/16 line. This meant that far objects would appear to be less sharp than near objects. Now, a decision is needed: since the lens won't stop down any more, what should be made to look sharp—near or far? If near, then the lens is set correctly. If far, then the far distance is moved to align with the f/16 mark and the near distance will lie outside the bracketing lines, meaning the near objects will be unsharp.

Most small camera photographs are probably made without any concern for this kind of precise near-far juggling. A subject is chosen; the camera is focused; an exposure is made. In this case the diaphragm is used only as an exposure controlling device. The small f-numbers are used when a very short shutter speed is needed (to stop motion) and the large numbers (small openings) are used when greater depth of field is desired and a relatively slow shutter speed can be accepted.

Depth of field is affected also by the focal length of the lens used. Most modern cameras permit changing the lens simply and quickly. Changing lenses also allows you to choose different perspectives.

The focal length of a lens is the distance from the optical center of the lens to the film itself, when the lens is focused on far objects. Lens focal length is measured in millimeters and described according to the ratio of the focal length of the lens to the film compared to the diagonal measurement of the film frame. Figure 1-41 sketches this. Traditionally a "normal" lens is one where this ratio is approximately 1:1. For 35mm cameras a "normal" lens has a focal length of 50mm.

A "short" lens is one with a ratio less than 1:1. And a "long" lens has a larger ratio. A short lens is also a "wide angle" lens; it has a wide field of view. A long lens is also a "telephoto" lens; it has a narrow angle of vision. Figure 1-42 sketches the relationship between lens lengths and the angle of view. Figures 1-43, 44, 45 show the same subject photographed from the same place with lenses of increasing length. These show how the perspective of the picture changes as the lens length is increased.

A moderate wide angle lens of 35mm focal length was used in Figure 1-46. The field of view is about what one would see standing behind the camera if your head is held still but you permit your eyes to move a little. Without changing position, a 50mm lens was placed on the camera and Figure 1-42 was exposed. This is a "normal" focal length

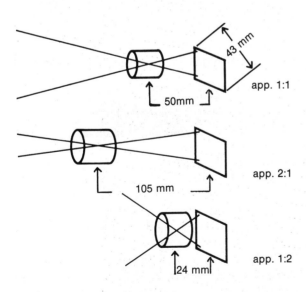

Figure 1-41: This sketch shows how the focal length of the lens is related to the diagonal measurement of the film frame being used to define "normal," "long" and "wide-angle" lenses.

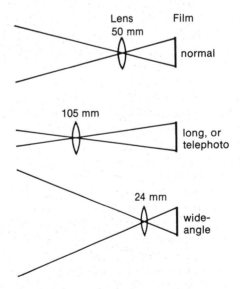

Figure 1-42: As the length of the lens increases, the angle of view is narrowed, as shown in this drawing.

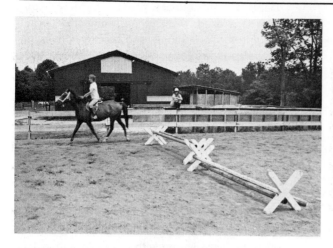

Figure 1-43: A wide angle lens field of view.

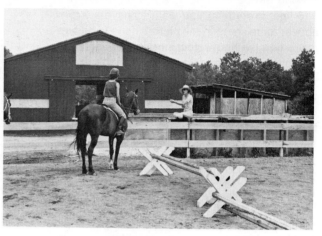

Figure 1-44: A normal lens field of view.

Figure 1-45: A long lens field of view. Note how perspective changes in these three figures.

lens for a 35mm camera. This field of view is close to what the eye sees if one stares straight ahead, with no eye or head movement. And Figure 1-48 shows the view of a 200mm lens. The perspective is similar to that seen when we concentrate, focus on a particular object and exclude surrounding detail.

These demonstration photographs were exposed at the same aperture and shutter, about 1/125 at f8. Studying them, note that the horse in Figure 1-43 is blurred at this shutter speed; the blur is maximum because he is traveling across the field of view. The depth of field does not change much between Figure 1-43 and 1-44, but is very shallow in Figure 1-45. The long lens isolates the subject both by excluding surrounding detail and also because it has less depth of field at a given distance and f-number than does a shorter lens.

The depth of field is affected not only by the aperture number but also by the length of lens. A short lens has greater depth of field at a given

aperture number than does a long lens, focused to the same distance, set at the same aperture, or f-number.

The exposure is the light that reaches the film. As can be seen from these examples, exposure is controlled by the shutter and diaphragm. Though these are mechanical controls, each is in turn evidently affected by aesthetic decisions: what in the picture will be focused sharply? What will be blurred or stopped? What objects will be equally sharp? What will be isolated, visually underlined? As is evident, these way of describing exposure controls affect the meaning of the picture.

The total exposure needed is ultimately affected by the film itself. Film emulsions have differing sensitivities, both to light energy in general and to specific colors of light. And the overall sensitivity of a film relative to the density produced varies to some degree with development. This is most important because it affects **contrast,** or the change

Figure 1-46: **A wide angle lens field of view.**

Figure 1-47: **A normal lens field of view.**

Figure 1-48: **A long lens field of view, illustrating the diminishing field of view as the lens length is increased.**

of silver density produced by a given change in image brightness.

Film emulsions and paper emulsions are similar. Both are silver salts supported in a gelatin coating. Film emulsions are supported on transparent materials and print emulsions are usually coated on opaque white paper. Film emulsions are usually lower in contrast than paper emulsions. And film emulsions rarely are developed as completely as paper emulsions.

The reasons for these differences are that the film emulsion is a matrix from which many prints can be produced. One rarely looks at the film as a finished object—it is a means to the print. The print is usually the finished object, and so it is developed fully, producing very black silver areas and very clear, white paper areas where these are desired.

The film matrix inherently needs much less contrast (density range from darkest to lightest) because this range is exaggerated when seen in the print which it produces.

Each film emulsion has a specific character. The terms that are widely used to describe these are **grain, speed, contrast.** These terms relate in this way:

a **high speed** emulsion tends to be low in contrast and have large grain;

a **low speed** film tends to be high in contrast and have small grain.

These relationships happen because a large silver salt particle captures light enough to become unstable, to produce an image with chemical development, more easily than does a small silver salt crystal. This gross simplification of the process is

true enough to help one understand why film that is very sensitive to light (or is "high speed") is appreciably more "grainy" than is low speed film. Slow film has much smaller silver halide crystals, which produces a finer grained negative.

The developer used to make the picture visible will also affect the apparent size of the silver grain because it changes the shape or contour of the silver crystals during development. There are developers which are called "fine grain." Other developers produce a more noticeable grain pattern. Neither kind is better or worse than the other— each produce different photographic results and each effect is a tool for the creative photographer.

"Fine grain" is a term often used to describe smoothness of tones in untextured areas of the image, like clear blue skies. But a "fine grain" developer may not be the best developer to use when richly textured subjects are photographed.

A fine grain developer usually has chemicals which actually dissolve the sharp edges of the silver as it is developed. This reduces the visibility of the individual silver particle; it makes a smoother aggregate image. The price paid for this polished effect is diminished clarity of tiny individual details. By analogy, weathered wood has sharply defined textures; smooth out that piece of wood with sandpaper and the result is a surface without sharp detail but with a smoothly modulated pattern; individual pattern details are minimized. Alternatives to fine grain developers are solutions which develop with high acutance, and those that are called high energy developers.

"Acutance" is a term used to describe apparent sharpness, the resolution of detail. As in the weathered wood analogy, a smoothed-out surface does not offer as much sense of detail as the crisp weathered wood before sanding. High acutance developers have little or none of the chemicals that act as silver solvents used in fine grain developers, that dissolve the sharp edged tendrils of silver even as they are being formed.

Finally, high energy developers produce more useable silver for a given amount of exposure and are important when a useful image is needed regardless of the specific quality of the detail. They make grainy pictures available in dim light. In tabular form:

Each of these developers produce useful and consistent results if the development time, the temperature of the solution, and the agitation are kept constant. The amount of silver developed is a product of the exposure **and** of these developing controls. Shadow areas in the negative, where there is little exposure, do not grow denser at the same rate as the brightly lighted parts of the picture. Though shadows remain relatively constant, highlight densities increase with increasing developing time, increased temperature, and increased agitation.

Agitation is needed to pump fresh developer into the emulsion at regular intervals, forcing out exhausted solution and chemical wastes. Agitation should be regular, and consistent. More agitation produces more contrast overall, but proper, controlled agitation is needed simply to replace exhausted developer in the emulsion and to prevent development streaks from forming. Each kind of film has its own sensitivity to light, and its own kind of response to different contrast situations. Some films are quite sensitive, some are not. Some are inherently high contrast, others are low in contrast. These different kinds of film each have special uses. The films offered for beginners to use, Kodak's Verichrome Pan, for example, are medium speed films with a rather low contrast response to the kinds of lighting expected. These characteristics reflect the expectations of the manufacturer, developed out of many years of experience in making and selling film for the amateur market.

Before the end of the last century, many photographers thought film had rather magical qualities, and the inherent sensitivity of film could be modified by special darkroom magic. A Swiss and an English team of chemists, Hurter and Driffield, developed standardized ways of testing photographic emulsions, and changed all that. They proved that an emulsion exposed to a standard light source, and developed in a standard developer would produce a certain amount of silver in the shadows and a certain amount in the highlights. If one is careful, repetition produces this kind of repeatable performance from a film and development becomes a dependable tool, rather than something magical.

CHARACTERISTICS OF POPULAR DEVELOPERS*

Fine Grain	High Acutance	High Energy
D-76, 1:1	D-76, 1:4	----------
----------	Rodinal 1:100	Rodinal 1:25
FG 7 1:15 w/sulfite	FG 7 1:15 w/water	FG 7 1:3 w/water
Microdol X 1:3	----------	----------
----------	----------	Acufine
----------	Ethol TEC	----------

*Developers are often mixed or sold as concentrated liquid stocks, and then diluted just before using. The ratio of concentrated stock to water is stated as 1:1, for example, meaning one part developer to one part of water. 1:4 means one part developer to four parts of water.

Hurter and Driffield's work led to the development of numbering systems to indicate the sensitivity of film to light. During the early years of this century there were many different systems. Each meter manufacturer had his own system, and for a time the photographer had to learn the numbers for the GE, Weston, Scheiner, and other makers of metering equipment. Recently, these have all been brought together into two international systems of numbering photographic emulsions. These are called The DIN & ASA numbers (D for Deutsche, A for American).

In Europe, the DIN numbers are used. In America, the ASA numbers. But these are related as shown on the following table. Fortunately, there are also relationships between film sensitivity (also called film *speed*), contrast, and grain:

FILM NAMES	ASA	DIN	SPEED	CONTRAST	GRAIN
Pan X, Pan F	25-50	14-17	very low	high	very fine
Plus X Pan FP4 Verichrome Pan	100-200	21-24	medium	moderate	fine
Tri X, HP5	400+	27+	fast	low	large

High speed emulsions will make a printable image from less available light than low speed emulsions. High speed emulsions tend to be grainy, and lower in contrast than low speed emulsions. There are also special films made that are very high in contrast, very fine grain, etc., for copying and for scientific work.

These numbers are found on the meters built into modern cameras—as in Figure 1-49. Setting the exposure for average contrast range subjects. Cameras with built-in meters require special attention in high contrast scenes, where the light comes from behind the subject. This is called backlighting. Or, in very bright, diffuse light, on the beach or in snow fields. This is called flat, diffuse lighting. Meters built into the camera offer compactness and efficiency, but like any metering tool must be used with care. Each camera and metering system has special problems and possibilities that will become evident only with use.

Use the metering system in yours straightforwardly at first; believe what it suggests. Expose a test roll of film on a wide variety of scenes, each time using the suggested meter-controlled exposure. Develop the film carefully and normally; proof it and print sample negatives from each kind of scene. Then decide if you need to change the

Figure 1-49: **The exposure index (or "ASA" number) is set on the camera, automatically adjusting the in-camera meter to the film being used.**

way you are using the meter. One change that may be needed is to increase or decrease the index set on the meter. If the test film is consistently overexposed *in the shadows,* try a higher index number. If the shadows lack detail consistently, try a lower index number.

How much should you change the index? The index numbers in the ASA system are arithmetic, linear; halving the index is the same as doubling the exposure, or opening the lens one stop. Doubling the index is the same as halving the exposure, or closing down the lens one stop. At first, change

the index up or down to produce a full stop change of exposure—either double it (from 125 to 250, for example) if the shadows are excessively dense, or halve it (from 125 to 64) if the shadows are thin and lack substance.

Such changes are often needed because the index is established for an emulsion using laboratory standard equipment, developers, and processing. If your camera has some errors of metering, or your processing is more or less vigorous than that used during testing, shadow density may be higher or lower than expected. The ASA index is *suggested* as a guide to exposure. It is in fact noted as the "manufacturer's recommended index." It is up to the individual photographer to determine whether it is in fact appropriate to his system.

Film must be developed for the lighting contrast conditions seen by the lens. Contrasty scenes will print easily if the film is developed a shorter time than that used for softly lighted subjects. On the other hand, when the light is very soft (on a misty day, for example) a longer developing time is needed. This leads to a definition of a *normal* condition:

A. A normal scene is one lighted by moderately diffuse light. There are definite but soft-edged shadows.

B. Correct exposure and development of this scene will produce a negative with just perceptible detail in dark hair and tree shadows and filmy transparent densities in clouds, white buildings, white shirts.

C. This negative will print easily without much burning or dodging on normal contrast grades of paper and when developed in a standard developer for about 2 minutes at 20-21°C will yield a print with delicately detailed highlights and deep shadows.

If the lighting is more harsh or more flat, the scene is not normal. Normal development would yield a contrasty or flat negative. Such negatives will require paper that is higher or lower in contrast to make a full scale print, where both highlights and shadows are correctly revealed.

Contrast controls for the entire photographic system can be schematically expressed this way:

Contrast

Conditions	Light	Film	Development
contrasty	harsh	fast	short time
soft	soft, diffuse	slow	long time

These are contrast controls aimed toward a normal representation of the scene. Film, development or paper may be used as contrast controls as noted, either separately or in concert. In speaking

of development time, one assumes temperature and agitation are held constant.

In the earlier section on **Printing Contrast and Local Control** (p. 17), these same conditions were seen as being problems of printing alone. One *had* a certain contrast negative and had to print it. Now there is the possibility of making a negative adapted to the contrast conditions of the scene. Both ways are used in small camera photography. On a given roll of film, the majority of scenes will be of one kind: contrasty, normal or flat. The entire roll is developed for these majority scenes. Those negatives will produce normal prints easily. All the other negatives will be higher or lower in contrast and will require the printing controls described earlier.

Film Development Mechanics

Film can be developed in a tray or in closed metal or plastic tanks. Tank development permits more than one roll to be developed at a time. It is not necessarily better development than tray; in fact it is harder to provide even development in tanks. The problem arises because the reel supporting the film in the tank prevents developer from reaching all parts of the film evenly and smoothly, without turbulence. The tanks that do the best job are of stainless steel, with reels of heavy wire to support the film. They offer minimum interference to the flow of developer. (Figure 1-50).

Figure 1-50: **Film may be developed in tanks for greater convenience. Wire reels are probably the best supporting system, permitting even agitation without flow marks.**

The steel reels do have some problems, but these are avoidable. One has first to learn to load the reels without damaging the film, without jumping from one track to the next, causing blank spots where film touches film. Practice loading a tank in daylight with a throw-away roll of film.

Figure 1-51: **Loading film on a wire reel. The first quarter-turn is the most important: pull the film tight to seat it firmly in the correct groove and the rest of the film will roll on easily.**

Most handling faults occur at the start of the spiral, in the first quarter-turn. Using either Kinderman, Nikor or Omega reels, the first insertion of the film a quarter-turn of the film onto the spiral frame is critical, and it requires more tension than at first try appears necessary. Once started in the right track the film flows on effortlessly. (Figure 1-51).

Uneven development is the problem with small-tank processing. There is very little liquid for the amount of film, therefore the developer must frequently be pumped into the emulsion, replacing the exhausted solution. This replacement process is the purpose of agitation. Insufficient agitation produces murky negatives with bad separation of tone. Improper agitation makes streaks or darkens the edges of the negative, leaving the center thin. Over agitation produces excessive contrast, with unprintable highlights.

Correct agitation periodically replaces old developer with fresh solution, and does it without continuing motion of the developer. Agitation should be a simple standard process, repeatable and predictable since it is one of the three controls for film contrast. Each kind of tank will require its own agitation gestures to produce even development and clear tonal separations.

Temperature is the third variable. The developer must be measured in the tank. The temperature should be the same each time. There is not much difference in the way the developer itself works between 68° and 70° F (or 20° and 21° C). But film developed in D76 at 68° for 9 minutes and the same scene developed at 70° for the same time will differ in contrast by a full paper contrast grade. Standardize on a temperature between 20° and 23° C and develop all film at the same temperature. If time, temperature and agitation are repeated each time then changes and corrections become predictable tools.

Summation of Beginning

Sometimes the shutter will control the meaning of a picture and sometimes the aperture. If the subject is quick moving, a fast shutter speed will "freeze" the image, let it be seen sharply. This often is exciting, but it can also create a stiff, frozen quality. A slow shutter speed will record a moving subject as a blur: this can be either frustrating or exciting. Look up the color photographs by Ernst Haas; see how blurred motion recording can be exciting. On the other hand, look at the photographs by Gary Winogrand to see how freezing an instant from the middle of a gesture can also be exciting, as Winogrand uses a very quick eye and shutter to capture relationships between people in motion and their environments.

He once described the amount of time he spent on a photograph as "about one-five-hundredth of a second," meaning that no matter what he thought happened before and after the moment of exposure, it was that particular shutter-controlled instant that the film saw.

The landscape photographs by Paul Caponigro illustrate another way, the wise use of the contemplative eye and the slow shutter. Moving water flows past Paul's lens and its reflected light blurs during a long exposure—the film averages the motion, transforming water into a smooth, magical mirror.

How do you learn these interactions of the lens, shutter and diaphragm and their effect on the picture? Principally by making trial exposures, making notes (mental notes are fine, but memory is not the best medium—written notes are best), making prints, examining what you have done, and going back to the beginning. Use the knowledge acquired from your own and from others' experiments. Analyse other photographers' work. Cut

out all the photographs from a group of popular and photographic magazines. Spread them out so you can study them side by side. Look how in each case the photographer used these essential elements of the medium:

Light
Contrast
Focus
Shutter Speed
Point of View
Color
Motion
Focal Length of Lens

Taking these in order:

1. LIGHT: The photographer can work with almost any light, as long as there is enough to expose the film. If the light level is low, a more sensitive (faster) film can be used. Or a "faster" lens can be used, one that is larger in diameter, that admits more light. Light can be "harsh" or "soft"; it can be "backlight" or "sidelight" (sometimes referred to as **crosslight**). Light can be "natural" (also referred to as **environmental** or **ambient**) or "artificial," meaning that it comes from man-made sources, room lights or supplementary light from flash bulbs or electronic flash.

Dim light is also referred to as being low-level light. This kind of light is difficult to measure on meters because they have to be more precise and because they use more battery power as the light decreases. It takes experience to accurately describe dim light as "flat" as opposed to when it is "contrasty."

There is a temptation to assume when a small amount of light is available the development time should be longer. This is called "pushing" the film; the development time is increased to make up for low light levels. This works **if** the light is flat; then the increase of contrast in the negative is exactly what is needed.

When the light is dim, but already high contrast lighting, increasing development will **only** increase contrast. It will not help the real problem which is insufficient light to record details in dark clothing, the shape and texture of human hair, in all the shadows that give a picture the sense of how things really look.

Any kind of light can make exciting photographs. Look at magazines and books being published and study the **light** in the pictures. Classified by the light, there are two broad categories of pictures. In one, everything is revealed, carefully realized, all the textures beautifully drawn. This is a tradition called "full scale, full substance," printmaking. Full scale means using the full tonal scale of the print (from a vivid black to a brilliant white),

but not exaggerating. Full substance means that all the tonal and textural meaning of the objects before camera have been accurately translated into black, white, and grey. In this kind of photograph the limits of the negative and the print materials were realized and used.

The thinking eye sees far more than the photographic film can copy, without sophisticated manipulation of exposure, supplemental lighting, development and printmaking. Don't be surprised if your first attempts fail at making **full scale, full substance+** prints. Achieving this is one kind of mastery of the medium.

2. CONTRAST: Contrast is controlled by direction of light, by the reflective qualities of the materials in the scene being photographed, by development of the film, the contrast grade of the paper used to make the print, the developer (concentration, temperature, agitation, and development time), and by the use of toners used to change the color or reflectivity of the silver image.

Taking these controls one at a time, the most easily controlled is film development. If the film is developed too long, it will produce negatives so contrasty they are impossible to print in the sense of photographically reproducing both the texture from highlighted areas **and** surface detail in shadows. Many photographers cannot control the process well enough to do this, yet they produce exciting photographs, partly because they are attuned to the actions in front of the camera and easily involve our attention. But if you want to show the substance of white cloth, skin, clouds, concrete, and also that of bark, of wet wood, clothing, fur, and human hair, then the exposure must be adequate to record detail in the shadows. Then develop a short enough time for the highlight densities in the negative to remain printable.

The silver in the brightly lighted image areas in the negative grows denser with longer development, but not the silver that represents the shadows.

3. FOCUS: Focus is a creative tool. If all the picture is in focus then everything is equal—this is a popular attitude and an effect achieved with short focal length lenses (35mm down to 18mm on 35mm cameras). The shorter the focal length of a lens the greater the depth of field—objects can be both closer to and further away from the camera and appear equally sharp.

The opposite is also effective: the longer the focal length of the lens, the narrower the depth of field—the smaller the distance between near and

+

A widely used term meaning using the full tonal scale of the paper from white to black to reproduce the full sense of the substance of the subject, textured white to deep, detailed shadows.

far objects that will be sharp. This distance can be increased if the lens opening is made smaller (stopping the lens down).

Selective focus in effect points our attention at the object in focus. In effect we demand attention, and also ignore objects before and beyond—these merely become unclear patterns. Focusing on a distant subject creates a frame of the space itself because out of focus near objects frame the sharp subject. Figure 1-52 illustrates this.

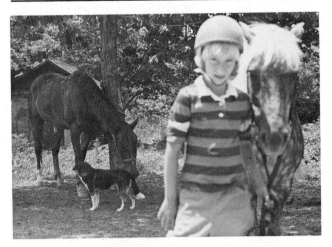 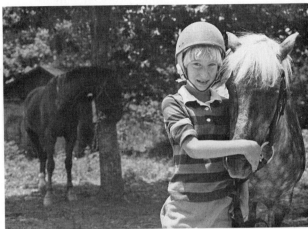

Figure 1-52: **Selective focus; using a large aperture, the camera can be made to tell the viewer what is important. The alternative tradition is having everything equally sharp, making the viewer decide what is important.**

4. SHUTTER SPEED: Fast shutter speeds can stop almost all human and animal motion. But even slow shutter speeds may give the effect of stopped motion, depending on the direction of motion relative to the camera. If the object moves straight toward (or away) from the camera, slow shutter speeds (down to 1/15th of a second) can be used and the motion blur will not destroy the sense of the object. This is because the shape of the image on the film remains almost constant. Figure 1-53 shows this. The image cast by the lens on the film when the object is moving at right angles is different. The slightest motion tracks the image across the film. The closer the motion is to a right angle to

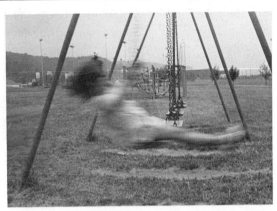

Figure 1-54: **Motion at right angles to the camera at a slow shutter speed; the image on the film is moving, and details of the subject are lost.**

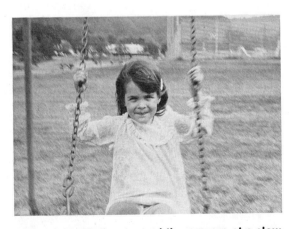

Figure 1-53: **Motion toward the camera at a slow shutter speed; the image on the film is almost unchanging, and the sense of the subject is retained.**

Figure 1-55: **Motion at right angles to the camera at a fast shutter speed. The short time of exposure allows the image of the moving object to be "frozen".**

the photographer, the faster the shutter speed must be. The shorter the exposure must be to **stop** the action. Figures 1-54 and 1-55 illustrate these effects.

Sports action photography usually requires very short exposures. Frequently the light available is not adequate to provide proper exposure at high shutter speeds. When this happens, a photo-grapher often will use supplemental lighting. One kind of light that is popular is commonly and inaccurately called **strobe** light; it should be called **electronic flash.** Flash is a light which lasts a very short time, with enough intensity to provide adequate shadow detail. Figure 1-56 shows an example.

Figure 1-56: **Motion may be stopped by the use of very short artificial light. Commonly called strobe light, the electronic flash has a very short duration, from 1/600-1/1000th of a second.**

A slow shutter speed requires a stable camera support or the whole picture will be unsharp because the image on the film will move during the exposure. It is best to use a tripod. If the camera must be hand held, support the camera by keeping your arms close to the body. Support the camera on bones, not muscles. Keep both arms under the camera; learn to focus with the left hand, squeeze the shutter with the right. Brace the camera against your head by wrapping the camera strap around your hand, putting it taut against your neck. You can make sharp pictures with shutter times as slow as 1/30th of a second, even when using a long lens.

Sometimes you may have to use even longer (slower) shutter speeds. These will be needed when working indoors, or outside in low light levels—in shade, at twilight, early in the morning. When the exposure meter indicates a shutter speed longer than 1/30th of a second, you should use a camera platform. Down to about one-half second this can be improvised: lay the camera on a car hood, lean it against a door-jamb, or a tree trunk. Squeeze the shutter. But even here there is danger of unwanted motion. A tripod is the best answer. A tripod will also change your vision, because it makes you move slowly, deliberately. But, any change in equipment, film, or photographic chemistry will subtly change the photograph.

5. POINT OF VIEW: You don't have to look straight at someone or straight at a building from your normal eye-level point of view. The photographs by J.H. Lartigue are exciting both because they are of interesting people and because they are made from a point of view about 30 inches above the ground! Lartigue was a small boy, working with a large single-lens reflex camera. The result is a different point of view, one looking up into the world of adults. The more common case is when

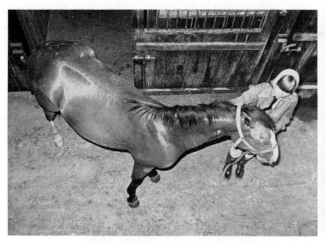

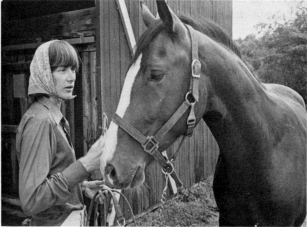

Figure 1-57: Looking *down* on an action.

Figure 1-58: Looking *at* a similar action.

Figure 1-59: Looking *up* at an event. The point of view significantly changes the meaning of an event, sometimes reinforcing it, sometimes nullifying it, depending on the information and feelings one is trying to evoke with the photograph.

photographers make pictures of children looking down on them rather than looking *at* them, or even *up to them.* The meaning of the picture changes with the point of view. See Figures 1-57, 1-58, and 1-59.

6. COLOR: Most photographic work described in the **Handbook** is concerned with black-and-white. Color photography poses special problems, though color printing systems are becoming simple. Unicolor, Kodak, Besseler, Cibachrome and other color printing systems are hardly more difficult to master than conventional silver printing processes. In fact, they are silver processes in which color is generated as a by-product of the silver development. Afterwards, the silver is bleached away. Once careful black and white printing is mastered, a color printing process can be easily learned.

Color transparency processing is dependable and equally easy to do. There is no reason you should not do color photography, even with simple cameras. But be alert to the fact that color in the photograph has very little to do with color in reality.

Each different color process makes a new definition of reality. It is best to expose test rolls for each brand of color film. This way you can discover what a given brand of film, or a color printing process does—how it changes the world you see into a new world, one of the color photograph.

Color transparencies record the same brightness range the eye accepts; they offer a brightness of subject and saturation of color no other color photographic process can match. You see an image of direct light rather than a reflection.

Not only does each film maker have a slightly different color system (and this changes the meaning of the picture), but even within a given product there will be variations. For example, High Speed Ektachrome, Ektachrome, Kodachrome 64 and Kodachrome 25 each have characteristic kinds of color, of contrast, sharpness, and color saturation. Only experiments with these will teach you which ones are best for you.

Figure 1-60: **Action stopped with a very fast shutter speed.**

Figure 1-61: **A similar action recorded with a slower shutter speed where the camera is "panned" to follow the action; the accuracy of the detail is lost, but the sense of the motion is enhanced.**

Color prints are now made by two methods. One uses color negative film; it is printed, either in the manufacturers suggested chemistry or in one of the several compromise (and simplified) chemistries available to the photographer (through UNICOLOR, BESSELER, and OMEGA). The second method uses color transparencies. These are printed on special color-reversal papers (Made by KODAK and by CIBACHROME). The color print made by either of these will differ from the transparency. It will be less brilliant, lower in saturation and higher in contrast.

Color demands a different way of photographing. The "taste" of color is important; this is learned only by critical looking at hundreds of photographic color prints, at paintings, at advertising art. By bringing this visual experience back to your color print you learn to judge it, correct it, and to make good prints. Most early prints in color are either muddy or harsh. At first there is so much excitement in producing any color at all! But, most first silver photographs are either pale or contrasty, with featureless whites and empty blacks—because the mere achieving of an image is so exciting. What is important is going beyond these first steps, going on to mature work.

Color can also refer to black and white photographs—to the delicate differences between different kinds of printing papers, to the changes in color produced by different developers, and to toning the print after development. These all disappear when a photograph is copied in a book. The color of a photograph in a book usually bears little relationship to the quality and color of the original print made by the photographer.

Any photographic paper can be made to produce different print colors by using different developers. AGFA Brovira 111, correctly exposed and then developed in KODAK Dektol, will yield a slightly blue-grey print; developed in SPRINT Quicksilver, it will be neutral, grey-black; developed in EDWAL Super 111 (also sold as *Platinumtone*) it will be warm-toned with tan highlights. Frequently, these color differences are apparent only if prints from the same negative are made and compared in good light.

Different papers inherently have different colors. KODAK Kodabromide is blueish in the dark tones. AGFA Portriga Rapid is quite brown, the actual color ranging from a mustard-brown (developed in *Dektol*) to a cold blue-brown (developed in *Quicksilver*). These differences in color affect our response, and the meaning of the image. Brown-toned papers produce a feeling of opaqueness, density in the blacks that does not happen with the blue-black papers. The brown-toned papers are referred to as "warm tone," and the blue-black are called "cold tone" emulsions.

7. MOTION: The sense of motion in the subject is integral to the meaning of the photograph. Very rapid motion frozen by a high speed shutter reveals nature normally concealed in an instant of time. The result may be exciting or be mere technical competence. In either case, the sense of the motion itself is often better achieved by slight blur in the image. Sharp, slightly blurred, and very blurred records of motion are useful. Figures 1-60 and 1-61 compare these.

Look at many photographs of motion, decide what pleases you, then go try it yourself and see if you can discover what kind of motion requires what kind of shutter speeds to get a certain effect.

8. FOCAL LENGTH OF LENS: This has been left for last because it is a very expensive control. Most modern cameras (even the inexpensive ones) permit lenses to be changed. A long focal length lens simply sees a smaller slice of the world than a wide angle lens. Because of this the compositional relationships between things change when you change a lens. A wide-angle lens tends to exaggerate space, making objects close to the camera and those further away *more* separated than when seen by the eye itself. A long focal length lens tends to squash distance, making graphic relationships between objects that the eye would otherwise not discover.

The photographer's problem is to learn to see what a lens will see, to imagine what he might see if a certain lens were used. Figures 1-46, 47, and 48 show these changes.

CHAPTER TWO
Basic Processes

Camera and Lens

During the last dozen years cameras have steadily grown more complicated inside, and steadily simpler to operate. The controls that formerly demanded attention by the photographer at each step now can be almost fully automatic, leaving the photographer free to concentrate on the moment of exposing film, on the act of photographing. Talbot, one of the early nineteenth century inventors of the photographic system of image making, called photography photogenic drawing, and Jerry N. Uelsman, a contemporary photographer refers to letting the light draw itself. Neither of these interpretations, made by photographic artists more than 130 years apart, concern themselves much with the mechanics of photography. And though photography is accomplished by machines, the machine should always be secondary to the vision of the photographer.

As the photographic machines have been made more automatic, the types of cameras available have been reduced and simplified, in response to the financial and practical needs for standardization.

The first cameras were remarkably like contemporary cameras. Daguerre's camera was, in effect, a single-lens reflex:

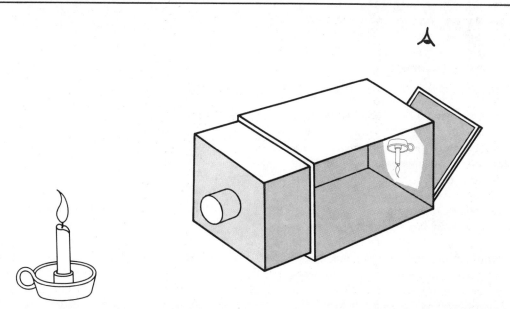

Figure 2-1: Daguerre's camera consisted of telescoping wooden boxes, with a lens and simple shutter at one end and a focusing screen with hinged mirror at the other. The operator looked down into the mirror and saw an erect but reversed image.

The slanted mirror permitted the image made by the lens, focused on the ground glass at the back, to be seen rightside up. When the film was placed in the camera, it displaced the ground glass and was then on the plane of focus.

The English produced an even simpler camera, one that soon dominated the medium. It was called a *view camera,* and was in fact a portable version of the *camera obscura,* the darkened room with a lens at one side and a translucent screen on the other

that had been known to artists since the Renaissance. The weight of the camera was reduced, and portability increased, by the use of a folding cloth

bellows. The lens was also placed on pivots and rails, so the image could be moved up and down, rotated left and right, to improve focus:

Figure 2-2: **The viewcamera consists of a lens support, a rigid frame holding a groundglass which can be displaced to permit the insertion of film, and a means for moving both film and lens about the normal axis of focus. These movements (rising and falling front, swinging front and rear, tilting front and rear) permit perspective correction and great depth of field.**

This camera dominated photography for about fifty years, and is still in general use today among professionals for architectural, advertising and commercial photography. It is not fast, nor easy to use, but it offers distortion correction, and holds a larger sheet of film than any other kind of camera.

Beginning in the middle of the 19th century, many experiments were made to perfect small cameras using dry film stored in a roll. These became popular in the mid-1880's, and an enormous commercial success in 1888, when George Eastman announced the Kodak system. He brought together the work done by many others including himself into a commercially dependable film, camera, and processing system. With the Kodak, the box camera was to become available to almost every household in America.

Just before the First World War, in Germany, Oscar Barnak developed a small camera using 35mm perforated movie film. It was manufactured by Leitz, and called the Leica. Again, there were many predecessors to this commercially successful, beautifully machined, dependable system of photographic engineering.

The Leica was a *range-finder* camera. The view camera was focused by direct observation of the image on the ground glass. The box camera wasn't focused at all, but depended on having the principal subject a fixed distance away. The Leica made focusing available, by using a supplementary viewing system and a mechanical computer that helped the photographer calculate the distance. This information was then manually transferred from the rangefinder to the lens itself.

In the 1920's, a compromise system was developed; the photographer could focus on the image directly but do it in a way that the film itself did not have to be handled (as with a view camera) each time the exposure was made. The rollfilm, twin-lens reflex became popular because a compromise film size (not as small as the 35mm format of 24 x 36mm, and not as large as the view cameras, which ranged up to 11 x 14 inches) could be used and yet a professional focusing and exposure control was available. The most popular of these was the Rolleiflex, manufactured by Franz & Heidicke, in Germany.

Just before the Second World War, there were successful efforts to return to the single-lens reflex concept. These new cameras brought up to date ideas used in popular large cameras from the turn of the century on, cameras that held a mirror between the lens and the film. The mirror deflected the light from the lens up onto a groundglass screen. The optical distance from the lens-to-mirror-to-screen was the same as the lens-to-film, when the mirror was removed. The image was focused by observing it on the groundglass. When the shutter was pushed, springs drove the mirror up, out of the path of the image. The mirror itself became a door, closing the groundglass off, and making a light-tight box. Then the film could be exposed by the shutter.

Figure 2-3: The small camera with a rangefinder is actually two independent optical systems. The photographer looks through a little window which accepts the light from two paths: one coming directly from the subject, and the other falling onto a rotating prism located at the right of the camera. The rotation required to make the images seen by both apertures coincide is mechanically computed into distance. Early cameras required the photographer to make this computation, then adjust the lens; later cameras have this linkage built in.

Figure 2-4: The twin-lens reflex camera is also composed of independent but similar optical systems. The upper lens is focused manually; since the lenses share a common lensboard, the lower is focused at the same time.

Figure 2-5: Single lens reflex.

The shutter used in the camera also went through a similar evolution. At first it was simply a plug that fitted smoothly over the lens. It was put back on the camera after the image was brought into focus. When the film was in place, the lens cap was removed, the exposure counted (from 5 seconds to several minutes), and the lens cap replaced.

When film became more sensitive, better shutters were needed. The first dependable shutters used air pistons to force thin sheets of black iron open and closed. This simple system was practical for exposures from about 1/5th of a second and

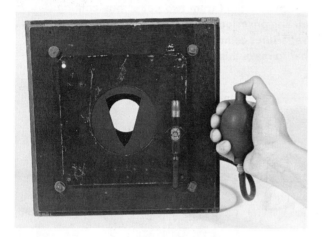

Figure 2-6: The Packard shutter was controlled by compressed air; the exposure time was determined by the operator: as long as the bulb was compressed, the bulb was open.

longer, and is still in use in special commercial applications.

Shutters were made to fit behind lenses in view cameras. These had to be compact, and in fact were adapted into the lens itself. They were in effect similar to the two-bladed shutter, but were made up of several small tapered blades of thin metal. These rotated away from the center of the lens into the barrel that supported the glass of the lens. This design of shutter, located between the lens elements, became standard for many years, and is still used on about half the cameras made.

The metal blade shutter located in or behind the lens had disadvantages for reflex cameras with a mirror in the body of the camera. The lens had to be fully open for focusing, yet there had to be a light-tight barrier between the lens and the film when the mirror was raised, just before the exposure was made. This problem was solved before the beginning of the century by using a curtain shutter, located just in front of the film.

The focal plane shutter was originally a miniature window blind with slots of varying size, made of opaque black linen. You adjusted the exposure time by cranking up the spring on the upper roller to different tensions, and by choosing which slot would expose the film.

This simple system permitted a camera made in the early 1900's to have dependable shutter speeds ranging from 1 second to 1/1000th of a second. It was adapted to the Leica and similar cameras by using two curtains, instead of one, and having the shutter move from right to left, rather than up from the bottom.

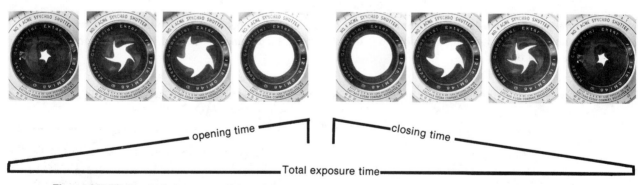

Figure 2-7: This set of photographs illustrate the opening and closing of the metal leaf shutter common to many cameras. Note the actual aperture passes through *all f-numbers* as it opens, leading to a slightly greater depth of field for a between-the-lens shutter than for a focal-plane shutter, for a given diaphragm setting.

Since two curtains are used, the gap between the curtains is controlled by the machinery that releases them. When you push the shutter, the first curtain starts traveling across the film. A short time later (standardized at 1/60th of a second) the second curtain follows the first, traveling at the same rate of speed. The interval between the first and the second release determines the shutter speed.

Figure 2-8: **From a Graflex camera, this roller-blind shutter illustrates the older style of focal plane-shutters: different width slits could be chosen, coupled to various spring tensions, to determine exposures from 1/1000th to a full second.**

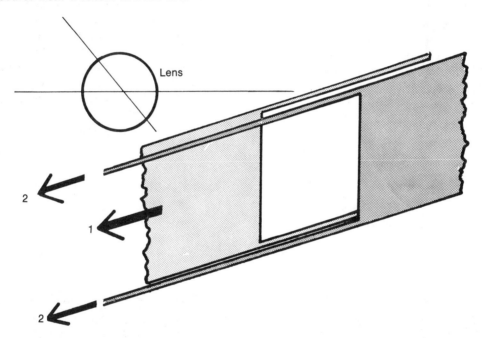

Figure 2-9: **The standard fabric focal plane shutter consists of two cloth curtains pulled by small straps.**

Recently variations of this idea of a shutter have come to be used. The most common is a focal-plane shutter made of thin blades of very strong metal that move vertically. Metal shutters avoid the principal mechanical problems of the cloth shutter which are linked to the fragility of the material. A Leica shutter, for example, can easily have pinholes burned in it if the camera is left facing the sun: the lens concentrates the light into an intense energy patch on the curtain, and the resulting hole will leave a straight-line trace on the negative.

Shutters were controlled by springs or by air pressure until recently, when miniature electronic solid-state controls became standard. Mechani-cally controlled shutters had speeds controlled by the discharge of a compressed spring through a gear reduction train. To change the speed of the shutter, one shifted gears, or tightened or loosened a spring set. During this period a number of exposure times were tried out, but eventually these were stabilized into a sequence of approximately two-to-one ratios:

1 second, 1/2, 1/4, 1/8, 1/15, 1/30, 1/60, 1/125 1/150, 1/500, and sometimes 1/1000th of a second.

It is important to realize that these are always approximate, and more important to realize these are ***nominal*** times.

The metal blade shutters located in the lens, open at a definite speed, limited by the stiffness of the very thin metal leaves. They stay open for a time determined by the gear train used to control the exposure, and then are driven back to a closed position by a second set of springs. The exposure time is measured from the half-open to the half-closed position. Graphed, it looks like this:

Figure 2-10: The metal leaf shutter takes about 1/500th of a second to open fully, and the same time to close. At 1/100th of a second this is 40% of the total exposure time.

But the focal plane shutter opens instantly. As soon as the curtain begins to move, the film is fully exposed across its width. Its exposure graph would look like this, for a similar exposure time:

Figure 2-11: **The focal plane shutter is open instantly, and the exposure produced is more nearly the exposure calculated.**

It's immediately evident that for the same nominal exposure time the focal plane shutter is somewhat more efficient. Not a great deal at moderate exposure times of 1/30th or 1/60th, but significantly greater at 1/500th. The blade shutter takes exactly the same time to open and close at a fast as it does at a slow shutter speed, so the total open time is significantly less, compared to the focal plane shutter.

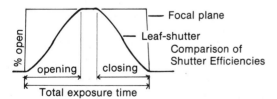

Figure 2-12: **Comparison of focal plane and leaf shutters at a high speed, showing relative efficiencies.**

These exposure times are nominal for another reason. Shutters are assembled on an assembly line from stock parts, and there are inevitable tolerances which produce small variations in speed, departures from the speed marked on the shutter control dial. A shutter speed marked 1/125th of a second may actually produce an exposure lasting as long as 1/100th or as short as 1/150th. This is not terribly important as long as the camera makes the same exposure every time. Such variations are inevitable, and are one of the reasons trial exposures and bracketing exposures are made when serious photography is attempted and the picture is irreplaceable.

When photography was new, lenses were used wide open because it was essential to gather all the light possible for the insensitive photographic emulsion. As improvements were made in the films, and it was possible to use less light, a desirable side effect was investigated. Making the opening in a lens smaller decreases the light and also increases the range of distances from the camera that are in sharp focus. The near and far distances that produce equally sharp images are called the hyper-focal points. The smaller the lens opening, the farther apart these are.

In the last century, lenses were sold in brass tubes, or barrels, with a slot cut on the side. One could insert a blackened plate of brass perforated with a hole. The smaller the hole, the smaller the lens opening that resulted. These metal plates were called **Waterhouse Stops,** and they used a special numbering system to indicate the amount of light passed. An alternative system, developed before the turn of the century but used only on very expensive lenses, was a movable diaphragm made up of eleven very thin pieces of blued steel, hinged at one end with tiny pins. These leaves moved toward the center of the lens when a sleeve of brass was twisted about the barrel of the lens. The sleeve was marked according to a numbering system which then became standardized throughout the industry into what are called **f-numbers .**

The numbers chosen were functions of the amount of light that could go through the lens for a given opening, It was found to be convenient to measure this transmittance as a proportion, and because of the way the silver emulsion reacts to light, a ratio of 2:1 was chosen. Therefore, one f-number passes either twice or one-half the amount of light as the next f-number, depending on whether the lens opening is being enlarged or reduced.

The terms "stopped down," and "f-stop" derive from the way the aperture control is made and the markings that are now conventional. Photographic lenses have used several different marking systems for measuring the amount of light that could pass a given size of opening. Until about forty

years ago there were two competing systems, but the "f-number" became the standard notation. The number is actually a simplification of a fraction. Look on the front of a lens, just beside the glass, and you will find a notation like *f 1:2.8.* This means the ratio of the diameter of the lens to the distance from the center of the lens to the film is one to two-point-eight. Since the lens is circular and the diaphragm that controls light passing through the lens is also circular, to decrease the opening by a factor of two, one has to shrink the aperture **area** by one-half. But the area is controlled by the square of the diameter, and so a reduction of one-half the light is created by reducing the diameter by 0.707 (which is the inverse of the square root of two).

Look at the numbers of the aperture ring: the sequence is 2.8, 4, 5.6, 8, 11, 16, 22, etc. Each one is either .7 or 1.4 times the next, depending on the direction in which you read the series. Calling a two-to-one change of light transmittance a "stop" is a part of the vernacular language of photography. Lens manufacturers put a mechanical detent (a tiny ball bearing that seats in a milled pocket when the control is moved) in the aperture control ring. This makes it easy to move quickly from one mechanical "stop" to the next. It was only logical to extend the term, to include "stopping down," which means to decrease the size of the opening. For a beginner confusion sometimes arises which comes about because the **larger the number the smaller the opening,** and therefore the less light available to the film.

Each stop change is a halving of the light if the aperture is being made physically smaller. Each larger f-number is a halving of the light **because** the aperture is being made smaller. These are different ways of saying the same thing.

In the 1930's the number of leaves in the diaphragm was reduced to five, for small cameras. Later, in the 1950's fewer leaves were used in some inexpensive cameras, and in cameras with automatic exposure control. The number of leaves is not in itself important, but the idea of varying the size of the opening in the lens to control either the distance between hyperfocal points or the exposure is of great importance.

Cameras began small because the copper daguerreotype plates were very expensive, and the lenses slow and relatively unsharp at full aperture. When the wet plate was invented, in 1851, the glass plate became the standard negative support. It could be scraped and reused if the exposure was incorrect or the image no longer needed. Because large pictures were desirable, the size of the negative grew quite large. Cameras making pictures as large as 20 x 24 were used in the field by William Henry Jackson and others, to make large landscape photographs.

Printing paper emulsions were very slow; in fact developers generally were not used to make the image visible until the 1880's. Development was done by the light alone, and could take more than an hour. Because of this, printing was by contact. If a large print was needed from a small negative, that negative had to be enlarged onto film and an intermediate negative made of the correct size for contact printing.

With the invention of standardized, dependable flexible films by John Carbutt in the mid-1880's, and the invention of chloro-bromide emulsions about the same time — which were sensitive enough to be exposed by the principal artificial light of the time, gaslight — small camera negatives that had to be enlarged became a common practice.

The very small negative of the 35mm format had had many predecessors in the form of what were then called "detective" cameras, concealed or disguised machines hidden in hats, shoeboxes, and watches, or even shaped like revolvers. But only with the standardization of the precision made 35mm format did the small negative become popular.

In Rochester, George Eastman established a factory to make film and paper and process the exposed film and make prints. Similar though not such extensive factories were started in Binghamton, New York, in England, and most European countries. Names like Kodak, Ansco, Ilford, Agfa, Gevaert, Ferrania, and Perutz became common. As these businesses grew, competition forced standardization and the gradual reduction of the number of film sizes available.

The explosion of popularity of the camera after the Second World War, when Japanese photographic firms combined forces to develop new optical glass and produce inexpensive, high-quality small cameras, accelerated both the trend toward small cameras and the diminished number of film formats. These are now limited to the following roll film sizes:

NAME	COMMON FRAME SIZE
110[1]	12 x 16mm
35[2]	24 x 36mm
	(15.9 x 22.9mm = "half frame")
126[1]	26 x 26mm
127	40 x 40mm, and 40 x other lengths
120, 220	6 x 6cm, and 6 x 7 and 6 x 9cm.

[1] in a plastic cartridge where the plane of focus is controlled by the cartridge rather than the camera.

[2] in a metal cassette. All other roll sizes use an opaque paper leader or parallel backing paper for light protection.

In cut film, or sheet film there are similar restrictions. Now, 2¼ x 3¼ inch, 4 x 5 inch, 5 x 7 inch, 8 x 10 inch and 11 x 14 inch sheets are the standard sizes generally available, and sometimes only in limited emulsions, e.g. Tri-X is the only emulsion Kodak makes in 4 x 5 Film Packs, once a very popular format offering film of every emulsion description.

In the same way, competition, standardization and increasing popularity of certain kinds of photography have encouraged the development of the 35mm single-lens reflex camera to the point that it now dominates the amateur photographic market. For snapshots, the smaller formats, using 110 cartridge film have increased in popularity until they now consume as much film as do the 35mm cameras.

Reflex cameras have dominated the amateur market because they simplify visualization of the photography. The picture seen through the lens is psychologically close to the picture seen in the print. All cameras have limitations; for example, the reflex camera is often larger and heavier than the rangefinder type. Rangefinder cameras in turn are for some people more difficult to use because of the intangible but real psychological distance from the subject created by the rangefinder optics, plus the fact that focusing is done by matching parts of the image that have been separated into focusing patches. Focusing with the reflex camera is much more intuitive.

Rangefinder cameras do offer an advantage in both negative sharpness and in lack of shutter noise. Inside most reflex cameras are mirrors which must be moved away when the exposure is made. These make an audible slap when the shutter mechanism is released, and they also cause some movement of the optical system, a vertical vibration not caused by the moving curtains of the camera shutter, and therefore absent in the rangefinder system.

In operation, the reflex camera stands between the rangefinder and the view camera in terms of *how* it is used. Historically, the rangefinder camera echoes the tradition of the snapshot camera system typified by the first Kodak camera of 1888. There was no viewfinder at all on the Kodak No. 1, merely an arrowhead embossed on top, indicating the way the camera should be pointed. The photographer was interested only in the subject in front of the camera. The view camera, on the other hand, offers a blank field, the groundglass. The picture appears on this field when the lens is opened. Psychologically, the photographer is concerned more for the picture in this field of view than he is with the subject before the camera.

Figure 2-13 shows schematically the difference in the way these cameras are used. The photo-

grapher using the rangefinder camera tends to look past the camera to the subject, letting the camera rise into the line of sight and intercept his attention. The reflex camera tends to be a channel through which the photographer looks at the subject. And the view camera image mostly is looked at for itself — the subject itself exists somewhere beyond. These are very simplified relationships, yet they are useful to contemplate. The reflex camera can be used either way—as a subject/action oriented machine or as a way of visualizing compositions and previsualizing the photographic print before the fact of exposure.

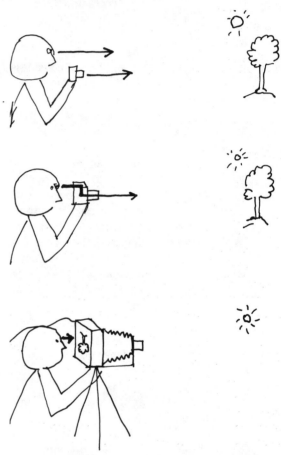

Figure 2-13: **The rangefinder camera encourages the photographer to see "past" the camera; the reflex camera stands between the rangefinder and the view camera in suggesting a relationship between the photographer and his subject; the view-camera permits the photographer to divorce himself from the thing before the camera almost completely.**

When dependable shutters became common, films become faster, and the diaphragm numbering system standardized, the determination of exposure became more of a problem. Many different systems were suggested, and combined. The principal exposure control systems that have been used are:

Metering Exposures

Exposure tables:
 Calculation by latitude and longitude
 Season and description of the weather.

Comparison (extinction) meters: cards with holes through which one looked, comparing the brightness of the scene with the absorption of a fogged piece of film, when the one exactly equalled the other, an exposure chart was then consulted.

Photogenerative meters: first produced in the 1920's, these remained popular until just a few years ago. A disc of metal was coated with selenium, which is photogenerative, producing an electrical potential proportional to the light energy impinging on it.

Photoresistive meters: a byproduct of the transistor revolution in electronics, it was these tiny transducers which change resistance, becoming more easily conductive as the light pressure on them increases, which revolutionized photographic metering systems, permitting in-camera meters to become the normal condition.

Figure 2-14: The photogenerative meter produces electricity when light interacts with the photosensitive plate; the photoresistive meter changes resistance with light, but requires a battery for current.

Both photoresistive and photoelectric meters are used hand-held, as well as built into the camera. Each kind of meter circuit has advantages and disadvantages. Sinply stated, these are:

Photogenerative	Photoresistive
great stability	dependent on battery condition
constant sensitivity	subject to dark sensitization and bright light desensitization
limited range	sensitivity limited by battery voltage.

The photoresistive meter should never be allowed to "look" directly at the sun which will desinsitize it for several minutes and make it produce reading with significant errors. Likewise, when it has been stored in the dark for a long time, bring it to proper sensitivity by pointing it at a normally reflective surface (e.g. the ground), and switch it on and off three or four times. This will cause current cycling that will stabilze the metering circuit.

It is interesting that the simplest and oldest metering system is still in use. The data sheet included with every roll of film (except Verichrome Pan and some other low cost amateur-directed films) has a "Daylight Exposure Table" which is simply an updated version of the 19th century exposure guide with its tedious calculations of latitude and longitude and season and type of lighting condition. Today these are simplified to a series of schematic drawings showing cloudy, bright, and very bright exposure conditions, and recommendations for exposure.

DAYLIGHT PICTURES

Set your exposure meter or automatic camera at **ASA 125.** If negatives are consistently too light, increase exposure by using a lower film-speed number; if too dark, reduce exposure by using a higher number.

If you don't have an exposure meter or an automatic camera, use the exposures given in the following table.

DAYLIGHT EXPOSURE TABLE FOR *PLUS-X PAN FILM*				
For average subjects, use f-number below appropriate lighting condition.				
Shutter Speed 1/250 Second		Shutter Speed 1/125 Second		
Bright or Hazy Sun on Light Sand or Snow	Bright or Hazy Sun (Distinct Shadows)	Cloudy Bright (No Shadows)	Heavy Overcast	Open Shade†
f/16	f/11*	f/8	f/5.6	f/5.6

*f/8 at 1/125 second for backlighted close-up subjects.
†Subject shaded from the sun but lighted by a large area of sky.

For handy reference, slip this table into your camera case.

Figure 2-15: A typical Kodak Exposure Table.

Comparison or **extinction** meters still exist in special circumstances as well. One of these will be discussed later in **Advanced Controls.**

None of these metering methods include the oldest and in many respects the most dependable: experience developing out of trial-and-error. The meter cannot think. It has certain assumptions built into its circuits. You must make certain decisions, and often these will run counter to what the meter indicates, or even what the manufacturer suggests. Only by making careful decisions, noting the effect of these on the film and on the print, and then checking them against renewed decisions arising from this experience can you begin to use any of the meter systems usefully.

The light reflected from the surface of the subject is what is photographed. The film makes a record of this light. The light itself is the subject of the photograph. This light must be measured carefully to provide the best exposure.

Light is measured by focusing it on the photosensitive cell. The cell changes the light energy into electrical energy. The electrical energy turns the armature of a small meter movement, The armature supports a pointer which indicates an exposure. On some meters the pointer moves across a dial marked in numbers that refer to actual amounts of light (either *lumens* or *candlepower/-square foot*). On most meters the dial numbers are arbitrary, and therefore they apply only to that meter. Because of the differing number systems, the measurements described in the *Handbook* refer to the *exposures* rather than to the numbers taken from the meter dial. The exposures are interchangeable from one meter to another; the dial numbers are not.

Meters are designed to measure either the light reflecting from the subject — the light that the camera actually uses to make the picture; or the light falling on the subject. The first kind is a *reflected-light meter* and is the meter discussed here. The other type is an *incident-light meter.* It is traditionally popular with filmmakers. The cameraman controls the lighting ratio (i.e., the difference between the brightest and darkest areas in the picture) in film work. Expressive photography is much more concerned with the found subject matter than it is with the assembled studio scene, therefore the reflective meter is more useful. In effect it measures the light actually used by the lens of the camera, not the total light available.

A handheld meter may see more or less light than the camera lens sees even when they are held side by side. Meters often have wide angles of view. To measure a certain area the meter must be held close to that area, yet not shadow it. Held further away, it may also measure the light reflected from objects next to the care. Some meters have optical aiming devices to encourage accurate metering.

Almost all meters are calibrated to provide cor-rect exposures when they are used to measure the light reflected from a "grey" card. This is a standard color of grey. It reflects 18% of the light falling on it. Sets of standard grey cards are sold by Kodak.

By comparison, white typing paper reflects about 90% of the light; cheap black construction paper about 5%.

The color of light is related to the whiteness of it. Film is not equally sensitive to different colors of light. Nor are light meters. The eye accepts light of different colors as "white" when they are, in fact, quite different. Coastal daylight, rainy days, and mountain moonlight all seem white to the eye; so do tungsten and fluorescent artificial lights. Yet all are different, and have different energy content.

Film is usually slightly less sensitive to red light than it is to blue light. Meters are made to produce correct exposure indications with coastal light that is "white." Mountain light is quite blue, and less exposure will be needed than the meter indicates. Where the light is red (as with sunsets or with tungsten light) more exposure will be needed. The amount less and more is between one-half and one-stop correction.

The meter must be aimed from the same direction as the camera. Photographic subjects that are curved or cylindrical reflect light more in one direction than another. Texture also influences light reflection. If the camera and the meter view the subject from different directions they may record different amounts of light.

Meters are made to measure 18% grey cards. If a meter is pointed at a surface which reflects more of the light, more exposure must be given to produce a correct negative. If the meter is pointed at a less reflective darker surface, less exposure must be given than indicated by the meter.

Subject	Exposure correction
deep shadows	two f-stops less than the indicated exposure
dark objects	one f-stop less than the indicated exposure
middle grey— grey card	use the indicated exposure
skin tones	one f-stop more than the indicated exposure
concrete	two f-stops more than the indicated exposure
white walls	three f-stops more than the indicated exposure

The fact that the meter is made to accurately measure only a grey card causes most of the problems for beginners in photography. If the meter is aimed at any other surface or tone, the indicated exposure must be interpreted.

If the most important large area in the picture which must be naturalistically rendered is skin, it may be simplest to point the meter there. Be certain the meter is not shadowing the area and that it is pointing in the same direction that the camera is looking. The actual exposure for caucasian skin should be one f-stop more than the exposure indicated on the meter because this skin is twice as reflective as the grey card and the meter is made to measure (and calculate the exposure for) directly.

Common physical equivalents of the subjects listed above are shown in the following table.

Subject	Common physical equivalents
deep shadows	under shrubbery, inside open doors, under cars
dark objects	blue-jeans, dark clothing, brown hair
middle grey	grey card, average grassy fields, Negro skin
light grey	sandpiles, clear north sky, highway concrete, caucasian skin
off-white	blond hair, cloudy-bright skies
white	white clothing, men's shirts, white paper

The term "stop" or "f-stop" is used in the **Handbook** to indicate a doubling or halving of the exposure. This is done by changing the aperture one f-number or changing the shutter control one position. On all contemporary cameras moving the aperture from one setting to the next will change the amount of light that can pass through the lens by a factor of two. Changing the shutter speed one position will accomplish the same thing.

For example, changing from f-11 to f-16 will halve the light. Changing from 1/30th of a second to 1/60th of a second will halve the light. Either can be called **reducing the light by a stop,** i.e., by a factor of two. Increasing the exposure by a stop would be opening up the aperture (e.g. f-11 to f-8) or slowing the shutter speed (e.g., 1/30th to 1/15th of a second).

Meter readings indicate only that light is present. If the meter is pointed at a polished mirror surface (e.g., chrome, water, windows) the reading may be meaningless if the light source is included in the view. Direct or mirrored sources usually print white. There is no variation within white in the print, although the eye is capable of seeing different levels of brightness when the sources are observed directly.

Most of the time the bright and dark areas of the picture average out and the total amount of light reflected is quite close to what would have been reflected by a grey card. Because of this it is generally possible to use a meter by simply pointing it at the subject and accepting the indicated exposure.

Using the meter as though all the bright and dark areas average to a middle grey is called the "average exposure" method. This works most of the time. The presence of strong direct light sources in the picture or of large bright or dark areas cause this method to fail.

When a photographer points the meter at the subject and accepts the exposure indicated, he assumes that the bright and dark areas are averaging to a middle grey.

Another way is to determine the exposure for the brightest important area in the picture and for the darkest area where detail must be recorded. The actual exposure used is halfway between these two exposures. This too works most of the time.

Contemporary films have enough latitude to permit any reasonable exposure method to work most of the time. Data-sheet, trial-and-error, averaging, and splitting-the-difference all produce usable results. When these methods fail, or when better control is needed, a more precise method becomes necessary.

Negative printability is mostly controlled by the exposure. Exposure determines correct rendering of dark areas in the subject. It also plays a large part in controlling the size of the grain in the image. Overexposure increases grain size. Correct exposure is determined by correct metering.

For printing from small negatives it is desirable to have a negative which is "thin," i.e., has no more silver than is needed to print detail in the shadows. This is a "minimum density" negative. It has small grain, and makes a crisp looking print. A minimum density negative can be exposed by pointing the meter at a very dark shadowed area of the subject and then making the actual exposure two stops less than the indicated exposure. Remember, the meter is made to read the reflection of a grey card. Because the actual subject is darker, the photographer must correct the indicated exposure and **place** the exposure in the correct tone for correct negative density.

In practice, the darkest area of the subject which must have detail in the print is metered. Since this area (because of the wide angle of the meter's view) will include darker tones, it will correspond to an exposure two f-stops less than what would be indicated by a grey card measured in the same light.

Meters built inside cameras have obvious advantages. There are also disadvantages. One is that they are placed so as to meter what the designer feels are important areas of the picture (as seen inside the camera). This takes from the photographer a degree of freedom. At the same time it frees him from routine measurements. This is desirable when he is working with rapidly moving subjects in a changing light environment.

When either telephoto or extreme wide angle lenses are used, the photographer must be cautious about the indicated exposure. For example, a 24-mm lens used indoors will often bring two or more direct light sources into the field of view, bringing the meter indication into error. On the Nikkormat FTN system, for example, the 24-mm lens metering for interiors will be low because of this. Outdoors, with normal areas averaging, this does not occur.

A telephoto lens may make a built-in meter require interpretation. The narrow view of a telephoto can easily isolate a single texture or color — skin, or grass, or bright clouds. The indicated meter reading must be interpreted since the subject matter differs from a grey card.

Exposure Index

Only through trial-and-error testing of a complete system can the photographer learn how to use it in all lighting conditions. With an unevaluated in-camera metering system a safe exposure can usually be achieved by walking up to a dark shadowed area, metering it with the camera, and then exposing two stops less than indicated. Use the meter as though it were a handheld meter. Check this exposure against the exposure suggested by the camera for the total scene.

Any given combination of film, camera, developer and development technique will produce unique results. It is necessary to experiment to determine how a meter, camera and photographer work best together. One of the first experiments should be to determine a System Index — this is the working film speed number to be used for a given type of film.

Cameras are made and assembled on production lines. Small tolerances in manufacturing the mechanical parts and the electrical components may cause the assembled camera system to err in measuring or controlling light. These errors usually cancel. For example, a shutter may be slow and

the aperture small. Sometimes tolerances do not cancel but produce definite error. The System Index tests will discover this and permit controlled compensation.

A System Index will help make evenly exposed, minimum density fine grain negatives. These negatives permit enlargements that retain naturalistic rendering of the subject and that have sufficient detail in the shadows to produce good tonal separation. The exact steps for determining a System Index (applying to either handheld or in-camera meters) are outlined in **Advanced Controls.**

Basic Photographic Chemistry

Most contemporary photographic chemicals are available premixed, either as liquids or as powders. These are dependable and useful, but sometimes it is desirable for the photographer to prepare solutions himself.

Safety must always be the first consideration when working with chemicals. Any chemical may be unsafe, but few of the standard photographic chemicals available are dangerous unless they are handled very foolishly. And recent concerns for ecological damage have diminished the number of those chemicals in common use.

Most photographic chemicals have a definite **ph.** This is a measurement of their alkalinity or acidity. A scale has long been established to measure the effectivity of any chemical in these terms.

ph Scale:

Acidity	neutrality	alkalinity
1 2 3 4 5 6	7 8 9 10 11	12 13 14

A **ph** of 7 is neutral. Chemicals with **ph** smaller than 7 are considered acid, and larger than 7 are considered alkaline. Acids will dehydrate the skin, removing the water; if very strong they will carbonize the tissue, causing burns of a severity proportional to the **ph** and the concentration of the acid. Alkalies will degrease the skin, and if very strong cause tissue damage similar to that caused by acids.

Because acids combine vigorously with water, always pour acids into water, and not the other way around. This will permit the acid to disperse, and the temperature increase caused by the mixing to be dissipated. To avoid splashing, pour the acid into the water along a plastic stirring rod, so it flows smoothly.

Certain weak acids will not react so vigorously. One of these, commonly used in photographic work, is called **acetic** acid. Still, it will burn tissues if applied directly, and skin and eyes must be guarded from direct contact with any strong acid.

When handling any concentrated acid or base, wear glasses. Most of the photographic chemical powders and liquids commonly used lie in the **ph**

region from 5 to 9, and will not cause immediate damage to tissue. Prolonged exposure to photographic chemicals may cause loss of oils in the skin, dehydration, cracking, and in the case of certain chemicals, allergenic rashes.

Insert your hands in photographic solutions only when necessary. Rinse them with clear water as soon as you can. Dry your hands after each operation. Keep your darkroom towels clean. Use a skin cream or baby oil to repair the inevitable slight damage done. If you have a history of dry skin, or of allergenic reactions, plan on using rubber gloves during those operations that require contact with chemicals. The Playtex Living Glove is an excellent glove for work with prints, and film tanks, because it is both thin enough to permit sensitive handling, yet is lined and does not become sticky, which a pure rubber surgical glove quickly does. Disposable industrial single use plastic gloves are suitable for some processes.

The proprietary solutions you will need are the four basic solutions you have already purchased, Developer, Stop, Fixer and Hypo Clearing solutions. But you also need a Film Developer, and you may wish to use a Toner to change the color of the print.

Popular Paper Developers:

Kodak: Dektol
 Selectol

Edwal Super 111 (platinumtone)
 (liquid concentrate)
Sprint: Quicksilver

Popular Film Developers:

Kodak: D-76 (powder)
 HC110 (liquid concentrate)
Edwal: FG 7 (liquid concentrate)
 Rodinal (liquid concentrate)
 Acufine (powder)

Popular Stop Bath:

Kodak: Indicating Stop Bath (liquid
 acetic acid +ph indicator)
Sprint: Stop (liquid acetic acid,
 buffered + ph indicator)

Popular Fixing Compounds:

Kodak: Liquid Rapid Fixer (two
 solution, concentrate)
 Hardening Acid Fixer (powder)
Heico: NH5 (liquid, two solution
 concentrate)
Sprint: Record (liquid concentrate,
 hardener separate)

Popular Hypo Eliminating Solutions:

Kodak: Hypo Clearing Solution (powder)
Heico: Permawash (liquid concentrate)
Sprint: Fixer Remover (liquid concentrate)
TKO Chemical:
 Orbit Bath

Popular Toner

Kodak: Rapid Selenium Toner
 (liquid concentrate)

These are all popular solutions with standard results when used with contemporary papers and films. Many other excellent proprietary chemical solutions and compounds are available; these should be tried when you believe they will produce a result you need. Frequently, the results vary from one solution to another by such small differences that until experience has taught you to perceive the difference, you may well not be able to see it.

There are rules for mixing each of the chemical compounds noted. Most are difficult to dissolve in water if it is colder than 35 degrees C (about 95F). And most of them also contain chemicals which begin to break down if heated much above 50C (about 120F). The liquid concentrates mix best if put into the bottle or tray, and pour the diluting water into them. If liquid concentrates must be added to water, use a Kodak stirring paddle to stir and mix the two liquids.

Powders should be dissolved at least 24 hours before being used. Certain chemicals dissolve slowly, and often reach a stable condition in which they are supported by the water, and then dissolve finally into solution very slowly. Powdered chemicals will also contaminate a darkroom; all powdered chemicals should be stirred into solutions in a space where chemical dust will not fall onto counters and work surfaces where print paper and film will later be handled. For the same reason, if any chemicals are spilled, they should be mopped up and the surface washed with clean water to avoid later contamination. A little hypo dust will mar or destroy a lot of work when it appears as tiny clear patches in film or prints.

The extremely concentrated liquid developers suggested for films offer special problems. Rodinal, for example, is used in dilutions down to 1:100, and sometimes even greater dilutions. The bottle is supplied with a soft rubber stopper that is easily penetrated by a hypodermic syringe, and this is the best way to measure the small amount needed. HC 110 can best be used by making an intermediate working stock. Kodak suggests a schedule of dilution on the bottle, and an alternate schedule is suggested later in the Handbook.

All these chemicals should be stored away from the daylight and at fairly constant temperatures. With some experimentation, you can usually find a shelf somewhere in a closet that stays at or near 21°C all year round, except perhaps in the hottest and coldest months. This is ideal for frequently used chemicals. For maximum keeping time, if there is no objection to having to bring them up to temperature, all of these chemicals will keep longest at about 12°C, or 55°F.

A schedule of special chemicals needed for Advanced Controls will be listed at the beginning of that chapter.

Development of Film

No matter what kind of camera is used, the same problems arise. These are determining the exposure, developing the film, and making the print from the negative. As exposure determination seems to become simpler, with automatic cameras, the problems of development and printing remain much the same as they have been for a hundred years.

To plan the development of the negative, the characteristics of the film being used should be understood. The following table outlines these:

FAST FILMS (about ASA 400) Tri-X HP-5	Generally these films are low in contrast and suitable for general work. (N.B. The Kodak company supplies films with the same number or similar names in several sizes of film which are **not** coated with the same emulsion. This creates some confusion, and developing chart information must be examined carefully before processing.)
MEDIUM FILMS (about ASA 125) Plus-X Pan FP-4	These films are of medium contrast. Slight changes in development time will cause sharp changes in contrast.
LOW SPEED FILMS (about ASA 32) Panatomic-X Adox KB 17, KB14	These films are subject to rapid increases in contrast with moderate increases in development time.

Among the medium speed films is Kodak Verichrome Pan. It departs from the description given to the other medium speed films because it is inherently a rather low contrast film, and will not change contrast quickly with changes in developing time. This makes it an ideal film for amateur use, where exposures are approximate and processing is often haphazard.

Film development controls the quality of the negative. The basics of development are **time** of development, **temperature** of the developer, and the **agitation** method used. Time must be measured accurately from the first second of immersion into the developer until the second when developer is last draining and the stop bath (or rinse water) is poured on the film.

The development plan outlines how the film must be developed to produce a negative which will print in a certain way. The development plan is determined by the nature of the subject before the camera, and by the effect desired. In terms of the film itself, increasing development will increase density in the more exposed areas. Increasing development will not help underexposed film.

The development determines how much detail will appear in bright areas of the original subject, as seen in the print, and what the feeling of these tones will be.

Development is controlled by time, temperature, and agitation. Until recently correct agitation could be produced only with the Kinderman, Nikor or Omega stainless steel tanks and reels. An economical tank for beginners is now available in plastic. The PATERSON 5002 single-reel universal tank is available from Braun North-American, Inc., Photo Products Division, 235 Wyman Street, Waltham, Mass. 02154. This tank has an adjustable reel accomodating 35 and 120 film sizes. The flanges of the reel permit adequate developer flow. The lid of the tank seals well enough to permit agitation as described here to be practiced. There is some leakage but no more than with the Nikor tanks.

The temperature of the developer must be measured in the tank, not in a graduate. The mass of the tank is sufficient to raise or lower the temperature of 450 ml developer several degrees. The thermometer used must be accurate. Cheap darkroom thermometers are often in error by more than a degree Celsius or Fahrenheit two degrees, and a degree Celsius error (with D-76, for example) equals a full paper contrast grade change error!

Standard Agitation

If you are working in a darkroom it is best to put the leaded reels of film into the tank and pour the developer in over them until the tank is full. If you are working in a lighted room, load the film onto the reels in a darkroom, place the reels in the tank and carry them into the light. Remove the filling cap on the tank and pour the developer smoothly and continuously into the tank.

The agitation described here[1] produces a complete exchange of exhausted developer for fresh solution with no continuing motion of the developer.

As soon as film and developer come into contact, the image begins developing. Most agitation problems occur in the first 45 seconds of development.

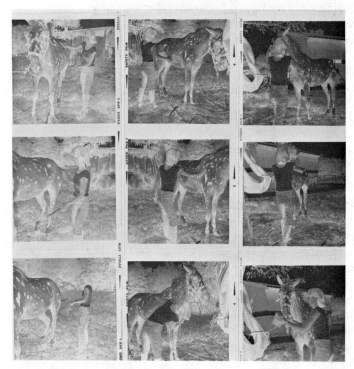

Figure 2-16: **(A) Illustrating correct small-tank agitation. Larger tanks must be held in two hands and rotated about their midpoints. (B) The effect of minimal agitation, normal agitation and twice-normal agitation on negative densities, showing the great increase in contrast with increasing agitation.**

When the tank is full of developer, replace the lid and invert the tank sharply. Do not twist, or rotate it. Simply turn it straight upside down, and then with an equally sharp motion turn it back again 'til it is straight up, in a normal position, Repeat this. Invert and straighten the tank 12 times in the first ten seconds. Continue for 30 seconds. Put it down. You may wish to store it in a holding bath of water at the correct development temperature if your darkroom is much colder or warmer than the desired developing temperature. A photographic print tray full of water works well. At the beginning of the second minute of development, repeat the agitation described, for 10 seconds. Invert sharply, and re-erect the tank. This is not a tossing, or a spinning of the tank, it is a sudden inversion, followed immediately by a return to the normal position.

What happens in the tank is that the liquid has inertia — it can be observed when you stir a cup of coffee, for example, and watch it continue to spin long after you stop stirring. The sharp inversion of the tank moves faster than the developer can follow. The fluid tumbles, and just as it begins to follow the direction of the tank's motion, the tank reverses itself, shearing the solution again and

neutralizing the movement just begun.

Make the following experiment:

Expose three rolls of film to identical subjects.

Develop the first roll for your normal development time.
Agitate the first few seconds the way you normally do, then do not agitate at all! Leave the film in the tank, without agitation for the normal time; stop, fix, wash, and dry.

Develop the second roll with the agitation described here. Fix and finish the film and prepare it for printing.

Develop the third roll with twice the agitation described here, agitating for 10 seconds every 30 seconds. Then finish it, ready to print.

Now make enlarged, full-frame prints from identical scenes from each of these three rolls. Negatives from the first roll may be muddy, with little tonal separation. The second roll should print well, with clear highlights and good tones throughout. The third roll should have highlight areas that tend to block up and lose detail, and also have very strongly separated tones in the moderate shadows.

Figure 2-17: **A contact proof strip and an enlarged sample showing a typical problem with agitation: the edge density apparent in the strip and the large print are caused by insufficient agitation.**

The difference between one agitation pattern and another is usually apparent in the quality of the mid-tones, and the density along the edges of the film. Bad agitation will produce a density wedge along the sides of the film; sometimes it becomes visible as density trails across the film leading from the perforations in the 35mm film.

Suggested normal developing times for medium and high speed films are shown in the STANDARD METHOD DEVELOPMENT Table. After a standard method is learned, it can be modified to fit new needs.

Developers are often used in a diluted form. They are mixed first as the manufacturer suggests, and this solution is called a "stock." In practice the stock is then diluted again. The degree of dilution is noted with the developer named first, the dilutent second. For example, D-76 1:1 means one part of stock developer and one part of water. For a small Nikor tank using 450ml this would mean 225ml of D-76 and 225ml of water. If the dilution called for

was 1:4, this would mean one part of the developer and four parts of water. Using the example of the small Nikor tank again, 90ml of D76 and 360ml of water. The Edwal FG-7 is used 1:15, which means 28ml of developer and 422ml of water. *The developer is always stated first,* the amount of water used to dilute it second.

The Standard Method Development does not make allowance for scenes of differing contrast. It presumes the lighting of the scene is of slightly higher than normal contrast — which is the case almost everywhere in the United States, except in urban areas, and when there are cloudy skies, and the light is diffused, filling the shadows by reflected light.

The significantly longer developing times suggested on the Kodak data sheet provided with the film will produce significantly higher contrast negatives. These will print with greater graphic impact, and less tonal feeling, than the developing times suggested here. These times presume that expo-

sure is being made for shadow areas; they will produce clearly articulated highlights without excessive density and consequently excessive grain.

But, frequently there are less than ideal contrast conditions when one is photographing. With automatic cameras, where the meter is built into the viewing system, it is difficult to make careful meter evaluations of specific areas of the subject. When this happens, one can still make reasonable accurate evaluations of contrast, and develop to fit those conditions.

The metering system offered by each camera manufacturer differs in the way the center of the picture area is compared to the perimeter. Because the upper third of a landscape scene is usually skylighted and is inherently much brighter than the foreground, averaging circuits are used. Some systems give the center of the picture more importance, because the designer presumes a small camera is most frequently used to photograph people, seen up close — and skin tones are then the principal subject. All metering designs try to account for the brightness ranges found in the scene, and they usually produce adequate exposures. Yet the brightness range determines the development required to produce a negative correct density for making a beautiful print; and these meters cannot easily tell the photographer what the brightness range is.

It is possible to use contrast controls outlined later, designed for hand held meters, with 35mm automatic camera photography, but it is unlikely. To do so would mean eliminating the principal convenience feature of the modern camera: quick accurate overall exposure determination of a wide variety of scenes, with almost no attention to mechanical calculations, and all done in the shortest time.

Because automatic cameras offer the photographer this real advantage, an alternate system of contrast control must be practiced, one which uses the metering system found in the camera and which also uses the good sense of the photographer, letting him make an educated guess as to the contrast range of the scene. This can be accurate enough to permit consistently good prints.

First, the photographer must check the camera against normal working conditions and verify that the automatic metering system — used with a given film and standard development — will produce a negative with printable shadow densities.

Second, the photographer must look at the scenes being photographed — and understand and remember the quality of the light.

Third, the resulting negatives will always be approximations of the exact density range needed for excellent prints and may require three paper grades (or corresponding developer controls) to

achieve excellent prints. The results of this system will be minimum density negatives that print well with minimum grain and which have fully textured highlights and open detailed shadows.

Correct exposure will produce fully detailed shadows and small grain for the film used. Correctly developed negatives will have highlight densities that print easily, yielding a sense of luminous and accurate light greys, so important to the representation of skin, cloth, and texture faces that tell us what the world feels like.

The method requires you to use the meter in your camera and to trust it. Let it take care of the shadows. Use your eye to determine the correct development pattern for the film. Development will control the highlights. As you prepare to expose the picture, describe the quality of the shadows:

1. The shadows are very sharp, as though drawn in ink; this is a High Contrast scene. The development plan for the film will be marked (N- -) on the roll. (See Figures 2-18, 19, 20, 21 for illustrations).

2. If the shadows are sharp, but beginning to soften on the edges (the shape of twigs disappear, for example, but larger tree limbs are clearly separated), call this a Contrast scene. The development plan will be marked (N—).

3. The shadows are present but are not well defined. Call this Normal. The development plan will be marked on the roll of film as (N).

4. There are no shadows; the light in the scene being photographed does not come from any sharply defined direction (except perhaps from a cloudy sky or diffuse fluorescent ceiling grid), the scene is Flat. The development plan is marked (N+).

The same observations can be made indoors. For example, the photograph includes a window; the light outside is bright and what is seen outside is also important. This is about the same problem for the film and developer as #1 and is a High Contrast scene. A scene in a room lighted with shaded floor lamps, or table and ceiling lights is approximately the same as #2 and is Contrasty. In a room with several different lamps and light colored walls, the light is reflected more, and the shadows softened — it is about the same as #3 and is Normal. Where there are large ceiling panels of fluorescent lights with diffusing grids, the problem is similar to #4 and is Flat.

The problem for the photographer working with the small camera is that a number of different contrast conditions can be met in a few minutes of photographic work. One can't deal equally with all these on one roll of film. Limit your problem — choose a limited range of contrasts. Expose and develop for these. Choose a range which can be compensated for during printing.

Figure 2-18: A "very high contrast" scene. The film was developed for about 60% of the "normal" time, then printed on normal grade paper.

When you expose a roll of film make notes on the contrast of the first pictures you make. If this is Normal, then *limit* yourself to scenes that are either Normal, Contrasty, or Flat. A normal scene, a Contrasty scene and a Flat scene — all exposed on the same roll of film and developed for the time proper for Normal scenes — will *all* print well if the paper contrast is chosen to fit the negatives as shown below:

Scene	Development	Paper Used
Contrasty	Normal	Brovira #2
Normal	Normal	Brovira #3
Flat	Normal	Brovira #4

These will all produce about the same quality of print. Variations between the grades are also possible. Develop for less than the standard two minutes, for example; this creates a somewhat flatter print, about a half-paper grade less contrast when developed one minute than development for 2 minutes. Or, develop the print for 4 minutes. This creates about a half-grade more contrast than developing for 2 minutes.

Grouping scenes with reasonably close contrast characteristics on a roll of film makes possible

quality printing. This can be bettered only by limiting oneself to simply one contrast range scene for the entire roll. From the point of view of a photo technician, that is ideal; but it is rarely possible for the creative photographer, unless a lot of work is done in one place, in one kind of light, with one subject.

By limiting the kinds of scenes exposed to simple contrast groups, a development plan for good negatives can be produced:

Scene	Development	Paper Grade
1. High Contrast	N—	#2
Contrasty		#3
2. High Contrast	N-	#2
Contrasty		#3
Normal		#4
3. Contrasty	N	#2
Normal		#3
Flat		#3
4. Normal	N+	#2
Flat		#3
Very Flat		#4

Figure 2-19: A "contrasty" scene: the film was developed about 85% of the "normal" time.

Figure 2-20: A "normal" scene.

Figure 2-21: A "flat" scene. The film was developed for about 125% of the "normal" time.

STANDARD METHOD DEVELOPMENT (21°C/70°F)

FILM (and size)	DEVELOPER	DILUTION	DEVELOPMENT TIME	DEVELOPMENT DIRECTIONS
TRI-X 120 35-mm	D-76	1:1	8'-9'	Agitate constantly the first 30 seconds, then agitate the first 10 seconds of each minute. Development time starts with the first wetting. Drain time is included in the development time. Dump diluted developers after using them once.
FP-5	D-76	1:1	8'	
PLUS-X 120 35-mm	D-76 D-76	1:2 1:4	10' 11'	
TRI-X	FG-7	1:15	10'	This is sheet film. In tray development agitation is continuous. The development time is for FG-7 without sulfite.
PLUS-X 120 120 35-mm	FG-7 FG-7 FG-7	1:15 1:20 1:15	10' 10' 8'	Development time is for FG-7 without sulfite. This time and dilution is with 9% sulfite. It is a compensating developer suitable for use in harsh light conditions.

After this point all the films are treated in the same way. Agitation should continue in all solutions.

SOLUTION	TIME	NOTES
Stop Bath	30"	Use a very weak acid solution. 20 to 40ml of 28% acetic acid stock in a liter of water is enough. Dump after using once.
Fixing Bath	2-5'	Concentrated liquid fixers remove silver rapidly. Do not overfix. Safe fixing is accomplished in twice the time needed to clear and last of the grey emulsion. Throw away the fixer when this time is double clearing time needed for a fresh solution. Kodak Powdered Fixer takes longer than liquid concentrates.
Rinse	1'	Rinse the film with tap water at 70°F, 21°C.
Hypo Clearing	variable	Use according to directions. This does not eliminate but changes the thiosulfate into a compound which washes out easily.
Wash	5', or	Fill the tank with water at 21°C, 70°F, agitate several times and dump. Repeat this ten times.
Wetting Agent	1'	"Wetting" the film with a wetting agent permits the water to flow off smoothly and not leave drops that would mar the image. Sponge or squeegee only if water is turbid.
Drying	2 hours	Do not dry film in heated cabinets unless necessary. Keep wet film away from all dust. Store dry film as soon as possible.

The first group (High Contrast and Contrasty) is common in high mountains and in the brilliant light of the desert. It requires careful controls. When photographs are made in industrial or in seaboard cities, where moisture and airborne solids diffuse the light, the problem of contrast control is lessened. The last two groups of scenes are most frequently found.

Practicing this kind of scene grouping will produce film that prints quickly and easily. The resulting negatives should print at between 10-20 seconds at f/11 with a Besseler enlarger, and 10-20 seconds at f/16 with an Omega enlarger. The Omega B-22 and B-66 enlargers may need a neutral density filter (Wratten No.96, ND 30 or ND 60) to reduce the light intensity to comfortable printing times for correctly made minimum density negatives.

Remember, even one stop over-exposure, and as little as 15% over-development will produce noticeably enlarged grain — a serious limitation to making excellent prints from small negatives.

There are several ways of controlling contrast with developers. One is through varying agitation. The experiment outlined earlier illustrated this when three different types of agitation were used to demonstrate its effect on contrast. But agitation should usually be kept constant, to avoid muddiness or streaking. Developing temperature could be changed, but here again it is best to keep this constant because the developer does not keep exactly the same characteristics as the temperature changes, though it does increase in effectivity with rising temperatures, and decrease with cooler working temperatures.

The control most frequently used is changing the developing time, while keeping the temperature and agitation constant, one roll to the next. In the section on **Advanced Controls,** the effects of changing time will be investigated thoroughly. Time provides a very sensitive control of the highlight densities, when the exposure is correct.

Another way of controlling contrast, which is to say of limiting the density of silver found in the highlight areas when the shadows are correctly exposed, is through varying the dilution of the developer. This is a very useful control with some of the liquid concentrate stock solutions, and of these the Kodak HC-110 developer offers exceptional qualities.

Contrast control through developer dilution uses the high energy Kodak HC-110 concentrated developer, with its almost unique ability to provide very clean separations of shadow densities and also offer linear separations of *all* equal exposures into the high densities, even though diluted to a very great degree. The effects of varying developer dilution for HC-110 and Tri-X rather than develop-

ing time can be seen by examining the parametric curve set, Figure 4-3l, Advanced Controls. These curves show the equal separation in the shadows and also the contrast variations possible by merely varying the concentration of the HC-110 developer while keeping time, temperature, and agitation constant.

The advantage of this system is that a widely distributed, very stable, highly concentrated, commercially available developer of known quality is used only at a standard time — one which is physically long enough to avoid problems inherent in short developing time. The concentrated syrup can be measured accurately with pipettes, but since these are usually only at hand in chemistry labs, this simple two-step dilution schedule has been prepared:

Make a working stock of 1 part HC-110 and 9 parts water.

Do not mix more of this than will be used in a few days.

(For example, 100ml HC-110 and 900ml distilled or de-ionized water.)

Dilution of working stock: Dilute the 1:9 stock as follows to make dilutions of approximately:

Dilutions*	1:0 stock	Water
1:30	150 ml	300 ml
1:40	112	338
1:50	90	360
1:55	83	367
1:60	75	375
1:65	69	381
1:70	62	388
1:80	50	400

*Total=450 ml for two-reel rank. Double this for a four-reel 35mm tank; Nikor requires 850 ml, the Kinderman about 950 ml.

All film is developed in HC-110 at 21°C–70°F degrees for five (5) minutes with standard agitation (30" the first minute, then the first 10" of each other minute).

Control dilutions for scenes of differing contrast:

FILMS

Development Plan	Pan X	Plus X	Tri X
N++	1:50	1:50	NR
N+	1.60	1:60	1:30
N	1:70	1:70	1:40
N-	1:80	1:80	1:50
N--	NR	NR	1:60

There is almost no loss of shadow speed with this developer, even at the extreme dilutions.

Make a 1:9 stock in small quantities. An old HC-110 bottle is useful as it holds about 500 ml. Store in the dark or away from daylight. This provides enough stock to develop several rolls; since the developer is used only once and discarded, the very diluted solutions provide repeatable results from one lot of film to the next.

The HC-110 produces a very sharply defined, quite small silver grain as seen in the print. This is especially true for Pan-X and Plus-X Pan film, films difficult to control in terms of contrast. The grain produced on Tri-X is not significantly larger than that produced by D-76, but it is more sharply defined, principally because of the absence of silver solvents in HC-110, compared to the large amount of Sodium Sulfite in D-76; these solvents are of significance even in D-76 dilutions of 1:1 or 1:2.

When using the HC-110 developer with the dilution controls suggested, the time/temperature relationships remain constant. HC-110 at lesser dilutions requires much shorter developing times. Medium and fine grain films require developing times of only 2-3 minutes with 1:31 dilutions. The difficulty arises that developing time variations of even 10 seconds become significant, approximating a half-paper-grade change of contrast. The five minute time and the decade change of dilution (e.g. a change of 1:50 to 1:60 approximates a paper contrast grade) means that the agitation to still-development time relationships remains constant. Percentage of error involved in measuring total development time (including filling and dumping) is minimized. This system works well with Ilford films as well. However they exhibit greater sensitivity to developer strength variations.

Development Plans for Ilford Films with HC-110 Dilutions

Plan	Pan F	FP-4	HP-5
N+	1:50	1:55	1:55
N	1:60	1:60	1:60
N-	1:70	1:65	1:65
N--	1:80	1:70	1:70

With all of these films using the manufacturer's film speed index is generally desirable. Some "high-energy" developers will produce greater densities overall than these HC-110 dilutions. When this happens, the working index for the metering system has to be a larger, or higher number. The whole purpose of this control system is to produce high quality, low density negatives that will print easily and well, rather than to "push" film. High energy developers produce high densities under extreme low light levels. And they also produce negatives that are more graphic and less tonal — that are not so much translations of colors into the grey scale of the photographs as they are graphic simplifications of the world.

The sense of graininess in 35mm is affected by exposure far more than most photographers are willing to admit. A correctly exposed minimum density negative is "filmy"; this means that the page of a book can be read easily while looking through the negative. The least overexposure will mar otherwise excellent negatives that would enlarge well and have maximum resulution of detail. Two stops overexposure will enlarge the grain so much that the maximum degree of enlargement without obvious grain is about 6 diameters.

If the quality — the sense of presence rather than absolute size — of the grain produced by Tri-X in interaction with HC-110 is unsuitable and a sensation of smoother grain is desired, then D-76 can be used in a similar wary, varying the dilution rather than the time.

D-76 is a vigorous developer and will permit full development of the useful silver in a small camera negative with moderately high dilutions. However, D-76 does not have the unique property of HC-110, which is to create even tonal separations down the exposure scale to the film base-density. The lower tones of the photographic grey scale are crushed together when film is developed in C-76 relative to the same film exposed the same way developed in HC-110.

The highlights tend to be less well separated when D-76 is used as compared with HC-110. Of course, for very high contrast situations this is to the good; it is in fact the essential character of a "compensating" developer, one which automatically prevents excess highlight densities in contrast situations.

The increasing dilutions suggested here change overall contrast and tonal separation within the grey scale. As dilution increases, the effect of the silver solvents in D-76 decrease to some extent. The physical sense of the image seems more delicately drawn, especially in skin tones, which lose the harsh, blocked quality overdevelopment produces.

Developing Control: D-76+

Scene	Tri-X	Plus X Pan
Very high contrast	1:4	1:5
Contrasty	1:2	1:4
Normal	1:1	1:2
Flat	Full strength	1:1

+Control is through dilution. Development for all combinations is 8 minutes at 21°C, 10 minutes at 20°C.

The keeping qualities of D-76 may cause changes in its effectivity. This is because of the steady decrease in *ph* with age. If used within two or three weeks, there is almost no change. If allowed to stand longer, or in partially filled bottles, there is a significant change in effective strength of the solution. If D-76 is to be used in a controlled and repeatable manner, mix the gallon of solution and then store it in quart sized brown bottles, each filled to the top.

Developing the Print

The print is a simplification of tones encountered in the world. The vast range of color and brightness are translated into grey equivalents, The white of the print can never match the sunlit world, nor can the black in the print be as dark as the shadows we see. Our translation is both from color to value and from solid to flat.

The photographic print has the ability to represent tiny variations of grey, evoking a marvelous sense of substance and of texture. Where there are variations of surfaces it is possible to capture variations of tone in the print. Large black areas of pure white or solid plack are also easily realized but these rarely relate to the original surfaces. One definition of the classical fine print is a "full scale — full substance" rendering. This print displays tones from solid black through to pure white in the same way the subject is seen to range from black shadows to glistening highlights. This print also records the sensation of substance — its mass and weight — in the object photographed. Full scale — dark to light; full substance — the sense of the original mass. Tonal scale controls the sensation of *surface* of the subject which one feels on viewing the fine print.

A print with a sense of internal light, which seems able to stand by itself, not depending on special surroundings, may be called a *fine print.* This sense of light does not often exist in a photo mechanical reproduction. Such a definition is subjective, and is dependent in part on experiencing fine prints. One cannot learn what to look for in a print by examining only reproductions in books and magazines. Original prints must be sought out and studied.

The reproduced print is a source of information about the photograph but is not the original photograph. It is always different, sometimes stronger! Learn to evaluate both print and copy. Each has its own character, its own visual values. Seek out fine prints and learn by the direct experiencing. Study reproductions to learn more about other kinds of photographic seeing.

What is actually seen when one looks at the silver print is rather complex. The print consists of a supporting paper or plastic sheet, an emulsion of gelatin filled with silver that has been reduced by development to a dark-colored pattern representing tones in the real world, and an overcoating of plastic or hardened gelatin that to some extent protects the image layer. Between the emultion and the paper is often placed a thin layer of *baryta,* or barium sulfate, which acts as a reflective surface for light. Sometimes this undercoating is colored, to influence our response to the picture, and with some papers (the Polaroid print, and some of the regular printing papers as well) there are also efflorescing agents that change UV light into visible white light, thereby "brightening" the print.

The eye sees the light that falls on the print reflected from the undercoating, and absorbed by the black silver. Therefore, the brightness range of the print is controlled by the materials of its manufacture and the quality of your processing. Processing which leaves chemical residues in the emulsion, or scum on the surface will dimish the sense of whiteness. Incomplete development of silver, or damage to the smooth surface of the print will diminish the quality of the black, and in the second, light will be reflected from areas which should be absorbent.

The sense of blackness is also influenced by our response to image color. Brownish silver makes a seemingly more opaque "black" than does a blue-black silver. Yet this is largely a subjective rather than a measurable response. Aside from toning, the color of the silver image is controlled by the grain size of the silver crystal grown during the development process: the very fine grain image looks brown, the coarse grain image looks neutral to blue-black. Changing the developer formula will, to some extent, affect the color of the print.

But the principal aspects of the print are controlled by the manufacturer. These are smoothness, color, texture and contrast.

Historically, photographic prints were made on rag paper which was sized (sealing the poresso the emulsion would not penetrate) coated, dried, packaged and marketed. The texture of the paper itself affected the way light reflected from the print. In 1866 the idea of calendering the paper with a barium sulfate and gelatin mixture to fill the paper and provide a smooth reflective substratum for the image-bearing emulsion was proposed. Baryta was not used on all papers, and until the Second World War one could buy papers with very rough textures, reflecting the felting operation of the paper making process. One could also purchase papers with a very fine texture, that had been smoothed out by the manufacturer until only a mirror-like surface was left. This paper was called

"glossy," and was originally made for commercial and industrial photography.

For the first hundred years of photography, the photographic print was made to look as much like a watercolor or a drawing as possible. This largely disappeared in the 1940's, as the west-coast tradition of "straight" photography, utilizing the full reflective range of the silver print, came to dominate American art photography. This movement was led by the photographers Edward Weston and Ansel Adams, and dominated the thinking of the purist group of the 1930's, called F 64.

The photographic papers made today bear little resemblance to those of the 1940's. Traditional paper has been replaced by stabilized, acid-neutralized cellulose compounds, and even these are disappearing as resin coated supports overwhelm the marketplace. With the displacement of traditional paper making processes, and the subsequent loss of textures developed naturally by the process itself, embossed mechanical textures are not imprinted on the papers when texture is desired.

While some textured surfaces are still available, they are limited to a very few contrasts and colors of papers, available almost completely in the "portrait" stocks, e.g. Kodak's Ektalure and Portralure.

The variations in paper surface normally used today in expressive work, at least by beginning photographers, are from glossy to dull-surface but smooth papers; from blue-black to brown-black image colors. Since almost all printing is done by enlargement, there are almost no contact printing papers made now; they have a distinctly longer tonal range; because they use more silver-chloride, produce a greenish-brown image color. Kodak, however, still manufactures Azo, but only in single-weight sheets.

Some manufacturers no longer make papers available to the amateur market. Many papers are made (for both monochrome and color) only in rolls, for automatic machine processing, and are unavailable in cut sheets.

The distribution system of American commerce has also limited the variety of products available to the photographer. GAF, for example, which was a competititive manufacturer of amateur film and paper products before the 1970's, is often impossible to locate — in terms of roll films and cut sheets of paper — because of distribution limitations and the increased market for automated printing requiring only roll stocks. Some materials that are generally available are:

Brands of Printing Papers Generally Available

Kodak:* Kodabromide, Medalist, Polycontrast, Poly Rapid

Ilford: Ilfobrome, Ilfospeed

Agfa: Brovira, Portriga Rapid

There are other papers, available through mail-order houses. Two of these are Luminos and Spiratone. Kodak and Ilford make other papers than those listed here, but they are often not stocked by local dealers. Most dealers have a paper sample book, with comparison prints made by the company on each of the special stocks offered, from which special papers can be ordered.

The contrast grade of photographic papers is controlled by the manufacturer, and though they are not identical, the numbers used by one are approximately interchangeable with another in most cases. The numbers are approximately equivalent in the American system but do not directly compare to the German notation.

American & English	Contrast	AGFA
1	very low contrast	1
		2
2	normal grade	3
3		4
4	high contrast	5
5		
	very high contrast	6

Both Kodak and Ilford make variable contrast papers as well. Variable contrast papers have two emulsions on the same support. Each is sensitive to a different color of light. By using filters to color the light from the negative it is possible to use combinations of these two emulsions to produce a wide range of contrasts with only one paper. It is sometimes difficult to achieve as rich a maximum black with these papers as with the graded papers because not all the silver is used with any one filter.

The print is subject to the same controls as the negative. As all silver emultions are similar in their response to exposure and development, the amount of silver visible in light areas is controlled by the exposure to light, and the quantity of silver in dark areas is largely controlled by development.

Time, temperature and agitation are also the principal controls for the development of the print.

The following experiment reveals the effect of these:

Make a trial exposure and validate it by developing the paper as you normally would. Then expose 8 sheets of paper (they need not be large,

*Kodak and Agfa are changing from traditional papers to plastic-coated sheets. Kodak's proprietary designation for this is RC, meaning resin coated.

and cutting 8 x 10 sheets into fourths will work just as well as using full sheets of paper) identically.

Development Time Test: develop one sheet for 45 seconds, with constant agitation. Agitate by immersing the print smoothly in the developer, lifting and laying it back face down, then lifting and laying it face up, etc. At the end of the developing time, drain it for 5 seconds, and then into the fixing bath, where the agitation should continue for 30 seconds.

Develop the second sheet for 1½ minutes. Agitate constantly for the first 30-45 seconds, than lift and replace the print each 15 seconds for the rest of the developing time. Stop and fix.

Develop the third sheet for 3-3½ minutes. Use the same agitation as with the second print.

Compare these prints. Choose the developing time that produces the print you like best, and use it for the following test of agitation:

Agitation Test: Develop a print for the time you have chosen, but use **no** agitation after the first ten seconds. Immerse the print, lift, replace, lift, replace, face up, and push it gently to the bottom of the tray. Do not agitate again in any way! At the end of the developing time, stop and fix.

Develop a second print for the same time, but agitate constantly during the developing time. At the end of the time, stop and fix.

Compare these prints. See what has happened to the overall tonal separation, to the sense of the blacks, and how there is little difference between the lightly exposed areas (the highlights in the subject). You can make similar tests using developing solutions that are at three different temperatures.

Temperature Test: One tray with developer at 18°C (65°F), one tray at 21°C (70°F), and the third at 27°C (80°F). Develop prints by inspection, using agitation for the first 30-45 seconds, and then at 15 second intervals for identical detail in the lightly exposed areas, where there are pale grey tones and very light textures. Pull the print from the developer when these seem similar, and stop and fix the prints. When dry, compare the overall contrast, and see what changes have been created in the image color.

The step-to-step operation of making a test expo- then exposing a print and processing it has been described in **Beginnings,** the first chapter of the Handbook, and need not be repeated here. Certain cautions need to be noted:

Contrast will also be affected by dilution. Developers may be diluted more or less than the standard dilutions suggested. Normal dilution

for Dektol, and Vividol are 1:2, but more water may be added to decrease contrast. Likewise, these may be used 1:1 or full strength, to increase contrast. Similarly, with Sprint Quicksilver, dilutions of 1:6 through 1:14 produce higher to lower contrast.

Stop Bath time should be long enough for there to be a definite change from the basic solution of the developer to an acidic solution, in the paper itself. The human skin is a sensitive **ph** indicator: the paper feels slippery when it is wetted with the basic developer solution. When it is in a properly working stop bath it quickly loses that slightly soapy feeling, and becomes non-slippery. If it doesn't, the stop bath is too weak, or is becoming exhausted. The Kodak Indicating Stop Bath, or the Sprint Indicating Stop will also change color about this time, from a yellow to blue, because they incorporate standard **ph** color indicators..

Fixing Time: The silver in the print will be etched away, as well as the unused silver salts if the print is allowed to stand in the fixing bath much longer than the correct minimum safe fixing time. Each proprietary brand of fixer will have suggested safe fixing times published on the package. It is well to heed these. Do not use a stronger bath than is necessary. When you have a choice, dilute the fixer for longer rather than shorter working times. A fixer with a one-minute safe fixing time is difficult to use in home processing because that short a time is hard to maintain. Twice the normal safe minimum fixing time will almost always result in the loss of some visible silver in carefully exposed and developed prints. The same agitation pattern should be used in the fixing bath as in the developer, so that unused silver is fully and completely removed from the emulsion, and also so that no chemical solids are redeposited onto the emulsion, limiting the brilliance of the print.

Interim and Final Washing: Water is increasingly expensive and difficult to obtain in many areas. Good water conservation habits are important. Do not wash prints in running water until you are ready to complete them, and then wash them only for the time needed to remove the unused chemicals. After fixing the prints, store them in a tray of plain water. As each new print is added, this tray will become a very weak fixing bath, so don't store more than 8 or 10 prints at a time, and change them to fresh water every half hour. When all the day's printing is done, cycle the prints through a hypo eliminating solution (Perma Wash, Hypo Clearing Solution, Archive, Orbit Bath, or one of the other proprietary solu-

tions) for the recommended time. This solution will change the thiosulfate (which is relatively insuluble in water) into a more soluble chemical that will wash out quickly. Use of a clearing solution permits the use of minimum water, and also makes a print that is more permanent. Final washing should be done a few prints at a time if a Kodak Print Washing Siphon is used; washing requires a vigorous movement of water past all parts of the print. Improper washing will result in staining, or in discoloration of the entire print within a few weeks, and eventual loss of the image.

Drying the Print: The print may be dried in several ways. Resin coated prints can be hung to dry on a line, held up by clothespins. Paper prints can be dried in blotter rolls, on stretched fiberglas screens, or simply placed on clean lintless cloth and allowed to dry face-up until they are no longer spongy or tacky to the touch, then turned face-down and covered with a piece of cardboard to keep them from curling, until they are dry.

Heat drying is used in commercial photofinishing plants to speed the process, and sometimes to fuse the emulsion into a hard shiny surface that is traditionally called ferro-typing. This glaze is confused with the normally glossy surface the air dried, "F-surfaced" (a Kodak nomenclature that has passed into the photographic vernacular to mean a glossy print, without texture) print produces — a definition that separates it from the heavily textured paper available for printing until recently.

Drying screens are easily made by making a frame of 1 x 2-inch nominal wood strips (redwood or clear white pine) over which is stretched fiberglas or nylon screening. This should be washed frequently, and for critical work waxed, to prevent transfer of chemicals to the print.

Figure 2-22: **A typical print drying rack. The frames measure 24x36 inches. In three feet of otherwise wasted counter space 40 prints can be dried at a time.**

The print is taken from the washing tray or print washing machine, swabbed with a soft viscose sponge, allowed to drain dry for 5-10 minutes, then placed on the screen face-up, until it is no longer soft. Then it can be turned over face-down and it will dry with little curling. After it is dry to the touch, the prints can be placed under pressure (a stack of books is adequate) for a day or so until completely flat.

Mounting and Finishing: The silver print is similar to a mirror — it is quite smooth and the dark places both absorb and reflect the light. If the print blacks are to be as vivid as possible, it is necessary that it be kept flat when you look at it. The simplest way to do this is by dry mounting. This is done by using a heat fusing sheet which melts at about 225°F (103°C), placed between the print and a supporting sheet of cardboard. The sheet is melted with an electrically heated press. Older style tissues were quite tolerant of temperature variations but the present tissue — formulated for use with temperature sensitive resin-coated papers — is not and requires controlled temperatures for adhesion without bubbles. Student grade mounting board is made by Cresecent and other paper companies; choice of cardboards is a compromise between your pocketbook and your taste. The most expensive boards offer surfaces with colors that are most compatible with the print paper itself, but probably shouldn't be wasted for trial prints.

Prints inevitably have small white spots caused by bits of dust on the negative, no matter how carefully one cleans the negative or blows off the dust. These can be spotted out on the finished print by using a very small paintbrush (Wirdson & Newton, Sable, Size 000, or 0000) and a liquid dye (Spotone) or Kodak Spotting Colors. The dyes are absorbed into the emulsion, and so seem easier to use, but it is quite easy to overspot, leaving a darker mark than is needed. The spotting colors will always be visible by glancing light, but can be mixed to match the area around the spot exactly, and so are preferred when the photograph being spotted is to be used for reproduction.

Storing Prints and Negatives:
Prints and negatives are alike in that they are both silver in an emulsion, supported by paper or plastic. This silver is easily damaged by atmospheric sulfur, and by sulfur compounds in the paper used to support the prints, or protect the negatives. Negatives are best stored in Print File storage sheets. These are transparent plastic, and permit contact proofing negatives without removing them from the sleeves; the sheets them-

selves store in standard three-ring binders. The negatives are easily collated with their proof sheets; this permits specific negatives to be located quickly when reprints are desired, with no handling of the negative until the time for printing.

Figure 2-23: **Plastic filing sleeves permit proofing without handling.**

Prints are easily damaged unless protected both from atmospheric sulfur and from damage by handling, abrasion and dirt. The surfaces of either traditional or resin coated papers are easily scratched. An archival storage box is the best solution, offering a standard sized snug container free of contaminating acid. The Light Impressions Portfolio Box offers ideal protection for mounted or unmounted prints.

Figure 2-24: **Prints are stored best in archival portfolio storage boxes.**

Summation of Basic Printing

The whole point of the technical discipline is to produce a method of working that frees the photographer to concentrate on the image, not on the mechanics of photography.

Note exposures, f-numbers and special problems on the back of the work print. A soft lead pencil is good for this; do not press hard. Excess pressure will cause marks on the surface of the print.

The finished print grows from an understanding of the possibilities of the photograph.

After you have "lived with" a print for a time, try making a finished print. It is difficult to make a final version of a photograph immediately after making a trial print. We usually see only one aspect of a picture at a time — the subject, the printing or the graphics of the print. With time we come to understand all the parts and how to bring them into harmony.

Making a finished fine print differs from making a trial print. The developer is used more conservatively so that the richest tones can be produced. Manipulations are made both with greater freedom and with greater understanding. The result is a new photograph.

If chemical modifications of the developer are used, add them just before use. Developer formulations are stable as manufactured, changing them makes them unstable. Modified developers decompose rapidly. Develop no more than one 8 x 10 inch print in each ounce of developer stock. If you are leaving the darkroom for more than a few minutes cover the developer with another tray to reduce oxidation.

There are several steps to making a fine print. First there is a contact print, a study proof. This yields basic information about the possibilities of the negative. Then there is an enlarged proof. Between this and the fine print may be one, or several, intermediate prints.

Make a full-frame print. Use the exposure and contrast information gained from the test strips. This print should be "straight," no attempts at local correction. Fix the print and examine it in white light. Study it for overall accuracy of the exposure; the correctness of the contrast grade; areas that may need special work.

Ask yourself: ***Should the whole negative be used for the print? What portion of it will make the best picture?***

The first test print may be harsh because the developer is fresh. Even here it is desirable to "bracket" — make prints a little darker and a little lighter than what you think is right. Do this until you have enough experience to predict accurately, changes when the print dries.

If the print seems too dark reduce the exposure about 50%. If it is too light increase the exposure the same amount. If the contrast seems too high reduce the contrast grade. Sometimes a full paper grade is too much change. When this happens

modify the developer by diluting it more, or using a stronger solution.

Look at the print again. Try to see it as work done by someone else. Look for the sense of the surfaces in the photograph, the rendering of textures and volumes, of transparency, and mass.

Decide what local manipulations are needed. Edge burning is often necessary to "bring in" the print toward the center; the eye is drawn inward by the dark edges. Some areas of the print may be rendered "correctly," yet need to be changed when seen as a part of the whole print.

The trial print will yield information needed to produce a fine print. The fine print is an **excellent** print in terms of printmaking and also it is the best rendering of the photographer's vision.

Make another print incorporating the planned changes. Assuming that the corrections made to this point are right, it is difficult to be certain of further changes until the print is dry. Tonal separations change and darken as the print dries. The amount of change varies from one kind of paper to another. Dry the print. Study it before attempting a final statement.

The print must be satisfactory on at least two levels: as a translation of reality to a print, and as shapes on the surface of a piece of paper. The subject of the print is the shapes and tones in the print, regardless of what these shapes are supposed to represent.

[1]Certain developers require much less agitation, e.g. **Acufine** and **Perfection.** These are sodium hydroxide activated systems and produce large grain when agitated. Correct agitation for these chemical systems is one very slow inversion each minute. The purpose is the same, to replace exhausted solution with fresh.

CHAPTER THREE
The Problem of Meaning

The Problem of Meaning:
Response — Critique

After the mechanics of photography are controlled, the problem of making useful judgements of the photograph arises. But the first of these problems is, in fact, the hardest to answer: what is the photograph for? Which is in turn a subset of what does it mean?

Few of us are articulate and able to state clearly what things mean to us, even objects or relationships much more important than photographs. For example, in a book of psychological counseling, this phrase tellingly appears:

"That's the only way I know how to handle the thing. I mean (pause) it all meant—it does mean something. But what it does mean, though, I don't know..."

The painful indecisiveness of this response to a simple question about meaning is most common. The photograph is a difficult object to talk about because much of the time we are not sure exactly what it is we are discussing.

If we limit this discussion of the photograph to the print, then the photograph is a piece of paper with dark and light tones. They may be in color or in greys. By societal training we learn quickly in life to associate these shapes with representations of

reality. But that process of learning is quickly forgotten and we are left with a consensual belief that the photograph is somehow a transcription of reality. In our simple way we frequently go one step more and confuse this consensus with reality, and say that the photograph shows reality.

All the photograph shows is a record of light that has been reflected from the subjects before the camera at the moment of exposing the film.

The problem of apparent reality arises because the mechanism of the camera draws with such facility, and does so according to a tradition of seeing which was codified in the 1400's and which has dominated western art since then. The principles of Renaissance perspective are mathematical and close enough to the spherical geometry on which lenses are usually ground that there is no disparity between the great tradition of drawing that began after the plague disappeared at the beginning of the 15th century leaving Europe free to begin the incredible social growth that resulted in the Industrial Revolution, and in our own age of technology—and in the representations of reality made by the camera. We have learned early to see the photograph as an illusion of reality.

Schematically, most of us "see" the photograph as a window, a window framing a miniature and somewhat magical world:

Figure 3-1: **(A) For many people the photograph is seen as a window onto reality.**
(B)For some others, the print is seen as a flat pattern of shapes abstracted from reality.

At the same time, there is another kind of mind, or another way of seeing, which to some degree always sees the photograph as what it is in fact, a set of shapes on a flat surface:

Figure 3-2 **The photographer often sees the world as a series of flat patterns, waiting to be abstracted by his camera.**

There is no fundamental reason both these ways of looking at a photograph cannot be useful, as long as we know how we are looking! But for a society raised on the idea that the photograph was a more perfect representation of reality than any other art could offer, here's Beaumont Newhall's description: "the very fact that it was a *photograph* implied that it was a truthful representation, and so the scene was viewed literally."[1] A painful, and dangerous logic that happens over and over again.

And the problem is not even that simple. Because whether you see the photograph as an illusion of a real world or as a complex pattern of flat shapes on a piece of paper, the meaning of either is hemmed in and colored by other habits we bring to the picture merely because we live in a certain society. By the time we come to school, none of us has an innocent eye, especially not in this age of television. The photographic artist may wish to create a language of his own, but it is difficult to find viewers who are willing to read it. Kandinsky wrote that he "labored under the delusion that the viewer confronts the painting with an open soul and wants to harken to a language unkown to him."[2]

This confusion about language occurs in part because no two of us look at the same photograph. We each approach the picture complete with filters that prohibit us from seeing it in certain relationships, intentions and even specific objects. We mask out things we don't want to see; much of the time this rejection occurs on a level below conscious knowledge.

The converse of this psychological refusal to see all that the photograph has to offer is that the thinking eye seems to have a gestalt imperative, an unending desire to organize into meaningful patterns any tonal arrangement. Morse Peckham described it this way:

"There is not a set of perceptual data so disparate that human perception cannot create order and unity out of it. To orient oneself to a situation is precisely to perceive it as a unified field, though at a cost of suppressing and perceptually altering data and configurations which you cannot so unify."[3]

We are determined to organize raw visual information into forms that mean something, even if we have to suppress or alter them—usually through non-recognition. But even the most nebulous shape *will* be given form by the inquisitive mind. This propensity has been given different names.

Mimesis is one, when it is a special mimicry, a copying the actions of another. It is largely passive. Of greater importance to most photographers is the problem of **projection.** This is a term used by psychologists to describe imposing meaning onto events outside your actual control. In photo-graphy, it appears when one adds meaning to the shapes one finds in the photograph, seen either as pattern, or as illusion. Gombrich wrote that "once a projection, a reading, finds anchorage in the image in front of us, it becomes much more difficult to detach it."[4]

Figure 3-3: (A) The photograph of three boys as the photographer saw them.
(B) A family photographer would probably see only the boys and unconsciously screen out the perimeter.
(C) A relative might see the boy of choice, and perhaps important features of the other boys.
(D) A photographic printmaker would probably see the picture as a complex pattern of shapes, with everything being equal: the three figures echoed in the three wiring boxes, and echoed again in the graffiti, etc.

Projected meaning can be of two sorts, one relating to the apparent shapes we see, and the other to the narrative meaning those shapes seem to have. In terms of the first, where pictures have shapes that puzzled us until we suddenly perceived them, Gombrich notes "once they are solved, it is hard, or even impossible to recover the impression they made on us while we were search-ing for the solution."[5]

The idea of the picture as a puzzle can be extended to the confusing world about us. A gestalt psychologist noted that one of our greatest problems is simply that we no longer see the world around us for what it actually is. We have to strenuously organize it into patterns, solved the puzzle as it were, and in Gombrich's terms it is

"hard to recover the impression" made on us before we came to this solution. This is what we learn when a new photographer comes into our familiar environment and sees it freshly—making photographs of patterns we can no longer see because we have "solved" our personal puzzle, made "order and unity out of it." As Robert Ornstein has noted in *The Psychology of Consciousness,*[6] we have to simplify the world in order to survive. The world would otherwise overwhelm our sensory system; but, it is unfortunate. It is the artist in us who sometimes permits us to look again, with a fresher, more nearly innocent eye, to see new patterns in the endless complex textures around us.

The projective meaning of a picture may seem almost simple-minded. Gombrich describes how "if you show an observer the image of a pointing hand or arrow, he will tend to shift its location somehow in the direction of the movement."[7] Such simple perceptions are used in assembling sequenced pictures, and in the projective creation of meaning within single pictures.

Gombrich also points out that we constantly revalue these decisions about the "meaning" of patterns. He calls this testing the consistency of our decisions. "Where we do not find this consistency...we revise our hypothesis about the type of message that confronts us. Within the context of our culture we do this so automatically that we are hardly aware of the process."[8]

Making a trial catalogue of the kinds of meaning we find in the direct, documentary photograph, we can list these:

The Photograph as Window	The Photograph as Shape
description	tonal relationships
illusion	graphic constructions
allusion	formal relationships.

The implications of these, psychologically, might be schematized thus:

outward	inward
directed, toward the picture	directed, toward reflexive psychological meaning.

Continuing with this schematic description of meaning possibilities inherent to the photograph, both these columns are brought into interaction with these:

education, and general knowledge of the world

political history, and the mood of the time
art history, and specific references to other art in the work
personal emotional and psychological history
understanding of signs and symbols
knowledge of special concepts or schemas involved.

And there may well be others. In turn, none of these are constants:

All the items in the list above are subject to modification by experience, training, and changes of health.

All the items in the list are kinds of knowledge brought involuntarily to the experience of the photograph.

We respond involuntarily, as well as with intention. These responses are subject to the educational processes that go on all the time. For example, if one's only visual experience of the world is commercial television, it is possible that an attitude of passivity is developed to the extent that no visual experience requiring extensive viewing effort may be deemed "good."

The kinds of responses discussed here all enter into that inevitable and largely involuntary final response most of us make in the first few seconds after encountering a photograph. We say, "I like it," or reject it and say "I don't like it." Actually, we often say "that's bad" when we mean that we just don't like it or say nothing at all, just walk away. This kind of response is not so much a critical judgment as it is an involuntary gestural response not unlike a child pushing away a cereal spoon because **at that moment** he doesn't want it. Offered it again a few minutes later, the response may be acceptance, because he's hungry, or because now he's **ready** to eat. Much of our rejection of strange photographs happens because we are not—at the moment of encounter—ready to eat.

Responses to the photograph are

logical, rational (verbal)	intuitive, mimetic, emotive, physical non-verbal).

One need not understand any of these responses to make involuntary gestures of acceptance or rejection. But if you wish to transcend simplistic levels of response, or to grow in an understanding of art, the innocent eye must acknowledge its natural biases and become a thinking eye—attempt to understand the forces involved in seeing.

In *Psychology of Consciousness*[9], Robert Ornstein describes how different religious and philosophical groups have, through the ages, devised methods that more or less effectively broke down our internal barriers between the two halves of our brain. The human brain is bilateral; not only is it

physically separate, but it seems to be split into two kinds of thinking. One is largely verbal and direct, the other non-verbal, visual and indirect. These two parts rarely speak to one another, except through marvelous externalizations of an attempted interior dialogue, some of which we call art.

Through verbal analysis alone, we can reach a high level of understanding. But, there are several kinds of language which must be learned to come to a full understanding of how we see what we see. Many things influence us. History—political economic and personal—is implied in the events at which the camera was pointed, and which we feel are "documented" by the photograph. These must be known to fully understand the meaning of the picture. There is also a tacit language of symbols (both in the objects before the camera, and in the shapes found in the print) which may be investigated. A simple example is the change of meaning in the gesture of the first two fingers raised in an open "V", which from 1940-60 refers to victory (in a military sense) and which suddenly changes to an anti-establishment sign meaning "peace" (contrary to establishment intentions) in the 1960's. The gesture alone, without full understanding of the real, the political and the social moment of the photograph, will be rich with meaning, unclear, or meaningless depending on the viewer's knowledge.

"Art is born of art, not of nature,"[10] writes Gombrich, and this points up the next difficulty. If the photograph is seen as a work of art, as differing from a source of information, then the language of criticism used to describe it becomes very important to the meaning.

Art mostly refers to and grows out of a dialogue with other art. The naive viewer who says he knows nothing about art but knows what he likes is in the situation of the unhungry baby described earlier. The artist is more nearly in the situation of an adult, offered a gourmet meal. The textures and sources of the foods, the way of eating them, and the tastes and smells involved may be definitely unpleasant, or impossible for the infant, delightful to the adult.

Not all photography is art, nor should it be considered as such. Most photography is about something else, is description and record-keeping. "While the number of printed pictures and designs that have been made as works of art is very large, the number made to convey visual information is many times greater."[11] And even when the photograph is intended as art, or is considered as art—because it is essentially a descriptive process, the photograph usually is **about** something, while the painting is usually about painting.

At the same time there is a subtle change information takes on when it is photographed. The photographer who makes a documentary photograph changes and transforms whatever is before

his camera through the act of making the picture. Documentation with a camera inevitably infers meaning through selection and isolation. There is a value ascribed by isolation, inferred by dislocation, or by changing or specifying a static point of view torn from the ongoing flow of reality.

The photograph is a traditionalized documentary reference to our world. It makes the photographer's world visible in a special way, using a consensual language of tone, color, and enforced one-point perspective. The numbers of photographic artists offering us their special views have grown with increasing rapidity the last few years. Examine the history books: before the Second World War, there are only a hundred-odd photographers listed, photographers who published extensively as artists. Most of them were commercial photographers first and foremost. They also produced pictures that survived for reasons other than the sheer information offered. Compare this to the present. In the first five years of their program of grants the National Endowment for the Arts has given 162 photographers working as artists financial assistance toward their work in art photography. And, the John Simon Guggenheim Foundation has given a similar number to photographers in the nearly forty years it has offered grants in this area.

Why all this effort? For the young artist, much of it comes from naive desires to make something that is handsome, that is likable; much of it also comes from an obscure need for therapy. But therapy may turn into art. "He had to write poems in order to get rid of something in himself," notes a writer about a poet.[12] And often this is the beginning of much great art. But art comes as well out of less lofty or paintful intentions. It comes out of practical desires and pleasant habits. Some artists produce a lot, and some very little. "Still, there are [those] who like to wait until they have something to say...If they do not stop [work] altogether they may produce work that is truly innovative because it is the product of necessity, the recurring need to make sense of a world that is always becoming incoherent."[13]

One man's logic may be incoherence for another; in art, the aesthetic logic obvious to the artist may be most unclear to a bystander, unless he is given a key to the language being used. And the key to that language is both experiential and critical. The viewer's life and art experience must be assumed at a useful level. The new work of art often requires criticism so as to become part of our general vocabulary, in order to become useful.

Not all photographs are art, few are intended as art and fewer yet attain to becoming art. However, the same critical language applies to informational and documentary photographs as to art photographs in the sense that **any** photograph contains

more than one layer of meaning if only because of the ongoing human need to make sense out of pattern, and pattern possibilities exist everywhere—independent of the intention of the photographer who is making what he believes to be a simple documentary, or scientific record.

The language of criticism may relate to any or all of the parts of the photograph:

 craftsmanship
 formal values
 semeiology (or sign language)
 symbols
 descriptive quality
 narrative content
 political relationships
 (real and implied)
 historical context
 art-historical problems of
 form, primacy, etc.
 intention versus accomplishment.

The problem of intention should be dealt with first because for a long time there was an argument about intention. The original thesis was that there was no way for the critic to find out what was **intended.** If the artist succeeded in doing what he intended, then the work itself shows what he was trying to do. If he did not succeed, the work is not adequate evidence, and the critic must go somewhere else—for evidence of an intention that did not become effective in the work itself.[14] Joseph Margolis, in his very useful book on the general problem of **The Language of Art and Art Criticism,** investigates this argument and shows that what has been called the "intentional fallacy," which presumed that a comparative judgement of the intention and the product was not possible, as stated in the argument above, was in itself not quite true. Partly because it depended on a too-narrow interpretation of words, and partly because some of the evidence against it had been suppressed by authors too eager to promote their thesis. He concludes his discussion of this subject with the note that "intentional criticism has, to some extent at least, a recognizable and not inappropriate place in the aesthetic examination of art."[15] Barbara Rose discusses the same problem in specific relation to visual artists (rather than writers) and concludes that "if we wish to keep pace with the art being done, critics must be willing to discuss what is implicit in an art work; that is, content and intention."[16] She agrees that these often cannot be verified, but they can be discussed. That discussion in turn becomes part of the total texture in which the work of art exists, thrives, and in turn gives birth to other art.

A phrase from Barbara Rose opens the door onto the last principal argument about this problem, which is that the work of art itself is simply a part of the texture of the society, inevitably reflecting the society as well as commenting on it. **What is a work of art** is a question whose answer is always dependent on the context-social, political, economic and aesthetic. We must admit that frequently we do not recognize new objects as being legitimate works of art. Part of this nonrecognition (and consequent negative critical judgement) is due to a logical problem. A work of art reflects on the culture in which it arises. To make a critical judgement of the work itself, the critic must somehow be outside the culture so that he can make a critical judgement of the culture and the work of art as interpreted or defined by the action of the artist. This is not logically possible unless the critic somehow steps outside the culture.

It is the friction between the work and the culture that eventually determines the value of the art; one or the other will wear down, give way. It is a delightful and astonishing proof of the strength of art that it is so often the culture that moves over, making space for the new ordering of "reality" that the artist's perception has made visible, and then critics often have to live down inappropriate words.

A witty description of this was written by a philosophy teacher just after the First World War: "Someone says to me: 'Show the children a game.' I teach them gaming with dice, and the other says 'I didn't mean that sort of game.' Must the exclusion of the game of dice have come before his mind when he gave me the order?"[17]

The language of criticism ranges from a discussion of the wet print, fresh from the hypo bath, to a casual conversation with friends, to a gallery owner's evaluation of the saleability of the work, to an intensive judgement made by a paid professional critic who publishes in a major newspaper or magazine. The accepted meanings of that awful word, "criticism" range from "severe, censorious, carping"[18] to the much more affirmative "able to discuss, to discern."[19] Both meanings are in common use: a problem for the artist is to discern in turn which critic is merely carping and which is able to discuss, and is discerning in his judgement.

There is a general shortage of continuing critical investigation of photography written by responsible persons who have the time and are paid for investigating new possibilities of photographic vision. However, the situation is vastly improved over just a few years ago. Articles appear frequently in **Artforum, Art in America,** and other art magazines and more frequently in popular photographic periodicals. A useful definition of professional criticism was written by A.D. Coleman:

"Criticism, by its nature, is a public activity. Its purpose, as a process, is to establish, develop and share a set of ideas and definitions intended to enable a group of disparate people—the critic, the

audience and the artist as well—to find in the work under discussion a common ground for their mutual experiencing of the world and their understanding of that experience."[20] This is a description that fosters an ideal; unfortunately, much of the criticism in the country does not meet this ideal, in part because the function and intention of the photograph is seldom clearly defined—by the critic for himself, or by him for the audience he addresses.

An analyst of contemporary art who has recently given attention to photography wrote that "the language in which photographs are generally evaluated is extremely meager. Sometimes it is parasitical on the vocabulary of painting: composition, light and so forth. More often it consists in the vaguest sort of judgements, as when photographers are praised for being subtle, or interesting, or powerful, or complex, or simple, or—a favorite—deceptively simple."[21]

Finally, the most telling criticisms of photography return to the central problem of the machine and its effect on meaning. Two arguments, a hundred years apart, show this. The first says "if photography be allowed to encroach upon the domain of the impalpable and the imaginary, upon any thing where value depends solely upon the addition of something of a man's soul, then it will be so much the worse for us."[22] This position argues that art is really an arena of the spirit, not of craft. A contemporary critic inverts these very fears of Baudelaire, the 19th century poet:

"Photography overcame subjectivity in a way undreamed of by painting, one which does not so much defeat the act of painting as escape it altogether: by *automatism,* by removing the human agent from the act of reproduction."[23] But this doesn't stand a critical test either because the human agent will always edit and distort in a manner unique to each personality. The camera itself will simply record the light being reflected toward it at the instant of exposure; it leaves the real act of aesthetic judgement to the intuitive vision which operates the shutter.

It is now necessary to find tools with which to penetrate those screens we involuntarily assemble before the unique image we call the photograph.

Returning to the list of critical topics suggested above, the criticism of craftsmanship would seem to be simplest.

Start by looking at your print. See how well it is crafted. This is different than looking at the 'subject' revealed in the print. Understanding the accomplishments of craft becomes the first problem. This can be assisted by comparing the image to a set of standards.

Choose a photograph you wish to use as a standard. This is simply what you think is an excellent print, and one which relates to your work. This must be an appropriate standard. Use a real print, not a memory of an ideal print.

The standard you use will change with experience. Most beginners choose prints with high contrast; the superficial vigor of large black areas appeals to them. As experience is gained with high contrast simplifications they seem less exciting. A richer tonal scale becomes desired. A change of taste requires a new comparison image.

When choosing a standard choose a suitable image. Comparisons with unsuitable standards are misleading. Experimental work cannot logically be compared to a 'straight' print, for example.

Some terms of craft comparison are:

clarity of whites
richness of blacks
liveliness of intermediate grey tones
image color
evenness of tone (agitation and development)
suitability of grain for image
absence of mechanical blemishes
suitability of paper surface, contrast grade and color
adequacy of mounting and finishing

Study your print. Compare it with the standard print; compare it with maximum black and maximum white patches from the same kind of paper. Compare the darkest places in the print to the black patch, and the small pure highlight whites with the white patch.

Decide what is the purpose of the print. A fine print will be judged by different standards than a print for newspaper reproduction. A fine print may use the whole scale of the paper; the reproduction print will look somewhat grey and flat, yet be the *proper* print for the purpose.

Your comparisons should yield affirmations. It is easy to comment destructively. It is hard work to make a comparison and affirm creative possibilities, yet at the same time recognize craft problems and seek their solutions. Affirmations will help provide energy to work out solutions. Even advanced photographers have difficulty with photographic materials. Unwillingness to recognize and analyse problems will merely inhibit growth.

Formal problems and those of art-historical references are similar; they interlock when one is making work you believe to be suitable for the gallery. Then questions of who did it first? and who's doing it now? arise, and must be answered. At the student level, however, the first questions are of balance, proportion, movement within the frame—in fact the same terms with much the same meaning that they have when discussing drawings and paintings.

The camera is a way to make a print, as well as a way to translate perceptions of reality. The language used in discussing prints and drawings is of use to the photographer. A term that describes the principal shapes in the print is called the figure-/ground relationship:

Figure 3-4: (A) **The simple figure/ground relationship of this photograph is schematically isolated in** *(B).*

The large central shape is that which generally concerns us first. It is the "figure" which lies in the rectangular area that is called the "ground." The area around the central figure will vary in complexity, one picture to the next. But a definite relationship exists between the placement of the figure and the five cardinal points of the image: the four corners and the center.

Figure 3-5: The cardinal points of the square format (after Arnheim).

A figure which is either centered, or is tied to one of the corners is considered to be stable. This considered opinion comes not only from artists but from psychological experimentation. Something special occurs when the figure is centered. First, it seems always that the figure is being influenced by the boundary, and not the boundary by the central figure. Of equal importance is the fact that "dead center is not dead; no pull in any one direction is felt because at the middle point pulls from all directions balance each other. To the sensitive eye, the balance of the middle point is alive with tension."[24] In *Art and Visual Perception,* Rudolph Arnheim describes at length the experimental verification of this analysis. He goes on to describe other relationships between the figure and the ground that are of value to the photographer, who has to encounter the composition rather than assemble it.

It is here that the traditional language about composition fails the photographer, because the draftsman can build up the picture bit by bit while the photographer must discover it and isolate it from the ongoing visual confusion around him. Photographic composition may relate to a painterly composition, or it may be controlled by the exigencies of the moment.

But, compositional analysis can be of use if the effects of certain compositions are observed, and this knowledge applied when the photographer next encounters a scene with similar elements.

An alternate way to describe the central figure/ground relationship noted above is to say that when the figure is centered, our attention is focused on the subject before the camera, and we tend to treat the photograph as a magic window. When the figure is at one of the other stable points, we tend to see the photograph as pattern, and to view the print as a flat space.

When the figure is truncated by the borders of the ground, ambiguities arise.

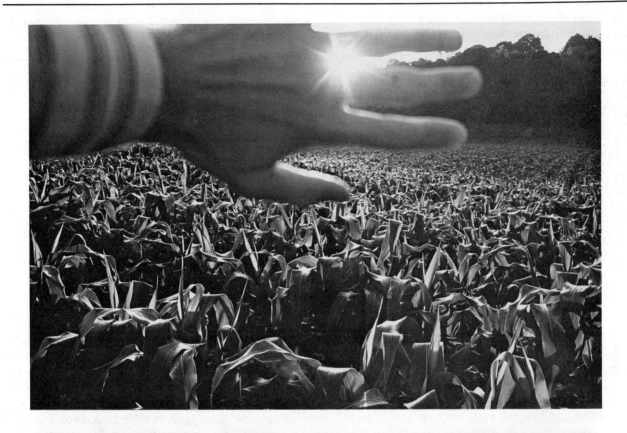

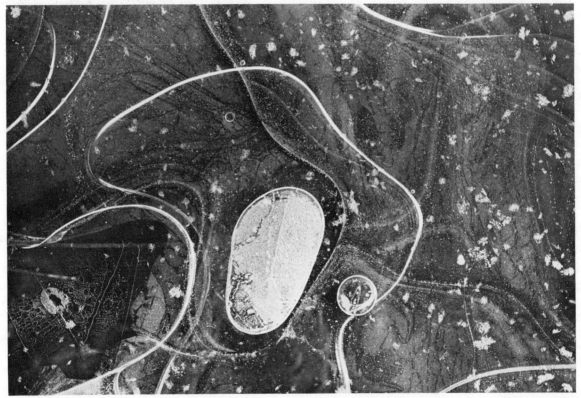

Figure 3-6: (A) Figure/ground becomes complex when illusionistic deep space is involved. The sun-star is a figure in the "ground" of the hand; the hand is a figure against the field of corn. *4(B)* In flat subjects, the grey oval is a figure against the linear enclosing form, which is in turn a figure against the rectangle of the photograph.

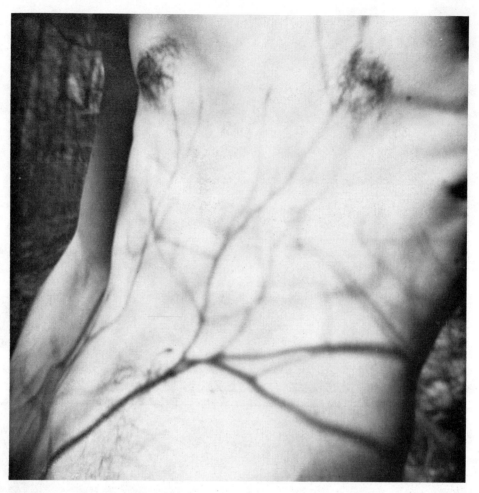

Figure 3-7: **A complex figure/ground relationsip in which the tree-shadows are a figure within the light-grey ground; identification of the anatomy suddenly identifies that ground as human skin; this becomes the new "figure" in the rectangular ground of the photograph.**

The viewer is not immediately certain which is the figure and which is the ground, and turns to other indicators to learn which is which. These are value (brightness), signs, and symbols. If the shape is easily identified by internal signs, there is no problem:

But when the shape meaning is clear but indefinite in associative value, then there may be confusion as to which is the important figure and which is the ground. (See Fig. 3-8).

The photographic print has other communicative possibilities which should be investigated. These are outlined in the following way:

Place a sheet of clean tracing paper over the photograph. Draw the borders of the print. Carefully outline each light area of the picture—the tones from light grey through to white. Mark this sheet "high values."

Replace this sheet with a clean piece of tracing paper. Draw the borders again, then outline all the middle grey areas. Sometimes a tone will be difficult to place; you will have to decide whether it is a middle or a light grey. Mark this sheet "middle tones." (See Fig. 3-9).

On a third sheet outline all the dark-grey to black areas.

On each sheet, using a soft drawing pencil, shade in solid tones all the areas within the closed contours. Do this carefully. Each tracing becomes a new visual statement.

Pin up the tracings. Study them. Look at each one. Study the patterns made. These can be interesting, dull, even, lopsided, scattered, clumped.

The character of the tracing will help disclose the composition of the picture, and the real subject of it. Photographers make pictures of **patterns of light** and they photograph **things**. The objects in front of the camera and the patterns coexist. Sometimes the pattern of light dominates the image, making its own statement; the pattern may

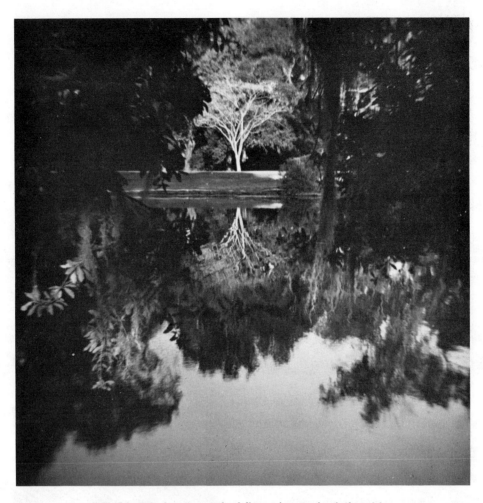

Figure 3-8: **A symmetrical figure/ground relationship.**

support the illusion of the thing before the lens, or distract from it and make its own statement. The tracings will help to reveal what the real subject of the photograph is in fact.

The composition may be analysed before the fact of photographing by making a simple pencil sketch of the principal shapes and lines in the proposed picture. It need not be elaborate; the purpose is to reveal the implications the masses and lines found on the groundglass. Our faculty for projection of meaning affects our perception of the subject as well as the print: many photographs have been made in order to "reveal" what was never there, except in the imagination of the photographer. The act of sketching the shapes before the picture is made can often be revealing of real intentions, if you are willing to see these.

Discover the scene you wish to photograph, then try making a sketch of what you thought you had photographed, without referring to the scene on the groundglass of the camera. Then go to the camera and compare what you see on the sketch to what you saw through the camera.

Carry this one step further. Make the picture you discover. Put down the camera, and in a workbook make a sketch of what you thought you had photographed. Leave the scene, and go on working elsewhere. When the film has been processed, make an extra contact proof print and mount it beside the sketch in the workbook. Compare the sketch and the print. The change in our perception caused by the passage of time will often reveal to us what we thought we were photographing, in contrast to what we in fact did photograph.

The next area of investigation is both more direct and more subtle. Sign language exists in every photograph. And symbols exist as well. These words are two of the most fleeting in our language; they interact and reflect one another. Yet there are differences. Signs exist in photographs quite clearly as words or marks or shapes that have distinct meaning, meaning which modifies inevitably our response to the rest of the content of the

Figure 3-9: (A) A photograph of a landscape. *(B)* Schematic of high values. *(C)* Schematic of middle greys. *(D)* Schematic of dark values. *(E)* Simple gesture interpretation.

Figure 3-10: (A) **A sketch of the picture, made to clarify the intention for the photographer.** *(B)* **The photograph.**

picture. Symbols also exist, and are both explicit (as with the "V" gesture described before), or are more obscure, as when shapes within the picture evoke meaning, without naming it exactly.

Shapes found in landscape details, and in exaggerated closeups of peeled paint and worn building details popular in photographic art suggest things to us—not only in the sense of these shapes suggesting familiar shapes like birds and donkeys and tigers which we discover on watching clouds—shapes without words, with powerful emotional force. It is these shape suggestions that become important.

Symmetry will also create suggestions of symbolic meaning and in the work of Jerry N. Uelsman the symmetrical shapes created by double printing take on iconic power. Psychoanalysis has used the covert, hidden symbol that surfaces in art to direct attention to desires of which the individual is unconscious. As Ornstein points out, this is a way one half our brain speaks to the other.

Discovering these shapes within the textural richness of the photograph is possible through the following simple analytical procedures. One is verbal, one is two-dimensional, one is three-dimensional, and one is a direct physical expression. Each of them has the possibility of revealing symbolic associations which are only of value if the photographer chooses to use and value them. In any case, they will not hurt, because we have very strong self-protective psychological screens that prevent us from seeing that which we are not ready to see. But at the same time these exercises should not be imposed from without, but developed and discussed only as far as the student is willing to discuss them.

The verbal analysis can be done in many different ways, with different teachers to guide you. This analysis is not concerned with the formal shape relationships so much as with the suggestions that are available to us from within the picture itself. They are always there, lying hidden, so we might as well take a look.

To see what might be found in the picture, some degree of concentration is necessary. Concentration is a focusing of forces, a building of attention.

Figure 3-11: **Photograph of a desert plant, seen and composed to accentuate its metamorphic possibilities.**

Normally concentrated attention causes us to exclude many things that would otherwise attract our interest, weakening our grasp of the problem before us. But concentration can be used to moderately increase our awareness of *possible* relationships, as well as excluding them.

In a quiet place, put the picture before you at a comfortable height, and in a good light, so you can study it without distraction. Make your body quiet. Sit still for a few minutes; close your eyes if necessary. Sit without slouching. You may wish to breathe deeply two or three times, releasing all the air each time you inhale; this will momentarily raise your perceptions and at the same time cause a temporary sense of well-being. You cannot give your attention to the picture if you feel nervous,

irritated, bored, or self-conscious. This preparation is simply a clearing away of trivia so that the photograph can be given the attention it deserves. When you are ready, address yourself to the picture.

"Concentration is a tool. Any tool must be used frequently to keep its edge and to be of value. There are two types of concentration you will encounter: voluntary and involuntary. You are probably familiar with the latter, because it occurs when something captures your interest and holds you taut. The former is better for this kind of work because you can retain awareness of yourself, and the subject of your interest. In any case, the aim is to increase your capacity to see."[25]

Allow the photograph to suggest what it will. Try not to ask whether those suggestions are "appropriate" or not, but be willing to accept the associations that develop. The associations may be with words, with other visual forms, or physical feelings. What is of importance at first is whether they lead you back to the photograph, or away into non-attention. In a workshop given some years ago, Minor White remarked that "we can encourage ourselves to keep coming back to the image itself, or we can permit ourselves to go further and further afield. If we take for example a common word like *house* and begin associating other words, it is easy to go straight off into the blue:

House—lawn—tree—squirrel—nest—bird— fly—sky—blue."[26] This kind of association can be called sequential. It's common and not of much use in discovery of picture content. However, working in a state of concentration we find it easier to associate in a reinforcing way, returning us to the photograph and its possible meanings:

House - window - house - door - house - shelter - house - condition—Here the associations return us to possible meanings that reinforce the attention, and help penetrate the surface possibilities of the picture, rather than leading us away into day-dreams.

In that workshop, White commented that "when studying an image, the first response may be unsatisfying. When this happens, put it aside and try again later. It may take a long time to come to an understanding of a complex image."[27]

A second way to assist understanding through verbal investigation requires the patient assistance of a number of people. Some of them can be photographers, but the majority probably should not. This is because though photographers can speak easily to photographers if they do only that, their language soon narrows and becomes precious.

Learn the difference between private vision and public consensus on the meaning of your vision. This can be done easily in a class or where a trusted and responsive audience is available.

You see possibilities of a picture in the original subject when you make a photograph and you see certain meanings in the print. You derive pleasure from the image. When another person looks at your photograph he may feel something similar or he may see something very much different. He brings his own experience to the image.

The photographic image will have a different meaning for each viewer. Most interpretations of a strong image will fall into a limited range of statements. But some images will have radically different meanings for people with different backgrounds, especially if they are not guided in their discovery by means of a title.

Your statement varies in clarity, one person to the next. Hardly any artist is willing to believe this until he has rude encounters with his audience.

Perform an experiment to show how easily meaning can change. Take any four photographs. Place them in line on the wall. Study them. Discover where they interact, and how they work together. Interchange the first and third print. Look at the new set created by this change. Discover what happens to the meaning of the set. Now interchange the second and third prints. Look at this new combination and discover what feelings it produces. Finally, interchange the first and last print and examine the result. Each set of images will have different visual meanings (some dull, some more exciting).

If the simple changing of the order of the prints changes meaning, then how much more seeing them through different eyes will change meaning! Each person sees his own image. This can be investigated where a group of photographers can work together. Exchange prints; each photographer offers and receives two prints. Take your two and make a catalogue of the contents. Note the **objects, shapes** and **associations** which these evoke.

Define **objects** as things which were before the lens of the camera; **shapes** as forms found in the print; **associations** as the feelings, thoughts and possibilities of meaning which arise as you experience the print.

This investigation should be brief. Keep it simple. Frequently direct your attention back to the print. It is easy to stray into private fantasies. You will uncover some of your own attitudes while doing this; about what photography ought to be, what prints ought to look like, and so on. Discover the range possible. Do not try to deny its existence.

When you have finished with your prints, meet as a group. Each person can read what he has written, and explain it if necessary. Many people are uneasy when talking about photographs. They feel they do not have an adequate vocabulary. They simply do not trust their own responses. They feel that being honest and telling what they feel means they are being "critical," i.e. being destructive. This kind of investigation is not inherently destructive but affirmative. You are finding out what is possible, not taking anything away.

A variation of this is to supply one photograph of your own and one taken from a magazine. Choose a picture you feel is interesting. Because the magazine photographs are not by you or your friends you may be less protective, and more free to respond.

Go a step further. Seek the responses of people who are not photographers. Photographers have certain responses to print quality, subject matter,

or even how currently popular the subject of the picture is in the competitive work being published.

Before you ask others about your photographs, decide what you wish to learn. Are you concerned with what people see in general when they look at a photograph, or what their response is to your special interests?

Take three photographs to work with. You may wish to include one which is not yours but which you have already catalogued. Ask fifteen persons to look at the prints. Find people who have time to look and who are in a relatively quiet place. Ask each person the same question: "what do you see in the picture?" This is different than asking what is seen in the print, or the photograph. The words used are important. Whatever you ask will in some way limit the answer.

The person you are interviewing must believe in your interest. Your attitude, the way you listen and the way you present the prints will all influence him. Take notes openly. Discover the person's background and attempt to discover how background relates to response.

When the person runs out of words ask: "is that all you see?" Do not be more directive. Gain general information but do not pursue specific goals. Watch the person's face: nonverbal communication is important in these interviews.

When you have completed one set of interviews, study your results. Does background affect response in any way you can discover? How many people saw something in the photograph similar to what you deemed important? How many people discovered other aspects of the image which were more important to them? How many people looked at the subject, how many saw the print as a print, and what was the general tone of the emotional response? Other questions may arise from studying your notes.

After the first try, specific questions have value. If the technique works for you, take these or other pictures and talk to new people. The next time ask specific questions, for example, "what relationships do you see between *this* and *that* in the picture?"

People generally see a photograph as a magic window sometimes through which they can reach out and touch the object on the other side. Sometimes they see it as a pattern of shapes, or tones. One person deals with the subject before the camera, the other with graphics. A person may respond both ways at once but one or the other will dominate.

A viewer will see the print through his fantasy about it. Your problem is to relate the answers given to your photograph and to your vision.

Try to carry this information back into your work with the camera. The following exercise is a way to do this consciously. Two photographers work together. One is a leader, the other the photographer. After an exposure is made, they change roles.

Having found a place to work, the photographer blindfolds himself. The leader takes him to the place the photographer describes. The camera is handled by the photographer but the leader verifies each step. Let the photographer estimate the exposure and attempt to make the settings on the camera, place it, focus it, and do all the mechanical work by himself. The leader verifies it as being right or wrong.

Meanwhile the photographer describes the scene he thinks he is photographing. The leader tells him to move left, right, etc., to produce the scene. But the leader asks no questions of his own. When everything is in order, and both parties believe they are making the same photograph, make an exposure. The photographer removes his blindfold and examines the scene on the groundglass or through the viewfinder.

Now, compare the mental image of the photograph, the groundglass image and the image the leader has seen. Let the leader describe what the effect of the image was on him. Exchange roles and repeat the work.

The next investigation is visual, rather than verbal. Take the tracings you made of the dark and light tone of the print. (Figure 3-9). Examine the tracings. Compare each in turn with the original print. Decide which pattern is dominant, i.e., which seems to carry the spirit of the image. Put the others away with the photograph. From the dominant tracing try to draw the essential gesture of the image. This relates to the *gestalt* of the print. Paul Klee called the gestalt the "living being" of the image in contrast to the mere form of it.

The gesture of this spirit may be a moving line, a shape, an arrow, an expanding field. It may be heavy, light, closing, or opening. The drawing of the gestalt is a nonverbal paraphrase of the photograph. (Figure 3-12).

Meanings within an image are sometimes hard to discover. Compare the image you had intended to the image produced. The tracing will help disclose the component parts.

Compare this drawing with the original print. See if they do in fact relate. If there is a difference of spirit there may have been mistakes made in tracing, or in choosing the dominant pattern. Perhaps the photograph you made was not what you had thought. There is a feeling of confusion when the drawing of the gesture seems to disagree with the image. Sometimes the analysis is rejected. Ask "what did I intend?" Then ask "what did I produce?" Sometimes one is unable to answer these questions immediately.

Figure 3-12: Photographs with similar shapes produce vastly different gestural reponses. *(A)* and *(C)* are of a plant and hair, but the responses *(B)* and *(D)* have different strength and meaning.

To some extent these analyses are still verbal. Usually we are stuck with words. There are things to be discovered about the picture that are hidden from us when we attempt to use only words. Phyllis Frede and Carson Graves at Ohio University suggested using clay, instead of words to dramatize the content of the picture and remove it from verbal areas.

Take a block of modeling clay, or potter's clay if that is available. Spread out clean newspaper (so as to prevent dirtying the clay, and the room) and sit down with the photograph and the clay. Quiet yourself, study the photograph for several minutes, and then without any verbalization, play with the clay, asking your body to tell you what it sees.

It sounds childish, but it really isn't. And if a group of photographers do it, it becomes even

more revealing as well as delightful. What happens is that you suddenly see not only what you can perceive, but you see vividly how others transform the pictorial content of their pictures into a three-

Figure 3-13: An illustration of a student's response to a photograph using clay, avoiding verbalization.

dimensional statement that at first glance may have little to do with the picture, but almost always has much to do with covert content.

Finally, you can try to move in response to your photograph. This may sound foolish, but it is no more so than moving to music, which we do freely enough. In many workshops, Minor White would suggest, demonstrate, and lead movement that both freed the muscles and encouraged relaxation

prior to concentration, and which also led to interpretation of the inner movements of the photograph itself. And these do exist.

This simple schematic of two common relationships of figure/ground where there are two figures in the ground describe stable and unstable configurations which can be extended into human movement, or "danced." (See Figures 3-14 and 3-15)

Figure 3-14: *(A)* **and** *(B)* **(after Arnheim) illustrate unstable and stable configurations of figure/ground where two figures occupy the same space.**

Figure 3-15: *(A)* **and** *(B)* **illustrate the same relationships that are found in the simplified drawing of the Figure 3-14.**

The photograph itself, never as simple as its schematic—always laden with other possible meanings and associations—can be uncovered and the riches possible within it discovered through direct physical non-verbal interpretation.

All of these investigations are prelude both to a return to work done with the camera, and also to the problems of making a critical judgement. As we work there come times when there are logical

stopping places, where we can sit and look over what we have done and to some extent decide where we should go from there, and how we should go about it. A student wrote that "understanding could come only after leaving behind the subject reactions, and the image could be seen for what it really was and what it contained...Viewers describing their experiences with the image from their own unique psychological perspectives could be

useful to the photographer in showing him how close or how far the image came to the concept the photographer had in mind when the image was created."[29]

There are many problems of discovering the content in the photograph that have only been listed, but these arise when any photograph is evaluated in a public way—in terms of publishability, or of gallery exhibition. These are topics that must be considered:

what is described
the implied political relationships
historical content of the image
art content as historical problems.

Many of these we assume automatically in the evaluations made unthinkingly when we compare a new photograph to another *of its type.* We frequently make assumptions about the photograph from the first-impressions we have of the intention of the photographer, derived from the style of the photograph.

Photographs are physical objects that may be categorized in many different ways. When one talks only about the photograph—without reference to any other art form and without concern for the ambiguities of its nature that have been described here—then the relationship that existed between the photographer and the subject is useful. These are the terms that have been used: the photograph has been called

documentary
pictorial
metaphorical

The term "documentary" is subject to more interpretations than almost any other photographic terminology. It was associated with "straight" or unmanipulated photographs, which by their pristine recording were presumed to be truthful, as noted in the quotation from Newhall cited earlier. But after the Second World War it became apparent to a number of critics that a photograph could be absolutely straight, with no trickery or manipulation and still not be documentary in the sense of saying only what was truthfully there.

William Stott has presented a clear description of this problem in his important study of *Documentary Expression and Thirties America,*[30] in which he demonstrates the significant shifts of meaning that the FSA photographers produced through the simplest tools: selection of point of view, cropping the print, and choice of which photograph from a set was actually published. As has been noted here, documentary photographs infer meaning through the act of selection, isolation, and perhaps most important, through relocation. In the examples Stott uses, the farm workers photographed by Lange & Walker Evans seen in their own natural surroundings are simply not the same as what is seen in the photograph, and that photograph has a new set of meanings when transported to New York, or to a midwestern college campus, or a history book, or a text on economics and politics.

The documentary mode has been devalued and fragmented since the photographic world realized that a straightforward, unmanipulated photograph was no more likely to be a "true" rendition of reality than was a romanticised, retouched vision. The state-supported photography of the 1930's turned into the propaganda documentation of the 1940's, perhaps best remembered in the elegant *March of Time* movie newsreels that were the principal source of weekly visual information for middle America before television. For those who didn't go to the movies, or who also read magazines, the indelible performance of the photographers who made pictures for LIFE during the period 1936-1966 reinforced this usefully believable picture myth. But an irremedial crack was formed in the American documentary mode by Robert Frank. With the publication of *Les Americans,* in 1956, he revealed documentation as a tool with which to pare away romantic notions, in contrast to the traditional supportive documentarians before him. Frank's pictures were not "pretty" and the pictorial element of FSA and LIFE documentary photography stood revealed.

An alternative way to describe the incoherent area that was formerly called documentary is to refer to the special subtypes which survive and are still published in this age of television. Photojournalism deals largely with events, though also with interpretation. The newer field of "social landscape" deal with interactions—man to man, man to environment—and may or may not be done for the photographer's personal sport or for a client. The portrait is usually cosmetic in intention, but may be "documentary" in the sense Cartier-Bresson used when he said that by the age of fifty, most people had the faces they deserved.

The only truly documentary photography is photographic record keeping, as used by science and engineering, where details are selected from the subject, and buttressed with dates, intentions, maps, and other appropriate data.

The pictorial mode was dominant for many years, and begins with attempts by photographers in the 19th century to emulate paintings, and produce objects that would be immediately identified with the other arts. Peter Henry Emerson and the fellows of the Linked Ring in England attempted to establish new standards for pictorial art, rescuing it both from the mechanical tricksters who manipulated photographs to look like painting, and the mere technical expert who hung hackneyed but perfectly printed photographs at the many photographic salons popular in England.

Pictorialism was identified in this country with manipulators, men who used bichromate-sensitized gum arabic instead of silver to make prints, confident that their soft-colored brush-stroked prints echoed the best of Impressionist art, and therfore became art. Pictorialism was also identified with a lack of distinctness, not only of focus but sentimental feeling or intention—vaguely sad or happy pictures with emotional smudges. This movement was dominant in photographic art for the first fifteen years of this century, then died out after the First World War. One of the most effective printmakers of the movement, Edward Steichen, turned to "straight" photography after that war, in response to his experiences as a photographic documentarian for the Signal Corps.

The pictorial mode did not disappear in one sense. This is a continuing concern for the beautiful print, the picture whose subject is its own shapes. There was and is a fundamental split in photographic values related to the use of the photograph. One side argues the photograph is a vehicle of communication of information about the world, that the medium is best used to speak of man's condition. The other side insists that the photograph is a printmaking process, and the product is an externalization of an artist's inward directed vision. Both sides have heroes that are rushed to the ramparts.

It was not until photography had come of age that in 1854 O.G. Rejlander presented the large assembled print called *The Two Ways of Life*—an allegory on the rewards of wickedness and virtue. He was followed by many others making allegorical and artificial pictures. The distance from allegory to metaphor is slight. Allegory is defined as the "description of one thing under the image of another," and metaphor as "to carry over, to transfer."[31] In fact, the one word is used most frequently to aid in defining the other. In our century, it is the photographic purist Alfred Stieglitz who suggested the photograph might carry significant meaning through creating a sense of metaphor—an echo in the viewer's mind that related not to what is described by the camera, but to something else, something alluded to, a mimetic response dimly but really perceived:

"I shall have occasions to mention the relation of a new poetic image to an archetype lying dormant in the depths of the unconscious...The poetic image is not an echo of the past. On the contrary: through the brilliance of an image, the distant past resounds with echoes...To specify exactly what a phenomenology of the image can be, to specify that the image comes *before* thought, we should have to say...it is a phenomenology of the soul. We should then have to collect documentation on the subject of the *dreaming consciousness.*"[32]

The special name given to the metaphoric possibility of the photograph—which exists because the viewer of the carefully made, straight print is torn between the knowledge that this is visual trickery, a magical reality, the concurrent desire to believe, the knowledge that it is only a print, and the great power of its verisimilitude—was *equivalent.* The dictionary meanings are appropriate: "alike in significance, equal in value, virtually or in effect identical."[33] The word was given significance by Stieglitz in his teaching and his photography. He made an attempt to make viewers conscious of the special quality some photographs have of making us aware both of the reality before the camera and the possibility of poetic reverberations. "In the resonance we hear the poem, in the reverberations, we speak it, it is our own. The reverberations bring about a change of being. It is as though the poet's being were our being. It is as though the work through its exuberance, awakened new depths in us."[34]

This curious, but undeniable power of the photograph to describe a visible world yet evoke another, one not present in the picture, was noted by many other photographers. Edward Weston was pleased when a painter saw his photograph of weathered cypress roots as being "like flames," and was equally distressed when viewers felt the sensuality of a sexual coupling in his photographs of elegantly contorted green peppers.

After the Second World War, the teacher, photographer, and editor Minor White formalized Stieglitz's ideas of equivalence, and made them the basis of his teaching and investigation of possible photographic meaning.

Later in White's teaching he formalized these ideas into a few apparently simple phrases which he called "canons of camerawork," implying that the camera imposed a discipline which echoed a monastic order's directives. The third of these canons was stated thus: "When a photograph is a mirror of the man, and the man is a mirror of the world, spirit might take over." To this he added that "it follows that 'self expression' as the aim of the photographer is not in itself sufficient."[35]

Current concepts in photographic aesthetics center about the formal and descriptive possibilities of the camera-image, yet one of the great strengths of the photograph is to be found in the tensions that exist between the descriptive and the allusionistic. The photograph yields a denotation that is usually consensually verifiable, *e.g. this is a picture of a rock*; however there almost always are connotations that arise as well. The photograph often leaves a residue of unverbalized meaning.

John Szarkowski has offered another way of

classifying photographs in *The Photographer's Eye*:[36]

the thing
itself

the detail

the frame

time

vantage point

a description of the
factuality of the object

isolation of the trivial
and change of value

selection as the princi-
pal act of composition

the unique ability of the
photograph

transformation
through point of view.

Photographs can be described in many other ways. Here are two catalogues, one established by terms relating to *technical means* have been used for the basis of classification. Terms encountered include:

cameras: the effect small cam-
eras and large format
cameras have on
the image.

films: the possibilities and prob-
lems with small film,
very fast film, fine
grain film, etc.

contrast: use of high contrast,
conversions from con-
tinuous to halftone
images, low key,
high key, etc.

prints: color prints, warm tone
and cold tone
papers, textured and
smooth surfaces,
whiteness of pa-
per stock, etc.

and a terminology relating to things in front of the camera includes:

landscape: the natural land-
scape, principally
unmodified by
man's working

cityscape: the city with or
without people in
interaction

social
landscape: the person inter-
acting with the
environment

figure: the naked human
shape

portrait: as psychological
record or public
document

snapshot: the private re-
sponse to a
moment, a mnemonic

scientific
record: the accurate catalogue
of detail

A new way to rephase the traditional catalogue of the kinds of photographs is according to the *Intention* of the photographer:

1. Where the *action* before the camera is of primary importance to the photograph (and, in its own time, to the viewer). This relies on the "magic window" effect of the photograph.

2. Where the *appearance* of the print—shapes, colors, linear and tonal elements—in fact, all the visual apparatus that photography has inherited from painting and drawing are most important.

3. Where the *suggestions,* allusions, puns, meta-phors and other associational insights the photo-grapher may have intended or the print acciden-tally creates are important. In many photographs of details abstracted from large complete forms, something similar to the emotionally suggestive images we have learned to accept from non-representational painting appear. These have defi-nite value, intensity, and meaning—though often we cannot paraphrase this meaning. In a way, these "meanings" are often like the feelings we have on wakening from a reverie, or daydream, when we briefly remember an incredibly vivid visual experience and turn to someone to tell them what we have just seen in imagination. Our transla-tion is often dull, but when done by a poet, it can, in turn, spark another's imagination.

4. Where the meaning of the photograph rises out of a dialogue with other *art problems.* Often the photographer is not so much concerned with the traditional uses of the camera to draw pictorial or documentary details from nature so much as he is involved with using the camera as a special kind of paintbrush, one which makes tonal rather than

linear drawings. Recent conceptual art, in which the word- or picture - game is the real subject of the artwork as, for example, in the work of John Baldessari. The photograph is then simply one among other mediums.

Investigation of the possible meanings in the photograph and photographic work can be healthily used as a therapeutic tool, by the individual or in concert with a trained therapist. Much investigation of the possibilities of the photograph as a way of revealing the source of unwillingness to come to terms with the world is now being done.

On a simpler level, the fact that many photographs are in fact the result of seeking to make sense out of a confused world has led to a recent use of the terms *external validation* versus *internal validation* in discussing photographs. External validation is what we must deal with when the photograph is in any way published, held up to the world for approval as a work of art, for example. Internal validation is what is sought when the photograph is offered as an example of a growing connectedness with the world—by someone using the camera to reach out, to make contact, to organize incoherent reality into something useful, not terrifying or puzzling.

When your photograph is finished, there is usually a natural affirmative desire to show it to others, to share, and to get their reaction. This in itself leads to validation, to judgement, to a critical response. But the critical response you desire may relate only to your own needs as an individual, and not in any way to gallery or publication standards.

Response by others at its most basic is affirmation or rejection of your work. Response is always judgemental to some degree. You may not desire this, you may desire only affirmation, a reassurance that you are growing and becoming more accomplished, just as a person, perhaps, more than as an artist. For many photographers, their growth as a useful person is far more important than any rewards or acceptance they could expect to earn as artists.

Choice of the kind of critical reaction relates to psychological needs. Photographs that are personally rewarding are made all the time, and though sometimes these photographs might be of therapeutic value to others, often they are of no special value as art. This does not devalue them as personal expressive investigation, and they should be honored for the pleasure they bring to the photographer and those close to him. It is very difficult to make photographs that reach inward to the rich emotional and perhaps spiritual resources we all carry and at the same time carry these out into a formal and technically satisfactory statement that will stand critical judgement.

There is a difference between the understanding of an image and making a judgement. Understanding is the result of response, experience and investigation. A judgement uses this investigation and moves on to attempt to assign value to the work.

Judgement often is necessary, though not always. We can "like" or fail to like a print. But if we need to make a judgement, understanding is necessary. But your photograph will not always be judged relative to your possibilities. There will come a time when it is evaluated by comparing it to existing photographs.

The question of value is raised when one attempts to make a judgement. You may value a print uncritically because it moves you, because you feel like saying "I like it." This is the way we usually choose prints to live with, to hang upon our walls.

Sometimes it is impossible for a photographer to judge his own work. But one can try. To do this it is necessary to discover the current standards of quality, why they exist, how they have changed and what they imply. Know this, add it to your understanding and your response, and you are prepared to make a judgement of where a photograph stands in contemporary photography.

Whether you need to raise the question of judgement at all depends on the way you are using photography. If photography is a means to psychological self-exploration, then this procedure may be unimportant. However, once a photograph is published a critical response will follow inevitably.

Judging requires language appropriate to the photograph at hand. Just as an inappropriate standard image will lead to confusion in judging craft, so inaccurate language prohibits accurate judgement. The image must be identified in a general way, i.e., placed in a category. A.D. Coleman recently referred to the "dialects of the language of photography" and wrote of young photographers who consistently speak "the language of Robert Frank." Such an analogy is useful.

Classification of an image precedes judgement. Inappropriate images cannot be competitively evaluated. Classifications are necessary, and classification is difficult. If the classification is inappropriate, the critical judgement may be useless or even destructive—both to the critic and to the photographer.

The photograph can be studied as an object, an example of its type. When it is looked at this way, the following terms may be useful:

1. *Presentation*

> Mounted or framed: color, size, type of mount. Size of print: in book, sequence, as individual print; the relationship between these and the environment.

2. *Medium*

Two-dimensional: silver, gum, silkscreen, gravure, etc. 3-dimensional: film overlay, photosculpture, hologram, etc. 4-dimensional: time based, conceptual.

3. *Texture*

Smooth, grainy, rough

4. *Composition*

Mass and line relationships: Kinetic, based on diagonals and curves
Static: based on balanced verticals and horizontals
Gestalt structure: objects centered, in tension, passive?
Dialogue between shapes, dominance of one.
Apparent pressures or motion: toward the edge, out of the surface, receding away.

5. *Perspective*

Flat, all on a plane without depth; deep, tunnel-perspective:
(1) mathematical, Renaissance, "normal"
(2) non-Renaissance, spherical, distorted.

6. *Tonality*

Soft (intimate)
Harsh (implications of public view, documentation, etc.)
Effect of tone on emotions.

7. *Rhythm*

Rhythm affected by alternating shapes, lines, relative mass of tones in print.

8. *Gesture*

Meaning of gesture
body language.

9. *Semeiotics*

The shapes used as signs, and/or symbols
the symbols and signs public (verifiable)
private signs and symbols.
If private, are there clues or are they assumed?

10. *Abstraction*

(meaning to draw forth) subject seen as itself. Or as standing for something else (metaphor). The camera subject unrecognizable, being used for associational possibilities?

11. *Point of View*

Psychological: is artist human, god-like, concerned, unconcerned. Literal point of view, up, down, inside. The person of the camera related to the "person" of literature, e.g., 1st, 2nd or 3rd person story-telling.
Subject reacts to camera; reacts to artist.

12. *Provenance*

When and where was the work made? How does this affect its relationship to other works of art and other artists?

13. *Biography*

Placement of work in artist's life; personal and cultural history.

14. *SUMMATION*

Look, react, think, catalogue, keep both feet firmly on the ground, avoid routine identification with any critical camp; come to your own conclusion, then double-check.

You may like or dislike a photograph without understanding it. To extend Paul Klee's idea that the artist makes an image that is a mirror of himself, we respond to images that mirror ourselves. Sometimes the response takes the form of hostility, sometimes of liking. Critical judgement requires personal response, and a knowledge of the standards of the medium.

Feel an esthetic response, then analyse the photograph. Learn the history of the photograph and of the photographer, study the art of its time; against all this place your own reaction. With this information there is a chance to make a useful critical judgement:

know the biographical or historical background of the work
know the theories that supported the work in its own time.
understand the meaning of the work in terms of the art of its time.
discover the methods used to create its effects.
balance your response against a summary of the above.

The quality of your judgement depends on your knowledge of the medium. The validity of your judgement depends on the thoroughness of your investigation and the sensitivity you bring to the photograph.

The change from a beginning photographer to a mature photographer is not only a result of increased technical competence, it is also a result of increased critical awareness of ourselves and of our images.

1. Beaumont Newhall, *History of Photography*, Museum of Modern Art: New York, 1964, p. 61.

2. *Modern Artists on Art: Ten Unabridged Essays,* ed. Robert J. Herbert, Wassily Kandinsky: "Reminiscences," Prentice Hall, N.J. 1964, p. 29.

3. Morse Peckham, *Man's Rage for Chaos,* Schocken, New York, 1973, p. 30.

4. E.H. Gombrich, *Art and Illusion,* Bollingen, Princeton, N.J. 1972, p. 228.

5. Ibid.

6. Robert Ornstein, *The Psychology of Consciousness,* Viking, New York, 1975.

7. Gombrich, op. cit., p. 228

8. Ibid., p. 231.

9. Ornstein, op. cit.

10. Gombrich, op. cit., p. 10.

11. William M. Ivins, Jr., *Prints and Visual Communications,* MIT, Massachusetts, 1953, p. 158.

12. Louis Simpson, *Three on the Tower,* Wm. Morrow, New York, 1975, p. 191.

13. Ibid., p. 156.

14. Joseph Margolis, *The Language of Art & Art Criticism,* Wayne State Press, Detroit, 1965, paraphrase of p. 101.

15. Ibid., p. 103.

16. Kay Tucker, *The Educated Innocent Eye,* The Image Circle, Berkeley, 1972, note 8.

17. Ludwig Wittgenstein, *The Philosophical Investigations,* Oxford, London, 1953, p. 70.

18. William Little: *Shorter Oxford Dictionary,* 3rd Ed., Oxford, London, 1969, p. 424.

19. *Webster's New Collegiate Dictionary,* G & C Merriam, Springfield, Mass., 1949, p. 197.

20. A.D. Coleman, "Because It Feels So Good When I Stop," *Camera 35,* New York, October, 1975, p. 29.

21. Susan Sontag, "Photography in Search of Itself," *The New York Review of Books,* January 20, 1977.

22. Charles Baudelaire, in *On Photography, A Source Book in Facsimile,* p. 107.

23. Stanley Cavell, *The World Viewed,* New York, 1971, p. 23.

24. Rudolph Arnheim, *Art and Visual Perception,* University of California, Berkeley, 1965, p. 6.

25. Minor White, in *Second Denver Workshop* (privately printed, Denver, 1963) ed. Arnold Gassan, p. 18.

26. Ibid., p. 18.

27. Ibid., p. 19

28. Arnheim, op. cit., p. 9.

29. Valerie Harms, "The Teaching Legacy of Minor White", *Camera 35,* June 1977, p. 64.

30. William Stott, *Documentary Expression and Thirties America,* Oxford, New York, 1973, pp. 159ff, 229, 230, 278-280.

31. Webster, op. cit., pp. 23 and 528.

32. Gaston Bachelard, *The Poetics of Space,* Beacon, Boston, 1969, pp xii to xvi.

33. Webster, op. cit., p. 279.

34. Bachelard, op. cit., pp. xviii-xix.

35. Minor White, in *A Notebook Resume of the Denver Workshop* (Privately printed, Denver, 1962) ed. Arnold Gassan, p. 39.

36. John Szarkowski, *The Photographer's Eye,* Museum of Modern Art/Doubleday, New York, 1966, pp. 8 ff.

CHAPTER FOUR
Advanced Controls

Advanced Controls

Contemporary photographic materials and machines are so forgiving, with a great deal of latitude in the materials and processes, and automated precision in the cameras, that one may make acceptable photographs with almost no attempt at a matching degree of excellence on your part as a photographic technician. But after the initial thrill of being able to make your own pictures, from the instant of seeing a possible subject through to making and mounting a print, the desire for better control and more precise statement of your vision may well lead to the desire to accept more responsibility for the finished product, and make better use of the materials available.

Greater precision in metering, planning development, determining exposure, modifying the processing of the negative and the print, and modulating the final print color can all become useful tools for the creative photographer. For the photographic technician they are, of course, necessary.

Advanced photographic controls require understanding of the special terms used in measuring the light absorption of the negative, and also of some simple chemistry. They also require much more patience.

A friend who is an excellent horseperson put it this way: "It is such a big change, just getting up on the horse and learning to walk and trot, and yet it takes so little effort. Then you start learning to control the walk, the trot, and it takes great effort to learn a little bit of control. But it's necessary, if you are to achieve anything with the horse." Photography is just the same—the first steps are quite easy and produce big changes quickly; more advanced steps often require a lot of work for what at the time seems to be very little improvement.

Simple Densitometry

The film used to make the negative will always absorb some light. This is because it has definite substance, and the layers of the film are less transparent than the surrounding air.

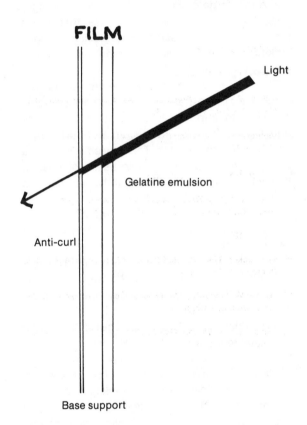

FILM

Light

Gelatine emulsion

Anti-curl

Base support

Figure 4-1: **Cross section of film showing absorption of light.**

The light striking the film is absorbed by the transparent support. This used to be cellulose nitrate, but that material was explosively flammable and was replaced before the Second World War with acetate based film. If you have old negatives, be careful of them because the nitrate not only burns very easily, it decomposes by itself after a certain arbitrary age. If the negatives are important, make copy prints.

Acetate films have a disadvantage for professional work, in that they change size with changes in relative humidity. This makes color separation printing quite difficult, unless all the film used is stored together all the time, so separation nega-

tives and printing matrixes swell and shrink at the same rate. This is not always practical, and in the mid-1950's a mylar based film was introduced. This film is dimensionally stable with humidity changes; it is also much stronger, and cannot be torn. Most sheet films are now mylar based products, and most roll films are still acetate based.

The film is used to support the emulsion; this is still gelatin, filled with dyes and silver-bromide photosensitive crystals. These vary in size. The larger the crystals, generally speaking, the more sensitive they are to light. In a very simple way, a large crystal and a small crystal each take about the same amount of light energy to become unstable. And a large crystal will absorb far more light after it's developed, be more dense, than will a small crystal; for the same amount of light initially striking the film it is therefore more efficient as a density producer.

The film + gelatin sandwich tends to curl up, much like a piece of paper painted on one side only will tend to curl, because the structure is now unbalanced. To prevent this, an anti-curl film of gelatin is put on the back. This is used to support a layer of dye, which in turn absorbs any of the light that comes through the film, light that isn't used up in the exposing of the picture.

Finally, a second layer of silver emulsion is often used to carry a super-fast silver. All of these layers are more opaque than the surrounding air, and so they absorb light. The least amount of light the film can absorb is controlled by the way the film is made, and the quality of chemical and mechanical handling given it by the user.

If you take a strip of 35mm Tri X out of its cassette in the dark and remove all the silver by using a fixing bath, wash it very thoroughly to remove all the anti-halation dye, sponge it off so there are no dust or dirt particles, dry it, and look through it, you will discover it has a definite greyness, a definite absorption. This piece of Tri X film in fact absorbs about 50% of the light striking it! Even before there is any image on the film. All picture-making must be done between 50% and 100% absorption.

Fortunately, the film reacts to light in an unexpected way. If we expose it to a certain minimum amount of light, develop and fix it, we will discover the film now has an absorbency, which is called *opacity.* If we expose another similar piece of film to double the amount of light, develop it exactly the same as the first, we find that there is a definite, but surprisingly small change in the opacity of the film. Rather than refer to "small changes" or "large changes" a special language has been developed to describe opacity more precisely.

Opacity is the ability of the film to absorb light. The inverse of this is transmission. Mathematically, this is written as

$$Opacity = \frac{1}{Transmission}$$

These are direct relationships. Because of the way the film responds to light and development, it is more useful to describe film opacity as *density.* Density increases according to the logarithmic curve, or

$$Density = \log Opacity = \log \frac{1}{Transmission}$$

Comparing these two ways of naming a relationship,

if the Opacity is	and Transmission is,	then the Density is
zero	100%	zero
50%	50%	0.30
75%	25%	0.60

From this, one can see a pattern emerging: as transmission is halved, density increases by 0.30. Put it another way: a two-to-one change in opacity or transmission is stated as an increase or decrease in density equal to 0.30.

There are special machines made to measure density, called densitometers. The simplest one made is the Kodak Model 1 Color Densitometer, which uses your eye as the photosensitive measuring device. The Kodak Densitometer compares light passing through the film to light passing through a calibrated grey plastic wedge. When the two light patterns are identical in brightness, then the position of the wedge can be read to determine density.

More elaborate densitometers use photo-electrical sensing devices instead of the human eye. They are in fact light meters just like the ones in cameras, and are subject to the same problem, being very sensitive to variations in voltage.

Any metering system used should be calibrated. This means in this case, measuring a known set of densities that have been established by someone else, and adjusting your machine to agree with the standard. A Kodak Calibrated Step Tablet can be purchased; or an uncalibrated one can be measured on a densitometer known to be accurate.

The densitometer should be used to measure a number of negatives that have made successful prints. Try picking out certain common areas:

Description of Measured Area	*Typical Density*
unexposed film	35mm Tri X = 0.28
between pictures	120 Tri X = 0.10
Skin details	35mm = 0.90
(face, body areas)	120 = 0.95-1.00

There is a difference between the typical densities encountered on 35mm and larger films. This is because the films are made differently. Tri X 35mm film has a grey dye in the film itself, put there by the manufacturer to reduce the shadow contrast. The larger films do not have this dye, the film base is clear.

Notice that even the clearest kinds of film have a minimum density, a definite opacity, which absorbs about 1/6th of the light that strikes it (i.e. has a density of 0.10). This absolutely minimum film density is controlled by the film materials and the chemical processing. If film is properly processed, completely fixed, well washed, dried without exposure to dirt, it will still have some density, which is referred to as *Film-base + Fog density.* The "fog" referred to is the undifferentiated image caused by heat, x-ray, cosmic-ray and other radiation that always affects some of the silver in the emulsion, silver which will then be developed out and appear as a definite density, but density that has no image-making functions. It hangs between us and the clearest possible image like fog, and is so called.

You can increase Film-base + Fog density by exposing the film to heat, by age, by poor processing, but you can never diminish it beyond the point you would have with fresh film, right from the manufacturer.

If you measure several "good" negatives, you may find that their densities differ from the typical densities listed above. Yet they printed reasonably well. This is because the materials, and our own critical standards, permit reasonable departures from an ideal negative, and yet we accept the results as being "good" or "acceptable." And there are times when definitely higher or lower densities are desirable for special reasons.

There is another density that is fairly constant. This is the density associated with a "grey card." Because a medium value, neutral color is so important in color printing, and is much more dependable to meter than what we have called a "textured white" and because the *averaged reflectance* of the majority of typical photographic subjects is slightly less than 20%—a grey card that reflects 18% is manufactured as a standard metering subject.

Most reflection type photographic meters are designed to "read" standard grey cards reflecting 18% of the incident light. They assume that the average value of principal photographic subjects are such that a little less than 1/5th the light falling on them will be reflected. They do not take into account strongly colored subjects. Meters, being unable to think for themselves, believe the entire world looks like a grey card. If the subject in front of the meter is more or less reflective, then the operator behind the meter has to interpret, or the exposure that is indicated on the meter will be wrong.

The first and most important error commonly practiced with the meter is assuming it is correct for your system. Here are the chain of variables in a photographic system:

meter
metering method
film
shutter
diaphragm
developer
thermometer
agitation method

We make casual assumptions about all of these, none of which are known to be true until we have verified the system! Analyzing these one at a time, the following assumptions are made, but must be proven before the system is actually right:

Meter: that the batteries are providing correct voltage for the range being measured (dim light conditions draw much more current).

Metering method: that the meter is being pointed at a portion of the subject that does in fact reflect about 18% of the incident light, and that the meter does not also see a much brighter or darker area at the same time.

Film: that the number used to indicate the sensitivity of the film to light when calculating the exposure (commonly referred to as the "ASA" number) is in fact the right number to use. Many films, for example, are less sensitive to reddish tungsten light than to white daylight, and the "ASA number" will indicate an underexposure.

Shutter: that the shutter does in fact open and close in the time indicated.

Diaphragm: that the diaphragm does in fact assume the correct f-number each time you set it, and that one f-number does in fact transmit one-half or twice the amount of light as an adjacent number.

Developer: that the developer is within correct ph tolerances, and that it is the developer you have used before with this system.

Thermometer: that the thermometer is correct, and is correctly used, and the developer is kept at the same temperature, or is used over the same temperature range during developing time, each time.

Agitation method: that the agitation is constant, repeatable, and provides the same degree of replenishment of developer to the film, over the developing time, every time.

All this sounds very complicated, and yet in fact most of the errors in the system tend to cancel out, and as long as the parts of the system are kept intact, we make generally acceptable pictures. It is only when enough experience has been gained that one wishes to examine any one piece of the system that more precise definitions are needed.

Assume that your system is working correctly, and you are making ideal negatives (whether in fact you are or not). Do the following experiment and validate this:

1. Set up a Kodak grey card in a convenient place outdoors where one can photograph it at frequent intervals, say every day, and have the same lighting. This should be even light, without broken shadows—either direct sunlight or open shade. The light should not be strongly colored, as would happen on a porch with a red brick wall and a strong colored red floor.

Figure 4-2: **Camera and grey card set up for system test.**

2. Set up your camera on a tripod, close enough to the grey card that the viewfinder is filled by the card. Don't focus on the card. Focus the camera on optical infinity (∞). This will make the image of the card out of focus, so any small variations of brightness on the card are lost in the blurred image.

3. Calculate the exposure by using a hand-held meter, or the meter in the camera. Set the meter to the "ASA" index suggested by the manufacturer of the film.

4. Expose the first frame of the film as suggested by the meter. Make a note of that exposure (e.g. 1/30th @ 2.8).

5. Expose the second frame exactly *five stops* less. There are two ways of doing this, theoretically:

if the first exposure is metered at 1/30 @ f2.8 the second frame exposure might be 1/1000 @ f2.8

(or it might be) 1/30 @ f16.

Either of these alternate exposures are *five stops less light.* Naturally, a convenient combination of shutter speeds and diaphragm openings would be used.

6. Make the exposure of the third frame four stops less than the indicated exposure, e.g. 1/500th @ f2.8

7. Make the rest of the exposures at one stop intervals, going on past the calculated exposure to three stops *more* than what the meter originally indicated, e.g. 1/4th @ f2.8. If you have an automatic camera, you will have to move the controls to *manual* in order to make these exposures.

8. Finish off the roll of film on "normal" pictures. Develop the film, fix, wash and dry it carefully. Examine the strip of the first nine frames. They should look like this:

Figure 4-3: **Holding the two halves of the test film: top, metered exposure, 5-stops less, etc.; bottom, continuation of test frames.**

If your system is perfectly tuned, the following observations and tests can be made:

The second frame will just disappear. It may be barely visible, but should be almost the same density as the unexposed film surrounding the frames.

Figure 4-4: **A typical highlight density should be *just* transparent enough to read through.**

The third frame should be definite, and yet not really very dense at all.

The ninth frame should be fairly dense, yet you should be able to read type in a book or newspaper through it, when it is held at an angle to the paper.

FRAME	DENSITY (35mm Tri X)	Exposure
1	0.70 - 0.80	Grey Card
2	0.25 - 0.30	Film-base + Fog
3	0.30 - 0.35	+ 1 stop
4	0.35 - 0.40	+ 2 stops
5	0.40 - 0.45	+ 3 stops
6	0.55 - 0.60	+ 4 stops
7	0.70 - 0.80	+ 5 stops (grey card)
8	0.80 - 0.90	+ 6 stops (caucasian skin)
9	0.95 - 1.05	+ 7 stops
10	1.10 - 1.20	+ 8 stops (textured white)
11	1.25 - 1.35	+ 9 stops (pure white)

The eleventh and twelfth frames should be just a little too dense to be able to read type through, as shown above. Of course if you hold them up to the light and look directly through, these densities seem fairly transparent. Holding a negative up to the light to evaluate it is most misleading. You can always see through maximum densities in this way, but that doesn't mean you can print through them.

Now *if* your system is exactly right, you will have achieved the densities described above. What can go wrong?

1. The "ASA" index you have set into the metering system is inaccurate for your system. If your meter has greater or lesser sensitivity than you expected it to have, or if your metering method is slightly in error, then your densities in the second and third frames (remembering the first is a reference exposure) will be too large, or two low.

FRAME	DENSITY	DESCRIPTION OF ERROR
2 -	0.30-0.35	overexposure index low
3 -	0.25-0.30	underexposure; index too high

Looking at the higher densities, errors may appear for the following reasons:

FRAME	DENSITY	DESCRIPTION OF ERROR
9 -	1.10-1.20	excess density; overdevelopment
11 -	1.10-1.20	deficient density; underdevelopment

In fact, the following experiment would demonstrate in terms of the print what the densitometer says in numbers.

If the densities of the film you have developed are about right (with correct minimum and maximum densities) make a print on normal contrast grade paper, from the tenth frame (which has a density about 1.10-1.20) which when developed for a normal time, agitated in a standard manner, fixed, washed and dried, is a very pale grey, just visibly different from the white of the paper edge (that part covered by the gripping blades of the printing easel).

Now, without changing anything in the enlarger system but the film, make a print from the first frame (representing the grey card). When it is developed the same way, washed and dried, it should look very much like the grey card. If they look close, but a little different, try looking at them through a strong yellow filter (Wratten No. 8 or 15). This will diminish the difference in color, and permit you to make a comparison of value more easily.

If the test is made correctly, the comparison should be close. If the density of your negative was high in the 10th and 11th frames, try making this comparison set on a low-contrast paper. If the 10th and 11th frame densities were low, make the set on high-contrast paper. Because that, in effect, is what these papers are for—to match the density range of the paper to that of the negative. And each contrast grade is approximately equal to the density range described by the number of steps listed in the sample table of densities. A normal contrast grade paper is designed to provide correct greys and blacks for a negative having a density range from about 0.25 to about 1.30 (black to white). The next higher contrast range paper is designed to produce a full scale print from a negative having a density range from about 0.25 to 1.15. The opposite is true for lower contrast papers: the next grade below normal is designed to produce a full scale print from a negative having a density range of about 0.25 to 1.45.

If the test you made produced the correct densities, then your system is fine. If the densities in the shadows were too large, you should double the "ASA" number you set on the metering circuit in your camera, or on your hand-held meter. If the densities are too low, then halve the index number. Once you find you no longer are using the *Manufacturer's Recommended Guide Number* which is all the "ASA" number is in fact, a recommendation for trial exposures, you are using a new number that is more appropriate to your camera and metering and developing system. It is logical to call this number your *system index.* It is yours because it is

developed out of the parts of your photographic system. You cannot change any part of that system without rechecking it, and you can't "give" your number to anyone else because they have a different system. It is foolish to say "I use Tri X at 1,600," and expect it to work the same way in anyone else's system. It might, but the odds are it won't.

The traditional way of presenting graphically the information you have already developed from your test roll of film illustrates how the density of the emulsion will increase as the exposure increases. This presentation dates back about eighty years. It was devised by F. Hurter and V.C. Driffield in 1890, and is also known as the *characteristic curve:*

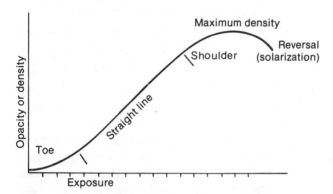

Figure 4-5: Typical *characteristic* curve, also known as the *d-log-e* curve or the *H&D* curve.

It is sometimes called the *H & D* curve, after the initials of the inventors, as well as the *d-log-e* curve, because the density is graphed against the log of exposure. Notice that the units of measurement on the base of the curve are exposure units, not linear units. Each exposure unit equals twice the amount of light of the next smaller unit or is a "stop" increase. This is important, and will help make clear some basic relationships about exposure and development.

If units of exposure each consist of a doubling of the next lower unit, then this is the relationship between quantities of light and units of exposure:

Unit of Exposure	Quantity of Light
1	1 unit (e.g. 1 second @ f8)
2	2 2 seconds
3	4 4 seconds, etc.
4	8
5	16
6	32
7	64
8	128
9	256 and so on.

As you saw when you made a trial of your system index, if the exposure was correct, the first unit of exposure caused a just perceptible increase, a small change from the film-base + fog. If the exposure were increased by one unit (which means by one f-stop, which is another way of saying by doubling the exposure) the first density step would increase sharply, but there would be surprisingly little increase in density at the upper end of the density range:

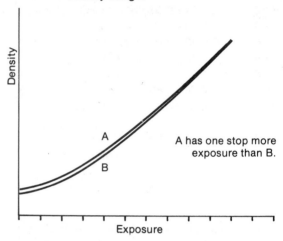

Figure 4-6: If two pieces of film are developed similarly, but one is exposed one stop more (double the exposure), the characteristic curves converge in the higher densities.

With the same development, two rolls of film, one exposed at half the system index of the other (which would produce twice the exposure at the first step above film-base + fog) will have almost identical densities at the eighth or ninth unit of exposure. Increasing the exposure will not measurably increase the density of the negative that is a result of brightly lighted areas of the subject.

When the film is increased in exposure, the effect can be shown as follows:

INITIAL EXPOSURE & INCREMENTAL INCREASE

Units	Total Exposure	Add one Stop of Exposure
—	FB+F	FB+F +1unit gain
1	1	1+1= 2X
2	2	2+1= 1 1/2X
3	4	4+1= 1 1/5X
4	8	8+1= 1 1/9X
...
8	128	128+1= much less than 1%.

Increasing the exposure will have almost no effect on the highlight densities. Changing developing time will.

To verify for yourself how this happens, try the following experiment:

1. Expose three rolls of film identically to a grey card as described earlier. The first frame should be the grey card exposed as the meter says, the second will be exposed five stops less, the third four stops less, and so on.

2. Develop the first roll one-half the time you normally develop film.

3. In the same temperature and concentration of developer, but using fresh solution, develop the second roll for your normal time.

4. Develop the third roll for twice the normal time.

When the films are dry, measure the densities of each frame. These can be graphed in a traditional way like this:

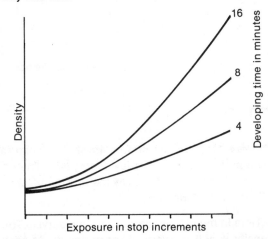

Figure 4-7: **Film which is exposed identically, but developed for 4, 8, and 16 minutes produces very different densities in the heavily exposed areas, and very similar densities in the lightly exposed areas.**

This presentation shows that although the exposures are identical on the three rolls of film, the shadow densities are quite similar and the highlight densities are quite different, and that these differences are controlled by developing time.

This is the fundamental fallacy that is revealed when photographers speak glibly of "pushing" film. For a given developmental system, increasing the developing time *will* increase the upper densities, those lying five or more stops above FB+F, but will have almost no effect on the lower densities. Those are markedly affected by the exposure, and small exposure changes in turn will have very little effect on the upper densities.

A note on making graphs should be inserted here. The graph showing the effect of developing time on density has only three points of reference, yet we did not connect those points with straight lines and sharp angles, like this:

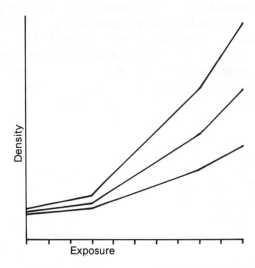

Figure 4-8: **Exactly the same points of information were used for this set of "curves" as in 4-7 — redrawn here as straight lines to show how *not* to graph your own information.**

because that doesn't show how things do in fact work. If a number of more rolls of film were exposed and developed for many times between the three you have chosen, you would find that the densities would increase in smooth increments, like this:

Figure 4-9: **If a large number of data points were made available, then the straight-line method shown in the last figure would begin to approximate the smoothed curve.**

and even then they would not all lie exactly on a smooth curve. This is because no matter how hard we try, there will always be small variations of process—differences of agitation, developing time, temperature, change of light during the exposing of film, etc., These variations will cause small changes in density so that a point will lie

slightly higher or lower than it ought to, were it to lie on a smooth curve. Engineers speak of "smoothing the curve" when this happens. The simplest way is to draw the line neatly *between* the points, letting the data bracket the graphical representation. If many more pieces of film were exposed and developed, one would find that in fact the data would "cluster" about the curve, like this:

Figure 4-10: **If a lot of film were tested, the densities would "cluster" around a central point, but the basic shape of the curve probably wouldn't change, as shown here.**

Since we are generating this information for our own use, it is perfectly legitimate to make graphical approximations, and in fact these approximations will often be found more useful in practice than would a more narrow-minded straight-line approach to the data. When you have only a few data points, connect them lightly with a smooth pencil line. Look at the whole pattern, then see if there are inconsistencies. These may be due to errors in writing down numbers, or in copying them. When these have been checked out, then redraw the lines in heavier smooth pencil.

The traditional characteristic curve shows clearly what happens to density with variations in developing time. But it is difficult to interpret in other ways, and there is much more useful information hidden in the figures.

When you make tests, you keep constant all the possible variable elements except one. This one variable is allowed to change in an orderly way; the effect of it on the process is observed. The changeable elements are also called *parameters.* And the presentation of the information may be both tabular and graphical, as has been done here. In these presentations, one parameter is plotted with reference to another. In the traditional H & D, or characteristic curve, we have plotted density as it is

affected by exposure, for a given developing time. There is a separate line, or curve, for each different time. Now, use the same information and change the curves around, plotting density as a function of developing time, drawing a separate curve for each exposure. Since the three rolls of film were exposed identically, one can discover what happens to a particular exposure as development time is changed.

Here is how this is done:

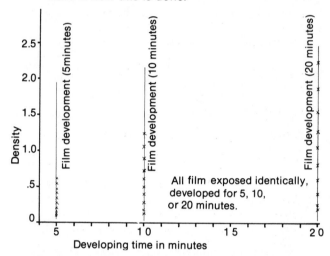

Figure 4-11: **The *same* information shown in Figure 4-7 is plotted here against *developing time.* The *x's* are the densities produced by identical exposures, different developments.**

Time in minutes is the base for the curves. The density is still the vertical (or ordinate). At each developing time used draw a light vertical pencil line. At the correct places on this line make a small *x,* appropriate to the density of that frame. When you are through, there are three columns of *x's,* each above the developing time for that roll of film.

Connect only the bottom row of *x's* with a smooth curve. Notice that it will change in density hardly at all from the least to the greatest developing time.

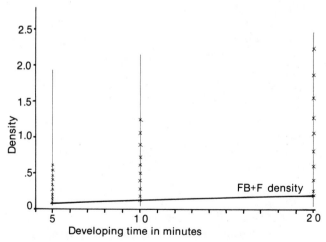

Figure 4-12: **Connecting the points marking Film-Base + Fog densities.**

Now connect the top set of x's. Note how much change in density there is from minimum to maximum developing time:

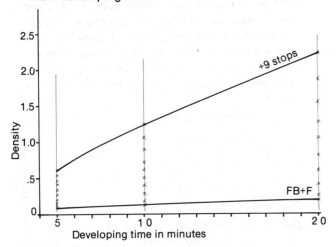

Figure 4-13: Connecting the points of the 9th stop above FB+F.

There are definite conclusions to be drawn. The change in developing time causes great changes in highlight densities, even though these films were exposed exactly the same. Change in developing time is therefore a control for contrast, since there is little or no change for shadows, the lightly exposed areas, even over wide ranges of developing times.

Now connect the middle set of x's, the ones representing the grey card densities:

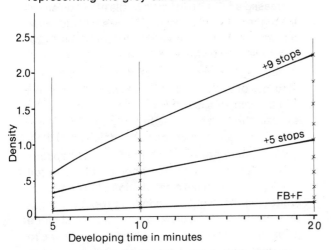

Figure 4-14: Connecting the points of the 5th stop above FB+F.

There is some density change from minimum to maximum developing time, but it is not great compared to that produced in the highlight densities.

Finally, smoothly connect the remaining sets of x's: produce a family of parametric curves that look like this:

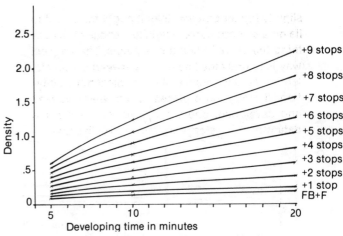

Figure 4-15: A complete parametric graph for a film/developer system.

The first use of this set of curves is to discover if your "normal" developing time is in fact correct for a normal contrast grade of paper. But first you have to know what normal highlight densities are for you, for your own printing system. Find at least eight or ten of your own negatives that print easily and well on normal grades of paper. Locate in these negatives areas that fit the description of "highest textured highlights," areas that when printed are just off-white, with definite detail. These might be textured clouds, concrete, white shirts, that sort of thing. Measure the density of these areas in each negative. Average the densities. The average textured highlight density for your negatives is now ready to be used.

On the density scale of your own parametric curves, mark the typical highlight density. In this example it is 1.18:

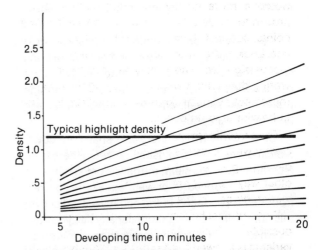

Figure 4-16: Parametric with "typical" highlight density line.

Draw a line at this density clear across the curves. Now, discover where that line crosses the curve representing the frame exposed for eight stops more than FB+F:

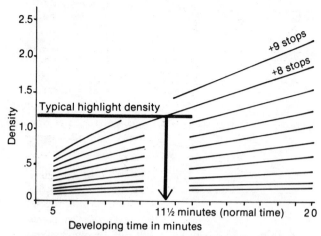

Figure 4-17: Discovering "normal" development time from the intersection of the typical highlight density line and the 8th stop above FB+F density.

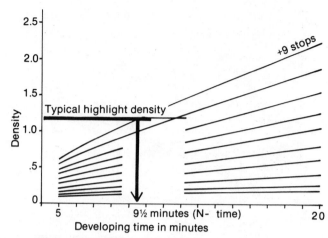

Figure 4-18: Discovering the time needed to produce a one-grade compression of density for a contrasty subject by locating the intersection of the 9th stop density above Film-Base + Fog and the typical highlight density line.

and drop a vertical line from this intersection to the base, where the developing time for a "normal" negative can be read. Validate this: find a number of photographic subjects you believe are normal in contrast, and photograph them; then develop the film for the indicated normal time, and see how it prints. If the shadow densities are thin, remember it is not because of the development, but because of insufficient exposure!

The parametric curves you have drawn also permit you to immediately discover the correct development times needed for high or low contrast scenes. A high contrast scene is one in which if your exposure is correct for the shadows, then a regular development time will produce excessive highlight densities because the highlight areas (light concrete, white shirts, etc.) will reflect too much light into the camera, relative to the shadows.

In the chapter on Beginning, contrast was described by making note of the kind of shadows one saw in the scene being photographed. There are precise ways of metering the subject to determine the contrast as well, and these will be described later in this chapter.

For a scene where there are sharp shadows, typical of the light in midsummer when there is no haze and the sky is clear, the development time will have to be reduced to prevent excessive contrast from being produced in the negative. To discover this time, follow the highlight density line you have drawn to the left. When it crosses the next parametric curve, the one representing the ninth stop of exposure over film-base + fog, drop a vertical. The time shown is the time required to reduce the contrast by a density range that will be equivalent, when printed, to a change of one paper grade.

What you have done is to use the curves to help you find how much loss of highlight density occurs with a certain decrease of developing time; this

decrease in highlight density is about what is needed to make a scene with a longer-than-normal lighting range print normally on your regularly used paper. This is possible because there isn't much change in the shadows when this development time is lessened.

One might ask, why not simply decrease the exposure? That would decrease the highlights as well, wouldn't it? A little but not much, as you saw in the table on page 96 . When the exposure was increased a full stop there was little effect on any of the higher steps of exposure, since each additional density increment is created by doubling the previous step's exposure.

Due to decreased development there will be a little loss of density in the upper shadows, and this can be compensated for in part by *Increasing* the exposure in high contrast, brightly lighted scenes, when you plan on decreasing the developing time.

When there are very soft shadows, as happens on overcast days, or when photographing in full shade, you can make a calculation of the development time that will be needed to produce a negative that will print easily and well on normal grade of paper by following the highlight density line to the right until it intersects the next parametric curve, which is the line for the seventh exposure stop above film-base + fog. Draw a vertical line down from this intersection, and you will find the time needed to increase the highlight density.

Due to increased development there is a little increase in upper shadow densities, indicated by the fourth line of the parametric curves, but this change is quite small compared to what happens in the highlight areas, the seventh, eighth and ninth stops of exposure above film-base + fog.

For *very* flat scenes, which you encounter on very foggy days, or after sunset—when you are

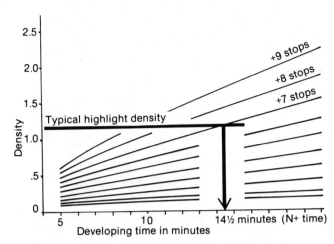

Stops of Exposure	Negative Density	Description of the Negative	Description of the subject in the print
-(FB+F)	0.28	clear film, unexposed	absolute black areas
1	0.32	just visible density	black
2	0.37	first faint detail	almost black
3	0.44	first significant detail	very dark
4	0.55	important details	deep grey
5	0.70	firm middle tones	middle grey, grey card
6	0.85	richly textured	major skin tones
7	1.00	sharp, linear	principal textures
8	1.15	last filmy step	lightest textures
9	1.30	first real opacity	clear white
10+	1.45+	opaque to reflected light	light sources and white in print.

Figure 4-19: Discovering the calculated time required to produce a one-grade expansion of density for a flat subject, by locating the intersection of the 7th stop density above Film-Base + Fog and the typical highlight density line.

looking down and do not include the sky in the picture—you may need to expand the density range of the film even more. To calculate the development time needed to do this, follow the highlight density line to the right until the next parametric curve intersects. This intersection of the highlight density line and the sixth stop of exposure above film-base + fog is directly above the required developing time to produce the increase over the previous expansion. Notice that with most films this time is proportionately longer than the increase of time of the first expansion over the normal time. The change from normal to one-grade expansion is less than the change from there to two grades of expansion.

The greater the expansion required, the proportionately longer the developing time must be. The effect of this is that with many films it will be impossible to expand more than two paper grades without developing for a very long time, and the effects of long development may destroy some of the desired image quality.

Expansion development encourages the production of large silver grain, and the long wet time encourages some migration of silver particles, plus some "flare," which is the development of emulsion on the fringes of heavily exposed areas. These effects appear as coarse visible grain in the picture, a blurring of small, but often significant detail, and a smearing of highlights.

When you increase the developing time beyond the normal time, there is an increase in overall density, which is useful because it provides an increase in contrast, and there is some increase in upper shadow densities.

Specific normal densities and their relationship to their appearance in the print are described here.

For a typical 35mm Tri X negative,

Notice that at three stops exposure above film-base + fog there is the "first significant detail" in the negative, but that the description of this in the print is "very dark." The fourth stop above film-base + fog yields "important details" and this prints as a deep grey.

Important shadow details are those found in dark clothes, in the texture of dark human hair, and in wet tree bark. All these print as dark grey; they are visually meaningful because they carry a richness of detail within them, detail established in turn by darker shades of grey going to pure black, as well as lighter shades of grey. This specific density, created by the fourth stop of exposure, will increase slightly when development is increased. Because this important density controls our perception of substance in richly textured dark surfaces, it is desirable to know what happens to it with developing changes and how we may make use of those effects.

Look again at the parametric curve you have drawn. Find the intersection of the normal developing time line and the fourth stop of exposure.

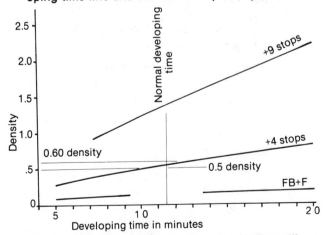

Figure 4-20: The typical 4th stop density line will intersect "normal" development time at about 0.55 density.

Draw a horizontal line at this intersection. It will vary, but it should be at about 0.55 density. It may fall as low as 0.50 or rise to 0.60.

For expanded development, look to the right, where this new density reference line crosses the expanded development time line. Measure, on the graph, how much increase of density there has been in the fourth-stop density line:

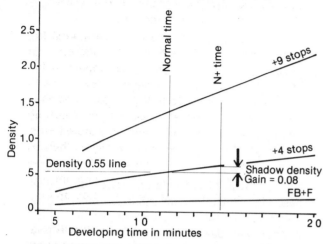

Figure 4-21: **The typical gain in shadow density caused by a one-grade expansion development.**

On a typical film/developer combination, this increase will be about .07. It may be lower, as little as .05, or higher, as much as .10. From the tabular information from which you made your parametric curves, discover what the normal separation is between the third and fourth, and between the fourth and fifth density step lines are. For example, from the table on page 101 we see that:

Step Interval	Density Increment
FB+F-1	0.05
1-2	0.05
2-3	0.07
3-4	0.11
4-5	0.15
and from there on	0.15.

The change in density in this example for the fourth stop line caused by the increase in development time is slightly more than one-half the normal density increment for that step. The implications of this are:

1. One could expose normally; the expanded development would yield both increased contrast and some unnecessary density;
2. One could reduce the exposure about one-half stop; this would not change the density range, but slightly decrease density overall.

Any desired effect is up to you. If the film is from a small camera, then the lesser density is desirable because the lower the density, while keeping a full range of printing densities available, the finer will be the grain in the print. And since expansion development tends to produce larger grain, then the reduction of grain achieved by giving the scene less exposure is desirable.

If you are working with large cameras, where the silver grain size is not so important, the larger separation of tones that will result from the slight increase of density achieved by the expanded development without any reduction in exposure may well be desirable, especially if the photograph is of architecture, or landscape, where the majority of visual information falls in the darker greys.

As one would expect, exactly the opposite effect happens when the development time is reduced. Look at your parametric again, and follow the fourth stop density line to the left. Where it intersects the compression development time used to reduce overall density when a contrasty subject is used, measure how much the fourth stop line has lost density.

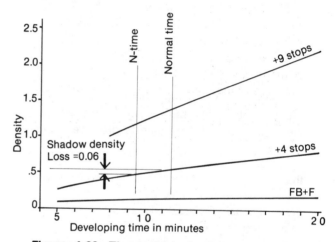

Figure 4-22: **The typical shadow density loss caused by a one-grade compression development.**

This loss of density will usually not be as large as the increase in density for the expansion, but it is generally in the range of 1/3 to 1/2 the normal density increment. In other words, if the decrease in density is .04, it is about 1/3 to 1/2 the average density separation of the third, fourth and fifth stop density lines.

The meaning of this to the careful photographer is that the loss in important shadow density concurrent with the decrease in developing time needed to reduce the density range as a means of coping with high contrast subjects can be corrected by increasing the exposure. This can raise the shadow densities to compensate for the diminished reduction of silver; the shortened developing time will still keep the maximum density where it should be, producing negatives that print easily and well on normal contrast grades of paper.

In addition, the visual separation of the shadow areas will remain clear. This is most important, as too often the total density range is the only thing considered in photographic exposure/development calculations, and the result is a print with correct highlights, but squashed and muddy shadows.

The implication of this advice is startling to many photographers: in high contrast situations, increase the exposure from a half-stop to a full stop to compensate for the diminished shadow detail separation, a result of the shortened development time needed for contrast control.

The ZONE SYSTEM and Metering

The Zone System is a method of calculating exposure and planning the development of negatives to produce a print with definite qualities. The System embraces the negative, print and photographic subject, linking them with common terms.

The Zone System dates from the early 1940's. Ansel Adams formulated the Zone System out of his personal method of exposing and developing. The name comes from his simplification of the photographic grey scale. Adams provided names for areas of the scale. The greys are visualized as ten distinct tones between black and white. These steps replace the smooth grey scale and permit us to name a specific area. Being able to name it we can refer to it in the print, the negative, or the original subject.

The Zone System is a tool. It permits accurate control of film, exposure, metering, and development. It permits accurate previsualization. It has great power as a nominative tool. One can name the parts of a picture which are most difficult to deal with, the individual grey tones. By naming them one can control them. It permits evaluation of any step in the photographic process, from the print to the negative, and to the exposure that produced it.

Between black and white are an infinite number of individual grey tones. These may be simplified to ten shades. Each of these ten shades is a "Zone." Any given Zone requires exactly twice as much exposure as the next lower Zone, anywhere in the scale.

The Zone System permits a photographer to calculate exposures while in front of the photographic subject knowing that after exposure and development he can produce a print with certain tones. The image becomes a predictable photographic equivalent of what the photographer sees when he looks at the subject. After preliminary testing of his materials and equipment the photographer is free of most risks of trial-and-error.

One use for the system is to predict the effect of exposure and development on a film. Another is predicting certain tones in the print before the photograph is exposed. A third is learning to previsualize changes possible if one wishes to depart from naturalistic renderings.

To use the System, one must learn what the names mean. When a name is mentioned, a mental image of that specific grey must appear in the mind's eye. For example, a negative is exposed to produce an all-over Zone V grey tone and then printed normally so that tone is realized. A second negative is exposed for exactly one more f-stop. Printing the second negative exactly as the first results in a Zone VI area on the print. The two grey tones are one Zone apart visually and are produced by negatives that are one f-stop apart in exposure.

Because of the nature of exposure-density relationships of film and paper, the grey areas called Zones are not evenly spaced. They fall into three main groups.

LOW ZONES
ZONES O, I, II and III are: the maximum black of the paper, almost black, very dark, and dark. Contemporary enlarging papers cannot differentiate O and I in practice, although these densities can be established on the negatives.
MIDDLE ZONES
ZONES IV, V, and VI are: dark grey, middle grey, and light grey. Zone V is the color of the Kodak Greycard (18% reflectance); Zone VI is often compared to average skin tone (caucasian) or to north sky.
HIGH ZONES
ZONES VII, VIII, and IX are: light grey, pale grey, and white. Zone VII contains the last major surface details. Zone VIII contains the least perceptible detail.

Zone III is often referred to as the "darkest detailed shadow." At the other end of the scale Zone VII is called a "textured highlight." Both of these names and the tones they represent are often misunderstood. Misunderstanding the name inhibits use of the System. Beginning photographers usually try to place fully textured light values in Zone VIII when they should be in Zone VII (e.g., light concrete).

Most textures and important tones occur in the middle Zones. The dark and light Zones add brilliance and strength.

The description of the tones is real. This is the way silver materials work, the way they look. The photographic grey scale crushes low tones and high tones. It is not neat equal steps, moving in a stately way from black to white. All the near-blacks

fill up the bottom four Zones. The middle tones (where almost everything happens) are only three Zones. The light tones bunch together like the dark ones. It is not the distribution one might desire — it is what silver produces.

The tones of the print are equivalent to the vocabulary and syntax of the poet; with these tones we communicate our thoughts through photography.

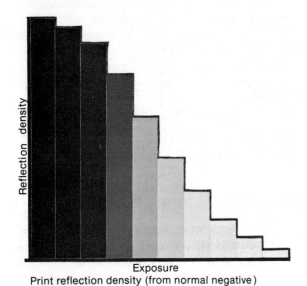

Print reflection density (from normal negative)

Figure 4-23: **The characteristic curve of the paper, expressed as a step-wedge of ten shades of grey. These are the actual increments available, and illustrate how the visual information of the print is principally confined to the middle five steps.**

The steps of grey illustrated above are produced by exposing film at one-stop intervals, in just the way you exposed the parametric tests earlier. The blackest patch is from film with no exposure, that is, with only film-base + fog density. The sixth patch is exposed to a grey card correctly, producing a density which will print on a normal grade of paper and produce a middle-grey tone. The next-to-last patch has a negative density of 1.20; this has been exposed on the print to produce a just-perceptible tone. The last patch, outlined here to make it visible, is pure white, and comes from a negative density of 1.35. There will be higher densities on the film, and while your eye could see what should be usable information in those areas, they will not print without manipulation.

Relating densities, the stops of exposure and the Zone system notation, when the film is correctly exposed and developed, and the right system index has been used for exposing:

Comparison of Parametric and Zone System

Exposure+	Zone	Subject Description	Print Description
FB + F	0	featureless black	blackest paper tone
+1 stop	I	very dark to black	least perceptible change
+2 stops	II	shadows within shadows	first tone change on some paper
+3 stops	III	deep textured shadows	darkest detailed areas
+4 stops	IV	blue jeans, hair	important dark shadows
+5 stops	V	ground, average shrubs	middle grey/ grey card
+6 stops	VI	caucasian skin, north sky	richly textured light grey
+7 stops	VII	skin highlights, clouds	light grey
+8 stops	VIII	white walls, T-shirts	very light grey with detail
+9 stops	IX	featureless whites, lights	paper white without detail
+10 stops	X		

reflections from the subject can continue to rise in brightness, and be recorded on the film in increasingly dense zones, but these cannot be printed without manipulations.

These comparisons are of course for a **normal** scene, developed for a normal time, and printed on a normal contrast grade of paper. If a scene is higher or lower in contrast, then the language of the Zone system offers a tool for describing the scene accurately and relating it to the development plan needed to provide a negative that will print easily and well on normal grades of paper. The Zone language also relates to metering the scene.

The exposure needed to produce a correct negative for the kind of film being used and the purposes of the picture can be related to the Zone system names for the tones in the subject and on the print.

The handheld exposure meter offers more flexibility than the in-camera meter, but either may be used to estimate accurately the contrast range of a scene so that correct development can be easily planned.

The procedure for **either** is the same:

1. Measure the shadows, which will determine the exposure of the film, which as we have seen controls minimum density.

2. Measure the highlights; by comparing the meter reading produced with a standard reading, determine the development plan needed. The highlight densities are controlled by development.

3. Having made a decision about developing time, make any corrections to the exposure that may be desired because of slight losses or gains in density that will be caused by decreased or lengthened development.

With a hand-held meter, this is illustrated:

Figure 4-24: *(A)* A "normal" scene. *(B)* Metering the shadows with a hand-held meter. *(C)* Metering the highlights with a hand-held meter.

In the first illustration the hand-held meter is used to measure the shadows, and a meter reading noted. You *do not* expose the film to this reading; it is used as the first half of a calculation of the brightness range of the subject being photographed. The highlight area is then measured. Its meter reading is noted. The difference between these is measured:

Highlight exposure	(e.g.) 1/500 @f11
Shadow exposure	1/30 @f11
Brightness range	= four stops.

In the following drawing this is illustrated:

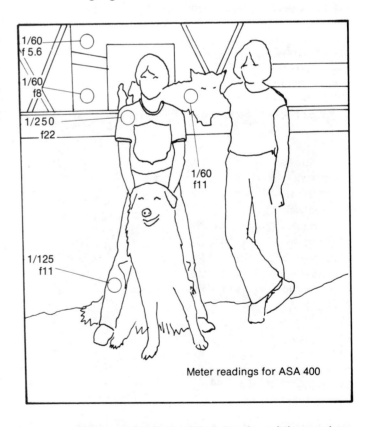

Figure 4-25: A simplified drawing of the previous Figure, with the meter readings for each area noted for an ASA 400 film.

The meter indications for the brightest detailed subject is four full stops from the indication for the **Important textured shadows.** Some photographers prefer to measure **darkest detailed shadows,** and with more practice you may wish to measure these instead. The measuring of important detailed shadows (dark clothing like blue jeans, average brown hair) is easier, at first. If you begin by misnaming the metering subject, you will underexpose the film and produce excessively thin negatives.

The Zone system names given to these same areas are Zones VIII (highlights) and IV (important shadows). In the example above, they both **meter** and **fall** in their correct place on the brightness scale. In other words, if we meter an area of important textured shadow, we can then **place** that meter reading on Zone IV; then we meter the highlight area to find out where it **falls.** In this first example, the shadow exposure was 1/30 @ f11; the shadows are placed on Zone IV. The highlights are metered at 1/500 @ f11; they fall on Zone VIII. This says the development would be normal, because the brightness range is what we would expect.

The actual exposure would of course be neither of the exposures read on the meter. Since the exposure is controlled by the shadow reflectivity—the amount of light reflected toward the lens from the dark areas where there must be density on the film to make a good naturalistic representation—the meter reading for the shadows can be interpreted to provide the correct exposure.

The meter believes everything it is pointed at is a grey card. In this example we have pointed it at shadows, and noted the exposure. The shadows are Zone IV, the meter thinks they are Zone V, so the actual exposure must be **one stop less** than the meter reading of the shadows.

If you pointed the meter at the shadows and simply exposed according to that reading, you would be making an exposure large enough to make a negative density that would print as middle grey. But a little less density is needed, in fact one stop less, to make those shadows print correctly.

What happens when a scene has a brightness range that is longer than normal, or is a high-contrast scene?

In the situation illustrated, the shadow areas are metered and this information will be used to control the exposure. The highlights are then metered, and it is discovered that they are **five** full stops brighter than the shadows. This means that if you **place** the exposure according to the shadow reflectivity, the bright places in the subject which should print with texture would be too dense, were you not to manipulate them during development. The obvious thing to do is to reduce the development time, so the highlights do not become so dense. In the Zone system notation, this can be visualized as **placing** the highlights on Zone VIII, even though they **fell** on Zone IX on the meter; this is called **planning a development for one Zone of compression.**

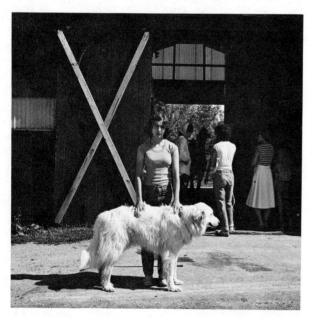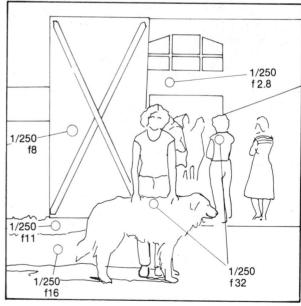

Figure 4-26: (A) **A "contrasty" scene.** *(B)* **Meter readings from this scene for an ASA 400 film, as determined by a 1° "spot" meter.**

If the shadows are placed on Zone IV, and the highlights fall on Zone IX, decreasing development time according to the parametrics will move the highlights back to a Zone VIII density.

As noted earlier, there will be some loss of important textured shadow density; this can be accounted for in the final exposure determination.

Exactly the opposite happens when the light is very flat, and the brightness range of the subject is consequently diminished. The same photographic subject can be discovered to be, in different lighting, metered as very flat, flat, normal, contrasty or very contrasty. The direction of the light, and the quality of it can change the brightness range through three stops without difficulty; if there are very dark and very reflective substances in the picture you choose, change it through five stops, or Zones.

A scene that has a low brightness range is shown in this illustration:

Here the brightness range is only three stops from where the shadows are placed to where the highlight reflections fall on the meter scale. The obvious thing to do is to increase the development time. This will raise the highlight densities so that what meters as a Zone VII value (when the exposure is controlled by placing the important shadows at Zone IV) will move up to a Zone VIII density, and the negative that results from this *expanded development* will print easily and well on normal contrast grades of paper. The exposure will be determined as before—by exposing one stop less than the indicated exposure obtained when the meter was pointed at the important shadow areas.

If the shadows are placed on Zone IV and the highlights fall on Zone VII, increasing development time according to the parametrics will move the highlights up to a Zone VIII density.

Occasionally scenes will be encountered that are more or less contrasty than these examples

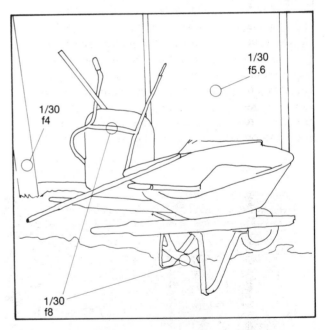

Figure 4-27: (A) A "flat" scene. *(B)* Meter readings for an ASA 400 film as dertermined by a 1° "spot" meter.

illustrate. Very soft light will be found on foggy days, in open shade, and with subjects which of themselves have a limited reflective range that will require two full Zones of expansion to print well on normal grades of paper. With small camera negatives, where greater enlargement is needed to produce a suitable print, it may be wise to expand only one Zone, and achieve the rest of the needed expansion by using higher contrast grades of printing paper. This way, the grain enlargement which accompanies extended development times

is moderate, and the coarsening of the tonal separation that accompanies higher contrast grades of papers is minimized. This is an example of the kind of technical compromises needed when the facility of the small camera is exchanged for the image-by-image control of the large-format film.

Extremely contrasty subjects can be handled using only exposure/development parameters; however there are some side effects which should be noted. With two Zones of compression, with some film/developer combinations, there will be a

significant crushing of the tones called Zone II-V. In some cases, changing to a more dilute developer used for a moderately long developing time will produce better results. The effect of a very dilute developer is that of using what almost appears to be two different developers at the same time: the one for the shadows is of almost normal activity, and the highlight developer exhausts itself quickly, producing densities which increase more slowly than anticipated.

An extremely dilute developer will produce steady reduction of the silver salts in the lightly exposed shadow densities throughout the entire developing time. This is because there is always a surplus of reducing agent, relative to the amount of silver that has been made unstable by exposure. However, if moderate agitation is used and there is sufficient interval between agitation cycles, the heavily exposed highlight areas quickly exhaust the very dilute reducing agent available. This effect in turn is accentuated by the release of larger amounts of bromine from the silver salts, as they are developed.

The reducing agent + accelerator breaks down the bond between the silver and the bromine, freeing the bromine which when there is little agitation immediately affects adjacent silver as an inhibitor. With very dilute developers, this means that highlight reduction takes place at a slower rate than shadow area reduction, and in effect two developers are operating at the same time.

This effect can be negated by excessive agitation, or it can be amplified by a reduced agitation schedule. Changing agitation will affect entire exposure/development processes, as has been noted in **Basic Processes.**

The thicker, sheet film emulsions will also benefit in extreme contrast conditions by a two-bath development. The effect is the same as with extremely dilute development. This is a trial and error process, requiring a calibration for each film and developer. Professionally acquired rule-of-thumb indicates that the developing time for an N— — condition is as follows:

1. Immerse the sheet of film in standard-strength developer for 15-20 seconds with constant agitation. Best way to agitate without streaking is to lay the film in the developer face down, lift and replace it face up, lift and lay it face down, etc., for the 20 second time. This will wet the film, break the liquid surface tension, rewet—all without directional flow.
2. Without draining, slide the film face up into a tray of plain water at the same temperature as the developer. Professional, mylar based films will not float; since no

agitation is desired, this is ideal. At the end of 2 minutes lift the film from the water and return it to the developer.
3. Agitate as before for 10-15 seconds. It is a great temptation to extend this time. Don't. You will only defeat your own intentions.
4. Repeat the water bath: immersion but no agitation.
5. Repeat the entire cycle until the **total time**—the sum of agitation and still development approximately equals your **normal development** time for this film/developer combination.

A third way to achieve contrast control especially with N— and N— — scenes is by using two-solution development. The first solution is a simple developer, containing only a reducing agent and a preservative. This is an inherently low-contrast developer, as you will discover by experimental work later in this chapter when you experimentally compound your own paper developers. The low contrast character of this developer is changed by the second bath, which is a weak alkali solution. This solution makes a more vigorous developer out of the solution carried over with the film itself. By using this new, stronger, but exceedingly dilute developer until it is fully exhausted (about three minutes), the silver in the shadow areas is fully developed, but the silver in the highlight areas—where density limitation is necessary—is hardly developed further because of the very quick exhaustion of the developer among those dense silver particles.

Two-solution Development for Contrast Control

Solution One:	Elon	2 grams
	Sodium Sulfite	15 grams
	Water	1 liter.
Solution Two:	Borax (Kodalk)	10 grams
	Water	1 liter.

The older literature describes a two-solution development for contrast control using D-23 and a Borax or Kodalk second solution. The contemporary thin emulsions do not react to this in the same way older thick emulsions did, and this procedure departs significantly from the older process. Instead of providing extreme compressions, the older process can in fact be used to provide vigorous expansions with medium and slow films. Development in D-23 followed by a three-minute Borax bath with constant agitation can produce three, four stop expansions with a total developing time of 12-15 minutes.

Using the dilute developer formed by Solution One, immerse a test roll and agitate normally for 30 seconds. Then once each minute provide a minimal agitation consisting of a slow inversion and equally slow righting of the developing tank. At the end of the test development time, lift the film from the tank and slide it gently into a second tank containing solution Two. **Do not agitate!** Let the film stand in Solution Two for three minutes, then drain and fix. Clear, wash and dry the film normally.

1. Develop the first test film exposed on the grey card target for 3 minutes. Lift and place in the Borax solution for 3 minutes, then fix.
2. Develop the second roll for 5 minutes, followed by a 3 minute soak in Borax with no agitation. Fix and wash and dry the film.
3. Develop the third test film for 8 minutes, followed by the Borax soak.

When you graph your information, you should have a set of curves that look approximately like this:

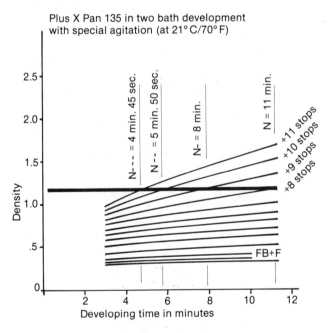

Figure 4-28: **Parametric showing a special two-bath development permitting severe compression development; non-standard agitation is used.**

From this set of parametrics you can now determine what, for you, would be the correct first-development times for the contrast situation you have encountered. Simply find the typical negative highlight density for your printing system, and find the points where that crosses the 9th, 10th and 11th-stop lines above film-base + fog. Or, in the Zone system notation, where the IX, X and XI Zones would be moved to a Zone VIII density by reducing the development of the highlights. Note how even with rather short developing times the

lower densities have remained rather fully developed.

If you are using sheet film it is very expensive to expose a full sheet of film for each density step. And it is not accurate to expose the film a bit at a time by withdrawing the dark slide, allowing the exposures to overlap. Silver emulsions have a peculiar property in that the larger silver grains tend to become desensitized during the first exposure, and subsequent equal exposures do not produce proportionate changes in density. The effect of this on testing film is that separate areas of film should be exposed for each density step. This is done automatically with roll film because fresh film is advanced for each test exposure. A simple tool for exposing sheet film can be made by cutting a piece of cardboard into a piece the same width, but about two inches longer than the darkslide for the filmholder:

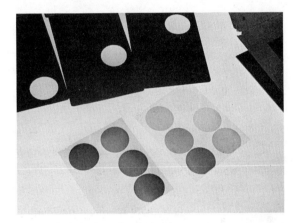

Figure 4-29: **Hard cardboard, or extra darkslides, make templates that permit six test exposures on a single sheet of cut-film, permitting complete system testing to be economical.**

These, with holes placed off axis as shown, will permit a single piece of film to be used for six density test exposures. An entire vertical line of a parametric testing can be accomplished with two sheets — an investment of six sheets for a complete investigation of a new film/developer combination.

A good graph paper to use for the parametrics is supplied in pads by K&E: Albanene Guide Line Prepared Tracing Paper No. 10-5645. It has a grid of inch-square lines divided into tenth of inch grids. The lines are printed in light blue. They are easy to see but do not dominate. Some graph papers have dark green lines; a graph drawn on this paper is difficult to read.

A set of homemade parametric curves are summations of the average forces working on the film: meter, shutter, light, temperature, film, emulsion, developer, agitation, and yourself, as operator of the system. One photographer's parametrics may

not exactly fit another photographer's working system. Note that even within the **Handbook** there are apparent inconsistencies. For example, normal developing time for Plux X Pan in the Standard Method Development is different from that found in the parametric curves. The Standard Method time includes an averaged contrast-reducing safety factor.

Figure 4-30 illustrates the three important areas of the typical parametric curve. Area **a** is to the left of the normal time line. Area **b** to the right and above Zone V. Area **c** is to the right and below Zone V.

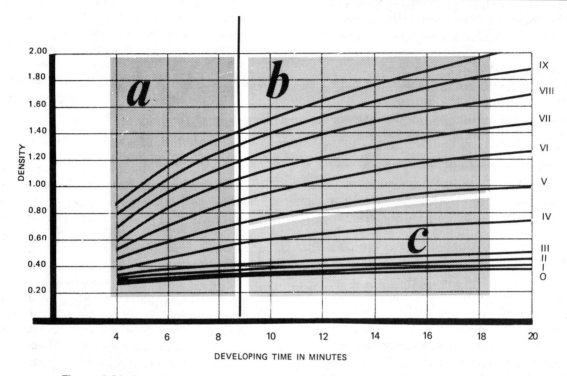

Figure 4-30: **A typical parametric curve set with the three principal areas marked.**

AREA A: TIME LESS THAN NORMAL DEVELOPMENT

The shape of the parametric curves to the left of the Normal time line tells how useful the film will be for compression development. Compare the curves in this area. Examples to study are for Plus X Pan 120 developed in HC-110 1:31 (Figure 4-44) and in Microdol X diluted 1:3 (Figure 4-45) illustrated in the sample graphs in this chapter. There are two criteria of importance: one is the slope of the line 1.20 and the Zone VIII line, the other is the absolute quantity of developing time that is below that intersection. If the developing time is already very short, as with the HC 110 time of 5 minutes, it is difficult to provide much more than one Zone of compression without getting into dangerously short developing times, where the results may not be repeatable. With the Microdol X, on the other hand, the normal time suggested by the graph is about 11 minutes, and one Zone of compression is about 9 minutes, and the second Zone would be (by extrapolation) about 7 minutes, which is still a comfortable time, with little chance for measurement error.

AREA B: TIME GREATER THAN NORMAL DEVELOPMENT
(ZONES V through VII)

Increasing development time increases density range. What the parametrics do not show are the other changes in the film, notably the increase in grain size and apparent loss of image sharpness (or acuity) as a result of processing effects on the silver in the emulsion.

All processing must eventually be evaluated in the print.

A 2½ times increase in development time is about the maximum that can be used with a medium-sized negative and still achieve smooth results (at four to five diameters enlargement). With a small negative even less development can be tolerated if an illusionistic rendering of smooth surfaces is desired. If the granularity of the film is desired as an aesthetic device, development can be extended even further.

A developer with little silver solvent will generally produce a more sharply granular image than one containing large quantities of sulfite or thiocyanate. Compare Plus X Pan in Rodinal and D-76 1:4 to verify this.

Examine the parametric curves for D-76 (Figure 4-36) Follow the 1.20 density line to the right from normal time. Note that at 20 minutes the Zone V line just intersects the 1.20 density line. It *is* possible to achieve two Zones expansion, but the parametric tells nothing about image granularity.

Study the Rodinal parametrics. On the Rodinal curve the same degree of expansion can be achieved in less development time. The preference for one developer over another ultimately depends on the quality of the resulting negative.

AREA C: TIMES GREATER THAN NORMAL DEVELOPMENT
(ZONES O through V)

The low Zones of the negative have little density even with extended development. This can be verified by examining the changes of the O, I, II, and even the Zone III density lines. The fact that the densities of the low Zones change little is of importance. Ansel Adams noted that the Zone System is predicated on this fact: increasing development time causes large increases in highlight density; increasing development time creates little more shadow density.

Highlight density control is achieved with ease; there is a direct relationship between development time and high Zone densities. Shadow separation control is more difficult; it is dependent both on the characteristics of a film and on the developer used.

Examine the parametrics for Tri X 120 in D76 1:1 and in HC-110 1:31. The Zone lines for O, I, II, and III are close together in the former; they remain essentially parallel throughout the usable range of developing time. The parametric curves predict that Zones below IV would be crushed together. If major areas of a picture require good separation of Zones II, III, and IV, then the negative exposure must be increased. Placing the subject one Zone higher (as can be seen on the parametric curves) results in separation of tones. Using a developer that produces more vigorous separations of low tones will also provide more definite rendering of shadow areas. This happens with HC-110.

Always verify the kind of silver image a film and developer combination produces by printing. Decide if it is useful aesthetically. The parametric curves permit anticipating controls and predicting tonal relationships for a developer and film.

SYSTEM INDEX DETERMINATION FROM THE PARAMETRIC CURVE

An accurate System Index for a new film and developer combination need not be determined by trial-and-error before making exposure and development tests for parametric curves. The tests incorporate Index information.

Make the exposure tests for the parametrics,

develop the film and plot the curves. Note the separation between what has been arbitrarily called the Zone O line and the Zone I line. If the System Index used was accurate, these two lines will have a density difference of 0.03 to 0.06. This is for 35-mm film. For a larger format film the difference will be 0.10 to 0.15. These densities are at Normal developing time.

If the space between the lines is greater than that, assume the System Index was numerically low and the film overexposed. The graph lines can be renamed. Zone I becomes Zone II, etc. If there is essentially no distance between lines, the System Index was too high. It should be lowered and the graph lines renamed. Zone II becomes Zone I, etc.

Advanced Printing Controls

Photographic silver print possibilities are being limited by the diminished types of printing papers available as the manufacturers steadily delete textures and colors and emulsions. In order to overcome these limitations, it becomes steadily more important for the photographic artist to take charge of all parts of the printmaking process.

Minimum development: It is useful to know the shortest time you can develop a properly exposed piece of paper to produce a "maximum black." Photographic paper responds the way film does to development. If time is increased the heavily exposed portions of the picture tend to darken proportionally more than light areas. Decreased developing time shortens the tonal range. There is a limiting condition: no matter how fully the print is exposed, maximum black areas cannot achieve full visual density with less than a certain amount of development.

a. Expose a quarter sheet of paper under the enlarger, set to make an 8 x 10 image, for 1 @ f11. Develop this, standard black patch for three minutes. Maintain the developer at a temperature between 70 and 75 degrees.
b. Cut a sheet of 8 x 10 inch normal contrast grade paper into quarters (American 2; Agfa 3). Expose under the enlarger as you did when making the Standard Black Patch.
c. Mark the pieces 10", 40", 60" and 90"; develop them for the length of time noted. Transfer them to the stop bath without draining.
d. Fix and dry these patches.
e. When the patches are dry compare them with a Standard Black Patch. The test with the shortest developing time that compares favorably with the Standard Black Parch is the Minimum Development Time. The next shorter developing time will definitely be more grey. Record this time.

Maximum development and Safelight testing: To produce a print with the longest possible grey

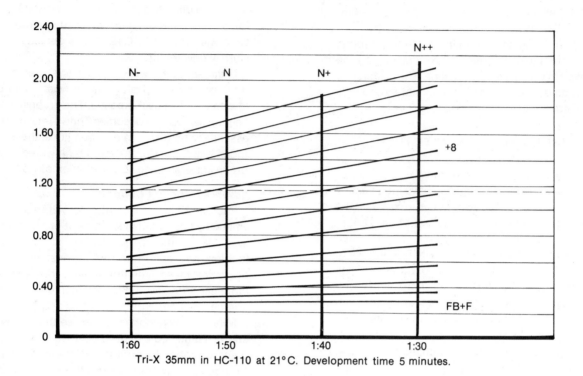

Tri-X 35mm in HC-110 at 21°C. Development time 5 minutes.

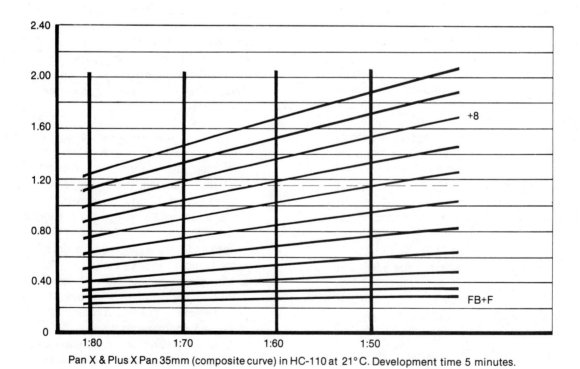

Pan X & Plus X Pan 35mm (composite curve) in HC-110 at 21°C. Development time 5 minutes.

Figure 4-31: **The effect of changing** *developer dilution instead of developing time* **as the base of control. All other parametrics shown in this section use changing time as the base.**

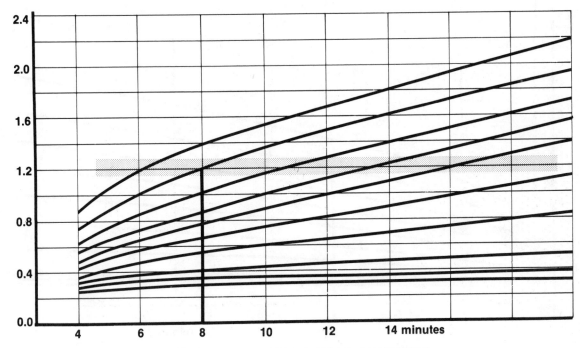

Figure 4-32: Tri-X 135 in D-76 1:1 at 70°F/21°C

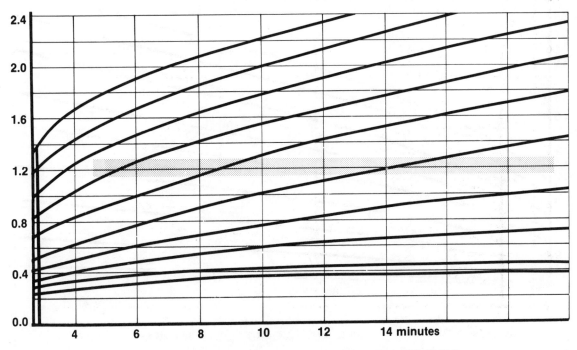

Figure 4-33: Plus-X Pan 135 in HC-110 1:31 at 70°F/21°C

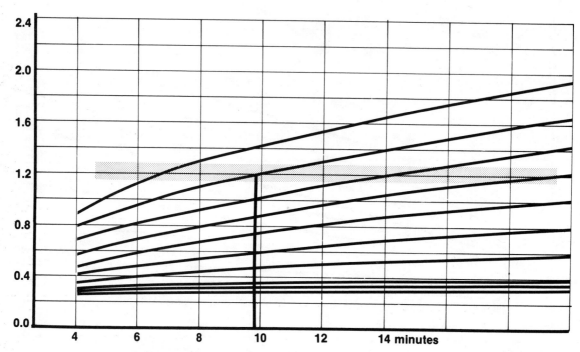

Figure 4-34: Plus-X Pan 135 in Rodinal 1:100 at 70° F/21° C

Figure 4-35: Tri-X 135 in HC-110 1:31 at 70° F/21° C

Figure 4-36: Plus-X Pan 135 in D-76 1:4 at 70°F/21°C

Figure 4-37: Panatomic-X 135 in D-76 1:1 at 70°F/21°C

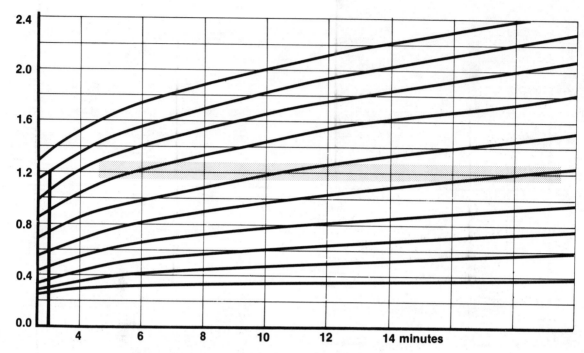

Figure 4-38: Panatomic-X 135 in HC-110 1:31 at 70° F/21° C

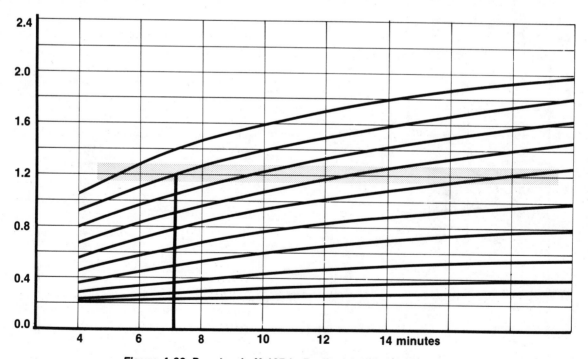

Figure 4-39: Panatomic-X 135 in Rodinal 1:100 at 70° F/21° C

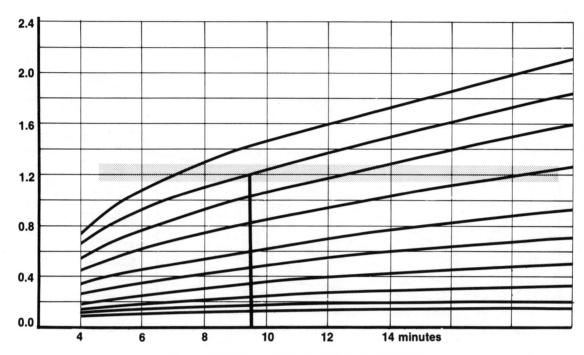

Figure 4-40: Tri-X 120 in D-76 1:1 at 70°F/21°C

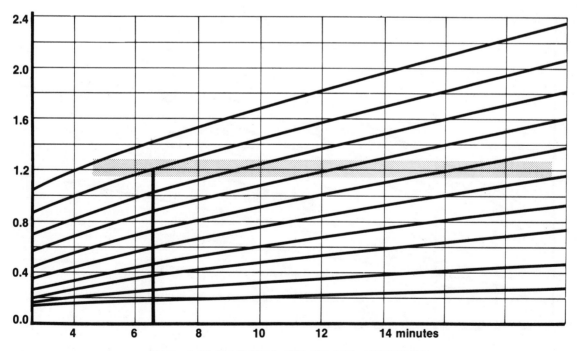

Figure 4-41: Tri-X 120 in HC-110 1:31 at 70°F/21°C

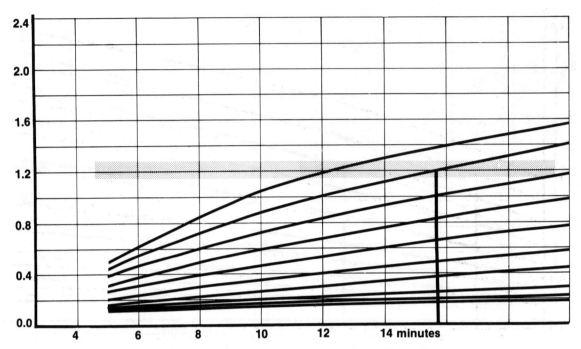

Figure 4-42: Tri X 120 in Microdol-X 1:3 at 75° F/24° C

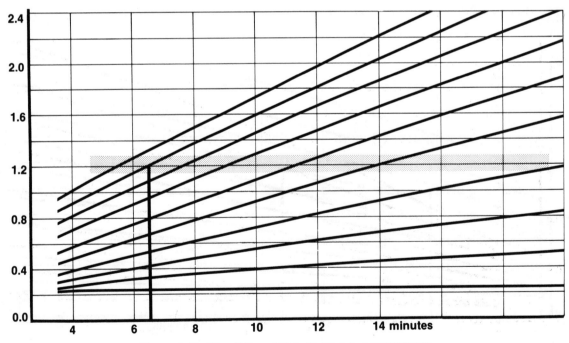

Figure 4-43: Plus-X Pan 120 in D-76 1:1 at 70° F/21° C

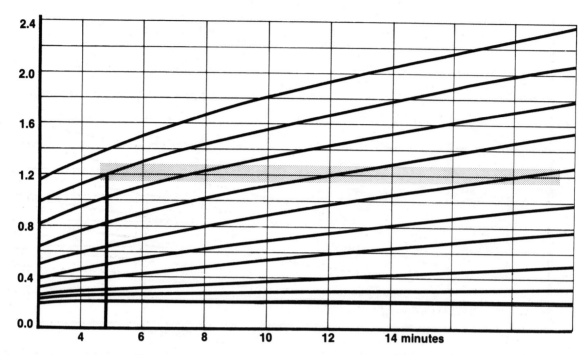

Figure 4-44: Plus-X Pan 120 in HC-110 1:31 at 70°F/21°C

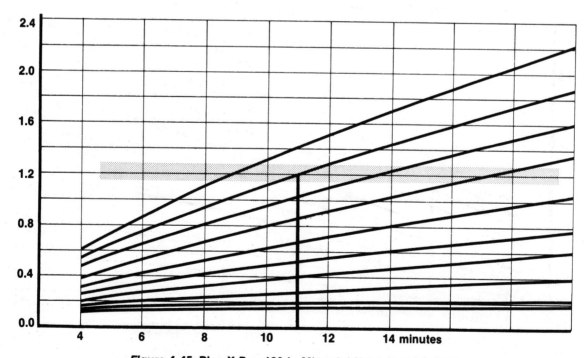

Figure 4-45: Plus-X Pan 120 in Microdol-X 1:3 at 75°F/24°C

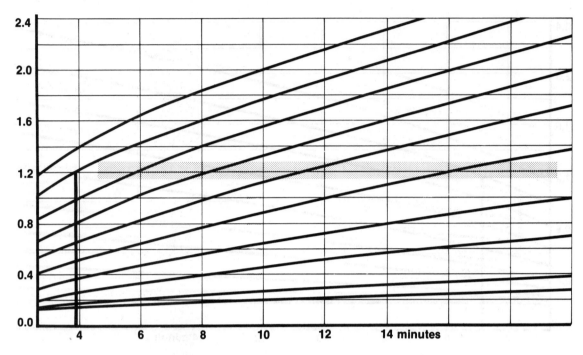

Figure 4-46: FP-4 120 HC-110 1:31 at 70° F/21° C

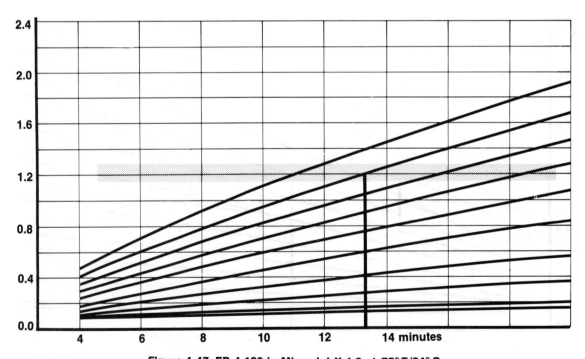

Figure 4-47: FP-4 120 in Microdol-X 1:3 at 75° F/24° C

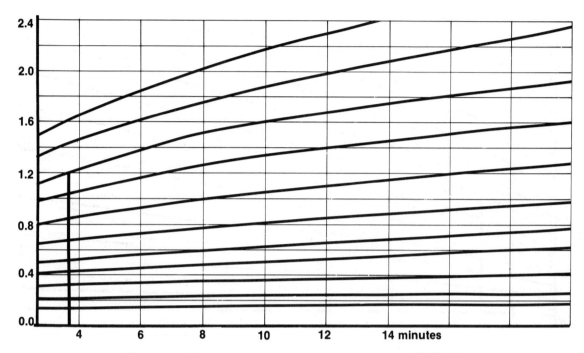

Figure 4-48: Tri-X Sheet (4"x5") in HC-110 1:32 at 70°F/21°C

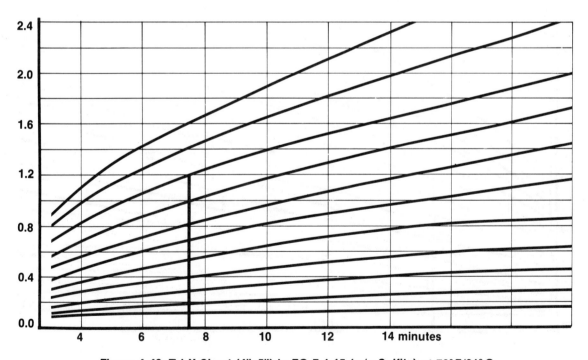

Figure 4-49: Tri-X Sheet (4"x5") in FG-7 1:15 (w/o Sulfite) at 70°F/21°C

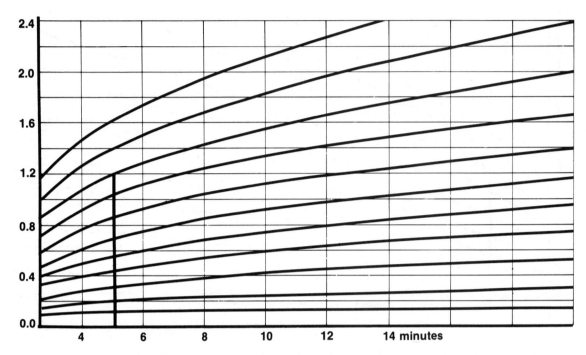

Figure 4-50: **Plus-X Pan Sheet (4"x5") in HC-110 1:32 at 70°F/21°C**

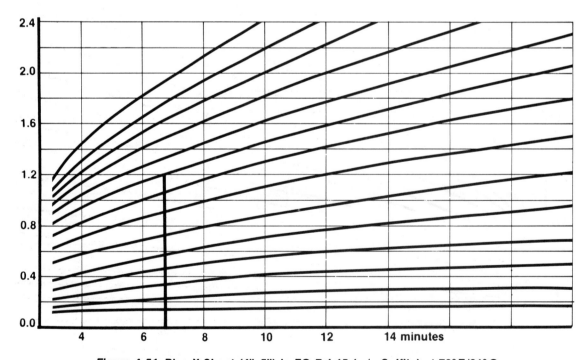

Figure 4-51: **Plus-X Sheet (4"x5") in FG-7 1:15 (w/o Sulfite) at 70°F/21°C**

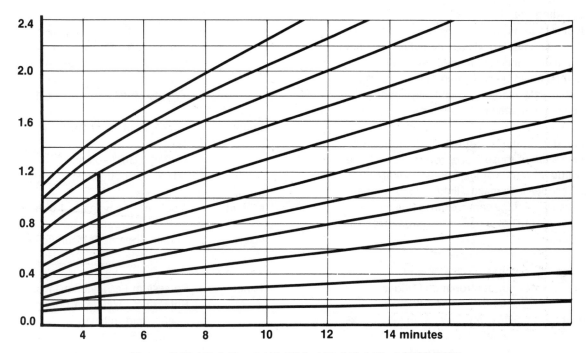

Figure 4-52: FP-4 Sheet (4"x5") in HC-110 1:32 at 70°F/21°C

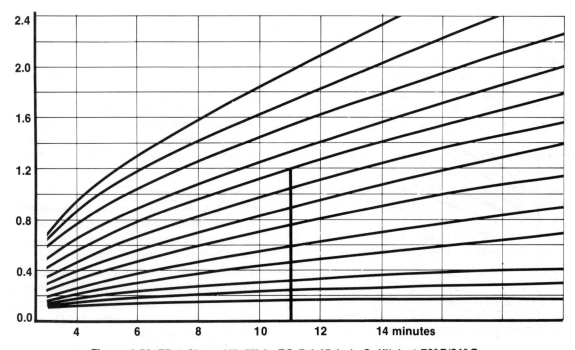

Figure 4-53: FP-4 Sheet (4"x5") in FG-7 1:15 (w/o Sulfite) at 70°F/21°C

scale it is necessary to push all materials and controls to useful limits. Increased development time changes the tonal range. Darks get darker without the pale grey tones darkening...to a point. Discover where this point occurs. How long can one develop a print, producing richer blacks but not degrading the highlights?

Reducing agents in developers will eventually reduce silver salts to visible densities whether exposed to light or not. Extended development will also do this. It can be prevented. Keep developing time within safe limits or chemically modify the developer by increasing the inhibitor.

a. Cut an 8 x 10 inch sheet of paper into fourths. Expose each of these pieces to produce a Zone VIII value. Try stops of 1, 2, 4, 8 seconds at f-22 or f-32. The idea is to make a light tone to compare with the white of the paper; expose four identical test patches but cover half of each with a piece of black paper.

b. Develop the patches for 2, 3, 5, and 7 minutes under your normal darkroom conditions.

c. Repeat the same test but develop in total darkness. This is a control set. Develop a fresh patch cut from paper never exposed to any light. This is the whitest white you can obtain from the paper you are using. The emulsion itself is grey and will never be as white as the paper that supports it.

d. Compare these patches when dry. Look for yellow stains, and dirty grey areas in the "white" paper. The longest developing time without color changes is the maximum developing time possible.

e. The maximum development time in which there is no difference between the lightest strip, covered or uncovered, from the first set is the maximum time in which your safelight is "safe," and the maximum development from the set processed in total darkness is the maximum safe developing time for all conditions, without modifying the developer.

Chemicals and scales are needed for many of the processes outlined from this point forward in the Handbook. Most photographic stores stock standard Kodak photographic chemicals. These are more expensive — because they are packaged in small quantities of a pound of less — than the same chemicals purchased through a chemical supply, but unless you are associated with a school or business, photostores and drugstores are often the only sources available.

Minimum quantities to purchase:

Reducing agents: Kodak Elon, 1 pound
Hydroquinone, 1 pound

Preservative: Kodak Sodium Sulfite, 5 pounds.

Accelerators: Kodak Sodium Carbonate, monohydrate, 1 pound
Kodak Kodalk Balanced Alkali, 1 pound
Twenty Mule Team Borax, 1 pound

Inhibitor: Kodak Potassium Bromide, 8 ounces.
DuPont "B-B" solution.
(or) Edwal "Orthothiazole"

Silver solvent: Sodium Thiocyanate, 4 ounces

Fixer: Kodak, Sodium Thiosulfate (Hypo), 5 pounds.

Toners: Potassium Ferricyanide, 1 pound
Potassium Oxalate, 1 pound
Acetic Acid (glacial), 1 liter
Sodium Sulfide (dessicated), 1 pound
Sodium Thiocyanate, 250 grams
Potassium Persulfate, 1 pound
Sodium Chloride, 1 pound
Silver Nitrate, 100 grams
Gold Chloride, 10 grams.

You will need a scale to measure these with. A student-grade triple-beam balance is best, but they are increasingly expensive. An inexpensive and useful balance for less than $20.00 is available from Balancing Act Scales, P.O. Box 26820, Tempe, Arizona 85282. Its capacity is 280 grams.

All chemicals react in some way with our body chemistry. Many are benign, some are hostile, a few are helpful. Most photographic chemicals are unfortunately to some degree hostile. The accelerators, being rather strong bases, dry and degrease the skin. The reducing agents, especially Elon (Metol) are frequently allergenic, and the allergic reaction tends to be cumulative. The acids dehydrate and eventually burn the skin. Do not handle **any** dry powder directly, always use plastic or paper scoops. Weigh chemicals onto quarter-sheets of thin dry paper, and throw these pieces away after being used once. When mixing chemicals, always wear glasses. If you do not need prescription lenses, buy a pair of clear safety glasses. If you should splash any chemicals into your eyes, turn the darkroom sink hose directly

Figure 4-54: (A) Weighing chemicals with a triple-beam balance. Use paper to protect the scale pen. *(B)* Weighing chemicals with the inexpensive *Balancing Act* scale.

onto your face and flush it with cold water at once. If you have any doubts about how a chemical will react with your skin, wear rubber gloves and avoid all contact. Be careful not to breathe chemical dusts, for they are often severe irritants even if not specifically dangerous.

A developer is a mixture of different chemicals that work in harmony to make visible the latent photographic image. Small changes of proportions produce different effects. The mixtures sold under proprietary names (for example, Dektol, LPD, Quicksilver) are stable and dependable. They store well in solution, remaining stable and useful for weeks, or months.

The basic components of developers are:

1. *Reducing agent.* The ingredient that causes the image to become visible. The exposed silver is reduced from a salt to a metal. Most contemporary developers use two reducers, with complementary characteristics. These are Elon or Metol (both are proprietary names) and Hydroquinone. Elon produces a low contrast image and can cause an overall fogging (greyness) with increased development. This is prevented by the addition of a restrainer or inhibitor. The color of the image is affected by the reducing agent. Elon produces a neutral black image.

Hydroquinone is a high contrast reducing agent. It is not as active as Elon and it does not work well at low temperatures. Below 60 degrees it does not work at all. At higher temperatures it is more effective, proportionately, than Elon. The image it produces is brownish-black. It decays rather quickly in solution, this decay being apparent as a brown discoloration and a loss of contrast in shadows.

2. *Preservative.* The primary purpose of the preservative is to remove free oxygen from the developing solution. Free oxygen destroys the reducing agent. The preservative also adds some alkalinity. Most reducing agents require an alkaline solution. The most commonly used preservative is Sodium Sulfite.

3. *Accelerator.* The reducing agent by itself is weak and must be activated by an accelerator. The accelerator is an alkaline chemical and Sodium Carbonate is most commonly used in film and paper developers. For very strong solutions this is sometimes supplemented with or replaced by Sodium Hydroxide.

4. *Restrainer.* The reducing agent eventually develops silver in the emulsion whether or not it has been exposed. Only by restraining its activity can an overall greyness be avoided. Restrainers actually prevent development but make controlled development possible, as auto brakes permit control of a car. Restrainers also change the color of the silver image. The most common restrainer is Potassium Bromide. Bromide makes the image greenish-black. Other restrainers produce different colors. DUPONT "B-B" solution preserves the blue-black tone of contemporary enlarging papers. KODAK Anti-Fog No. 1 is used in place of Bromide in some formulas and also preserves the original silver image color. Restrainers change the contrast of the image. Increasing the amount of the restrainer increases contrast.

5. *Solvent.* Chemicals are dissolved in a solvent so they may interact and can be carried into the emulsion of the film or paper. Water is the usual solvent and tap water is usually adequate. Distilled or de-ionized water is needed for some

special formulas. When water is mentioned in the **Handbook,** tap water is meant unless otherwise noted.

To introduce yourself to the component parts of the developer, try the following experiment. Remember as you work that all silver emulsions are similar; film and paper emulsions differ in sensitivity to various colors of light, and in graininess, but otherwise are the same. Film emulsions are coated on a transparent support, and paper emulsions are usually coated on opaque supports. But otherwise they react much the same to developers used to make the image visible. So whatever you discover while making these tests of paper developers will apply to the negative as well. The real difference between film and paper developers is in strength: film developers are much weaker because usually films are developed so as to use only a little of the silver.

Select a negative that prints easily and well, and has rich detail in both the highlights and shadow areas. Don't select a high-contrast, purely graphic image that will defeat the purpose of this investigation.

Using your regular developer and developing procedure, find the correct exposure needed to make a good print. Develop, stop, fix, and store this print in a tray of water.

After you have verified that your test print has proper detail in both the highlights and the shadows, expose four identical prints on 8 x 10 paper. Then cut the exposed but undeveloped prints in half, and store them safely in a photographic paper box, so they won't be exposed to excessive safelight while you prepare the rest of the experiment.

1: Now set out two clean trays. In each of them put two liters of water at 22-24 degrees C.

2:	*In the left tray*	*In the right tray*
	stir in one tablespoon Sodium Sulfite	stir in one teaspoon Elon
	stir in one tablespoon Hydroquinone	stir in one tablespoon Sodium Sulfite
3.	develop one-half a print marked 1L develop for at least three minutes	develop the other half, marked 1R develop from two to three minutes
4.	stir in a tablespoon of Sodium Carbonate	stir in a teaspoon of Sodium Carbonate
5.	develop one-half print 2L for three minutes	develop one-half print 2R two to three minutes
6.	stir in ⅛ teaspoon of Potassium Bromide	stir in ⅛ teaspoon of Potassium Bromide
7.	develop one-half print 3L for three minutes	develop one-half print 3R for three minutes

8. combine the two trays and stir the solution a few seconds. Develop one of the last half sheets for three minutes, and one for five minutes.

When each of the prints is developed it should be stopped, fixed and placed in a water storage tray. When all of them have been fixed, neutralize them together in Hypo Clearing Solution, Perma Wash or another hypo eliminating solution and give them a final wash. Dry them, and study them.

The Hydroquinone * requires much more Carbonate to become effective. In fact, as you see, the Elon and Sulfite alone are an effective, though low contrast developer. The Hydroquinone also takes longer to produce a final image. The Bromide has more effect on Hydroquinone than on Elon, suppressing its activity more. Yet, if the amount of Hydroquinone were to be increased, or if the developing time were to be lengthened, the effect of increasing the Bromide would be to increase the contrast, because as you will see from your prints the shadow areas of the print were not suppressed by the Bromide, only the highlights.

Knowing what the component chemicals of the developer do permits you to more intelligently evaluate the results of any developer, and if necessary to make experimental modifications to produce a special result. Changing the balance of components will also change the image color to some extent. Increasing hydroquinone *will* increase contrast. It will also cause the image to become subtly more greenish-brown. This may be undesirable or not, depending on your taste.

Contemporary developers use the reducing agents described, plus a more recently discovered chemical sold under the trade name of Phenidone. It resembles Elon but can be used in much lower concentrations, and can act as a weak, moderately active or very energetic reducing agent. It is of importance because it is used in the liquid concentrate developing stocks sold by Kodak, Sprint and others, and it stores well in liquid form. It is also non-allergenic, and so becomes a useful replacement for Elon.

Other reducing agents are also used. Amidol is a trade name for a vigorous reducing agent which has somewhat mystical overtones for the followers of Edward Weston. Ansel Adams feels it is too heavy for contemporary printing. It has a very high reduction potential, which is a measure of the chemical pressure existing between the reducing agent and the bond between the silver and the bromine ion. Hydroquinone has the lowest, having a reduction potential of 1. Amidol is the highest with a reduction potential of 32. It is also sold as 2, 4, Diaminophenol Dihydrochloride. It is unique

*The Hydroquinone interacts synergetically with the Elon when they are combined in solution, making it more effective than it can ever be by itself.

among the reducing agents in that it works well without a strong base, in fact it will keep best in solution when buffered with a small amount of citric acid (available in drugstores).

Glycin is also listed as Para-hydroxyphenyl amino acetic acid, and is used in warm tone developers and in special formulae requiring long developing times. It changes color immediately after being mixed, and looks like it is exhausted (a dark tan to brown) within a day, but stores well in solution.

Film developers may use some other reducing agents, combining Hydroquinone with Elon or Phenidone, or use p-aminophenol by itself. This chemical, used in Rodinal, works in very great dilutions of 1:100 to produce high acutance negatives. Other reducing agents available, though not commonly used, for special film developer formulae are Pyrogallic Acid, the oldest developing agent known to photography, and Pyrocatechin, a more recent organic chemical that produces a negative similar to one made by "Pyro," where the image is both reduced silver and a color, or stain, in the gelatin. The stain image is very fine grain, but is difficult to measure and to quantify by traditional methods, and so has not been reinvestigated recently.

The tables below offer comparisons of several popular paper developers, two of the most popular film developers, and complete instructions for using Dr. Beers' two-stock paper developer that is probably still the best overall developer formula available for contrast control, and for clear, neutral colors in the middle greys.

Paper Developer Formulae[1]

(mix all but Amidol in 3 liters of water, then add water to make 4 liters)

Chemical	Developer				
	D-72[2]	54D[3]	Agfa 115[4]	Agfa 105[5]	Amidol[6]
Elon (Metol)	12.4	10.8	---	4	---
Sodium Sulfite[7]	180.0	160.0	340	52	29.0
Amidol	---	---	---	--	8.8
Glycin	---	---	116	--	---
Hydroquinone	48.0	42.4	32		---
Sodium Carbonate[8]	320.0	352.0	568	120	---
Potassium Bromide[9]	76ml	32m	32	4 ml	6ml
BB Stock[10]	---	---	---	--	60ml

Notes: NB: all weights are in grams.

[1]Formulae are from Morgan and Morgan, **Photo Lab Index** various editions from 1941 to present. Note that formulae disappear, and are not to be located in later editions, not only in the **Index,** but in most reference sources.

[2]D-72 is a generic name for **Dektol.**

[3]54-D is a cold-tone developer formula, formerly made by DuPont.

[4]Agfa 115 is a warm-tone developer. Glycin is available from Dignan Photographic, Inc., 12304 Erwin St., Hollywood, California, 91606. Normal dilution is 1:3; dilutions up to 1:6 (with 3-4X normal print exposure and development of 5+ minutes) produces very warm tones with excellent separation.

[5]This formula produces tones much like the old Metinol U, formerly distributed by Agfa. Use full strength.

[6]This formula is for 1 liter only, and must be mixed as it is used; decay time is about 1 hour.

[7]Sodium Sulfite is dessicated, which is the same as anhydrous.

[8]Sodium Carbonate is monohydrated, which is the form in which Kodak offers it through camera stores.

[9]This is a 10% solution. To make a 10% solution is easy with the metric system: weigh out 10 grams of solid, dissolve it in about 80 ml of water, then add water to make 100 ml.

[10]"BB Compound" is a proprietary DuPont chemical. If it is not available, add increased amounts of Potassium Bromide stock until the whites are clear. Amidol is a very powerful reducing agent, and will produce a slight chemical fog on contemporty papers unless proper amounts of inhibitor are used. Don't confuse density with strength, when printing.

Beers Developer Formulae

(mix all chemicals in 3 liters of water, then add water to make 4 liters)

Chemical	Stock Sol. A	Stock Sol. B
Elon (Metol)	32	---
Sodium Sulfite[1]	92	92
Hydroquinone	--	32
Sodium Carbonate[2]	94	126
Potassium Bromide[3]	44ml	88ml

Notes: NB: all weights are in grams.
 [1]Sodium Sulfite is dessicated or anhydrous
 [2]Sodium Carbonate is monohydrated.
 [3]Potassium Bromide is in a 10% solution.

These stock solutions are mixed in different ratios and diluted with water to make a working solution for contrast control. The range of control is about one full paper grade, from Low to High.

Contrast Control Dilutions for Beers Developer

	Low	2	3	Med.	5	6	High
"A"	500	435	372	310	250	190	128ml
"B"	0	65	128	190	250	310	872ml
water	500	500	500	500	500	500	0ml

NB: the "B" or Hydroquinone stock decays more

rapidly than the "A" or Elon solution. It will keep best in a collapsible container, e.g., a reused "cubi-tainer."

If one makes a study of the various fomulae that have been published, small differences in quantities of chemicals may be noted in what should be the same formula, published in various publications at different times. For example, variations over thirty years in the D-19 formula are: Elon, 8-8.8 grams; Sulfite, 360-400 grams; Hydroquinone, 32-34.4 grams; Carbonate, 188-220 grams. The effects of these changes are minimal if the proportions are kept the same, one formula to the next. The most noticeable effect would be in the time needed to produce a certain density of silver for a given exposure. What is important here is to begin to realize the quantities and proportions used for different solutions, and the way these interact.

Film Developer Formulae

Chemical	D-23[1]	D-25[2]	D-76[3]	D-19[4]
Elon (Metol)	30	30	8	8
Sodium Sulfite	400	400	400	360
Hydroquinone	---	---	20	32
Sodium Carbonate	---	---	---	220
Borax	---	---	9	---
Sodium Bilsulfite	---	60	---	---
Potassium Bromide				20 g

Notes: NB: all weights are in grams. Dissolve all chemicals in three liters of water, then add water to make four liters.

[1]D-23 is a low contrast developer suitable for general scenes, or two-bath control as described in the test.

[2]D-25 is a "fine grain" developer similar to D-23, which has come back into popularity with large format film users.

[3]D-76 is the most popular general purpose developer formula.

[4]D-19 is a high energy developer, used in this text for reversal processing.

Perception of visual density is often misleading because of the color which the silver grain seems to take on when processed in different developers, or with different papers which are of the same contrast grade but differ in emulsion or undercoating color. The simplest way to compare these, without regard for the content of the picture, is to make a step wedge out of "normally developed" film used for the parametric tests. Neatly assemble a row of strips cut from the first nine steps of the parametric series cutting away the perforated film. These strips will be about 1 x 1½ inches, and can be taped together along the edge with Scotch Magic Transparent Tape (3M Catalog 105), which has a low printing density. The film patches will provide exact comparison information without misleading the eye because of "what they are about."

Figure 4-55: Assemble your own step tablet of film produced during parametric testing; printing this carefully on different papers, or paper/developer combinations will then display their particular responses without emotional interactions with picture.

Make contact proofs on each of the kinds of paper you want to try, using the assembled step-wedge. There will be some trial and error here, because each new type and contrast grade of paper will have different sensitivity to the light. If the negative characteristic curve looks like this:

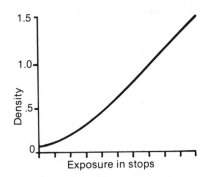

Figure 4-56: The characteristic curve of the negative.

then the print paper's characteristic curve is approximately a mirror image of it, and looks like this:

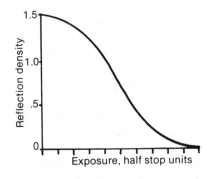

Figure 4-57: The characteristic curve of the print.



The effect of this on the print's appearance is that small variations in exposure, changes required by differing paper's sensitivities, mean significant changes in the appearance of the lightest details. The separation of detail and the overall sense of quality of the blacks is controlled by the inherent contrast of the emulsion itself, modified by the development chemistry and agitation.

The step-wedge you have assembled will make a stairstep approximation of the characteristic curve, that looks like this:

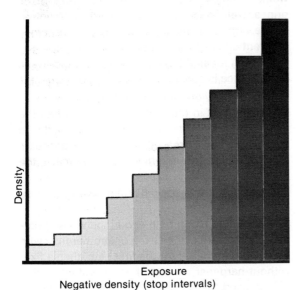

Figure 4-58: **The characteristic curve of the negative shown as steps of grey.**

Note that the separation of tones is changed by the kind of response the paper has to increasing exposure. It is **not** a straight line response, which means that there will be "distortions" of highlight and shadow detail, caused by the paper emulsion's response to light. No two papers, or paper/developer combinations are identical.

When you have made contact proofs which have identical highlights, from the step-wedge, dry and flatten them. Place them edge to edge in a comfortable place, with good light. Study them and see how color and density are affected by the chemistry and the emulsions. What should immediately be obvious is that "warm-toned" papers like Agfa Portriga Rapid which seem to have a greater visual density (richer black) actually are not more dense. In fact, what really happens is that the near-black densities are slightly more crushed together, because of the characteristic curve of that paper's emulsion, and the brownish color has an apparent opacity only as a function of the image itself.

When you have selected the papers you wish to work with, those that produce the best image color for your taste, the kind of tonal separation that you feel would work well with the pictures you are making, you might wish to investigate the effects of toning to modify the color of the silver print.

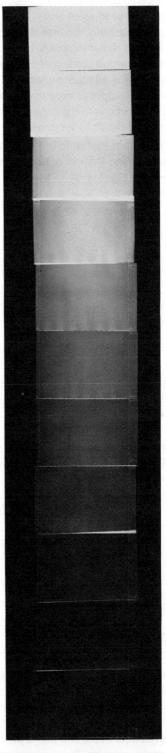

Figure 4-59: **The step wedge you assembled (see Figure 4-55) will make a print that looks about like this. Notice that those clearly separated tones seen on the negative, especially in the shadows, are crushed together by the curve of the paper.**

All the way through this text you have been using the hypo eliminating solutions more or less on faith. The following information should be noted with regard to fixing:

1. Overfixing is the best way to prevent thorough washing of the print. Sodium Thiosulfate (hypo) becomes harder to wash away.

2. Effective washing requires swift passage of water against fully exposed paper. Sluggish washers that permit contact of one sheet against the next prevent adequate washing.

3. As the fixer approaches exhaustion, and has more silver, it clings to the paper and is progressively more difficult to wash away.

A comparison of four different fixing and washing processes, and their effectivities, is shown in the following table:

Washing Methods[3]
Following Fixing[1]

Wash Time in Minutes	I	II	III	IV
3	Note 2	4+	3+	3+
6	6+	3+	3+	3+
10	4+	3+	2+	1+
25	3+	2+	2+	1+

The numbers under the Methods are the residual hypo in the washed prints, measured in mg/cm^2

Notes:

[1]This information derived from a paper prepared by Dr. Stuart W. Fenton, Chairman of Chemistry, University of Minnesota.

[2]Untreated paper washed for 6 minutes had hypo too large in quantity to be measured.

[3]The methods are

I: no post-fixing treatment, plain wash.

II: Kodak Hypo Clearing Solution used as directed.

III: Orbit Bath working solution used after hypo.

IV: Orbit Bath incorporated into the hypo (120ml/4 liters)

The Orbit Bath + hypo mixture is stable. If no toning is anticipated, this is the best solution for minimum washing and maximum permanence, since the contemporary archival standard is 1.0 mg/cm^2 of residual hypo, and this is achieved after ten minutes of washing. Both economic and ecological demands are met.

Toners can be used to modify the color of the image for intensification, for other aesthetic reasons, or to make the inherently unstable silver image more permanent. Selenium metal is popular

for this and can be chemically deposited on the silver either for intensification, or for a color change.

Toning for intensification and for greater permanence is commonly done by using Hypo Clearing Solution or Perma Wash as a buffering agent. This permits the toning to be done immediately after the fixing is completed. Earlier processes required the print to be thoroughly fixed, completely washed, and then ph-neutralized in a weak borax solution before toning, or the selenium would be precipitated out on the white areas of the print as well, causing what was called "split toning" — the high and low tones of the print assumed different colors as a result of toning.

If toning for slight intensification and increased permanence is desired, the following procedure is widely recommended.

1. Fix the print in the first fixing bath for half the total fixing time. At no time should fixing baths be over-used; the increased silver waste products make removal more difficult and increase the chance of staining.

2. Wash the prints for 5-10 minutes in running water.

3. The second fixing bath should be without hardener. If you are using NH-4, or another fixer with an integral hardener for the first bath, then a fixer without hardener, or plain hypo + water solution can be used for the second fix. This is not stable and must be used once, then dumped. Mix 1 kg of hypo in 4 liters of 25 degree C water. It will cool as it is dissolved, as sodium thiosulfate has a negative heat solution. Fix prints 5-7 minutes, with constant interleaving.

4. Without rinsing, transfer the prints to the toning bath. A useful way to do this is to lay a clean tray upside down between the second fixing bath and the toning tray. Lift all the prints to be toned from the fixer, and place them on the overturned tray; this acts as a drainboard. Lift them one at a time and place them face up, at regular intervals, into the toner. As soon as all the prints to be toned are in place, interleave them bottom to top in a steady rhythm.

The composition of the toning solution will vary with papers and contrast, but basically it is this:

Selenium Toner for Permanence

Water (24-26° C)	3 liters
Rapid Selenium Toner	200ml (you may need more)
Hypo Clearing Solution	800ml
(or) Perma Wash	90ml
Water to make	4 liters.

The image will change color slightly after five or six minutes. The color change is an enriching of the

blacks, and a shift toward a purple. It is not a radical change of color; the change in intensity is apparent in a sudden "deepening" of the blacks and near-blacks.

5. Wash the prints immediately in cold running water. Water above 20°C will almost completely remove the selenium tone. Wash for 3-5 minutes and then return the prints to either

Hypo Clearing Solution (or)

Perma Wash (working strength)

for the recommended time suggested by the manufacturer for unwashed prints. An alternative solution is to move the print from the post-toning wash to a Kodak HE-1 bath:

Kodak HE-1 Hypo Eliminating Solution

(mix in 3 liters of water, then add water to make 4 liters)

3% Hydrogen Peroxide solution	500ml
3% Ammonia solution	400ml

Interleave prints for 5-6 minutes, then wash for 30 minutes.

If there are problems with staining, these can usually be traced to acidic water supplies. The addition of 50-150ml of a 3% ammonia solution to the toner + clearing agent will eliminate this problem.

Gold may also be used as a protective coating for the silver. Gold chloride toning can also change the color radically, producing a red-purple that may or may not be displeasing; it is close to the characteristic color of photographs from the end of the century.

The gold chloride toner is inherently more expensive than the selenium toner, but the cost may be minimized if prints are fixed, washed, dried, and stored for a reasonably short time until there are enough to justify toning all at once. The Kodak Gold Protective Solution GP-1 has a useful life of six or seven 8 x 10 prints per quart.

Kodak Gold Protective Solution, GP-1

(mix in 750 ml distilled water, then add more to make 1 liter.)

Gold Chloride, 1% stock	10ml
Sodium Thiocyanate	10 g

NB: make a 1% stock of gold chloride by dissolving the contents of a one-gram tube in 100ml distilled water. Add the stock to the water as noted. Dissolve the sodium thiocyanate in 150ml of distilled water separately, then stir it into the gold chloride solution. Use at once.

Kodak no longer sells gold chloride, but it can be purchased from several professional sources. One of these is D. F. Goldsmith Chemical and Metal Corp., 909 Pitner Avenue, Evanston, Illinois 60202.

The prints must have been properly fixed and

neutralized and washed. They may have been selenium toned, or not, as you desire. The gold toning for preservation will take about 10 minutes; the change in color is slight.

Other color changes may be effected for aesthetic reasons that have nothing to do with longevity. Kodak Brown Toner, for example, is a single-bath, proprietary solution that produces a brown color image in a completely fixed and washed print. It can be combined with a mild selenium tone to produce both a color change and an image intensification. The toner works very rapidly; start with a dry print, immerse it and agitate constantly for 15-20 seconds, then transfer to selenium toner + water (in a 5-7% strength) to complete the toning.

Recent attitudes toward toning have changed and toning has gained in interest. One of the standard toners is the sulfide redevelopment process, which produces a sepia color.

The neutral black silver image is changed to a white silver salt. Then that salt is redeveloped in sodium sulfide, producing a brownish, sepia colored print.

The chemical logic is that silver combines with ferricyanide to form silver ferrocyanide. This new chemical is not soluble in water; however, it *is* quite soluble in a hypo solution. Failures in sepia toning usually result, therefore, when the print is improperly washed, and has residual hypo. When the hypo-rich print is immersed in the first bath, the silver combines with the ferricyanide, and then simply washes away. To avoid this, Perma Wash, Hypo Clearing Solution or Orbit Bath must be used, followed by a suitable wash.

Kodak Sulfide Sepia Toner (T-7a)

Solution A:

Potassium Ferricyanide	75 g
Potassium Bromide	75 g
Potassium Oxalate	195 g
Acetic Acid (28%)[1]	40 ml
Water (distilled)	2 liters

Solution B:

Sodium Sulfide, dessicated	45 g
Water	500 ml

These stock solutions are then diluted for use. Stock A is diluted 1:1. Stock B is diluted 1:8 (e.g. 125 ml to a liter).

Immerse the print in solution A. The silver will combine with the iron salt and the bromide, which will create a new image of silver bromide. Since

[1]Acetic acid is sold as "glacial," meaning it will freeze at about 16°C when it is 99% pure. To dilute this to 28%, dilute glacial 1:3 with water.

this is a white chemical compound it will be almost invisible against the paper base, and so the image is said to "bleach." When this is complete, in about one minute, rinse the print thoroughly and immediately with running cold water. Then place it in the sulfide redeveloper, or toner, which will complete its action in about a minute. Wash the print at once in fresh running water, then refix in a hardening fixing bath, neutralize, and give it a final standard wash before drying.

There is some confusion between gold toning for preservation and gold toning to produce a large color change, to produce a print approximating the nineteenth century print. The Kodak Gold Toner T-21 is suitable for this:

Kodak Gold Toner (Nelson) T-21

Solution A:

Water at 50 C	4 liters
Sodium Thiosulfate	960 g
Potassium Persulfate	120 g

Mix the hypo before adding the persulfate. Stir in the persulfate vigorously. The hypo will cool the stock as it dissolves, and though this mixture should be milky, it may not, so warm it until it is. Then allow it to cool.

Water at 18-20° C	64 ml
Silver Nitrate	5 g
Sodium Chloride	5 g

Dissolve the silver nitrate completely. Use rubber gloves and do not allow the silver nitrate to touch the skin. Do not use commercial salt, which frequently has sugar added.

When the Thiosulfate mixture is cool, slowly stir the second solution into the first.

Solution B:

Water (distilled)	250 ml
Gold Chloride	1 g

When you are ready to tone, add half (125 ml) of the gold chloride stock to the entire "A" stock. Stir rapidly while adding these together.
To use, pour off the clear liquid, allowing the sediment to remain. Heat the toner to about 40 C. Presoak dry prints in fresh water. Tone them until the desired color is reached (5-25 minutes), then refix, neutralize, and give them a final wash.

Finishing, storing, and displaying prints requires special skills and tools. The silver print is fragile, the emulsion cracks and scratches easily, and the color of the image will change with the presence of sulfur, either from the air or from the supporting cardboard and the interleaving paper.

Yet finishing steps are needed because it is hard to come to a completed relationship with a print until it is somehow isolated, set aside — whether in a book, in a frame on the wall, or perhaps merely pinned to a study panel. The thinking eye is so sensitive to different directions that the physical meaning of a print changes between looking down at it, lying on a table or in the tray, to looking out at it, hung from or pinned to a wall.

As soon as the print is dry it should be removed from the drying rack and stored under moderate pressure. This will permit the fibers of the paper to set in a smooth sheet, without ripples, making it easier to examine, and complete. Some people prefer to spot prints before they are mounted or matted, others prefer to wait.

When the print has been flattened, store it temporarily in the paper boxes from which the paper came. These should be kept away from heat and dampness. Then, when one is sure the print is worth the investment, you may wish to mount it, or both mount and overmat it for additional protection.

Seal Dry Mount Tissue is a thin paper with a fusible material coated on both sides. This chemical melts at a temperature of 255 F, which is marked on the heat controls of most dry mounting presses. The mounting tissue should be adhered to the back of the untrimmed print with a "tacking iron," a small, thermostatically controlled electrically heated tool.

Because of the way the tissue melts, it is best to attach the tissue with a light pressure, near the center. Then the print + tissue can be trimmed together, either with a straightedge and sharp mat knife, or with a paper cutter. The cutters with a roller-blade do this kind of cutting better than do those with a knife-blade. The latter tends to pull the tissue away from the paper, leaving a thin edge of tissue irregularly exposed.

The print may be mounted onto a support. A heavy cardboard is most frequently used, but it is not the only nor even the best support. A print may be mounted back-to-back with another, unsuccessful, print. The sandwich that results is quite stiff, and the print is held smooth and flat. The print may be mounted onto a thin sheet of acid-free paper, like Hollinger Corporation's Perma Life Bond. This will do the same thing as using an old print, with the advantage that the mounting paper can be larger than the print and provide a support for centering the print during a subsequent overmatting. The print might not be mounted at all, but simply be flattened and then held to the mat by means of a tape hinge, or corner-gripping tapes. This last obviously needs an overmat.

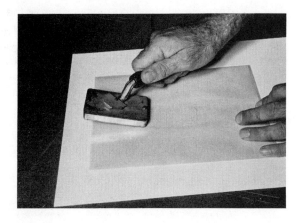

Figure 4-60: (A) "Tacking" irons come in various shapes and sizes. Here, a rectangular one is used to partially melt dry-mounting tissue onto the back of a print. Note the tissue is a little larger than the print. *(B)* The print is then turned face up on a clean cutting board and trimmed to size with a sharp blade and straight edge. *(C)* After being positioned on the mount board, a corner of the print is lifted and the mounting tissue fused to the supporting board. This is done on two adjacent corners. *(D)* The print is then placed in a 225° F dry mounting press, protected by a clean smooth cover sheet of acid-free paper; the press is closed for 20-30 seconds. *(E)* The mounted print is removed, placed face down, and cooled under pressure to ensure adhesion. Here, the hand is moved firmly and steadily over all areas of the print. A piece of heavy glass will also work.

The reason for all these methods is that the print needs to be held flat because of its smooth reflective surface, but it also needs to be protected from abrasion and from chemical contamination. The overmat protects the surface, but unless both it and the supporting mat are free from sulfuric acid the protection itself will eventually destroy the print. Acid-free mounting and matting board can be obtained in wholesale quantities from Andrew Nelson Whitehead Paper Company, in New York; retail quantities of precut sheets in differing grades of quality (all acid free) can be obtained from the Hollinger Corporation, Arlington, Virginia, and from Light Impressions Corporation, Rochester, New York.

The overmat should be cut first. Its outside dimension is controlled by the print size, and by the purpose to which the picture is being put. Standard size frames and boards are often available at a discount, and this may determine the size. For example, 8 x 10, 11 x 14, 14 x 17, 14 x 18 and 16 x 20 inch sizes are stock items from Light Impressions, both in mats and frames. The opening size is obviously controlled by the photograph. The placement of the opening on the overmat is determined by your sense of taste. The opening may be

smaller than the picture, or may reveal the entire picture + a small relief of white paper.

The opening is carefully and lightly drawn in pencil on the back side of the mat. A tapered blade, held in a device called a mat-cutter, is then used to slide out the window, following the pattern. The Dexter Mat Cutter is the least expensive machine for this.

Figure 4-61: **The Dexter Mat Cutter is an inexpensive, hand-held mat cutting tool.**

The blade is set to extend below the mat cutter slightly more than the thickness of the board to be cut. The blade is slid into position on the penciled line, at the start of one side. Cutting should be done on top of another board of the same type. The cutter is braced against a metal straight edge, because the cutting pressure is both down and to one side, and the cut is made.

Figure 4-62: **The Dexter Mat Cutter is adjusted with blade extended to slightly more than the thickness of the mat board to be cut, as shown.**

The cut extends about ⅛ of an inch beyond the corners at both ends of each side. This permits the beveled cuts to overlap, producing a clean release when the cuts are complete. If this isn't done, the corners will break, leaving clumps of paper fibers that must be tediously trimmed and sanded. Over-cutting will leave scars on the mat.

The simplest finishing procedure, after the over-mat is cut, is to join the overmat to a support by

means of a gummed tape hinge, located across the top. Although students frequently do use pressure sensitive tape because it is easier, and always available, it is a dangerous habit, even for work prints. The adhesive is rich in sulfur, and will discolor both the print and the mat; it will also fail as a bond within a year or two.

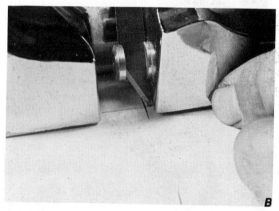

Figure 4-63: **(A) The desired opening of the window mat is drawn on the back of the cardboard. (B) The blade of the Dexter Matt Cutter is inserted just before the start of the cut. The cardboard must be supported on two pieces of masonite or other firm material, leaving a groove where the blade will travel. (C) A straight-edge is positioned as a guide for the Cutter. The Cutter is then pushed along the straight-edge until the blade slightly overtravels the other end of the opening.**

Locate the unmounted print on the backing board, under the window in the overmat. It is best to wear cotton editing gloves for this, as grease from fingers may mar the print. Hold the print down and move it gently until it is in correct position. Place a smooth weight on the print so it cannot shift, then open the window mat. Mark the print's top edge with a light pencil line, just for a check. Take a 1-inch strip of acid-free linen tape (available from Light Impressions), fold it lengthwise so the adhesive side is out. Moisten it, and slip it between the print and the mat, along the top edge, so the print is now hinged to the mat. Press the print-tape-mat junction until it is dry and adhered.

An alternate method is to place the print under the window in the correct position, hold it in place, and then with the overmat tipped away, affix the print to the backing board with small diagonal strips of linen tape that just capture the corners:

Figure 4-64: The finished window-mat is hinged to the undermat with linen tape. The picture is now protected against casual abrasion.

And a third system is to dry mount the print onto a large sheet of acid-free paper, such as Hollinger's PermaLife Bond paper, which comes in sheets as large as 24 x 28 inches. The print can be placed on the center of an oversized sheet; this is located under the window on the overmat, the edges marked and the paper trimmed to size. This system offers a floating print, stiffened by the addition of the dry mounting tissue and the bond paper, yet thin enough to be trimmed out and remounted in one of the conventional systems described above if need arises.

The print can be protected further during storage by covering it, under the window mat, with a sheet of acid-free interleaving tissue. Individual, unmounted prints may be protected for long periods of time by storing several together in acid-free envelopes made of PermaLife paper, which are made in 8½ x 10½ inch and 11½ x 14½ inch sizes. These have flaps to seal out dirt as well.

Mounted or unmounted prints should be protected during long term storage from dirt and chemical damage in an archival storage box. This is simply a heavy-duty cardboard container made of materials that have been buffered to a ph of 8.5, i.e. with enough excess basic material that many years will pass before they become acidic and begin to affect the silver images on either negatives or prints.

Figure 4-65: (A) Alternatives to dry mounting are holding the print with corner tabs; (B) Or, hinging the print to the undermat with linen tape; (C) So that it is free of both mats if need arises to remat.

Figure 4-66: **Frame sections, showing how the picture is protected on all sides.**

The finished prints may be displayed to advantage in metal frames. These have largely displaced wooden frames because of their flexibility, and comparatively low cost. If you are uncertain about a picture, and wish to examine it as though it were finished, it is easy to assemble a metal frame with screw-type clamps, slip a print in, held to a backing board by pressure alone, and observe it as a finished production — without ever having to mount or mat it. This is fine for short-term study. For long times the gelatin or resin print surface should never be allowed to press directly against the glass of a frame; with humidity and temperature cycles there will inevitably be adhesion.

Life Expectancy of RC Papers

The resin coated photographic papers present special problems to the photographer concerned with archival storage. They are much more sensitive to the effects of ultra-violet light, humidity and temperature variations as revealed in the detail photograph. Comparison prints were made from the same negative on a gelatin-based print material and on RC Glossy surface. Both prints were then exposed to normal daylight in a sheltered place, unprotected by glass. After 50 days the plastic surface of the resin coated print failed dramatically and suddenly. The traditional gelatin emulsion was essentially unaffected.

Figure 4-67: **Detail of suddenly deteriorated RC paper. Line is equivalent in length to 1" on original.**

CHAPTER FIVE
Special Processes

Special Processes for Photo-printmaking

During the last dozen years the photographic processes have moved into printmaking arts and in return many attitudes toward the print that are common among printmakers have been accepted into photographic arts. The result is a hybridization of lithography, etching, silkscreen and photography. This chapter is intended for both the photographer seeking to make prints more substantial and tactile than the pure silver process permits, and the printmaker desiring to utilize the image-making processes of photography.

The films discussed earlier are all "continuous tone" emulsions designed to reproduce the reflective values of objects seen by the camera more or less naturalistically. Many photo-printmaking processes require emulsions which are much higher in contrast, and which simplify the long-scale values of the world to either the presence or the absence of light, to white or black. The characteristic curve of these emulsions (compared to a conventional emulsion) looks like this:

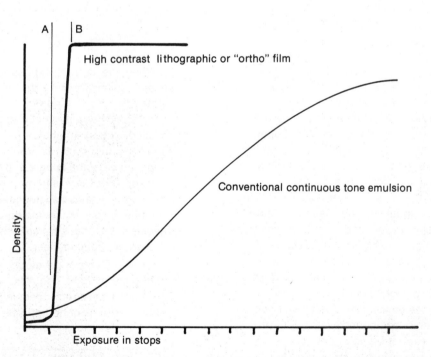

Figure 5-1: Comparison of characteristic curves: conventional film and very-high-contrast ("ortho" or "litho") film.

These very high contrast films are referred to as **process** or **ortho** films. The first is more accurate, referring to their use in reproduction process photography, but the latter term has overcome, and it refers to the photosensitivity of these emulsions. They are (with the exception of Kodalith Pan Film, Type 2568) insensitive to red light, i.e. are typical of **ortho**-chromatic emulsions. They are all

relatively slow, and have recommended exposure guide numbers averaging 10-12 for daylight or arc-light, and 4-8 for tungsten light. Because of the very steep slope of the characteristic curve, it is necessary to expose very accurately, and errors of ¼th stop will produce noticeable differences. If only a few negatives are needed, it is simplest to expose by bracketing and developing film in trays, observing the development under a red (Series 1*) safelight.

The density that appears under the safelight is always greater than what will be visible under white light, because of the eye's relative insensitivity to red light. A way to make a judgment of the maximum density is to turn the film over, face down, just before you believe it is fully developed. When the image is developed on the back of the film, it has achieved full density without filling in details.

These emulsions have very sharp "toes" and equally sharp "shoulders" and *almost* vertical straight-line portions. Very small changes of light value cause very large changes of density. Like all other characteristic curves, these can be modified by the choice of developers. Proprietary litho developers are sold as separate "A" and "B" stocks, in liquid concentrate or powders. They are mixed and kept separate, and combined for use only as needed. Once combined, tray life ranges from 20 minutes to two hours. Special handling procedures to guarantee repeatable results will be described later in this chapter.

The developers commercially available for use with ortho films are for the most part quite similar. Kodak, Agfa-Gevaert, and others make prepared liquid concentrates that store well and are convenient to use. Kodak sells several different solutions, e.g. Kodalith Developer, Kodalith Super, which will produce no obvious differences until after a great deal of experience is acquired. Agfa-Gevaert's Gevaline chemicals are essentially interchangeable with the Kodak chemistry. There is one proprietary compound which has some significant differences however, and that is Kodak's Fine-Line Developer (Catalog No. 146-5228) which permits the development of a finer detail with ortho materials, and is referred to in special processes described later in this chapter.

Should a suitable developer be needed when there is no proprietary compound available, one of the standard older formulae will work.

High Contrast Developer
(Ilford ID-33 & Ansco 70)

Stock A:

Water (50°C)	750ml
Hydroquinone	25 g
Pot. Metabisulfite	25 g
Pot. Bromide	25 g
Water (cold) to make	1 liter

Stock B:

Sodium Hydroxide	50 g
Water (cold)	1 liter

Sodium Hydroxide has a positive heat of solution; it generates heat when dissolved. Starting with cold water, and stirring constantly, the B solution will be about at working temperature when thoroughly mixed. These store reasonably well separately. Brought together, they begin to decay. The working life is no more than two hours. Development time for typical ortho materials is between 2 and 3 minutes.

Examining this formula, and comparing it to the Paper Development Test and the Beers Formulae in the last chapter, one sees that this is a pure hydroquinine developer, with a great quantity both of strong accelerator and of inhibitor. The effect is to produce a very high energy developer — with an extreme tendency to produce vigorous blacks — but balanced by a large amount of inhibitor that tends to let nothing be developed at all. The net result of this chemical push-and-pull is to create extreme contrast: nothing is developed unless the image exposure crosses a critical threshold, and then suddenly *all* the silver seems to develop at once. These developers produce no visible image, given a correct exposure, for 30-50 seconds. Then there is a sudden appearance of a faint image over all the film which then stays constant for another 40-60 seconds. Finally, there is a rapid filling in of density overall.

When the correct exposure and development relationships are met, the image on the film is either clear (a minimum density controlled by the film-base + fog) or totally opaque (a density far exceeding that attainable on conventional films, and lying above 3.0). Underexposure causes a late appearance of the image, and even with extended development there is uneven production of silver; the image remains translucent and brown. Overdevelopment causes the fine detail to fill in, as silver begins to be reduced even in the parts of the image that should remain clear.

As with all other developers, time, temperature and agitation are controls. Developing time is controlled by direct observation, as with prints. Temperature is quite important, both for repeata-

*All photographic emulsions were insensitive to all but blue light until the 1880's when Vogel and others discovered ways to sensitize silver salts to green and yellow light. These emulsions were called orthochromatic, or "right color" sensitive. About the turn of the century additional sensitization was developed, making film sensitive to red light as well, and became *pan*chromatic, i.e., "all color" sensitive.

bility and because the hydroquinone rapidly loses effectivity with falling temperatures, becoming ineffective below 15° C Since this is the only reducing agent in the developer, it is mandatory that developer temperatures be maintained between 20 and 24° C.

Agitation is a principal control with ortho films. Constant agitation will produce somewhat greater maximum density, and will also produce some loss of detail in fine lines. For maximum clarity of fine detail with sheet films, e.g. Kodalith Ortho Film 2556, Type 3, agitate constantly for the first 20-30 seconds and then stop agitation. The ortho films are made with both mylar and acetate support materials. The mylar is heavier than water, and will lie still at the bottom of the tray without assistance. Acetate films tend to float. To achieve *still development* with acetate films, small weights are needed to keep the film completely under the liquid. Small glass graduates, or stirring rods work well and are usually at hand in the darkroom.

Still development increases the clarity of fine detail in several ways. First, as the silver salts in the heavily exposed areas begin to be reduced to silver + bromide by the action of the developer the free bromine is released into solution. If there is no agitation, the bromine tends to stay near the developed area and inhibit development in adjacent areas. This shows it schematically:

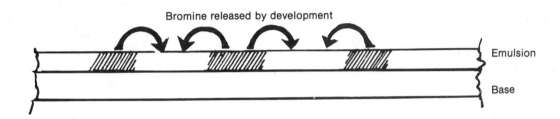

Figure 5-2: **During still development, bromine released from the silver-bromide bond by reduction precipitates out adjacent to intensely exposed areas, inhibiting development and improving detail reduction in small dot areas.**

Second, agitation pumps developer into these lightly exposed areas, increasing the chance of some reduction of silver, and clogging of details. Third, agitation carries with it some contaminants from heavily exposed areas that tend to make silver that has only been exposed below the threshold suddenly capable of development.

The developers for ortho films are all very sensitive to acid contamination. The tray used for developing ortho films should be used only for developers. Plastic trays are absorbent, and when they are used for acids hold some acid despite washing. To demonstrate this, pour a little Indicating Stop Bath into a plastic tray. Allow it to stand for 10-15 minutes, then wash it out in the way you normally wash trays. Now pour a few drops of Perma Wash or Hypo Clearing Solution, both being basic, into the tray and observe the purplish discoloration that develops from the residual acid and *ph* indicator that have clung to the plastic. This revealed contamination is sufficient to cause a shortened developer life, streaks and other irregular processing of ortho films.

You may also contaminate the process with acid carried on the fingers. Since the film must be immersed, lifted, drained, rewetted, and so on for several cycles to provide strong agitation if a deep tray of developer is used, the acid on the skin will often cause faint density streaks. These can be avoided by wearing rubber gloves, by rinsing the fingers thoroughly in hot water after each immersion in stop or fixing baths, or both of these together.

Because of the short working life of litho developers after the A & B stocks have been combined, it is often difficult to generate a dependable exposure/development/density relationship. The following method will minimize these problems.

When using mylar-based ortho materials, a thin film of developer can be used on a modified one-shot basis to produce exactly repeatable processing, hour after hour. The process requires the use of three graduates.

Measure out 300-400ml of A and B stocks into separate graduates. Have available a third graduate (the Paterson 150ml straight-sided plastic graduate is exactly right) and a clean 8 x 10 flat-bottomed tray with no ridges. Wet the bottom of the tray with plain water, and dump it. Lay the film emulsion up in the tray. The thin film of water will grip the ortho film. Pour the small graduate half full of A stock, then fill it with B stock. In one smooth motion, pour the contents of the small graduate over the film. Agitate by tilting the tray vigorously, so the developer flows all to one end, then to the other, then to one side, then to the other. Agitate

for 15-20 seconds. Stop agitating. The thin layer of liquid will cover a piece of ortho film up to about 8 x 10 inches. Be sure when you stop agitating that there are no dry patches where bubbles are under the film. If there are, gently tip the tray until the entire sheet is wet. Mylar film will lie quietly under a thin layer of liquid and develop evenly. The normal development time is 2-3 minutes. When development is complete, lift the film, let it drain for 3-5 seconds, place it in the stop and then the fixing bath, and agitate normally.

Pour half of the developer back into the small graduate. Throw away the rest of the developer in the tray. Add equal parts of A and B stock until the small graduate is full again. When the next sheet of film is ready, use this part-fresh/part-reused developer and pour it over the film in a smooth motion. Repeat as needed, This method will permit several hours of work with exactly repeatable relationships between exposure, developing time and density. It is also an economical method, using only a little developer for each sheet. Whether one is making a few quick tests or producing many high-contrast negatives this method works economically and repeatably. It encourages correct temperature control: the stock graduates can be stored in a water bath.

This same procedure should be used with Kodak Fine-Line Developer; this compound encourages the development of very fine detail, and is essential to the production of special kinds of halftone negatives to be described later.

Ortho film is available in 35mm as well. Kodalith Ortho Film 6556, Type 3 can be purchased in 100 foot rolls for loading into reusable cassettes. Roll film has many uses for contemporary photocopying and printmaking. Projection slides of line copy or tables of information may be presented in correct black and white relationships but this means that the lines are black on white areas and when seen on a brightly illuminated screen the image is fatiguing and often unclear. Presenting white lines on a black screen often makes the image easy to read in brightly lighted rooms as well as in correctly darkened auditoriums.

For the printmaker the film offers advantages in that halftone images can be correctly copied directly from ink reproductions and halftone dots reused. A carefully corrected lens is needed. The Nikon Micro-Nikkor is probably the best lens available. It compensates automatically, making the diaphragm corrections needed as the image-to-object ratio increases (see the Basic Photo Series, Vol. 1, "Camera and Lens," for a discussion of bellows extension and the effect on exposure and apparent f-number of a lens).

Use a Micro-Nikkor, or a conventional lens with bellows or extension tubes, light the copy with two

150-watt photoflood lamps. The distance from the lamp to the center of the copyboard should be about 18 inches for material smaller than 8 x 10 inches. Larger originals will require greater lamp distances to avoid uneven lighting.

Expose for 1 second at f-8, when using Kodalith Ortho Film, type 3. Develop in Kodalith Super Developer at 21° C/70° F, with standard agitation, for 3 minutes.

Small changes in exposure and development cause large changes in the densities. Fine detail may be lost by slight increases in exposure or development. Some trial-and-error investigation will reveal the minimum exposure development times for true blacks while retaining fine details.

Fix the film for 1½ minutes in a Rapid Fixer. For slides which have only immediate usefulness a short wash of a minute is sufficient; the thin emulsion and low-absorption base on the film permit very rapid drying. For slides that must have a long life, process carefully and dry without heat.

The ortho films are also excellent reversal materials, and may be processed for positives by the chemistry outlined in the Handbook after first development is completed in a suitable high contrast developer. Small changes in chemistry, exposure and times produce large changes in density.

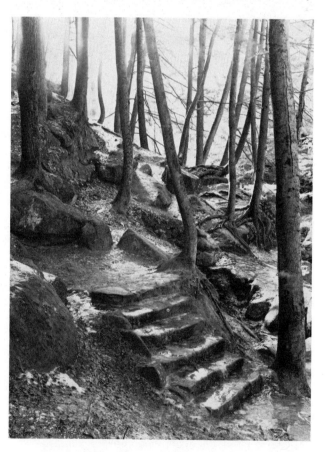

Figure 5-3A: **A conventional print made from a silver negative. Note the continuous tones of the print (reproduced here in halftone).**

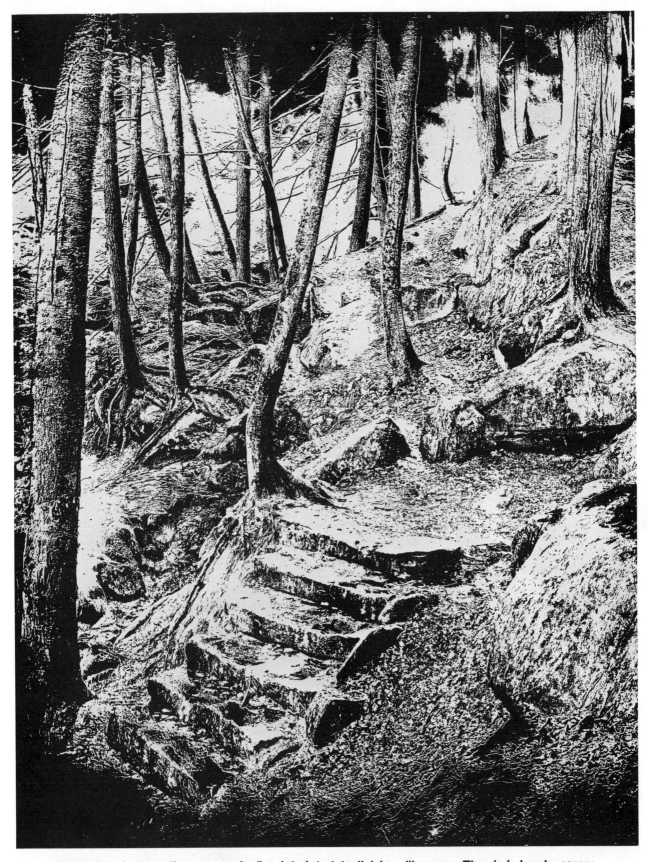

Figure 5-3: A "tone-line conversion" printed (originally) by silkscreen. The dark bands across the bottom and top of the conversion are manipulations created during processing.

Continuous tone as well as high-contrast reversal images can be made with the ortho films by using diluted developers, e.g. HC-110 diluted 1:60, or as high as 1:100, with development between three and eight minutes.

Ortho films can be used in non-standard ways. When developed in weaker developers (conventional film or paper developers using Elon, diluted from 1:1 to 1:4) the emulsion remains inherently high contrast, but the slope of the characteristic curve will be lowered. Density changes can be controlled to provide useful tones. Dilute paper or film developers will produce a vigorous but full-scale continuous tone image on the ortho films. The contrast characteristics are suitable for what are called "tone line" conversions. These are produced when changes in density are used to create line information. The effect is to transform smoothly changing tone into strictly linear patterns. Such a transformation is used in silkscreen and lithographic printing, and can also be applied to photographic etching. The more texture in the original, the more detail there will be in the conversion. Untextured areas of the original appear white or black.

The original negative or an enlarged negative may be used in a tone-line conversion. In either case the negative is contact printed onto either Fine Grain Positive or Ortho film. The positive produced should look dark and of normal contrast. When examined against the bottom of a white darkroom tray it will look like an overexposed print of normal contrast. The whites will appear grey; some of the shadows will seem too dark. Viewed as a transparency there will be full shadow detail.

Dry the film print. Tape the negative emulsion down to the glass of a contact printing frame. Use 3M's Magic Transparent Tape No. 810. It is thin and the adhesive does not bleed. Place the film print over the negative, emulsion up. Bring them into exact register, and tape them. The images are assembled into a sandwich, in register but with the emulsions separated. The assembly, viewed with transmitted light, appears nearly balanced but the positive image is stronger than the negative. The sensation is that of looking at a very dull and flat print.

In the darkroom place a piece of litho film on top of the positive-negative sandwich and close the printing frame. Hold the frame under the enlarger at about a 45 degree angle. With the enlarger set for 11 x 14 inch prints, the lens set at f-8, and the timer at 10 seconds, expose the slanted printing frame. Turn the frame a quarter turn, maintain the same angle, and expose again. Repeat this for all sides.

Light passes through the slots left between positive and negative images in register but separated by two thicknesses of film base. Properly exposed and developed the film will blacken where the image was exposed between the positive and negative emulsions and remain clear elsewhere.

Develop the film in a developer designed for litho negatives. Developing time at 21°C will be 3 to 5 minutes. If the image appears before two minutes the film is overexposed or the total sandwich density is too thin.

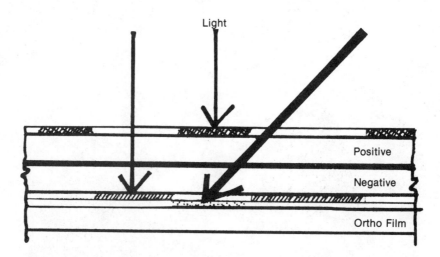

Figure 5-4: A simplified schematic illustrating why slanting light produces a line density in the tone-line conversion: either the positive or negative originals block direct light, and only where there are passages seen at a slant, caused by the separation of the silver images by two thicknesses of film base, is a high-contrast latent image produced.

High contrast conversions are the simplest manipulation of a continuous tone image by using ortho materials. The original negative is printed onto the ortho film, which is then developed in a litho developer. Those parts of the negative falling below the threshold of the characteristic curve remain clear. Those parts falling above are dense. A few tones that fall on the steep slope will tend to break up into granular random dots of silver, approximating what happens when a halftone screen is used. Pieces of film can be joined together with 3M Magic Transparent Tape.

Figure 5-5: (A) **The original negative.**

(B) **Enlarged high-contrast conversions. Each area was exposed and developed for a pebbly dot, or texture. In this example, these were then cut to fit and taped together.**

(C) Screened as black.

(D) Screened with color areas (here seen only as changes in value).

(E) A simple high-contrast conversion, made directly from a negative to a positive, using the ortho characteristic curve.

(F) An original negative, and the resulting contact high-contrast positive, from which was made another negative, and then an enlarged high-contrast positive.

(G) **To the high contrast photo image were added drawings made on acetate, and overprinted in color, to produce a photo-conversion deliberately resembling a child's coloring book.**

Other non-standard uses for ortho film include "posterization," and "high contrast conversions." Posterization is a process of separating the tones of the original subject into density patterns. All the very light tones, for example, are exposed and developed to produce a pattern of silver on a piece of ortho film. Then the medium tones (which will include the lighter tones as well) are exposed and developed on a second piece of film. Then the middle-greys (which in turn will contain all the lighter tones) and finally the dark greys. These four pieces of film, in this example, are then used to create photo silkscreen resists. The last could be screened first, as a dark color, and then the next as a lighter, opaque color, and so forth, until the highlights would be screened over the whole image as a pattern of small bright colors.

For many photo-printing processes intermediate positives will be needed. A positive should

(H) **Final print.**

Figure 5-6: "Posterization" achieved by using the high-contrast conversion possibilities, but breaking the positive into many small density layers. The original by Richard Ross was silkscreened as a color print.

distort the tonal separation of the original negative as little as possible. Because of the nature of the characteristic curve of silver emulsions, some nonlinear distortion is inevitable.

A contrasty film that is useful for some positives is Kodak Fine Grain Positive (7302) which can be handled under a yellow paper safelight and developed in paper developers. A wide range of contrast control is available by increasing or decreasing developer strength (the Beers formulae work well), and by increasing or decreasing time of development. This film is excellent for the toneline conversion described earlier. It is available in 4 x 5 and 8 x 10 sheets.

For making photogravure positives the best film at present is Kodak Commercial (6127) which is a blue-sensitive film that can be developed in a red (Series 1A) safelight.

Photogravure positives can be made by placing the negative in the enlarger in normal position (emulsion down), and adjusting the enlarger as though a normal paper print were to be made. When these preliminaries are complete, prepare the following developer:

Developer for Photogravure Positives

Water (21/22° C)	1200ml
Hydroquinone	6 g
Sodium Carbonate (mono.)	12 g
HC-110 concentrate	30ml

Stir the hydroquinone and the carbonate into the water for about 30 seconds. Pour the water into the HC-110 concentrate in the tray. This solution is adequate for three 8 x 10 positives developed together. With constant agitation the first minute, and interleaving every 30 seconds after that, developing time will range from 5 to 9 minutes, depending on contrast desired.

Expose the Commercial film through the antihalation backing. Place the film on the easel emulsion down. A starting exposure for a Besseler enlarger (8 x 10 print area) for a normal negative should be about 10 seconds at f-22. Exposing the image through the backing will mean that the image is in a correct left-right relationship for exposing the gelatin etching resist, used to control the iron etchant on copper gravure plates.

Densitometer Control of Print Exposure

Silver printing lends itself to trial-and-error methods that are both expensive and wasteful. Because one can quickly see the results of a trial exposure, little thought is given to making two or three trial prints. Platinum, palladium, gum, gravure and other processes prohibit this because of material cost and because of delays between the test exposures and the validation in the print.

Step 1. Examine the negative. It may be well to make a silver print for study purposes. Determine the Zone VIII areas. Choose one that is large enough to be meterable with the densitometer. Determine the density of this area. For a normal negative it will be about 1.30 (somewhere between 1.15 and 1.45). Verify that the shadow densities are normal (about 0.30 for first important shadow areas).

Step 2. Make a good print. This means trial-and-error until you learn what a good print looks like and how the materials should be handled. Keep a notebook record. When you have a good print, note the exact conditions. This is now a standard print. The negative that made it is a standard negative.

Step 3. To print a new negative, first measure its Zone VIII density. Then proceed down a series of steps as outlined below;

3a. New density 1.20
3b. Standard density 1.30
(for example)
3c. (subtract line 3b from 3a to obtain the difference)
Difference -0.10

A correction must be made from the O/T table below. Note the algebraic sign of the difference. Since it is negative, refer to the T column opposite a density of 0.10 in the O/T table. T = 0.79. If it had been positive, the 0 column of the table would be used.

3d. Correction factor X 0.79
3e. Standard exposure 15.0 minutes
(from trial-and-error)
3f. New exposure (line 3d × 3e) 11.8 minutes This will produce a correct highlight density exposure from the new negative. In tabular form the computation is:

1. New density D_n
2. Standard density D_s
3. Difference $D_s - D_n$
(— = T; + =0)
4. Correction (from O/T table)
5. Standard exposure Minutes
6. New exposure (4 x 5) Minutes

A Short Table of Opacity (0) and Transmission (T) for Printing Exposures

Density	O	T	Density	O	T	Density	O	T
0.00	1.00	1.00	0.10	1.26	0.79	0.20	1.58	0.63
0.01	1.02	0.98	0.11	1.29	0.78	0.21	1.62	0.66
0.02	1.05	0.96	0.12	1.32	0.76	0.22	1.66	0.60
0.03	1.07	0.93	0.13	1.35	0.74	0.23	1.70	0.59
0.04	1.10	0.91	0.14	1.38	0.72	0.24	1.75	0.57
0.05	1.12	0.89	0.15	1.41	0.71	0.25	1.78	0.56
0.06	1.15	0.87	0.16	1.44	0.70	0.26	1.82	0.55
0.07	1.18	0.74	0.17	1.48	0.68	0.27	1.86	0.54
0.08	1.20	0.83	0.18	1.51	0.66	0.28	1.90	0.52
0.90	1.23	0.81	0.19	1.55	0.65	0.29	1.95	0.51
						0.30	1.99	0.50

A table of 0.00 to 3.00 is published in the Photo Lab Index.

When working with any silver emulsion there will be exposures and developments that are not quite right, where the image produced has excessive silver density. This silver can be removed by controlled chemical etching. The etching referred to here uses variations of an interaction of silver with Potassium Ferricyanide, and a controlled interaction of the compound resulting from those chemicals with Sodium Thiosulfate, or hypo.

Silver combines with the *ferri*cyanide to form *ferro*cyanide, a compound not soluble in pure water, but quite soluble in a hypo solution. These three different results can be achieved; for continuous tone negatives:

Correcting Overexposed Negatives with Farmer's Reducer

Stock A:

Potassium Ferricyanide	18.75 g
Water	1 liter

Stock B:

Sodium Thiosulfate	240 g
Water to make	1 liter

Use 35ml of A, 140ml of B, and dilute to make a liter. Pour the mixed solution over a dry negative; agitate for 20-30 seconds in tray. When the desired density is almost achieved, move the negative to a washing tray with running water. Wash two minutes, use Perma Wash or Hypo Clearing Solution, rewash and dry. The stock solutions interact and destroy one another. They store well in darkness until mixed.

Correcting Overdeveloped Negatives with Farmer's Reducer

Stock A:

Potassium Ferricyanide	7.5 g
Water	1 liter

Stock B:

Sodium Thiosulfate	20 g
Water to make	1 liter

Immerse the negative in the A stock for 1-2 minutes with constant agitation. This negative **must** be thoroughly fixed, treated with hypo eliminating solution, and carefully washed before attempting this treatment. Drain the film then immerse it in the B solution for 3-5 minutes. Wash, neutralize, rewash and dry.

The treatment may be repeated if necessary. The time in the first bath is controlled by observation; some of the silver will become whitish as it changes from a metal to a new salt. When the correct density is approached, drain and move to the hypo solution where those newly formed salts will be taken into solution. Once density is lost it cannot be restored.

For the litho films a different version of the process is available, using the same chemicals. Chemical etching of the silver in litho negatives is usually desired only **between** the densely exposed silver areas, to clear up fine line detail, or to open the space between dots in the halftone.

Hypo can be dissolved in water until there is almost no free water left, and then when that solution is put onto a dry emulsion there is little penetration into the dense areas where there is image silver compared to the penetration into the open gelatin that has little silver. This fact permits the ferricyanide-hypo mixture to etch the halftone dot image from the side, laterally through the emulsion. Changing the size of the dot without significantly decreasing its maximum density is a way to control halftone contrast. And, because the ferricyanide and thiosulfate interact, it is possible to make a solution which self-destructs in a very few seconds. The total effect is of a vigorous etchant that opens up line and dot detail, but does not function long enough to cause damage to the maximum densities.

Dot Etching Solutions:

Stock A:

Sodium Thiosulfate	2 kg
Water to make	2 liters

Stock B:

Potassium Ferricyanide	300 g
Water to make	1 liter

To use these stocks, place the dry sheet of ortho film face up on a piece of glass. This should be lying flat, and a good way to support it is by placing it on an overturned photo tray in the darkroom sink. Measure 100ml of the hypo stock and separately measure 5-10ml of the Ferricyanide stock. Combine them, stir, and pour smoothly over the film. Spread the etchant smoothly over the film.

The working life of this solution is dependent on temperature.

Functional Life* of Dot Etching-Solution

concentration	Temperature		
	18°C	21°C	24°C
5ml	110	90	75
10ml	125	105	85

*in seconds after combining A & B stocks.

As soon as the etching is completed to your satisfaction, the film should be washed, neutralized, rewashed and dried.

Many printmaking processes require continuous tone negatives of the same size as the print. If the original negative is 35mm and the print size is 8 x 10, a duplicate negative must be made. The best material available is a duplicating film which has been pre-exposed to the top of the characteristic curve. Any additional exposure will cause a diminution of density. Kodak's Professional Duplicating Film SO-015 is the only such film now being manufactured, though DuPont and Kodak both manufactured such films until the Second World War. The film is made for duplicating continuous tone negatives and is a recent addition to the Kodak catalogue. It is similar to the Super Speed Duplicating Film used for line copy work in that it is ortho-chromatic, though lower in contrast.

A parametric presentation of the characteristics of the film is shown in Figure 5-5. This parametric differs from those in Chapter 4 because the film has been exposed to a calibrated step-wedge, and developed for a constant time. The variable here is the exposure time of the entire set of information points. The development time was determined by making a preliminary set of parametrics in which development times for a trial exposure were tried, attempting to produce a set of curves with separations similar to the original step-wedge densities.

The film is relatively insensitive, with a trial exposure time of 40 seconds with an enlarger set to produce an 8 x 10 inch patch at an f-5.6 aperture (typical for most contemporary enlargers except the Omega B-22, which would require an f-8 lens setting). Insufficient exposure will cause the shadow areas of the copy negative to be crushed (as these are still on the "shoulder" of the copy film). and the highlight densities to be exaggerated, and yet still dense. Overexposure will cause exaggerated separations of the shadow tones and loss of detail in the highlights, as these areas would be overexposed and "run off the curve."

The film shows normal sensitivity to over all density/development controls. The overall density shift of the maximum density available rises from about 1.5 at 1½ minutes development in D-72 diluted 1:3 and used at 21°C to almost 3.0 when development is countinued for 6 minutes.

There are many times in photographic printmaking as well as in expressive and applied photography that a positive black-and-white transparency is needed. These are also called diapositives. There are two general ways of obtaining them. One is to make positive prints from existing negatives, by contract or by rephotographing. The other is to expose film to the original subject and then process it for a positive image. This latter process is called "reversed processing" and is standard in the movie industry for 16mm film productions.

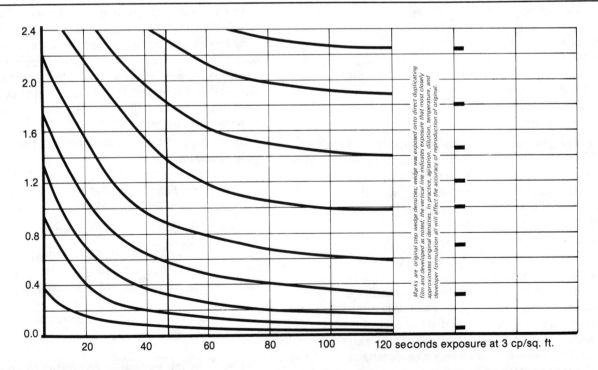

Figure 5-7: **Parametric of Kodak's Direct Duplicating Film, showing how the film loses density with exposure, and yet increases contrast with increasing development.**

There are advantages to reversal processing in terms of grain size, and disadvantages in terms of latitude of the process, and the uniqueness of the image.

Making film prints from negatives was once popular; Leitz made a compact contact printing cassette for this purpose. Recent developments in slide copying machines have created new interest in this method. Using a Bowens Illumitran or a Honeywell Repronar it is possible to make black-and-white positives from negatives that have a projection quality to match the best prints.

The camera is loaded with Eastman Fine Grain Release Positive (5302). This film is available in 100 foot spools for bulk loading in cassettes. It is exposed on the slide copying stand at one-half stop increments from a standard negative to determine a normal exposure. After exposure it is developed in the following developer:

Film Positive Developer:

Water	750ml
Sodium Sulfite	46 g
Hydroquinone	16 g
Sodium Carbonate	90 g
Potassium Bromide	8 g
Water to make	1 liter.

Develop the film for 5 minutes (useful range is 3-6 minutes) at 21 C. The film may be selenium toned, by the same process steps as noted in Advanced Controls for prints, for intensification or for color change.

Reversal Processing of Films

Copying prints is economical and straightforward with the following chemistry. The Kodak process for Direct Positive Film (5246) or Panatomic X Film has been modified to increase the contrast and produce higher maximum density without significantly increasing grain size. This produces slides that are "projection equivalents" of the original prints. The chemical compounds noted are designed to produce a slide that will provide a projected image ranging from apparent black to clear film in an auditorium seating 200. Standard Kodak Carousel projects are assumed. Denser blacks can be produced by increasing the Sodium Hydroxide as much as 20%; decreasing it proportionately creates softer tones.

Reversal processing first produces a conventional negative. Then instead of removing the unused silver, the silver metal image is etched away. After the negative image has been "bleached" the remaining silver is exposed and developed. If the negative was properly exposed the complimentary image produced will be a full scale positive.

Because the negative and positive images are physical complements to one another, full contrast control cannot be accomplished by increasing or decreasing the development time. To do so changes one portion of the tonal scale or another. Increasing or decreasing the activity of the developer changes the tonal range to use the entire silver density range desired. These controls are straightforward. Sodium Hydroxide is the principal accelerator and Hydroquinone is the contrast controlling reducing agent. Changing the proportions of these stocks in the developer will change the contrast. Increasing the Hydroxide increases contrast. Increasing Hydroquinine increases (and to some degree hardens) the separation of low tones.

These processes are suitable for roll and sheet films. Some experimentation is always necessary with a reversal process to determine accurate system indexes. Expose by metering the important textured *highlights* in the subject; place exposures at Zone VII. Meter the highlights, then expose two f-stops more than the indicated meter exposure.

Reversal Processing for Copying Prints

For processing Kodak DP-402 (5246) or Panatomic-X; approximately 8 rolls (36 exposure) may be processed in each liter of solution (excepting toning bath).

First Developer: 1 gallon of D-19, modified by adding

Sodium Thiocyanate	8 g
Sodium Hydroxide	2-10 g

(5 grams normal for making slides from silver prints).

Potassium Bromide	20 g

Bleach:

Water (125° F or 52° C)	750.0 ml
Potassium dichromate (=bichromate)	12.0 g
Sulfuric acid (concentrated)	15.0 ml
Water to make	1 liter

(Note: allow solution to cool before carefully adding sulfuric acid)

Clearing Bath:

1: Water (125° F or 52° C)	750.0 ml
Sodium sulfite	100.0 g
Water to make	1.0 liter

or 2: PermaWash, 30ml per liter of water.

Second Developer:

Kodak Dektol (=D-72), Vividol, 54-D diluted 1:1 or film developers, full strength.
Film developers produce warm-tone diapositives.

Fixer:

Use any standard or rapid fixing bath.

Hypo-Clearing with Toner:

Working solution of hypo-eliminator	1.0 liter
Kodak Rapid Selenium Toner	
(one time use only)	20-60 ml

Reversal Processing Steps

All temperatures should be 21°C/70°F — Use Standard Agitation throughout.

1. First developer	7-9 min.
	8 normal
2. Water rinse (constant running water)	2 min.
3. Bleach	3 min.
4. Clearing	2 min.
5. Water rinse (constant running water)	30 sec.
6. Wetting agent	30 sec.

Lights can be turned on at this point for rest of processing.

7. Re-exposure: hold film 12 to 14 inches from 100-watt lamp for 30 seconds each side.

Be sure no water drops are on film surface — they may cause uneven exposure.

8. Second developer	2 min.
9. Water rinse (constant running water)	30 sec.
10. Fixer	Manufacturer's minimum time
11. Hypo-clearing with toner	maximum of
(single use)	1-1½ min.
12. Wash	5 min.
13. Wetting agent	30 sec.
14. Dry and mount	

NB: As an alternative to steps 6 & 7, a "fogging" developer may be used. This compound reduces all the silver left in the emulsion without the action of light. Previously published editions of the Handbook list the chemicals for the Kodak FD-70 Fogging Developer, but both ecological and legal problems make obtaining some of the chemicals difficult in many states. The only stable fogging developer available commercially at this time is the Sprint Quicksilver Developer, diluted 1:9, plus 30ml of Quicksilver Redeveloping Converter #2 added to each liter of working solution. Develop for 3 minutes with constant agitation the first minute.

Reversal Processing of Other Films

Recent changes in the emulsions of standard films have permitted reversal processing with a minimum of modifications of developing solutions. The complex Arneleon chemistry offered in earlier editions of the Handbook has been deleted from this edition.

Most contemporary films will respond to reversal processing when treated the same way that the "direct positive" emulsions are processed. Occasionally, high speed, double-coated emulsions will exhibit some signs of incomplete reversal or of residual silver that has not been removed at any point in the processing cycle. A test roll should be run of any new emulsion.

If there are patches of unchanged silver in the finished diapositive (which appear as grey densities in the highlight areas, resembling "solarizations") then the developer must first be modified by adding Sodium Thiosulfate to remove part of the silver during the first development.

Too much Thiosulfate in the first developer will cause the diapositive to appear "thin" and have a grey, rather than black, maximum density in the unexposed film surrounding the image.

If the density range of the slide is not adequate (i.e. the highlights are correctly exposed, but the shadow areas are thin) the contrast of the film may be increased by adding either a concentrated Hydroquinone stock, or a Sodium Hydroxide stock, or both. Since the image color is controlled by the development of the residual silver (not by the development of the negative image), the additional Hydroquinone will not cause changes in the color of the slide.

Stock	Chemical	Quantity
1	Sodium Thiosulfate	100 grams in 1 liter of water.
2	Hydroquinone	100 grams in 500 ml of warm water. Add 100 grams Sodium Sulfite as a preservative. Add water to make 1 liter.
3	Sodium Hydroxide	50 grams in 500 ml cold water. After it dissolves add cold water to make 1 liter.

By using these stock solutions the following reversal processing problems can be solved:

Reversal Problem	Solution
Contrast low	Add 25-150 ml of 3 to each liter of first developer.
Max density low	Add 20-100 ml of 2 & 3 to each liter of first developer.
Partial reversal	Add 5-20 ml of 1 to each liter of first developer.

After the first development is completed, the processing steps are the same as those noted above. The first developer in all cases is D-19 modified.

Masking for Contrast and Color Control

Prior to making color photosilkscreen, gravure or other halftone color prints it may be necessary to produce color separation negatives. Depending on the halftone process to be used, it may be desirable to limit the density range of the original color transparency which is being separated into primary colors. The only alternative is to control densities in the separation negatives totally by exposure/development. While this **can** be done, it is not usually wise, because extreme contrast development controls also causes nonlinear tonal separations; values are muddy and there is a lack of articulation between tones. It is best to make a photographic mask, bound in register with the

original transparency. The net density of the mask and transparency is determined by adding the mask's maximum density to the transparency's minimum density, and comparing this to the maximum density of the transparency plus the mask.

If the transparency has a density range of 2.4 and the mask has a maximum density of 1.4, then the approximate density range of the mask + transparency is 1.0. This sandwich has all the visual information of the original transparency, but now it is distributed over a much smaller density range; a separation negative made from the masked transparency can be processed normally, providing clean and equal separations of density throughout its density range. This avoids the irregularities that occur when extreme development controls are used — shortened development times, or very great developer dilutions.

The mask must be an exact physical echo of the transparency, not only in density but dimensionally. To make this kind of mask, diffusion is used to produce an unsharp image. This permits relatively easy alignment of the mask and transparency after processing. A very sharp mask would be almost impossible to align with complete accuracy, and any misalignment would produce sharp density changes that would look like a line-drawing superimposed on the continuous tone image.

Kodak Pan Masking Film (4570) is used to make the mask. It is a dimensionally stable film with no anti-halation backing; the exposure is made through the base.

The mask is made by diffusing the light with two sheets of Kodak Diffusion Sheet. This is placed on top of the glass in a contact printing frame. The transparencies to be masked can be ganged together and at least a dozen exposed at once on a single sheet of 8 x 10 Pan Masking Film.

The transparencies are taped emulsion down with small strips of 3M Transparent Tape onto the contact print frame glass. The glass and transparencies are then blown clean, and (in total darkness) the Pan Masking Film is placed emulsion away from the glass. The pressure back is put on, the frame placed in normal printing position under the enlarger, and the sandwich exposed.

With a Beseler enlarger set to cover an area of about 11 x 14, a typical exposure is 15 seconds at f-5.6. This will provide a rather high minimum density of about 0.30-0.35. Development will largely determine the maximum density. Develop the sheet of Pan Masking film in an 8 x 10 tray in HC-110 diluted 1:50 for 5-9 minutes. The time of development will be controlled by the masking density needed, depending on the process for which you are preparing color separation negatives.

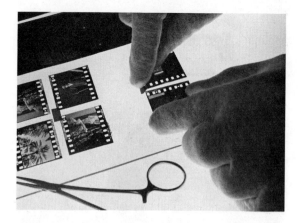

Figure 5-8: (A) **Transparencies to be masked are first stripped from their mounts, cleaned, and taped emulsion down on glass from a contact printing frame.**

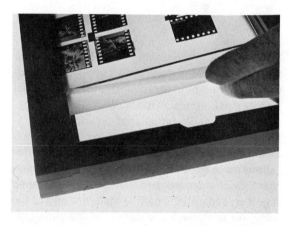

(B) **The frame is modified by using two pieces of glass separated by two layers of .003-inch Kodak Diffusion Sheet, as shown.**

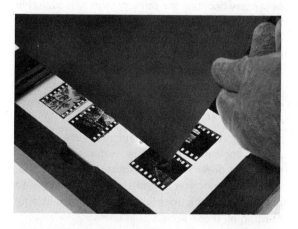

(C) **The Pan Masking Film is placed emulsion *up* in the frame, the back clamped shut, and the exposure made through the diffusion pack.**

(D) **After developing, the film is fixed, washed, dried and registered to the transparencies, emulsion-to-emulsion.**

Approximate Density/Time Relationships

Time	d-max
5'	0.95
9'	1.50

Complete the processing normally as for other films, and when the mask is dry cut out the individual frames and bind each transparency in contact with its mask, emulsion to emulsion. The combination of the Kodapak diffusion sheet and the separation of the emulsions will have produced a soft shadow image which is easily aligned. The perforations make excellent patterns with which to align them. Once the mask and transparency are taped together, separations can be made for any of the nonsilver processes; the density of the mask permits making separations to the specifications desired for any of these processes.

Masking is also an aid to color control. The separation negatives can be made with colored light as a means to producing more accurate renditions of certain colors in the print. This is necessary because the primary pigments available for silkscreen, lithography, etching and gum printing are not pure. There are always color contaminants and a neutral density present, and only the process yellow approximates an ideal. To overcome this in part the separation may be deliberately unbalanced so as to reinforce the pigments where they are weakest.

Several masks may in fact be made, one to correct for saturation errors — darkening of the blues and greens — one to correct shifts in hue, which is a function of the magenta, and one to restore brilliance to highlights. In professional printing all these are used at times.

A single mask is often useful. Using a Wratten No. 33 (magenta) filter, a mask to correct greens (allowing for the neutral density present in the pigments) is made by exposing a transparency sandwiched with Kodapak Diffusion Sheet and Pan Masking film as noted before. The density of the mask is controlled by the amount of contrast control desired, and this mask in fact can become the contrast mask discussed earlier. But since it was produced with colored light it will affect the greens differently than the rest of the transparency, permitting them to transmit more light during the making of the separations, and subsequently printing with greater brightness. If the Wratten No. 33 seems to exaggerate the color when used with the high density masks described here, you may wish to substitute a CC30M color printing filter.

Kodak provides two excellent films for color separations. The old standby is Super XX Pan film (4142); the new emulsion is Separation Negative Film, Type 1, (4131). The Super XX is less contrasty; the Type 1 Separation film is perhaps finer grained. Either works well. Previous editions of the Handbook offered specific exposure and development criteria for separation negatives. This was an error, for there are far too many different systems, each with its own characteristic color temperature lamps, lenses, etc.

For example, here are the red, green and blue separation filter exposure times, and development times for Super XX, for three different conditions. These figures indicate a range of situations one might encounter, and the varied exposures and development times; yet they were all derived by the same method, which will be described:

FILTER:	Red	Green	Blue	
Set 1:	14"	40"	80"	exposure
	5'	3'	4'	development.
Set 2:	23"	21"	28"	exposure
	4'5"	4'	7'15"	development.
Set 3:	10"	7"	4.5"	exposure
	2'30"	3'	4'40"	development.

Set 1: a Durst 601 with a 75**W** lamp was used.

Set 2: a Leitz Valloy II enlarger was used. In set *3,* there was no transparency at all; the original was a Polaroid XS-70 print lighted by 3200° K lights, and the separations were made with a view-camera. All three of these produced functionally identical results, i.e. well balanced prints. The first two by photosilkscreen, and the last by gum printing.

The method for achieving balanced separations is this: place a density step tablet on a sheet of separation film. This density tablet may be one made up of segments from parametric testing (see Advanced Controls), or can be a Kodak step tablet; these are sold uncalibrated and can be measured with a standard densitometer.

Illuminate this with light from the enlarger. Set the enlarger at f-8, and give a trial exposure with a Wratten No. 29, red filter in the light path. Make a trial exposure of 20 seconds. Develop this in HC-110, diluted 1:60, for five minutes at 21°C.

Repeat this with another piece of film, the step tablet and a Wratten No. 61, green filter. Expose for 15 seconds. Develop for six minutes. Repeat again for the last sheet with a Wratten No. 47B filter; expose for 25 seconds, and develop for eight minutes.

Make a simple graph of the results. Take a density near the high end of the step wedge you have used, e.g. 1.8, and locate its negative image on each of the film negatives. Measure this density on each negative. On the step wedge, measure a density that is close to film-base + fog, and then

measure each of the film print densities that correspond. The results will probably look something like this:

Color Separation Trial Densities
Original Step Wedge

Density	Red	Green	Blue
1.8	0.40	0.35	0.45
0.25	1.45	1.50	1.30

Graph these relationships, and see what they look like. The horizontal line is the original density. The vertical is the density of the film copy.

Note that we have simplified the whole graph to two points — opposite ends of the step tablet. If you were to plot all the points, you would find they

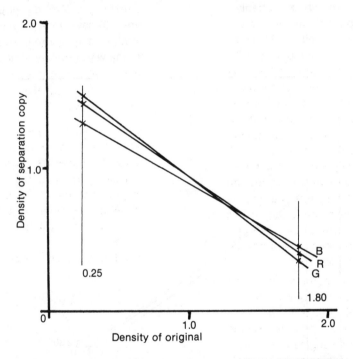

Figure 5-9: **Typical simple color separation trial densities.**

made a wavy line, not the simple straight line drawn here. But this simplified presentation will offer you more useful information than would a complete set of points.

This test must be interpreted so as to learn how to correct the results. The aim is to produce three lines that lie quite close together and have essentially the same slope. When this happens you have produced separation negatives from a neutral density source that, if printed in balanced pigments by a halftone process, would reproduce a grey step wedge resembling the original densities.

The first place to look is at the bottom of the graph, at the minimum densities. Note that the green density is lowest, but that it is about where a minimum density should be on a separation negative to provide linear translations of tone, i.e. about 0.35-0.40. A thinner separation negative would squash shadow detail, and make muddy color. The red and blue densities are higher than needed, in this example. Looking back at the section on Densitometer Control of Print Exposure earlier in the chapter, and noting that the red exposure is 0.05 too high, the blue exposure 0.10 too high, compute the changes that must be made to bring

these into line with the green density. These changes are figured from the opacity/transmission table; one finds the red exposure should be multiplied by 0.89, and the blue exposure by 0.79. Our new trial exposures would then be:

Red: 20" x 0.89 = 17.75"
Green: 15" (unchanged)
Blue: 25" x 0.79 = 19.75".

For practicality, these would be rounded off to the nearest second and be 18", 15" and 20".

The upper end of the graph is a little less cut-and-dried. One must decide which contrast range is "right." That will be controlled by the process for which the separations are being made. Let's assume they are for a photosilkscreen print, and the desired range between these two density points is 1.00. The red separation is closest, being 1.05. To correct it would take only a few seconds reduction of developing time. The green is next, being a range of 1.15, and this 15% error would probably require about a 10% reduction in developing time. The blue has the largest error, being 0.90, and would require an increase in developing time. But

since the blue negative is inherently somewhat flat, relative to the others because of the nature of the emulsion in the presence of blue light, it will probably require about a 25% increase in developing time to correct this short density range. This all may seem arbitrary, but if one examines the parametrics for a medium speed film developed in HC-110, one finds these percentages supported. In any case, make this sort of assumption, calculate the new development times, and see what happens:

Red: 5' × 0.95 = 4'45"
Green: 6' × 0.90 = 5'25"
Blue: 8' × 1.25 = 10'

Bring all this together, and you have completed a set of exposure and development plans for the next level of testing. Remake the red, green and blue exposures and develop as you have calculated. Red = 18" exposure, 4'45" development. Green = 15" exposure, 5'25" development. Blue = 20" exposure, 10' development. When these tests are finished, and measured, and plotted the resulting graphs will probably look something like this:

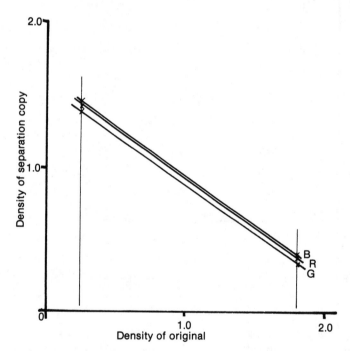

Figure 5-10: Densities after modifying exposure and development.

They are not **exactly** the same. The green, for example, is a little less dense all the way up the line than the other two. But they are parallel and rather close. This is about all you can expect for now. With more experience, finer results will come. A set of separations that graph like this will print very well.

Of course if there are errors, you may have to go back and start again. The worst thing that can happen is when the graphed lines are not parallel, but definitely cross, like this:

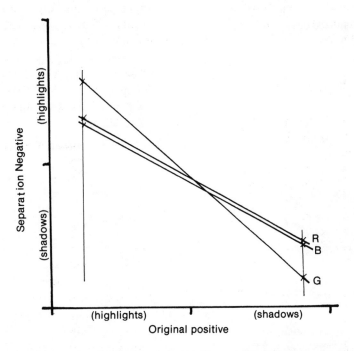

Figure 5-11: **Example of separations with differing contrasts.**

Then there is nothing but trouble if corrections are not made. Visualize the possibilities: if you were to print these separations so that the highlights are neutral, i.e. the densities of all three colors are in balance, then in effect the graph could be redrawn to look like this:

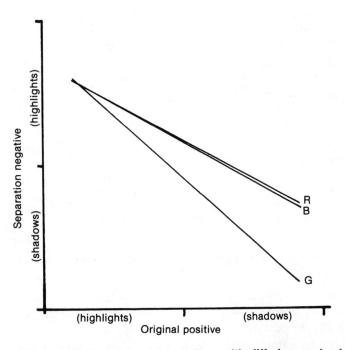

Figure 5-12: **Example of separations with differing contrasts.**

But look what happens in the shadows! The green filter separation has much less density than the others. To interpret the effects of this sort of density error, refer to the standard color wheel for additive and subtractive colors:

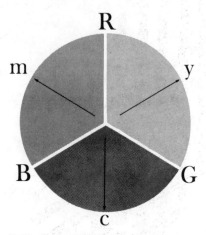

Figure 5-13: Color Wheel, illustrating subtractive primaries.

The primary colors in the separations are red, green and blue. Their complementary colors, the ones that will appear in the print are cyan, magenta and yellow respectively. If you diminish the **green**

negative density you will increase the **magenta positive** density. Therefore, all shadows would have a red-blue or purplish cast. The degree of this color error is proportional to the difference in slope of the three separations.

Now the shadows are neutral, but the green negative density is much higher than the other separations in the highlights, and the resulting positives will have deficient amounts of magenta. The positive will appear to have an excess of green.

Separation Negative Color If density is low in:	Positive Print Color the print appears to be rich in:
green	magenta
red	cyan
blue	yellow.

If density is high in:	the print seems rich in:
green	green
red	red
blue	blue

Imagine the opposite problem: suppose you balance your exposures from this set of separations for neutral color in the shadows. This would be like gripping all the separations at the low end, as shown in this graph:

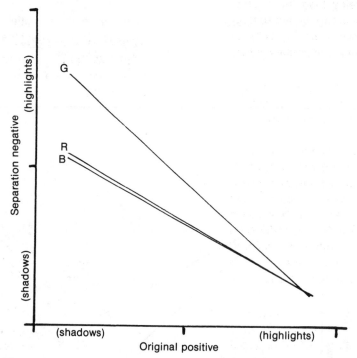

Figure 5-14: The separations of 5-11. printed for correct shadows.

When one primary separation has a contrast differing from the others, there will always be unbalanced color somewhere in the grey scale. You can select any single value to be neutral, but all others will depart from neutrality. If you choose a middle-tone for neutrality, e.g. a light grey ap-

proximating the reflectivity of skin, then with the example we have been using, the highlights would become greenish and the shadows tend to be purple-to-red.

If the original is not a transparency, but a print, e.g. from a Polaroid or Kodak self-processing

camera, and color separations are desired, the process is similar. Make up a target the same size as the prints to be made into separations. It should have equal areas of black, white and middle grey (e.g. a piece of an 18% grey card). The black can be from construction paper, and the white is simply a piece of typing paper. Photograph these as you would the original print, through the Wratten 29, 61 and 47B filters. Adjust exposures and developments to create three similar negatives, with the same high and low densities, just as was done with a transparency.

Separation negatives can also be made by projection printing, enlarging rather than contact printing the transparency onto the film. There are advantages and disadvantages. The enlarged separation will be lower in contrast than the contact separation; this can be compensated for in development. The enlarged separation often is not as sharp as a contact separation, due to diffusion and internal flare, the thickness of the transparency and the mask, and the mechanical problems many enlargers have with vibration and alignment. The grain of the separation is mostly in the separation negative itself. When the negative is larger, the final grain size is smaller. But since the halftone processes for which these separations are intended are often more grainy than the original image, the advantage is nullified. Contact separations have distinct advantages in remaining always in register, and by eliminating unnecessary optics, always crisp.

For most of the color printing processes discussed in the Handbook, the separation negatives must be transformed to halftone positives or negatives.

Halftone processes transform the continuous grey tones of the photograph into small dots which are averaged by the eye and which from a certain distance appear to be grey tones. One could say that all photographs are in fact halftones : even silver images, examined under magnification, break down into dots of silver with blank spaces in between. In practice however, the halftone is generally a concern of ink or pigment reproduction of the silver images.

Changing continuous tone silver images into halftone images usually involves the use of a screen to break the particular grey value into a spot of density. The first such screen was used by Talbot, in the first years of photography. Later, when photogravure was perfected by Klič, a random pattern of rosin or asphaltum grains was used. But the first regular screen can probably be credited to Ives' use of a glass ruled screen.

The glass ruled screen is a series of rows and columns of tiny apertures formed by the spaces between ruled or engraved lines filled with opaque

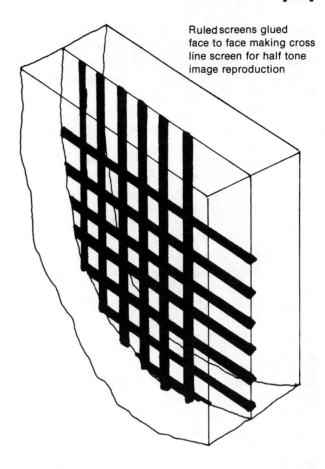

Ruled screens glued face to face making cross line screen for half tone image reproduction

Figure 5-15: **Ruled glass screen: two rulings were filled with opaque pigment, then placed face to face at right angles, making tiny openings at regular intervals.**

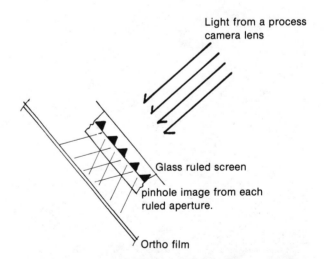

Light from a process camera lens

Glass ruled screen

pinhole image from each ruled aperture.

Ortho film

Figure 5-16: **Light from the process camera lens is seen by each ruling opening as a special source; the pinhole image of each lens varies slightly from that of its neighbor, producing circular latent images of differing sizes in the high-contrast ortho film.**

pigment. The spaces remaining between the lines become tiny lenses (just as in a pinhole camera; an explanation of how this works can be found in any college physics text; see Huyghens' Wave Theory of Light). Each tiny lens in effect makes an image of light it sees, which when it is used in a "process" camera, is the pencil of light coming toward it from the iris of the camera's lens.

The images formed by the array of apertures in the ruled screens are always in soft focus, and when the light seen by adjacent holes is very bright the circular image formed by each screen opening overlaps. When these overlapping images are exposed onto a special high contrast film (generally referred to as "ortho" or "litho" film), the result is total exposure of the film, producing large black areas.

When the screen images are formed by less intense light, the circular images no longer add to full exposure for the ortho film, and the result is a pattern of dots that do not quite meet. When the dots of light formed by the screen meet completely one says the screen is closed, or that there is 100% closure. The dot opening is measured in percentages. It can also be approximated usefully by measuring the average transmission of the opaque and open areas of the film with a densitometer, **provided** the dot size is small compared to the densitometer's effective area of measure.

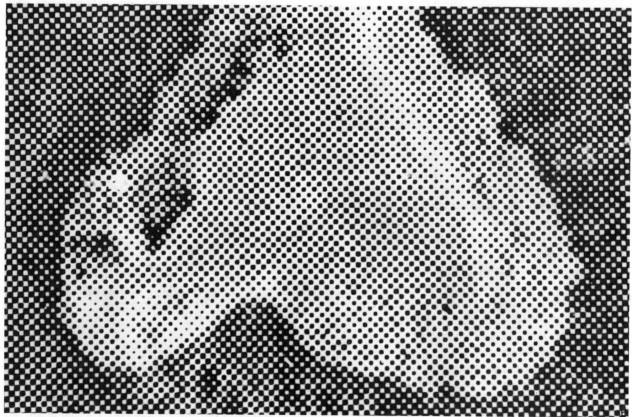

Figure 5-17: A 133-line halftone image (presented in negative) *(A)*, and a 12-diameter enlargement *(B)*. The densitometer can be used to measure the small-dot screen percentages.

The dots become smaller as the light grows less intense. This is because the simple lens formed by the ruled screen produces an image which "falls off" rapidly as one travels away from the axis of the lens. This is true of all simple lenses, and is of great use in producing a dot that varies in size with the intensity of light.

The light source which the screen sees is the aperture of the process camera which in turn is part of the lens system pointed at the original photograph being transformed from grey into halftone. Because light travels in straight lines, each part of the original photograph being copied reflects a different amount of light toward the process camera lens, and therefore each part of the screen will produce a different size of dot, one which should be proportionate to the reflective brightness of the print being copied.

The ortho film is extremely sensitive to very small differences of exposure. This extreme sensitivity is what makes it useful. With a small change of exposure, when it is properly developed, the film will change from remaining clear after development to having totally black densities (in excess of 3.0). This permits the screen system to work: the tiny variations in latent image density created by the falling off of light intensity as the screen's image is evaluated by the emulsion of the ortho film become critical variations, changes of exposure that cause the film to remain clear or become black after being developed.

The process is not linear. Changes of reflectivity from the original photograph proportionately relate to changing dot sizes produced by the glass screen only through a short tonal range. Prints which exceed this range require manipulations in the exposure of the ortho film.

The glass screens were both very expensive and fragile. They were largely replaced in the 1950's with a plastic equivalent, the *contact screen.* The name implies the major difference between the screens: the glass screen made an image, and was held away from the ortho film in a frame that was adjustable, to permit changing the focus of the tiny pinhole images. This change of distance influenced contrast: basically, the closer the screen was to the film, the more contrasty the halftone image that resulted.

The contact screen is a plastic sheet with a mechanically produced varying density pattern which if it were physical rather than visual would rather closely resemble an egg-carton: waves of density move across it in both directions. These are interposed between the image formed by the process camera lens and the ortho film. The densities are calculated by the manufacturer to relate to

Figure 5-18: **A contact screen, seen by transmitted and reflected light.**

normal reflective brightnesses of photographic originals, to the characteristics of the ortho films being made, and to the interaction of these with the developers available. The result is when the contact screen is placed in front of ortho film and exposed to the focused light in a process camera, a very good pattern of latent halftone dots are generated in the emulsion of the litho film.

Both the glass screen and the contact screen have inherent limitations in terms of contrast. Neither of them produce a straight-line response, i.e., where the size of the dot produced is truly proportional to the density of the original subject. The effect is most noticeable in the shadows, where details tend to disappear into blackness.

Contrast control with halftone screens is accomplished by secondary exposures. These are either made through the camera by changing the aperture or the lens after the first exposure is finished, and through the back of the camera by using an unfocused low-level yellow light which will fog the film. The exposure through the lens changes the latent dot image because it affects silver that was not reduced in sensitivity by the primary exposure, in effect using new emulsion. The exposure through the back of the camera achieves its effect by adding controlled units of exposure to the latent image already produced. Since a small change in light level will cause large changes in areas that have had little exposure, but insignificant changes in the areas which have had large exposures, *flashing* with a low-level light permits a sharp reduction in contrast and reinforces weak shadow details.

The methods described by Kodak for using their contact screens are limited to copy camera operation. The problem with this is that much creative work in photographic printmaking (to separate it from production work, in the printing trade) is done in the darkroom under non-standard conditions, in fact under conditions which can rarely be reproduced one darkroom to the next. Printing trade production specifies the exact equipment to be used in a manner standard for the industry.

Because of the experimental nature of photographic print making with halftone processes for the art photographer, many of the processes and ideas discussed here will depart from the legitimate and useful standard processes noted by Kodak and the makers of other graphic arts materials.

Halftone screened images with a standard dot pattern can also be produced by using Kodak Autoscreen film. This is an orthochromatic high-contrast emulsion with a pre-exposed 133-line halftone. If a piece of the film is removed from the box and developed without any exposure, a tiny dot pattern equivalent to about a 1-3% density will appear. With additional exposure, the size of the dots gradually increases, eventually producing a dot that merges and ultimately a pattern that shows almost no openings. This film permits the print-maker to make a ruled-screen image without the expense of either the glass screen or the contact screen.

There are other ways of making halftones. One is to use the "self screening" capabilities inherent in the large silver grain of Tri-X film. This is usually masked by variations in tone in the subject. But a Tri-X negative can be used to produce a halftone positive directly, transforming the continuous tone grey image into dots of varying size and closeness.

Another way is to use a non-standard screen to make the halftone. Any translucent surface that has regular variations in density or transmittance may be used to make halftones. The problem is to analyze the characteristics of the screen and to control the image densities and contrast.

A densitometer can be used to read the effective ratio of the dot to the clear film around it. This relieves the print maker of the problem of estimating percentages of opening or closure and places the change of dot size from one experimental process to another on a measurable basis, without depending on the evaluation of an inexperienced eye. A densitometer will average the amount of light passing through the openings in the high-contrast emulsion and produce a reading which is a useful and repeatable measure. This tool fails when the dot size is large, relative to the aperture of the densitometer probe, or when a very "soft" dot is produced. For the Kodak Model 1 comparative densitometer, the readings are useful until the dot size is equivalent to a 40-line per inch screen. At that size the eye finds it easy to make its own comparisons.

For screens of 65 lines per inch and finer equivalent scale a useful set of limits are:

90% open = density of 0.05
50% open = density of 0.30
10% open = density of 1.00
5% open = density of 1.30

The reason that these controls are needed is that the size of halftone dots that can be reproduced differ from one printing process to another, and also vary according to the fineness of the screen being used. Sometimes the effects of exceeding the limits appropriate to one process are opposite to the effects on another printing process. For example, very small halftone dots begin to reduce contrast with hand-inked lithographic plates because of the smearing of ink from one dot to the next in rolling up and printing, which diminishes the tonal separation. However, with silkscreen printing a very small dot of the same size range

tends to become more contrasty, because the dot is acting as a narrow passageway for the viscous pigment. The small dot opening offers more hydraulic resistance to the pigment and medium than the more open dot does. It quickly builds up a lining in the opening of the photo-resist, effectively

diminishing the size of the dot even more; this same effect is proportionally not as significant on a large dot. The end effect is that the contrast range *in the print* is greater for the screened print than for the lithographed print, when made from originals having identical dot patterns.

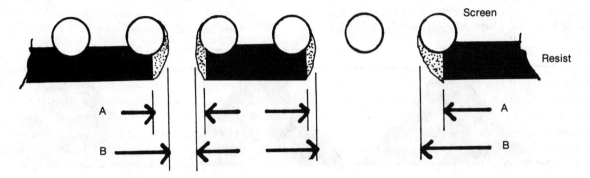

Figure 5-19: **The effect of pigments on very small silkscreen orifices is illustrated. The pigment quickly coats the opening of both the small opening to the left and the larger opening, but has a proportionately greater effect on restricting pigment through the small opening indicated by the letters A-A and B-B. This effect increases the contrast of small-dot silkscreen prints.**

Similarly, the gravure print also is a dot structure that will be affected because the amount of ink that can be held in a shadow area is controlled by the depth of etch, the size of the dot, and the effectiveness of the surviving *land* that supports the ink-removing tool (be it tarleton, hand, or blade) and which keeps the ink in place. Too small a land, and the amount of ink left on the plate will actually decrease relative to a larger land.

Effects of multi-color printing also change the dot-sizes that are most effective. An image that is to be printed in one color (black, or an equivalent) can have a much longer scale in the halftone than an image that is to be printed in three or four colors. As the halftone dots merge and overlap, a visual intensification of the density range develops. An image to be printed in full color requires a much "flatter" halftone dot original than one to be printed in one color.

The choices of dot size and the choice of printing medium will therefore affect the dot size range in the halftone translation of an image. The following table offers starting places for halftone images being printed from gravure plates, silkscreen, and litho plates. The assumption is the photo litho prints are from standard grained metal plates printed on sliding-bar presses.

It is always possible to make separations and then proceed with halftones by trial-and-error, but it is easier to determine the nature of the particular halftone screen process and make separations to fit the density range of that screen. The tests should be done in the same way you expect to

Density Equivalents for Halftone Screens for Photo-Printmaking

Photosilkscreed (halftone positives)	60-100 line min.	line max.	20-60 line min.	line max.
B & W Density	0.15	0.85	0.10	0.90

photogravure (positive)	Zinc: 200line min.	max.	Copper: 200 line min.	max.
B & W Density	0.10	0.90	0.40	1.60
Color Density	0.10	0.80	0.40	1.40

metal-plate lithography (halftone negatives)	80-30 line min.	line max.
B & W Density		
Color Density	1.40	0.10

All densities except for copper photogravure are halftones measured with a Kodak No. 1 Densitometer. Copper photogravure uses a continuous tone positive. "Min." areas are equivalent to Zone VII-VIII textured highlights in conventional prints. "Max." areas are equivalent to Zone III darkest detailed shadows in conventional print notation.

make halftone positives, either by contact printing or by enlargement.

Kodak makes contact screens for producing positives and negatives, in either magenta or grey. The function of the magenta color is to provide a pattern density which can be varied through the use of colored filters over the light source; these change the effective contour of the dot screen. With glass ruled screens this was done by moving the screen closer to or further away from the film,

in effect making the integral pinhole lenses cover larger or smaller circular areas and increase or decrease the contrast of the image.

Contact screens were designed to be used in process cameras where they are held over the ortho film by vacuum pressure. An initial exposure is given through the camera, and then modifying exposures, changing the color of the light by the use of filtration, given through the lens (in effect making a second dot pattern superimposed over the first), or by controlled fogging of the entire sheet of film. Similar controls and fogging, or flashing, can certainly be used in photo-printmaking for expressive purposes.

If the density profile of the magenta contact screen measured with white light is assumed to look like this in cross section:

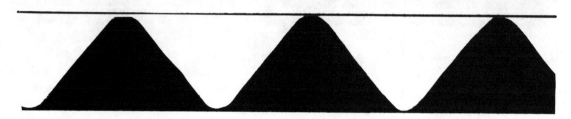

Figure 5-20: **The regular density pattern of the magenta contact screen illustrated in this schematic cross-section.**

then with yellow light, the effective density pattern might be seen to look something like this:

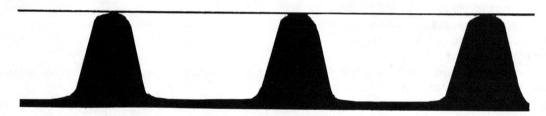

Figure 5-21: **Illustrated with yellow light, the effective density increases sharply in the middle of the dot, protecting the dot center from additional exposure during a flashing with the screen-in-place, but encouraging a buildup of middle and heavily exposed dot.**

which means the second exposure will add light to the marginally exposed sides of many halftone dots, but guard the centers from additional exposure, increasing the overall size of the marginal mid-and-low value dots, but not significantly affecting the size of the dot in the highlights. Flashing, on the other hand, will increase the size of the marginally exposed dots, as well as to some extent modifying the smaller dots.

The effect on the smaller dots is not as great as one would naively expect because the flashing (a controlled fog) has great effect on the marginally exposed silver, but much less effect on the well exposed silver for the same reasons that exposure affects the shadow areas of all silver emulsions more than the highlight areas, as described in the introductory section of Advanced Controls. Because the characteristic curve of ortho film is much steeper, the exposure range from toe to shoulder is shorter but the same logic applies.

Flashing can be done in the darkroom by using a Series OC yellow safelight. A safelight with a 40 watt bulb, at three feet from the film will produce a noticeable change in a normally exposed halftone image with about 10 seconds of flash. Flashing can easily be overdone, resulting in diminished tonal separations or fog density that must be printed through when exposing diazo or bichromate sensitive silkscreen resists or lithographic plates.

The first problem to be overcome for the beginner working with halftone images is evaluation of the dot. The non-standard processes tend to produce a soft dot, with a fuzzy profile, rather than the very precise hard dot possible with a contact screen and precise flash exposure. The soft dot appears to the eye as a brown image superimposed on the black image of the dot. You have to teach your eye to look through the brown cast, and see it as a variable, to be controlled in making the next halftone image.

If one makes a halftone from a separation negative, the result is a halftone positive. The photo-

Figure 5-22: The effect of flashing without the screen:
(A) was given an exposure suitable for the shadows, but no flash, and the same development as
(B) which was given a flash of 25 seconds, 30 inches from an OC safelight, illuminated with a 25 watt
lamp. The additional exposure to the latent image enlarged the dot overall.

silkscreen and zinc photogravure processes described later both require halftone positives. The dot size for the photosilkscreen is limited by the capabilities of the screen, and the screen printer's experience. A large dot (10-50 lines per inch) is easy to handle without screen clogging. A small dot (60-100+ lines per inch) can be handled if the operator has enough experience to prevent drying and clogging of the highlights. The final dot size is therefore a practical as well as an aesthetic problem, one which must be decided on in the darkroom. A halftone 35mm image has a certain dot-screen count. When this is enlarged, the dots are enlarged and the absolute count of the number of dots in a linear inch decreases.

For example, if the halftone is made by contact onto a piece of Kodak Autoscreen film, the dot pattern is 133 lines per inch. Enlarging this to a 10 x 15 inch picture will be about a 10X or 10 *diameter* increase. The 133 line pattern is now about 13 lines per inch, which is quite coarse. The dot pattern will be very visible at a viewing distance of less than 10 feet. And when one is close, the dot pattern will tend to dominate the picture.

If a smaller pattern is desired in the finished print, a larger initial halftone must be made.

1. Sketch out the size of the finished print.
2. Estimate the screen size desired, in lines per inch.
3. Divide that screen size into the screen size available.

Figure 5-23: (A) **A color halftone photosilkscreen print, seen in a domestic environment, at normal distance.**
(B) **A selected detail from a positive, presented at actual size, showing the size of the dot used.**

Example: Image size = 10 x 12.

1. Dot pattern desired = approximately 25 lines per inch.

2. Screen being used is Autoscreen (133 lines per inch).

3. 133/25 = 5.3

4. 12/5.3 = 2.25.

The long dimension of the halftone original should be 2.25". Either a separation negative that is about 2.25 inches could be made, or a contact separation could be enlarged through the halftone screen.

The first generation of halftones is always characterized by a "soft" dot, a silver image with sloping sides. This means that the exposure from that soft dot will have some ambiguity. In an exaggerated schematic of this, the soft dot is shown in profile, and the possible shape of the dot that could be produced from it with different exposures is shown in this drawing:

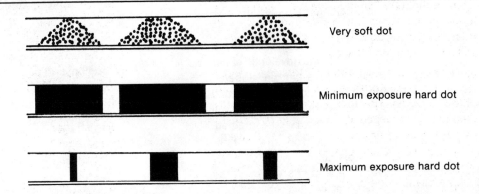

Very soft dot

Minimum exposure hard dot

Maximum exposure hard dot

Figure 5-24: The "soft dot" will always be converted by the next high-contrast process step into a hard dot, and can be made into a larger or smaller dot, depending on exposure.

Such a possibility always exists because the materials the halftone is exposed on to—silkscreen resists or etchings resists— are in themselves high contrast photosensitive substances that have a characteristic curve similar to that of ortho films: almost vertical, but with some latitude. The size of the dot in the photoresist will vary as a function of exposure when printed from a soft dot halftone.

This is not necessarily bad, but it does introduce another variable in the making of resists for halftone printing. When the soft dot is enlarged and copied the profile of the dot is inevitably simplified, and the result is a cleaner dot with a more precise profile.

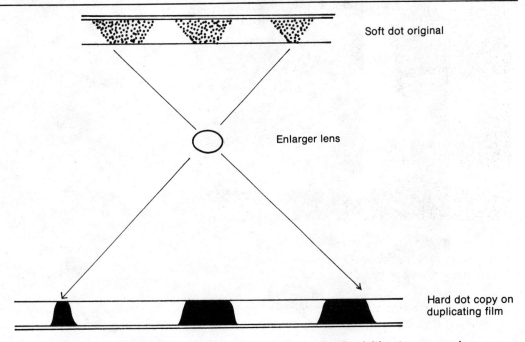

Soft dot original

Enlarger lens

Hard dot copy on duplicating film

Figure 5-25: The soft dot is a variable which must be considered when enlarging (either to a reversal, or as in the illustration to a direct copy, e.g. with SS4 film).

The separation negative produces a halftone positive. Both zinc gravure and photosilkscreen require halftone positives. Usually the photosilkscreen positive must be enlarged. To produce an enlarged positive is simple when Kodak SS4 Super Speed Duplicating Film is used. This is an ortho emulsion pre-exposed to the top of the characteristic curve. Additional exposure will reduce density. Exposing SS4 to a halftone by contact or enlargement will produce a latent image that is identical to the source image. Copies of halftones can be made without other intermediate film materials.

SS4 is about as fast as Type 3 Ortho film; it can be exposed with the enlarger and developed either with Kodalith developers or Fine-Line developer. It works well with Fine-Line and still development to produce exact copies of halftones. Exposure will determine what part of the soft dot will be retained.

Registration is sometimes a problem with halftone printing; exact registration begins with the separation negative. If separations are made by contact, there are essentially no problems provided that wash and drying temperatures are kept moderate. Heat should not be used to dry separations or halftone positives made from separations.

When halftone positives are being enlarged, the small positives must be placed in the enlarger in the same orientation each time (as no enlarger is exactly square and produces a wedged image). To guarantee enlarged separation positives will be in register, the following procedure is recommended:

Enlarge the first halftone onto ortho film and process it. Wash the first halftone and return it to the enlarger. Put the second halftone in the negative carrier. Verify that the projected image is in fact in register with the first halftone. Refocus or adjust the enlarger to bring the two images into exact register. Remove the first halftone and wipe dry the enlarger. Expose the second halftone on ortho film, and process it. Using the first halftone, repeat this registration procedure for the third halftone.

Registration of separations made from 35mm transparencies is quite simple because of the many points of reference provided by perforation patterns and edge identification numbers. Larger transparencies should be marked with small "x" scorings in the emulsion, scraped with the point of a sharp art knife. Three marks should be made to provide complete registration guides.

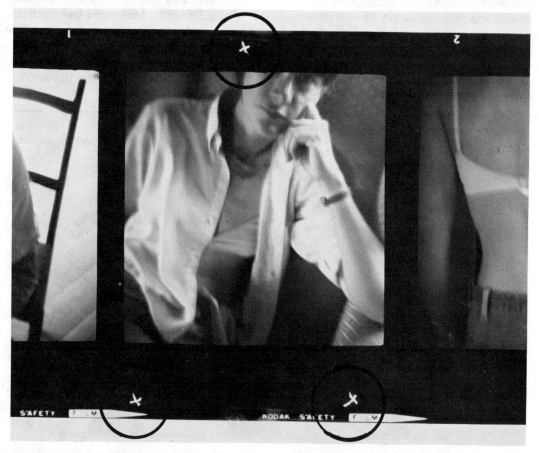

Figure 5-26: **A print made from a separation negative to show the *x*'s scored through the color emulsions on the original transparency to facilitate registration of all subsequent steps.**

Any halftone system can be tested for determining the separation negative density range that is most suitable. Tests should be made by the method you plan to use, either contact or projection. If by contact, a Kodak Photographic Step Tablet No. 2 can be used. If projection halftones are planned, make a step tablet from pieces of parametric testing film, as described in Advanced Controls.

Expose the step tablet onto ortho film through the halftone screen you are investigating. Do not use any flash or other secondary exposure. Develop the test sheet the way you would develop the halftone. Continuous agitation will produce different results than initial agitation followed by still development; the dot in heavily exposed areas will tend to close up and contrast is increased.

Develop the film normally; stop, fix, wash and dry. Measure the density of each step in the original step tablet and in the halftone print. Graph the original densities along the horizontal axis, the halftone along the vertical:

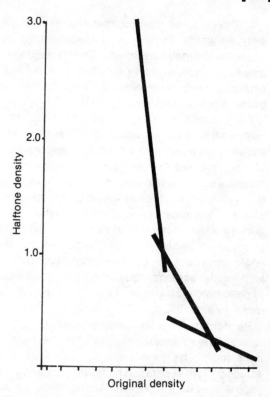

Figure 5-28: **Simplifying 5-27 into three contrast ranges.**

The middle of these lines is of moderate contrast, the lowest part of the curve is quite flat, and the part to the left is quite contrasty. Knowing this, you can adjust your separation negative densities to fit the screen, using whatever section is suitable:

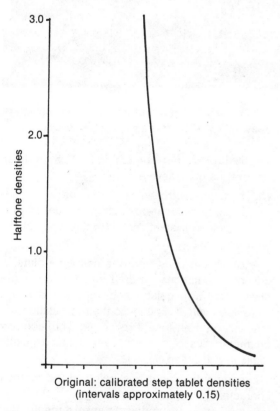

Figure 5-27: **Transfer curve of a Kodak contact screen, produced by exposing a Calibrated Step Tablet to Type 3 Ortho film, developed in Fine-Line Developer with still agitation, as described in Chapter 5.**

This illustration shows how densities in the step tablet are changed when converted by the halftone screen to dot densities. The curve shown is one produced from a Kodak Magenta Contact Screen. Examining this, it can be approximated by three straight lines:

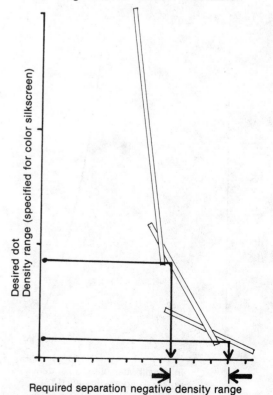

Figure 5-29: **Showing how one can use the transfer curve to estimate the separation negative density range needed for a given kind of contrast.**

Pick the densities desired from the vertical line, and see where they intersect the characteristic curve for the halftone screen. The projection of these intersections down onto the base will indicate the density range needed in the separation to produce the desired results.

What other kinds of halftone screens are available, what kinds of response do they have, and why should one be concerned at all? Working from last to first, the regular line screen pattern of the magenta screen will interact with itself if one color is layed over another unless they are carefully aligned to reduce *moiré.* Moiré is a pattern produced by the interaction of two regular patterns, and is controlled by the size of the patterns and the angle between them. Color photoreproduction with regular screens requires them to be angled at approximately 30 degree intervals to reduce the moiré to a minimum.

Random or irregular patterns avoid moiré. This is one of the strongest arguments for investigating nonstandard halftone systems. With a random screen pattern separation halftones may be superimposed without concern for the angle of the screen because no moiré is possible.

There are several ways to achieve a random pattern. One source is the finely textured "non-glare" glass sold for framing pictures. The irregularities in this glass change the direction of light falling on the ortho film just enough that the image

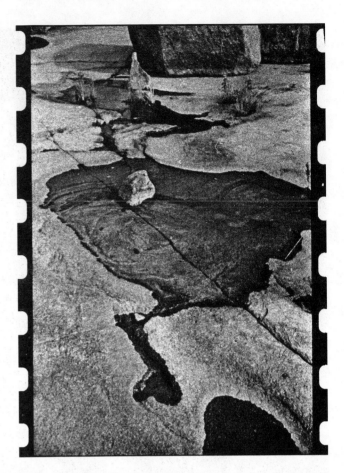

Figure 5-31: (A) Halftone made using non-glare glass.

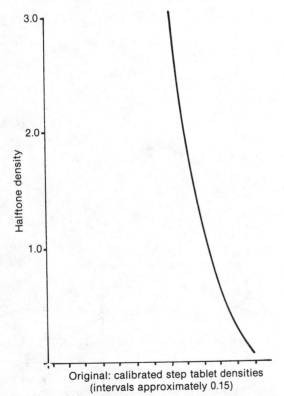

Figure 5-30: Transfer curve for non-glare glass used as a halftone screen, illustrating its very-high contrast.

will be broken into random dots. The contrast, however, is quite severe.

With suitable controlled separation negative densities, useful random-dot halftones can be produced. The equivalent screen to this is about 150 lines per inch.

Another source is from the collotype plate. A grid of reticulations can be formed by coating a glass plate with gelatin and baking it dry in a collotype oven. This is described in detail in the chapter on Half-tone Processes. The contrast characteristics of a sheet of reticulated gelatin looks like this: see Fig. 5-32

Experimental work has shown that the contrast characteristics of the reticulated gelatin sheet can be modified by using dyes to absorb the light, in addition to the absorption and diffraction effects already present in the gelatin pattern. With the addition of dye, the linearity of the gelatin sheet can be extended to a remarkable degree.

The effect of this is to produce a half-tone screen that produces very nearly linear translations of separation negative densities into halftone densities, with equal value being given to both highlight and shadow areas without need for flashing to control dot size.

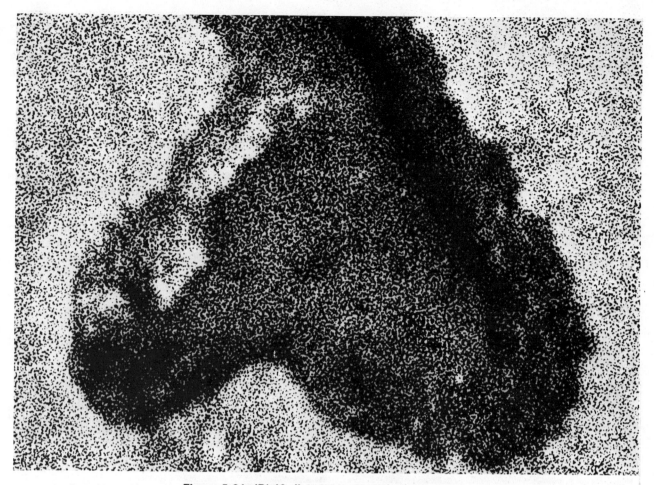

Figure 5-31: (B) 12-diameter enlargement of a detail.

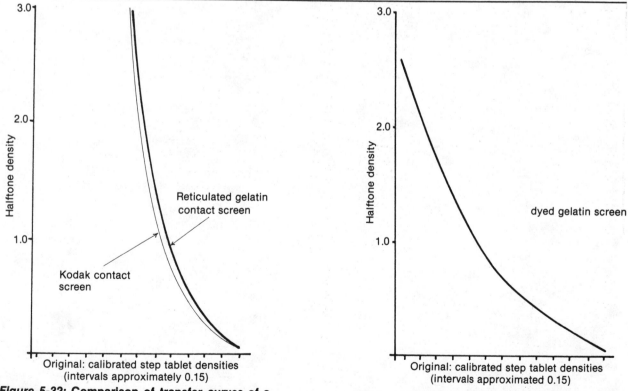

Figure 5-32: Comparison of transfer curves of a Kodak Contact Screen and an undyed reticulated-gelatin collotype screen.

Figure 5-33: Transfer curve of a dyed reticulated-gelatin contact screen, showing contrast control.

Halftone negatives can also be made from separation negatives by using the grain structure of the film itself, by a process called "self-screening." A separation negative with a maximum density range of 0.80* is enlarged on to Tri X Pan sheet film.

A typical exposure for a Beseler enlarger , from 35mm to 3 x 4 inches, is about 2 seconds at f-32. A neutral density filter may be necessary to reduce the light to a useful value. In this case, a Wratten No. 96 ND 0.60 would permit an exposure of 8 seconds to be used, or 2 seconds at f-16.

This enlarged Tri. X film positive is then developed in D-23 diluted 1:1 (or simply mix 4 g of Elon and 50 g of Sodium Sulfite in 1 liter of water) for 4 minutes at 21 C. Agitate constantly for the first thirty seconds, and then lift the film from the

*35mm negatives often lack large simple tones suitable for densitometer measurement, so in this case the minimum density is the perimeter of the 35mm frame (what was the dark film surrounding the picture in the original transparency) and the maximum density is the fully exposed film lying outside the 35mm film strip itself, but still masked by the contrast mask to which the transparency had been matched when the separation was made. Measuring these definite areas means that the image densities lie safely within those density limits, and in fact usually fall within a range of 0.30-0.40 if defined in terms of Zone III and Zone VIII values.

Figure 5-34: (A) Halftone made using dyed gelatin screen.

Figure 5-34: (B) 12 diameter enlargement. (Note lessened contrast, and apparently softer detail, a function both of finer halftone and low screen contrast transfer curve.)

developer and lay it back in the tray at the beginning of each minute for the rest of the developing time. Develop face up, but do not agitate except for this lift-and-replacement each minute. At the end of development, stop, fix, neutralize and wash. Dry the film.

The Tri X grain is large enough that it will function as a diffusion pattern, creating significant—though tiny—variations of transmittance within a given continuous tone area. Exposing this film by contact to a sheet of Type 3 Ortho, and then providing proper development will break the very low contrast positive film image into tiny dots of opaque silver, in other words create a halftone from a continuous tone. The pattern is quite fine, approximating that of a 300 line screen.

Expose the film positive, which should have an image density range from maximum to minimum not exceeding 0.40, by contact, using the enlarger as a light source. The emulsions are in normal printing position. The enlarger should be set at f-16, and a trial exposure of 10 seconds be used.

Develop the ortho film in a smooth bottomed tray. Wet the tray with water; dump the water; place the film face up on the bottom of the tray, and pour smoothly over the film 150ml of Kodak Fine-Line developer—75ml of *A* Stock, 75ml of *B*. The developer must be between 21-24° C. Agitate by tipping the tray sharply, end-to-end and then side-to-side for 10-15 seconds. Stop all agitation.

Figure 5:35: (A) **Halftone made using self-screening process.**

Figure 5:35: (B) **12 diameter enlargement.**

Figure 5-36: **Halftone made using Kodak Auto-screen film.**

After about 40 seconds the image will begin to appear. It will be faint, and the heavily exposed perimeter will be only a slightly darker grey. At about 1½ minutes the perimeter will quickly turn black, and in the next 30 seconds the image will develop fully. Pull the negative at the end of two minutes development, stop, and fix.

A correctly exposed and developed self-screening negative will appear like a slightly con-trasty conventional negative to the eye. Under a 10-power magnifier a definite dot will appear. In the unexposed perimeter of the 35mm film (which prints black) there may be a random speckling of silver. The dot formed by this process is a soft dot, and may be difficult to evaluate by eye as there is a definite brown cast to the dot edge. The soft dot *negative* is much more difficult to evaluate by eye than the positive. The best proof of the process is to make an exposure onto a *blue-line* or *brown-line proof* paper. These are diazo process proof materials used by printers to validate their own negatives. Until experience is gained in evaluating negatives, such proofing is probably necessary.

The contrast of this self-screened image may be reduced, and a more definite—though still random—dot produced by using the same separation negative and film procedure just described, but by adding a sheet of Kodapak Diffusion Sheet to the process. The Diffusion Sheet goes between the negative and the contact print frame glass, textured side toward the glass. The tiny, random corrugations in the diffusion screen work in conjunction with the Tri X grain to create a slightly coarser pattern than the film alone produces, but a more definite one. It is useful for halftones intended to be enlarged for photosilkscreen use because the Diffusion Sheet produces a definite dot in the black perimeter of the 35mm frame; this will appear as a definite opening in the maximum density of each color or as a reduction of contrast.

The soft dot self-screened image may be transformed to a hard dot at a suitable size (of both image and dot) by enlarging the halftone negative onto ortho film, and developing the enlarged halftone positive in Fine-Line developer, using the same method outlined. A larger quantity of developer may be needed if the positive is larger than 8 x 10, but by using the modified single-shot method described earlier one may produce repeatable results with great economy of chemicals, and also produce very clean dot formation.

CHAPTER SIX
Alternate Photographic Processes

Alternate Photographic Processes

The silver process has dominated popular photography since the beginning of the 19th century when Wedgewood and others tried vainly to capture the fleeting patterns created by light falling on silver compounds. But even after the camera obscure picture was captured, by Niepce, Daguerre, Bayard, and Talbot in the third decade of that exploratory century, problems inherent in the medium continued. The most significant of these was permanence. Perhaps the next most troublesome was physical fragility of the print.

Silver is attacked by sulfur and decomposes. One may guard the silver by using gold, selenium, glass, special papers, but not avoid decomposition forever. Many efforts were made to develop photographic processes that either didn't use silver, used silver in passing, or used silver in combination with more permanent and inert metals.

To make the picture brilliant, very smooth and highly glossed papers began to be used. The more brilliant the print, the more physically fragile it is.

Fading of silver prints had been noted from the days Talbot established a photographic printing establishment at Reading, England. In fact, in 1855 the Photographic Society of London established a committee to investigate causes of fading, and make recommendations about how it could be avoided. Their suggestions were to fix the prints better, wash them better, and avoid sulfur. The investigations continued, and eventually the idea that toning would also help preserve the print became prominent.

Within a dozen years after the silver process became commercially usable a number of other photographic printmaking ideas were explored or perfected — often to a degree that is difficult to match today. It is interesting that most of these alternative printmaking methods depend on photosensitivity of iron salts, or the peculiar properties of certain chromium compounds. Potassium bichromate was discovered to be photosensitive by Mungo Ponton in the spring of 1839; he published a process using bichromate as a cheap way to reproduce drawings without the use of silver. Bichromate was combined with a natural binder, gum arabic, starch, glue, gelatin, in experiments by Talbot as early as 1852. By 1855 the idea had moved from Scotland, where Ponton lived, to England and on to France, where Alphonse Poitevin developed a photolithographic printing process using bichromated gelatin. It was called collotype, and he also invented the first permanent photographic printing method, called carbon printing. Carbon printing was announced in 1859, collotype in 1867.

A combination of processes was assembled by Karl Kliĉ in Vienna in 1879 into a new printing system called photogravure. His process was a bringing together of Talbot's idea to use a rosin dust fused onto a metal plate by heat (known to etchers as an aquatint ground), and the carbon process — invented by Poitevin, perfected by Swan in 1864 — to make a photographically controlled etching. The picture was as permanent as the ink and paper itself.

Collotype, gum, carbon and gravure prints all depend on the peculiar property of bichromate (also dichromate) salts, which is to become insoluble on exposure to light; they also tan, or increase the melting point of natural organic colloids.

Iron salts were used in photographic printmaking as early as 1842 when Sir John Herschel described the *cyanotype* process in a report to the Royal Society. He used it first for copying complicated mathematical notes he was unwilling to give to clerks, for fear of errors of copying. The Focal Dictionary describes iron salt processes as "based on the reduction of ferric salts of organic compounds (citric, oxalic, etc.) to the ferrous state by ultraviolet or blue light action. The ferrous salt will (1) Combine with potassium ferricyanide to form Prussian blue (blue print process) .(2) Reduce silver salts to silver (Kallitype). (3) Reduce palladium or platinum salts (Palladiotype, Platinotype)."

A group of compounds based on a nitrogen chemistry that had been used to make dyestuffs

were discovered, in 1881, to be photosensitive as well. Berthelot and Vieille noted that diazos were sensitive to light, and since then new adaptations of this fact have been appearing in photo-printmaking. The term diazo is an abbreviation of diazonium. These salts are inherently unstable, and the instability can be linked to couplers in an alkaline medium so that the action of light will either make or destroy dyes. They are essentially sensitive only to u.v. radiation, though the intense visual blue light of an arc will also decouple them. They are impermanent: all azo-dyes will be destroyed by prolonged exposure to sunlight or u.v. radiation. But the diazo process can and has been linked to other materials, in which the original reaction is a method for achieving a more permanent print. The diazo chemistry is used in the 3M Color proofing system by many printers, and is also used to produce photoresists for silkscreen printing, and resist coatings for photo-offset printing plates.

There is no print that has the smoothness of tone and the lustrous appearance of the silver print, except the silver print itself. And the history of alternate printmaking processes is marked with ambivalent attitudes — sometimes trying to emulate the silver print and sometimes turning away from those qualities and investigating possibilities implicit in alternate printing methods.

There are many surfaces for the photograph other than a smooth or glossy piece of paper. Photographs can be put onto canvas, dishes, walls, or other firm or rigid surfaces — wherever you desire — by preparing your own emulsion or purchasing liquid emulsion ready to be applied to nonstandard supports.

Rockland Colloid, 599 River Road, Piermont, N.Y. 10968, has been supplying emulsion for non-standard applications for many years. They sell a projection-speed emulsion, No. CB-101, and a faster emulsion No. CB-201. These are gelatin-based emulsions which are semisolid at room temperatures.

Gelatin is sold as a powder that is made from either bovine hoofs and hides, or from pork skins. The hoof-and-hide gelatin is cured by an alkaline process, and is the basis of traditional photographic chemistry. Recent market changes have forced the introduction of pork gelatin, which is referred to in the trade as being acid-cured. Gelatin is now measured by the Bloom Index, which is a measure of the ability of the colloidal form to withstand crushing and shearing forces. Photographic gelatins may be purchased from chemical supply houses by requesting hoof-and-hide gelatin with a Bloom Index between 150 and 225.

Gelatin will absorb about 16 times its own volume of water without losing coherence. When properly swollen, the water + gelatin is a special substance called a colloid, a suspension that has a measurable internal cohesion. This collodial substance will melt at about 35° C/95° F. At about 50° C/130° F the organic links that form the essential membrane in the colloid begin to decay. The gelatin breaks down; the process cannot be reversed.

Between 35-50° C/95-120° F, the gelatin is a liquid that can be sprayed, brushed, squeegeed or silkscreened. As it cools it will regain its semisolid consistency you are familiar with in desserts. In a thin film, when it dries it will shrink and if the surface under it has a tooth, and is chemically clean, it will adhere. It will adhere so well, in fact, that sheets of gelatin were once used to make frosted glass by being baked in place and then torn off, pulling tiny particles of glass with them. Poor adhesion is a result of a flexible support, improper drying, or the presence of surface oils that defeat the gelatin's attempt to grip. The thin film of gelatin is also moderately brittle, and grows stiffer with age. There are emulsifiers used with the Rockland FA-1 gelatin, designed for fabrics.

The Rockland emulsions are characteristic of all silver halide-gelatin emulsions. When they are first warmed, their response is rather erratic and they have lower sensitivity than they have if they have been aged, or ripened. Bringing the bottle of gelatin to 50° C/120° F for two-four hours will increase the sensitivity of the emulsion, and also increase the quality of the maximum black.

The projection speed emulsions are treated chemically just like any other photographic emulsion. Development can be controlled by modifying the contents of the developer as noted in Advanced Controls. There are obvious mechanical problems, linked to the nature of the support materials used. A good way to work is with plastic buckets of developer, stop, fix, eliminator, each with its own color-coded plastic sponge purchased in the kitchenwares department of your grocery store. The appropriate chemical can be sponged onto the irregular surface and spread with gentle, regular crossing strokes until the picture is fully developed. Chemical fog and staining are minimized by increasing the Potassium Bromide about 20% in most standard developers. The use of the combined fixer-eliminator possible with Orbit Bath permits reasonably permanent pictures with the use of 10-15 careful spongings of the object with clean water. Permanence is often not a factor, since many of the uses to which these emulsions are put are not intended to be longlasting, being experimental, ornamental or for publicity.

It is also possible to make your own emulsion. Details are spelled out in the Kodak pamphlet AJ-12, *Making a Photographic Emulsion.* This pam-

phlet is free; write to Customer Service, Kodak Park, Rochester, New York 14650. It describes in detail how to make a usable silver-bromide gelatin emulsion. In outline form, make these stocks:

A: combine 45 grams Silver Nitrate
with 415 ml distilled water (under photographic safelights);
set this to one side while making up a gelatin solution that contains:
B: 10 grams of gelatin dissolved in
385 ml distilled water; let this swell. Then, add
C. 30 grams Potassium Bromide, and
1.3 grams Potassium Iodide.

Raise the temperature to 53-55°C, and maintain it while adding the Silver Nitrate (solution A) slowly (20 ml every 10 seconds). Stir constantly, and maintain the temperature for 10 minutes after mixing. Warm the gelatin to 43-44°C, and mix the Silver Nitrate + Bromide + Iodide with the gelatin.

Note that you now have about a liter of chemicals. Allow the raw emulsion to cool and jell. Dispersion of the silver is accomplished through mechanical mixing. Tradionally, it is called "noodling" because the solid gelatin is forced through cheesecloth, tearing it into slivers, or noodles. Put the gelatin in a washed piece of cheesecloth, immerse it in cold water, and twist the cheesecloth tightly around the gelatin, squeezing it out through the fabric. Strain this mass of noodles in a sack of 2 or 3 layers of cheesecloth (no iron should contact the emulsion at **any** point in the process). Wash the noodles by flooding them with cold water, allowing them to sit for 2-3 minutes; drain, and repeat. Wash five times. The washing process eliminates unbonded salts. Strain the remaining noodles and heat them in a waterbath to 53-55°C; maintain that temperature for 15 minutes. Cool it to about 40°C and coat it on the paper or other support you plan to emulsify.

This material is moderately fast, about ASA 10, and can be used to make camera negatives as well as for printing. It is of course a color-blind emulsion, being sensitive only to blue light, and duplicates the emulsions in use at the end of the century.

Nonstandard emulsions must be put on something, be it glass, paper or more esoteric supports. Paper is the most commonly used support, and it in turn bears some examination. Most papers have an excess of sulfuric acid, waste left over from the papermaking process. Many papers also have iron contamination. The best papers (those with the least acid and the least iron both) are Rives BFK, Crescent Bristol vellum surface, 100% rag, Crane's Kid Finish Ecruwhite, GL 1816-0525 or Kid Finish

White CH-2111-275), or the back side of outdated photographic paper that has been cleared of silver in hypo, neutralized, washed and dried.

These papers each have different absorbencies, and the emulsions (gelatin and others to be discussed later) may penetrate deeply, or lie on the surface. It is important to realize that once one leaves the traditional and standard processes — the commercial and proprietary silver print, anything goes! The result is or should be controlled by your own sense of taste, your own perception. Papers that have open structures are usually sized, i.e., treated with colloids that fill the porous structure of the paper and yet do not destroy the "tooth" that permits the emulsion to adhere evenly. But they do not have to be sized. Unsized papers will permit a deeper penetration of chemicals and emulsions. This may be wastefully expensive, it may be a cause of staining, and it may be a way to a richer, denser image. The information presented here is intended to provide a safe initial working method; suggestions about the use of sized versus unsized papers will be offered but individual experiment will have to be the final factor.

The gelatin emulsion will work well on unsized as well as sized papers, or even on glass. Gelatin has very high adhering powers provided it has never been overcooked, held above 55°C. In fact, gelatin itself is an important size, as will be noted in the section of Bichromate Printing.

If the gelatin is to be coated onto glass, the surface must be thoroughly degreased. If the glass is fresh from the package, it is easily prepared, as follows:
Clean the glass by soaking it in Kodak TC-1 tray cleaning solution:

Potassium Dichromate	90 grams
Sulfuric Acid, conc.	90 ml
Water (to make)	1 liter.

Dissolve the Dichromate in the water, then add the Sulfuric Acid slowly, stirring constantly.

When the plate is clean, water will "wet" it perfectly, without forming globules that stand separately.
Glass being used for experimental negatives may be given an undercoating of hardened gelatin to insure adhesion of the photosensitive emulsion:

Water (distilled) @ 20-21°C	1 liter
Gelatin	5 grams
Chrome Alum	0.5 grams.

Allow the gelatin to dissolve in the water, then stir in the Chrome Alum. The glass should be cleaned, washed, and dipped into this subbing solution, and stood on edge to dry. The long dimension of the plate should be horizontal, and the glass should be supported by pencils or dowels so excess gelatin can flow clear of the glass.

The Kallitype is a silver-iron printing process which was popular in the nineteenth century, then fell into disfavor because of fading. Using hypo eliminating solutions and washing the print carefully will minimize if not eliminate these. The quality of the paper, its freedom from acid, is of importance to permanence.

The Kallitype process offers an image which has a surface resembling the platinum print, and a more straight-line response to the visual information in the negative than does the regular silver print, plus an image color that resembles the platinum print. Because it uses silver for the image, there is, however, the instability that is inherent in all silver-based prints.

The Kallitype process is in part a printing-out process, with a subsequent image development. Prints must be made by contact. Enlarged negatives can be made using the Kodak Professional Direct Duplicating Film (SO-015).

The final image is formed of metallic silver. The photosensitive emulsion is an iron salt. The salts used are those used for ferrocyanotype, but the sensitizer is compounded differently and only a faint image results from the direct exposure to light. The final image is created by adding silver nitrate to the print.

After being exposed to the negative by strong daylight, mercury vapor or arc light (for an exposure time similar to platinum) the print is immersed in a simple alkaline developer. Fixing is done in a weak sodium thiosulfate solution which has been buffered with ammonia.

The printing paper must be prepared by being sized, if a quality rag paper is being used. For first experiments a heavy bond typing paper may be used, without additional sizing being needed. For final prints on Arches, Reeves, Strathmore or other papers a starch sizing may be desired.

The sized paper is sensitized by spreading the photosensitive emulsion with a plastic brush. This may be done in weak tungsten light, but the paper must be dried in darkness. It is best to complete the drying with gentle heat before printing.

Kallitype Sensitizer:+

Ferric Oxalate	5.0 grams
Oxalic Acid	0.3 grams
Silver Nitrate	2.5 grams
Water	30 ml

When the paper dries, warm it to complete the drying and expose immediately. A fully visible image will not be produced. Exposure is complete when the shadows are fully visible, but the print will be overexposed if detail appears in the middle tones or in the highlights, The image looks pale brown, against a yellow background. The following developers produce different image colors.

Kallitype Sepia Developer:

Potassium Sodium Tartrate	15 grams
Potassium Dichromate	0.1-0.3 grams
Water	315 ml

Kallitype Cold-tone Developer:

Borax *Twenty Mule Team*	8 grams
Potassium Sodium Tartrate	30 grams
Potassium Dichromate	0.5 grams
Water	315 ml

Kallitype Black Developer:

Borax *Twenty Mule Team*	30 grams
Potassium Sodium Tartrate	22.5 grams
Potassium Dichromate	0.3-0.4 grams
Water	315 ml

Development may be done in weak tungsten light. A correctly exposed print cannot be over-developed. The image appears in a few seconds. Leave the print submersed in the developer for 5 minutes to be certain that full development has been obtained.

Wash the print for two minutes in running water following development. Fix it for 10 minutes in the following fixer:

Kallitype Fixing Solution:

Sodium Thiosulfate	50 grams
Ammonia 0.880 specific gravity	12 ml
Water to make	1 liter

After the print is fixed, use a hypo clearing solution as directed for double-weight prints, and then wash thoroughly.

The print may be air dried or heat dried, and mounted by any standard method.

Other ironbased photosensitive printing systems that are of use to contemporary photo-printmaking are the cyanotype and the Van Dyke, or brownprint process. The Van Dyke print is similar to the Kallitype in that it is an iron-silver reaction:

Van Dyke Emulsion

Ferric Ammonium Citrate (green scales)	2.5 grams
Oxalic Acid	.4 gram
Silver Nitrate	1 gram
Water	30 ml.

Mix in the order listed; the Silver Nitrate may dissolve slowly and the solution should be made at least 24 hours before use. Store in brown bottle, preferably in the dark.

To use the emulsion, coat the paper (which may be sized or unsized: unsized paper will have a less

+This is the simplest useful variation of many versions published on the process.

crisp image, but somewhat greater density) and let the emulsion dry in the photographic darkroom. Standard photo-safelights may be used; this emulsion is blue-sensitive only.

Expose by contact. The exposure source may be daylight, arc-light u.v. fluorescents or sunlamp.

Developer
Borax (Twenty Mule Team)	5-10 grams
Water	1 liter.

Develop for five minutes. At the end of developing the image will appear a little flat, with some highlight fog and weak shadows. Fix in a simple Sodium Thiosulfate solution:

Fixer
Sodium Thiosulfate	10-20 grams
Water	1 liter.

Use a hypo neutralizer and wash thoroughly for permanence. Be certain that no iron comes into contact with the emulsions during mixing or coating or processing. Brushes used to spread the iron-salt emulsions must be free of metal. Japanese sewn-bristle brushes can be used, or brushes can be made, using the fibers from a soft camel's hair watercolor brush and resetting them, binding them to a wooden handle by means of an epoxy, casting resin, or RTV rubber compound (all available at automotive body-shop suppliers). The foam paint-brushes available at paint shops can be used. These will not last long, and require careful washing out after use, but are inexpensive and can be considered almost as throwaway tools.

The Cyanotype, or Ferrocyanotype, was used in the nineteenth century for conventional printing by Gustave LeSecq — documenting the gothic structures of Paris for the French government — and occasionally at the turn of the century by Clarence White and others of the pictorialist movement. Recently, the process has been revived for itself and combined with gum printing and other manipulations. The image is intense blue (Prussian blue). Mix two stock solutions:

Stock A:
Ferric Ammonium Citrate (green scales)	68 grams
Oxalic Acid	1.3 grams
Water (distilled) to make	250 ml.

Stock B:
Potassium Ferricyanide	23 grams
Oxalic Acid	1.3 grams
Ammonium Dichromate	0.5 grams
Water (distilled) to make	250 ml.

Store these in brown bottles, or in the dark. Mix equal parts of A & B when ready to use, and spread the emulsion immediately on the paper or cloth to be printed. This emulsion is sensitive only to blue light, and standard photographic safelights can be used during preparation. Some workers like brighter surroundings; the yellow "bug" lights are also safe, and will provide bright working conditions. If using sized paper, the emulsion will go far, about 10ml being adequate for an 8 x 10 inch sheet of printing paper. Unsized paper or cloth will take much more.

Spread the emulsion with a nonmetallic brush and dry it in the dark. Print by a u.v. rich light source. The image forms as the light acts upon it, i.e. it is a "printing out" process. When the print is dark enough, wash it in cold water until the yellow Dichromate stain is gone. Different papers will have trace minerals that interact with the iron-salt process, and a number of minor variations in color may be produced, one paper to the next.

The last of the iron-salt processes is the most expensive and perhaps the most elegant print of the alternatives to a silver print. J. C. Burnett exhibited the first platinum prints in England in 1859, but it was twenty years later that William Willis made available a commercial platinum paper, sold by the Platinotype Company, in London. The image is most stable; the iron is etched away during the post-development process, leaving only platinum.

The price of platinum rose steadily from the 1880's until it became too expensive for a competitive market and commercially made platinum paper was discontinued before the Second World War. As a footnote on its history, three sequential editions of a standard reference text on photographic processes, published from 1930-1945, list the platinum process merely as a commercial process in the early edition, offer the chemistry because the process was no longer commercially available in the middle edition, and then refers to it in passing as an obsolete process in the later edition. The platinum print was often overprinted with a gum-bichromate image (to reinforce the blacks, and to add color) by the major photographic artists of the Photo-Secession — Steichen using the method to produce powerful mood statements, and Clarence White to produce stronger tones in his commercial portraits.

The chemicals have been difficult to obtain, specifically the correct ferric salts and the platinum salts. One can still shop around and locate these at different prices, but a special distribution company has been established called Elegant Images, 2637 Majestic Drive, Wilmington, Delaware, 19810, that provides a dependable source of all the chemicals as well as student kits for making a few trial prints. Prices vary with the market in rare metals, but the cost of making a single 8 x 10 platinum print (paper, sizing, emulsion, developer,

clearing bath) will range from $1.50-$3.00. This is not exorbitant if the materials are used sensibly, and the prints are worth the investment. Other printing methods — photogravure, for example — are far more expensive if only a few prints are made because of the investment in inks, copper, etchant, and special equipment.

Platinum, like gravure, has an essentially straight-line response to light. Unlike the silver process, it does not add an "S" shaped characteristic curve to the negative formation, and therefore it does not tend to crush shadow details. The negative for platinum printing can range from what would be considered a normal negative for silver printing to a contrasty one, without any problems in reproduction.

The highlight densities should be in the range of 1.25-1.50, which is about what one would expect from a fully developed view-camera negative. The negative density range (minimum to maximum) should be about 1.10-1.30. Much shorter or longer ranges require extreme contrast control mixtures of emulsion, and tend to go grainy or flat, respectively.

If the original negative is too small for a suitable contact print, then an enlarged duplicate negative can be made by using Kodak's Direct Duplicating Film, as described in the opening section of Chapter 5.

Paper may be sized or unsized. Sized paper uses less emulsion, but also produces a flatter and less rich tonality than does the unsized paper. If a sizing is desired, chemically pure dextrin can be used, although there has been no problem with its coarser equivalent, ARGO White Starch (available in grocery stores). It must be cooked in glass or unchipped enamel. Starch forms a suspension not unlike gelatin, and is prepared by placing one tablespoon of starch in the top half of an enamel or glass double-boiler; cover it with water; heat and stir, using wood or plastic spoons. As the starch swells and melts a thin paste will be formed. When it is smooth, add two cups of boiling water slowly, with constant stirring. Bring this mixture to a boil by removing the top part of the double boiler and holding it directly over a low heat. Hold the mixture at the boiling point, with constant stirring, for two to three minutes. Place the starch back over hot water to keep it warm. Spread it on the paper by using a sponge or sponge-brush. Size twice: spread in one direction, hang the paper to dry, and in about 20 minutes it will be dry enough to take a second coat. Size at right angles to the first coating. As soon as the paper is dry, store it flat, under weights, protected from air and chemical contamination.

The platinum print emulsion is compounded of chemicals that do not dissolve well at room temperature. The solutions do mix easily at about 30°C, heating the liquid over a water bath, but even then it will take the better part of an hour to dissolve fully. It is best to prepare the developer 24 hours before it is needed, and Stock C may be warmed before using to bring all the platinum back into solution.

Chemicals needed for the platinum printing process:

The Photosensitive Emulsion
Oxalic Acid	100 grams
Ferric Oxalate	100 grams
Potassium Chlorate	100 grams
Potassium Chloroplatinite	2 grams

The Platinum Process Developer
Potassium Oxalate	500 grams

The Clearing Bath
Hydrochloric Acid	1 liter

Other chemicals that may be used as color modifiers:

Lead Oxalate	100 grams
Gold Chloride	1 gram tube
Mercuric Chloric	100 grams

Make toner stock solutions as follows:

Mercuric Chloride	2 grams
Water (distilled)	30 ml
Gold Chloride	1 gram
Water (distilled)	30 ml

The emulsion is mixed from three stable stock solutions. These are combined just before spreading onto the sized paper. They may be stored in medicine dropper bottles. Because of the cost of the platinum salts, only mix emulsion to coat one 8 x 10 inch sheet at a time.

SOLUTION A
Water, hot	60 ml
Oxalic acid	1.1 grams
Ferric Oxalate	16.0 grams

SOLUTION B
Water, hot	60 ml
Oxalic acid	1.1 grams
Ferric oxalate	16.0 grams
Potassium chlorate	0.3 grams

SOLUTION C
Water	60 ml
Potassium chloroplatinite	12.0 grams

This is a large amount of platinum. A smaller quantity may be used in a proportionately smaller volume of water. For example, 3 grams of platinum may be dissolved in 14 ml of water.

If you wish to modify the tonal scale and the color of the image, mercury, gold and lead compounds may be added. From 2-6 drops of the Gold Chloride stock, and 1-4 drops of the Mercuric Chloride stock may be added to the standard 46 drops of emulsion. The Lead Oxalate is mixed into the A and B stocks. Use from 30-45 grams in each of these basic stocks. The lead will dissolve slowly.

Effect of the modifying chemicals:

Lead makes a less brown tone, and increases contrast slightly.

Gold increases platinum density, and in large quantities make the image color move toward purple.

Mercury increases the warmth of the print. Used in conjunction with the gold there is a reinforcement of effects of each. An excess of mercury will produce a splotchy orange print.

Figure 6-1: **The negative may be masked with "goldenrod" or other photo-opaque paper to provide a clean edge.**

The emulsion is mixed according to the contrast needed:

Contrasty Negatives (with normal shadow density and highlight densities about 1.50)

Solution A	22 drops
Solution B	0 drops
Solution C	24 drops

Normal negatives (with highlight densities about 1.30)

Solution A	14 drops
Solution B	8 drops
Solution C	24 drops

Flat Negatives (with highlight densities about 1.10)

Solution A	8 drops
Solution B	14 drops
Solution C	24 drops

The sensitivity of the emulsion is very low. It may be mixed in dim room light (avoiding direct expo-

sure from fluorescent or window lights) and dried in a dark room. It dries quickly. Ten minutes is sufficient. The moisture must be driven out by heat to insure clear highlights. Lay it on an electric hotplate for a few seconds; move it smoothly and rapidly so that no part of the paper is overheated. Use it immediately.

The emulsion is easily spread with a flat Japanese brush. This brush is sewn to a wooden handle. It contains no metal that could contaminate the emulsion. Large round brushes absorb too much of the platinum. One layer of bristles on the flat brush can be trimmed off, reducing the loss of platinum but not reducing the spreading ability of the brush. Wet the brush with water before using, then squeeze it out.

Figure 6-2: **To conserve emulsion, the actual image area is marked on the paper used for the platinum print. The corner marks are about ¼-inch outside the image.**

A small quantity of the emulsion is mixed and spread on the paper. Prepare paper for printing by first outlining the area to be printed. Pour out a line of emulsion along one edge of the printing area;

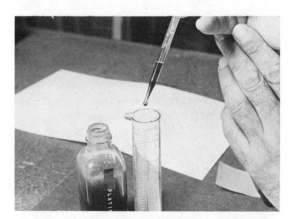

Figure 6-3: **The three platinum (or palladium) solutions are measured by the drop, into a small graduate.**

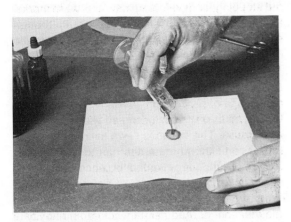

Figure 6-4: **After mixing, the emulsion is poured immediately onto the paper.**

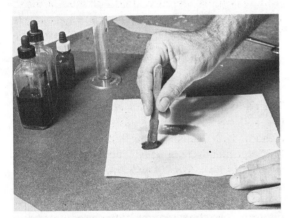

Figure 6-5: **A brush containing no metal is used to spread the emulsion. The sized paper will resist the liquid for a few seconds, permiting even spreading.**

Figure 6-6: **Spreading the emulsion by stroking at right angles to the first brushing pattern.**

rapidly paint this across the paper toward the opposite edge. Pour the rest of the emulsion along the opposite edge and paint back toward the starting place. The quantity of emulsion suggested in the mixing instructions will luxuriantly cover an 8 x 10 inch area (or five 4 x 5 inch prints). Always work on clean surfaces. Any trace of iron causes stains.

The emulsion must be completely dry, or the image will lack contrast. After it has dried to the touch while hanging, warm it over an electric hot-plate. The traditional definition is that the paper crackles. It is possible to overdo the heat drying and break down some of the emulsion. The paper temperature should not exceed 38-39°C, which is warm to the touch, but not uncomfortable.

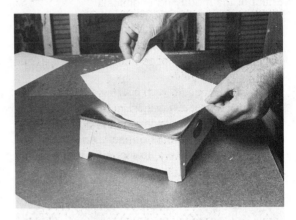

Figure 6-7: **After the paper has dried to the touch (10-20 minutes), it is heated over an electric hot plate to about 36°C.**

Figure 6-8: **Using a contact print frame, the print is exposed to a strong u.v. light source — here a mercury-vapor sun-lamp. The exact distance between the lamp and frame must be noted, as exposure is controlled by the inverse-square law (i.e. doubling the distance would decrease the exposure by 4x).**

As soon as the paper is dry, expose it. It must be exposed by contact, to a u.v. source. The contrast is to some extent affected by the time of the exposure, and increases with time. In other words, the Exposure = Intensity x Time relationship of silver materials is not completely true here, and so an exact densitometric control of exposure is not possible. Densitometer control will, however, produce a very close approximation that, tempered by experience, will yield excellent prints.

There is some "printing out," i.e. a color change is visible in the emulsion at the conclusion of exposure. But this is not definite enough to be used as an exposing guide.

A typical exposure with a 475 watt sunlamp, as illustrated, will be about 30 minutes if the lamp-to-frame distance is 18 inches. As the contrast of the emulsion increases, the printing speed decreases. From Flat to Contrasty, the exposure factors are about 0.80, 1.00 and 1.50.

Figure 6-9: **After development (not shown because it is essentially instantaneous), and bleaching, the print is washed and dried.**

The print is developed in 500 grams of Potassium Oxalate dissolved in 1.5 liters of water. This solution is reusable; when Mercuric Chloride has been added to the sensitizer it will contaminate that developer, and prints without mercury should be developed in a separate solution. The developer may be used to completion, i.e., until there just isn't enough to wet the paper safely in a single pass. It is important that the print be wetted smoothly, without stopping, or developing may form wash marks. Development is almost instantaneous, though everyone doubts this and lets the print lie in the developer for a time, more or less through habit.

The print looks significantly different wet than dry, and unfortunately its values look different at each stage of processing. When first developed it looks a bit darker than it does after being cleared. After clearing and washing, when it is dry, it loses brilliance to the point that, when compared to a silver print, it dries almost a stop darker and about half a contrast grade flatter. If you think the wet print is what you want to see, the dry print will be too dark and flat. A rather thin looking, slightly pale wet print will dry to look correctly exposed.

The developed print contains both platinum and iron salts (plus mercury, gold and lead, if those have been used). The iron (and some mercury) is removed in the clearing baths. Three trays may be used, or one tray used three times. Each contains:

Hydrochloric Acid (conc.)	15 ml
Water	1 liter.

The baths are each good for two 8 x 10 prints (or the equivalent area). The print is drained after development, placed in the first acid bath at 20-24°C and agitated normally. The acid will remove most of the iron. After five minutes it is drained and moved to the second acid bath where additional "iron" is etched away, and after another five minutes moved to the third bath. When two prints have been cleared, throw away the first bath, and move the trays up one step, mixing fresh acid for the last bath. This way there will always be fresh acid for the last clearing solution.

Wash the print in vigorously moving water for 20-30 minutes at 20-25°C. The prints can be air dried on a drying rack, and then pressed flat when they are dry to the touch.

The heavy Rives BFK does not need the stiffening that thin silver prints require, plus the surface is not glossy, and mounting is not required. The simplest finishing process is to adhere the print to a support with a hinge of acid-free linen tape, then overmat it. (See Advanced Controls for details).

The print may be waxed, for more brilliance, overprinted with gum, or lacquered (see photogravure prints in this chapter).

The solutions store reasonably well. The platinum salts themselves are stable over long periods of time. The ferric salts are not, and should be used within six months for maximum effectivity, though they will work for several years. The developer is stable until it is almost a sludge, and the limit is its capability of wetting the emulsion.

The platinum emulsion will produce good prints with the sensitization described, but a deeper tone and a more vigorous print can be achieved by

sensitizing it twice. The first layer of emulsion is spread and dried; immediately a second layer is spread over the first. The second layer can be a higher contrast mixture than the first, or have lead in it, achieving a subtle color mixture impossible with one coating. This also increases the cost of the print, but in terms of the effect is certainly worthwhile.

The working chemistry of palladium is nearly identical to that of platinum. The handling of the emulsion is the same. The C solution of the emulsion is compounded as follows:

Sodium Chloropalladate	9 grams
(Palladium Sodium Chloride)	
Water (distilled)	60 ml.

As with the platinum, smaller quantities may be mixed. The palladium salt prices have remained close to platinum prices for some time. The principal change between the two is in color, first. The palladium is also less permanent. It is warmer, tending toward the orange. Palladium chemistry was popular in the 1920's and 30's when that metal was significantly less expensive than the platinum.

Potassium Bichromate may be added to the platinum developer (not the palladium) for an increase in contrast. If a 10% stock solution is made (10 grams of Potassium Bichromate in 100 ml of water), this can be added as needed. 1-5 drops per liter of developer produces a noticeable change; 10-20 drops increases the contrast about a half-contrast grade (compared to the silver print). More simply causes the image to appear granular.

Poitevin's gum-bichromate process was exactly suitable for a photographer who wished to produce photographs that competed directly with late Impressionist etchings. The process permitted and encouraged the photographer to scrub out details, alter tones, and in general take away from the photographic print the onus of sharp objectivity. The gum print is inherently a high contrast printing process that has been adapted to continuous tone printing. It is sensitive to physical manipulations and to environmental conditions that may be difficult to control, i.e. relative humidity and ambient temperature. In our time it is used both as a way to print color texture and tone (derived from a photographic negative) as well as to emulate the silver print.

A recent addition to the gum-bichromate catalogue of prints is a commercial variation called by a number of names, e.g. Brite-Line, Kwik-Print, Watercote, and Proof-Kote. These are designed to be used in proofing four-color halftone negatives, but will respond to continuous tone as well as halftone negatives. They are premixed photosensitive liquids which have been buffered to retard the inevitable bichromate aging process. Nevertheless, they have a definite shelf life and should be used quickly.

The bichromates are in themselves photosensitive to blue light, and lose solubility through exposure. They should be weighed, mixed and stored under weak tungsten lights, which are low in u.v. The liquid is photosensitive to a degree, and once combined with an organic colloid (gum arabic, casein, starch, gelatin) there is a steady loss of solubility or rise in melting point of the colloid without *any* exposure to light. Gravure tissue, for example, is estimated to lose 7-10% solubility per day, becoming effectively useless after five or six days. This is sometimes referred to as an increase in "speed" of the emulsion, whereas in fact it is an increase in chemical fog. Once exposed, there is a continuing chemical interaction between the bichromate and the colloid which goes on for some time, and if identical exposure/development relationships are desired then exactly the same age-/time/temperature/humidity/development conditions must be established. This is an heroic task in most amateur darkrooms, and so the medium is noted for being difficult.

The negatives used for bichromate printing may be either continuous tone or halftone. Continuous tone negatives reproduce well, provided that they are of short density range. A maximum density range that can be handled with a single-coating of emulsion is about 0.50- from dark shadows to textured highlights. Longer density range negatives will require two or more emulsion layers — one for the highlight detail and middle tones, another for the middle tones and shadows. It is possible to change colors between these exposures, producing a definite color shift, and this was commonly done in the period of the Photosecession.

It there is to be more than one printing of a negative, or if color separation negatives are being used to produce a color print, a registration system must be established. It is not practical to attempt to register the image to the negative by matching detail in the negative and the print by eye. After the first layer has been developed and dried, the second layer of gum will obscure the image to such a degree that it becomes invisible under the negative when one tries to align them for reprinting.

The negatives used for sequential printing may be registered visually or mechanically to marks or holes located near the edge of the printing paper. Registration systems will only work if the paper has been preshrunk. The amount of preshrinking needed will depend on the paper. Rives BFK, for example, has a very stiff fiber structure that will yield only with a presoak at 50°C that lasts at least 30 minutes. The negatives are taped onto pieces of opaque paper the size of the print stock. Black construction paper may be used, or a thin orange

paper may be purchased from a local printer that is used for masking sheets of negatives prior to exposing offset plates.

Figure 6-10: **"Goldenrod" paper is available from printing supply houses. Here it is being prepared for masking a negative that will be printed by Kwik-Print. Wherever light strikes the bichromated emulsion, pigment will be left. A mat-knife is used to trim a slightly oversized opening.**

For visual registration, a one-hole punch is used to make three holes equidistant around the perimeter of the masking sheet. The paper is laid on the printing stock, and the location of the register spots marked with a pencil. When the gum-pigment emulsion is spread on the paper, dabs of it are placed on the register spots as well. The masking sheet is aligned with the printing paper, the exposure made, the image washed out, and the spots are now well defined, high-contrast marks that can easily be registered to the next negative.

Figure 6-11: **The negative is then taped into the window of the goldenrod. The window may be taped, or if the negative itself has a black border, the corners only may need taping, just to hold the negative in place.**

All the negatives are registered together on a light table, and the holes punched in register, so that aligning the easily visible round pigment spot with the hole in the mask will automatically align the image-bearing negative as well.

Mechanical registration pins and punch sets are available in both round and oblong designs from printing supply houses. The negatives are registered as they are taped into the masking sheets; when they are all aligned, the stack of masks is punched, and the paper on which the print is being made is also punched. Each negative will be automatically aligned with the preceding print when the punch holes are placed over a set of register pins.

Halftone negatives are ideal for bichromate printing systems. They produce a thoroughly hardened emulsion that grips firmly the supporting structure, and has vivid color and great density. The dot may be very fine, up to 250+ lines/inch, and the "self screened" random dot process described in Chapter 5 is ideal. The advantages of halftone for bichromate printing are that printing conditions are ideal: humidity, temperature and age variations in the gum, exposure and drying have little effect on the picture as compared to the printing of continuous tone negatives.

It is possible to produce similar but not identical prints for edition sets and to repeat conditions one time to the next, if sufficient care is taken. But a question arises: should the medium be forced into repeatability, or should the possibilities of the process be explored with some sense of play? The first attitude is traditional to photographic literature, and the second is currently popular with photo-printmakers.

After experimenting with single-color prints, it is possible to make well-balanced color prints, using contrast-masked separation negatives as described in Chapter 5. It should be pointed out that the vagaries of the process essentially preclude the production of edition sets, though sequential prints will cluster about a desired balance within interesting and usually acceptable limits.

Bichromated emulsions should be used as soon as they are dry after being sensitized. They should be processed immediately after exposure to obtain repeatable results. The bichromate usually used for photosensitizing is Potassium Bichromate because it is cheaper than other bichromate salts. Ammonium Dichromate is perceptibly "faster" however. Note that Dichromate and Bichromate are synonymous terms.

CAUTION: exposure to chromates sensitizes skin and produces "chromic acid poisoning." Always wear rubber gloves when sensitizing gelatin gravure tissues, or when handling chromate sensitizers for gum solutions.

The gum (or gum-bichromate) print is made by placing an emulsion of watercolor and bichromated gum arabic onto sized paper. After drying, the emulsion is exposed by contact with a UV light source. The image is developed by floating the print

on water. The water penetrates the gum and permits the unhardened gum to dissolve. Development takes 30 minutes. After one layer has dried, the paper may be coated with new gum and exposed again. Different colors may be used in whole or in part for each emulsion layer.

The effect of the gum print is variable. An approximation of the silver print is possible. But the process is naturally adaptable to a manipulated image where color, texture, and other manipulations are desired.

The literature available on the gum print is extensive. The following is a working outline of the procedure.

Preparation for Printing

Size the paper and prepare the gum. Each process takes several days.

Powdered gum arabic is available from all professional chemical supply houses. To a liter of distilled water add 300 to 350 grams of gum arabic. A specific gravity of 12.5° Bé is desired. Mix by shaking and then allow to stand for three days to dissolve completely. Distilled water should be used. To prevent bacterial growth, add 2.5 grams of Mercuric Chloride as a preservative. **Mercuric chloride is a deadly poison.** After dissolving, the gum solution has a light tan color and is of syrupy consistency.

The paper may be smooth or textured. A lightly textured paper (Rives BFK) is suitable for many images. The paper must be sized. Gum often requires several layers of emulsion, so sizing must be thorough. The sturdiest sizing is gelatin, hardened with formalin. Apply it in two layers: the second fills tiny bubbles left in the first.

For dimensional stability the paper must be presoaked. Rives paper, for example, will swell and increase its length about 2% the first time it is wetted. Soak the paper for gum printing in hot water at 50°C for thirty minutes before sizing.

Knox or A & P gelatin is satisfactory. Some other chain store proprietary brands tend to clump. Three packets of gelatin are poured into one quart of cold water (15 to 17°C). It will swell, absorbing most of the water. After 15 minutes warm it to 35°C. Two to three quarts of size are necessary for an even coating. Immerse the sheet of paper in the size. Draw the paper out under a glass rod (about ⅜ or ½ inch in diameter — the rods provided for towel racks are suitable). The rod will break down bubbles and smooth out irregular places. Hang the sheets to dry on a line strung with clothespins.

When the first layer is dry repeat the sizing. After two layers have been applied, harden them by floating the sheets on a solution of formalin. The hardener is formaldehyde 37%, available at most drugstores. Use 25 ml in a liter of water. Use the hardener in a well ventilated room.

Some of the spray starches seem to provide acceptable sealing for single-printing. Insufficient sizing will produce general color staining. The pigment used to produce the image will cling to the fibers of the paper, causing color fog.

A soft negative will work best if the result desired is an emulsion of the silver print. Line negatives, and other high contrast negatives, work well for vigorous prints and produce color statements with tactile richness.

Potassium or Ammonium Dichromate may be used to sensitize the gum. Ammonium is faster in printing speed.

Use a saturated solution. The sensitizer is then added to the gum in small quantities, not diluting the gum excessively.

Gum Sensitizer

Ammonium Dichromate (or Potassium)	29 grams
Water, hot	75 ml

(dissolve, then add cold water to make 100 ml)

When the dichromate is dissolved, it may be neutralized (brought to a **ph** of 7 or 7.5) by adding concentrated Ammonium Hydroxide solution drop by drop until there is a just-perceptible change in color, from orange to yellow. **Ph** sensing tapes are available from chemical supply houses and will offer more precise information on the acidity or alkalinity of the dichromate sensitizer.

Below 21°C/70°F some of the salt will precipitate out. Warm it before using. Equal quantities of saturated sensitizer and gum mixed with pigment are used. Disposable one-ounce medical plastic cups are suggested for measuring gum solutions. The gum's viscosity gives it a large meniscus. The one-ounce cups are well marked and large enough in diameter to minimize the effect of the meniscus. It is necessary to stir the gum-pigment mixture very thoroughly. Use glass or plastic — no metal! If color separations or edition prints are being attempted, it is desirable that all the prints of a given color be done at a given time. Because of continuing action, each print should be stored for the same time (e.g. an hour after exposure) to equalize these effects before beginning development.

Once mixed the gum begins to become insoluble. After several days it is useless. For accurate printing it is best to coat the mixture immediately after combining and to use the paper as soon as the gum emulsion dries.

Coat the emulsion with a brush. It may be fiber or a polyfoam plastic spreader. Brushing the gum aerates it and causes it to set. Work quickly; then dry the paper in the dark. Contrary to statements published in older texts, bichromate emulsions are photosensitive when wet. Work in dim room light, away from fluorescents and window light.

Older texts call for a blending brush. This is necessary only for simulating the silver print.

Pigments for the Gum Process

WINDSOR AND NEWTON watercolors and the GRUMBACHER gouache colors are dependable and provide definite colors with the least amount of flaking. Other watercolors do not have enough pigment density. PRANG poster colors produce broad effects .

Notes should be kept on amounts of pigment and gum used for a print. Pigment to gum ratios that have been successful with contemporary materials are 5 to 10 grams of pigment in 100 ml of gum (before sensitizer is added). The gouaches provide excellent solid-color area statements. The watercolor pigments provide good continuous tone images. High contrast negatives used with gouache produce images similar to silkscreen statements but with more luminosity. SHIVA waterbase block printing inks also work well for strong color.

Exposing and Developing the Gum Print

The bichromate sensitized gum is hardened only by blue and ultraviolet light. A mercury lamp is acceptable. A xenon-pulse light used for exposing offset plates is excellent. With a standard sun lamp at 20 inches, an exposure of 3 to 6 minutes is sufficient. A two-tube desk model fluorescent lamp will expose small prints satisfactorily. Exposure is about 25 minutes at 12 inches. Xenon-pulse exposures range from 1-4 minutes. Overexposure can be reduced somewhat by extended development; underexposure cannot be helped by shortened development.

Develop in plain water, immediately after exposing. This prevents image changes caused by "continuing action," i.e., hardening begun by light that will continue even when the light is removed. Several trays of water at 27° C/80° F work best. The print is immersed by sliding the paper in smoothly, emulsion up. After 40 to 60 seconds the paper will be wetted. Lift it by one end and then lay it face down onto the water. It will float.

Rocking the tray causes irregular development. Development is water penetrating the gum and dissolving the unhardened gum next to the paper. This disperses into the water. Eventually the hardened gum adheres to the paper; this is the image.

Development may be speeded by sliding the paper carefully out of the water and reinserting it. This reduces the development time to about 15 minutes. With still water total development takes about one hour. The paper should be moved from one tray to fresh water in the next tray every quarter-hour to prevent pigment redepositing it-

self onto the print. Lampblack is most prone to staining.

Development may be accelerated by washing the print with running water, with the definite risk of destroying fine detail. Areas may also be worked with a soft camel's hair brush, or entire areas may be scrubbed out, or given texture by using a brush. Again, there are different philosophies at work, one which argues this print should look as much like a silver print as possible, and the other that believes the experimental development of the picture is the function of the artist. When development is complete most of the bichromate stain will be gone, but when the last exposure and development have been made and there is still some stain it may be removed by soaking the print for five minutes in 30 grams of Potassium Alum dissolved in one liter of water. Wash the print for 15-20 minutes in running water to remove the alum. The alum will also tend to shrink the paper.

The gum print is tough after it dries, and it may be flattened in a dry-mount press, silkscreened or printed upon. The gum process can also be applied over platinum and other nongreasy printing emulsions. The finished print may be overmatted and framed for finishing.

Gum printing may be done on a number of supports other than paper. Cloth accepts gum pigment printing without preliminary sizing, and in fact supports the pigment better than do papers because of the fibers which help the gum adhere.

The commercial processes mentioned earlier have acquired the generic name of "quick proof," after the trade name of one of the products listed. The Kwik-Print (formerly Kwik-Proof) system uses bichromated emulsions with intense pigments. Kwik-Print is the standard and is wiped on; the emulsion is also available as Watercote, which is airbrushed onto the support. The colored pigments are supplied in commercial process colors (process red, blue, yellow and black) as well as other colors keyed to standard printing inks. The original process uses textured plastic sheets (mylar or less expensive plastic-stabilized papers) instead of paper, providing very quick cycles of sensitization, exposure, washout and drying, because the support is non-absorbing. A color may be spread, dried, exposed, developed, dried and be ready for a second color in about 10 minutes with the Kwik-Print system.

The Kwik-Print pigments, like other bichromate sensitized pigments, will work on whatever support you desire to spread them on, provided there is enough tooth to support the colloid during development. The emulsion contains volatile agents that encourage quick drying. The pigments can be mixed to provide any intermediate color or shade.

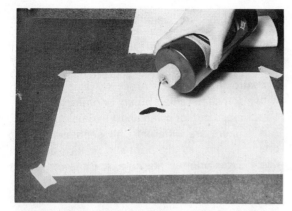

Figure 6-12: A small pool of Kwik-Print emulsion is poured in the middle of the work area. The "paper" is a plastic with a mechanically textured surface similar to semi-matte photographic papers.

Apply the emulsion from the bottle by pouring a small pool onto the support. Spread it smoothly in left-to-right wiping motions, using a Webril Appli-pad supported on the Webril Applicator (or Kwik-Print Wipe supported on a Kwik-Print Block). As soon as the emulsion is spread in one direction, make similar strokes up and down, to even the coating and buff the solution dry. Thick coatings have higher intensity colors, but are also more difficult to expose and develop.

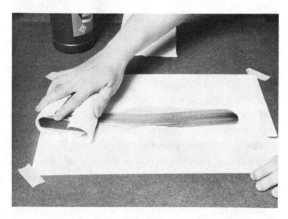

Figure 6-13: A wiping block supports a cotton pad, and the emulsion is spread quickly.

Kwik-Print can be used on fabrics. As might be expected, the synthetic fabrics which have smooth extruded fibers will wash out to a clean "white" without color in the highlights. Natural fibers, which have a more open and fibrous structure, will retain pigment that appears as a "stain" unless the cloth is sized. Starch sizing works well.

The Kwik-Print emulsion is stirred, mixed to the color desired, and poured onto the clean, flat fabric. It may be supported on a plastic sheet, or on a pad of newsprint. The emulsion is spread smoothly in left-to-right and then up-and-down strokes to spread, smooth and partially dry it.

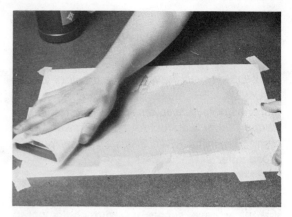

Figure 6-14: A second pad is used to buff the emulsion smooth and dry.

Because of the more complex nature of the support, compared to a Kwik-Print on a plastic sheet, the cloth should be dried flat to avoid color wedging created by the pigment flowing downhill. Any folds or creases in the material will be retained as color marks.

Figure 6-15: The masked negative is placed over the Kwik-Print emulsion for exposure. Note the register holes punched along the edge, where they can be trimmed away later.

Figure 6-16: After exposing, the Kwik-Print is washed with warm water. Ammonia may be used to accelerate washout, and Kwik-Print offers *Brightener,* which is a reducer to compensate for overexposure.

Once the pigment is dry, it is exposed and washed out in the regular way.

Expose under a contact negative. A sunlamp exposure at 18" will range from 3-6 minutes, depending on the color. A regular photographic #2 photoflood may be used as well, and the exposure will range between 4-8 minutes.

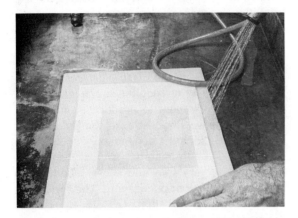

Figure 6-17: **After washout, the image may be dried by hot air and recoated for another image layer, or another color.**

Develop under a strong spray of water. The temperature should be between 20-25° C, and the image will appear at once. The adhesion is good with halftones, and the print may be wiped gently with a wet cotton Webril and Kwik-Print pad. Details may be scrubbed out with pressure. Overexposure can be reduced by using an ammoniated water (consisting of 30ml of 28% Ammonium Hydroxide in 4 liters of water). If further reduction is desired, Kwik-Print offers Brightener, a liquid which will reduce the image density.

Figure 6-18: **The same negative used in demonstrating the previous system is used to expose a sheet of 3M's Color Key. Exposure is made through the base, to facilitate adhesion of the image to the support. Development is begun by pouring a small pool of 3M Color Key Developer onto the emulsion of the dry proof.**

When one color has been developed, washed, and dried — another can immediately by applied, and printing continued. The plastic based printing sheets available for Kwik-Print are dimensionally stable and nonporous; no preliminary sizing is needed as is necessary with traditional papers. The color of these synthetics is a neutral, rather hard white, with a texture similar to that of Kodak's matte surfaced RC papers.

Figure 6-19: **A cotton pad is used to spread the developer smoothly and evenly, then the proof is buffed lightly as the unhardened diazo emulsion begins to break up in scum.**

Figure 6-20: **Within a few seconds the development is complete.**

Figure 6-21: **Scum and chemicals are washed away. The print is dried by blotting off the water.**

Figure 6-22: **A complete proof of a halftone color image may be assembled by using the process colors, exposing and developing, and stacking the assembled transparent prints in register.**

The diazo process is also useful for making proofs of halftones. 3M Corporation's Color Key system offers standard process colors plus a number of other colors which can be exposed to halftone negatives or positives, and then developed with a proprietary developer. After development, which consists of swabbing the exposed plastic sheet with developer and Webril-wipes to remove the dye substances affected by light or development, the film is rinsed to remove the excess developer and solid waste, and then dried on blotters. As soon as it is dry, it may be stacked in register with the color proofs made from the rest of the halftones. The result, bound together and taped to a piece of white paper, is an accurate prediction of what a halftone would look like printed with process colors on a press.

The Kwik-Print process was developed to do the same thing. Each process has advantages and disadvantages. The Kwik-Print pigments are reasonably permanent; the diazo pigments are fugitive. The Kwik-Print requires much practice in spreading the pigment to produce even and repeatable density without streaks; the Color Key is mechanically smooth, dependably regular. The Kwik-Print support material is heavy and stiff; Color Key is very thin and easily taped into a mockup of a book or page layout. The Kwik-Print cost is about 1/3 to 1/2 that of a Color-Key picture the same size. They have dissimilar appearances because the Kwik-Proof is a matte image and the Color-Key is a glossy image. Obviously each has its own use, and photographic printmakers willing to experiment will discover how these materials conform to individual creative expression.

CHAPTER SEVEN
Halftone Process

Halftone Processes

Daguerre announced publicly the details of his photographic process in a demonstration in August, 1839, and only a month later the first etchings were made from a Daguerreotype, when a photograph was reproduced in ink. Within twenty years a number of different processes were invented in attempts to translate the continuous tone of the silver image into an equivalent print in ink. Bas-reliefs using bichromated gelatin were created and either electro-plated with metal and used as printing matrices, or were impressed into lead plates which were in turn used as masters from which impressions were made. But these methods of printing were slow. Talbot experimented with photo-engraving for years, until he succeeded in 1858 by combining aquatint ground with a bichromate sensitized gelatin resist and making what he called "photoglyphic engravings." A few years earlier, in 1855, Poitevin discovered that bichromated gelatin not only became insoluble when exposed to light, but changed in its ability to absorb water. Exposed gelatin absorbed less water than unexposed gelatin. This fact led him to develop a photo-lithographic printing process, called collotype — for lithography is simply a process of creating an image on a support that is wet where no ink is desired, and accepting of ink where a tone is desired.

The collotype and the photogravure print both depend on the changes produced in gelatin by the interaction of bichromates and light. The collotype and the gravure print are both halftone printing systems, where the photograph is translated by the materials into spots of ink whose size varies directly in proportion to the density of the negative.

Collotype and photolithography are similar in that they are both halftone processes, and differ in that the metal lithographic plate is exposed to a halftone positive (in which the dot is established) and the collotype is exposed to a conventional negative — the dot is in effect created in the gelatin surface itself.

Collotype

Collotype is a halftone process. The print is an ink image. The halftone is very small, and the shape of the inked area is not a dot but a line. Because of this the collotype halftone pattern is very hard for the eye to resolve, and the sensation is of looking at a continuous-tone image. The collotype has been used for reproduction of medical photography and copying of other art images because of this sense of continuous-tone reproduction it produces.

The collotype plate is a film of gelatin supported on glass (although grained zinc plates and even heavy plastic sheets have been used). A very fine pattern is produced in the gelatin by drying it rapidly; this causes the surface to reticulate, or to shrink unevenly, producing a network of interlocking ripplies.

The gelatin used will produce an image whose contrast and fineness of halftone pattern both vary according to the Bloom of the gelatin used. Older texts refer to hardness, specifying a hard or medium gelatin for collotype printing. A standard testing method is now used to determine the Bloom index which is a measure of the resilience and resistance to penetration of the gelatin under force which is less than that required to rupture the mass.

The gelatin used should be in range of 150-240 Bloom. Knox (food grade) Gelatin falls midway in this range. Whatever gelatin is used, enough should be obtained to carry through a complete series of testing and printing because the source of the gelatin (in terms of bone or skin) affects the nature of the pattern of the reticulation and the ink/water interactions that result in the print.

The photosensitivity of the gelatin is produced by using Potassium or Ammonium Bichromate. This is added to the gelatin as part of the liquid used to dissolve the colloid When the reticulated gelatin is exposed to a continuous-tone negative, the ability of the gelatin to swell and absorb water is reduced by interaction of the light, the bichromate and the gelatin's molecular structure. The net

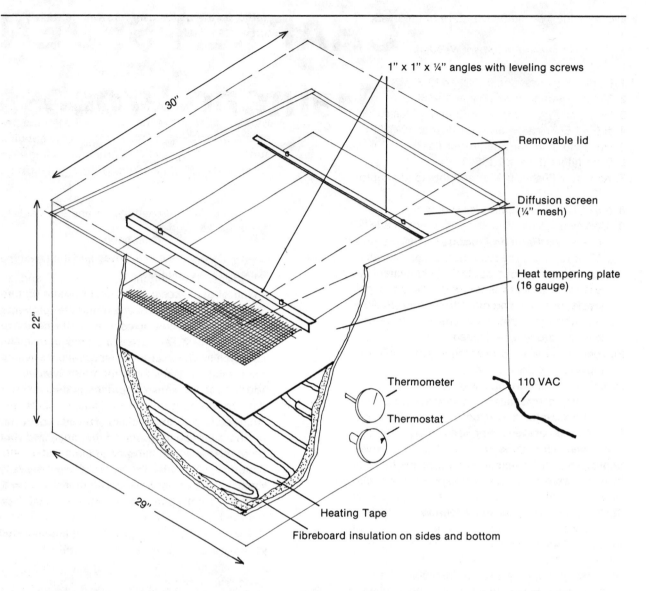

1" x 1" x ¼" angles with leveling screws

Removable lid

Diffusion screen (¼" mesh)

Heat tempering plate (16 gauge)

Thermometer

Thermostat

110 VAC

Heating Tape

Fibreboard insulation on sides and bottom

Figure 7-1: **Cut-away drawing of a collotype oven. The plate is supported on leveling screws set in aluminum angles. The heating tape, at the bottom, is isolated from the plate by a sheet of 16 gauge aluminum or galvanized metal, to even the heat, and air currents are reduced by the presence of a coarse-mesh screen just below the leveling system. The slanted cover is merely covered with canvas or black linen.**

effect is that where there has been exposure to light the gelatin becomes less absorbent of water. Because it will remain "unwetted" when the whole surface has been subjected to wetting, the exposed areas will then accept ink, whereas the unexposed areas (swollen and full of water) will reject ink.

Collotype is then a planographic printing process which closely resembles stone lithography, and some of the terminology and most of the techniques of lithographic printing are used for collotype, although the essential image making is photographic.

The temperature of the box must be controlled and set at 50°C. A precision thermoregulator is

FISHER Scientific Company Cat. No. 15-178. However a standard electrical baseboard heater thermostat may be used, provided the element is bent slightly to cover the temperature range needed. A manual control can be made by supplying electricity to the tape through a light-dimming SCR switch, of the kind available in most hardware stores, made for residential use. Figure 7-2 shows a collotype oven with the cover removed (and without a heat dispersion plate). The heating tape is seen at the bottom. Halfway between the tape and the glass collotype plate should be a sheet of aluminum (of the sort sold in most hardware stores). The aluminum heat dispersing plate prevents currents of hot air from circulating and

averages the internal temperature of the oven.

Special Equipment Needed

1. 91 mm Buchner funnel (Fisher 10-356D)
2. 500-ml Filtering flask (Fisher 10-180E)
3. No. 5, one-hole stopper for filtering flask
4. 500-ml Erlenmeyer flask (2) (Fisher 10-039F)
5. No. 5 stoppers for Erlenmeyer flasks
6. 9 cm filters (Fisher 9-795C)
7. Aspirator (Fisher 9-956) and threaded adaptor (Fisher 9-975B)
8. 5 feet ¼" rubber tubing for aspirator
9. Collotype Oven. The oven is a box made of three-quarter inch plywood. A useful size is 18" x 16" high. The top is not flat, but slopes 2-4 inches. The oven is electrically heated. An easy way to heat it is to use the heating tapes made for protecting pipes from freezing. 200-400 watts of heating tape is needed. In a warm climate less will be needed.
10. Precision Level: to level the glass plates for coating and drying.
11. Lithographic printing supplies:
 Composition roller, support, and cuffs.
 Lithographic inks (black or process colors)
 Potassium Carbonate, reducing oil, spatula, rollup slab, Lithotene, etc.
12. Flat Press, with felts to control pressure
13. Waxed Paper and "Goldenrod" paper for masking
14. 55 grams of granular skin gelatin (150-240 Bloom)
15. 500 grams of Ammonium or Potassium Dichromate
16. 1 liter Sodium Silicate
17. 500 grams Alum
18. 1 liter Glycerine (=Glycerol)

The collotype plate is supported midway between the heat dispersing plate and the top of the box. Supports are metal anglestock which has been drilled and tapped to accept 12/24 screws. The screws are the actual support of the glass, permitting each plate to be individually leveled in place. The location, and number of screws, will depend on the size of plates and the number desired at one time. Heavy angle should be used because the plate glass will deform light-weight stock and the glass will become unlevel during curing, causing printing problems.

The cover frame which supports a piece of canvas (for strength) and a piece of black linen or nylon (for light-tightness), is sloped to prevent condensation from dripping back onto the plates. The minimum slope is 1" in 12". The oven should be placed on a very solid support, away from casual traffic, so the plates can cure without being disturbed.

Preparing the Plate

Grain the surface of the plate glass by grinding it with a lithographic levigator, or lay it on a lithographic stone and use another stone as the grinding surface. Use 320 mesh Carborundum. A fine even tooth is desired. It need not be deep, but must be uniform.

Coat the plate with Substratum and set it aside to dry. Heat the oven.

Level the dry plate in the oven and then heat the oven and plate to 50°C.

Weigh out the correct amount of gelatin (Figure 7-5) for the plate and add the amount of cold water indicated in the following table. Allow the gelatin to swell for at least 20 minutes (problems with image irregularities often stem from insufficient swelling time). Heat the gelatin and the water to 43-45°C. Add the correct amount of dichromate sensitiser and then filter through the paper, using the Buchner funnel assisted by an aspirator. Stir gently; allowing bubbles to be absorbed but maintain the gelatin temperature in a water bath. Pour the gelatin onto the leveled glass plate (see figure 7-6) which has been prewarmed in the oven. Spread the emulsion evenly. Cover the collotype oven. Bake the plate for four hours or until hard and dry to the touch. The plate may be exposed immediately.

Prepare the negative for printing by masking out the area surrounding the image with opaque paper (the yellow paper used by printers called "goldenrod" is economical and lint free).

Place the negative on the plate. Remember, the image will print reversed left-to-right. Cover the negative with a piece of glass to hold the negative and plate smoothly together and expose to electric arc, mercury vapor, or sunlight. For initial tests try 4 minutes at 18 inches from a standard NUMADE arc light.

The plate is "developed" by soaking it in clear water between 12-14°C. This washes out the bichromate but does not allow excessive swelling of the gelatin (which appears as coarsened image detail and loss of highlight separations). Soak the plate for 10 minutes and then drain (Figure 7-7), and then repeat at 30 minute intervals until both water and plate are clear of any yellow Bichromate stain.

Dry the plate completely before beginning printing from it.

]194[

Printing the Collotype Plate

The collotype plate is prepared for printing by being "etched". This term is a carry over from engraving, just as "development" (the washing out of the Bichromate sensitizer) is a carryover from photographic printmaking. "Etching" means wetting the surface of the gelatin, preparing it for the printing ink.

The contrast of the image is affected in part by the pH of the gelatin. The gelatin can be made to swell and become more absorbent (relative to the exposed and hardened areas) by adding a few drops of ammonia solution to the etchant. However, the ink will not adhere in the presence of ammonia. If ammonia is used in the etchant to increase contrast, that etching solution must be washed away by flowing a neutral etchant (glycerine and water only) onto the plate. This is mopped off before inking.

The 3:2 ratio for etchant is a starting point. Individual plates, and variations in ink, will require adjustments. More glycerine in the etchant will permit more ink to adhere. More water will reduce the amount of ink taken by the plate. When the balance for a particular plate/ink combination is discovered it should be recorded and used again for that plate the next time it is printed.

While the plate is being etched, prepare the lithographic ink. Standard lithographic printing inks will work. Contrast is controllable in part by stiffening the ink with Potassium Carbonate.

The stiffer the ink, the higher the contrast (see Figure 7-8). If the ink becomes too stiff it may be eased by the addition of a reducing oil.

When the ink has been spread on the rollup slab and rolled into a thin, smooth layer, begin rolling up the plate. Roll very slowly, with light pressure (Figure 7-9). The collotype image is much more sensitive to rolling speed and pressure than the lithographic stone or plate. Roll up slowly and if there is overinking, remove ink with quick, light rolling. Ink roller speed will control how much ink is taken by the plate; the plate may be rolled almost completely clean by very fast rolling.

Like all lithographic prints, the collotype plate does not print repeatably until several prints have been inked and pulled Figure 7-10. Allow five or six impressions to be made before attempting to judge tonality, contrast, or inking technique.

The unexposed areas outside the image will always accept some ink. To keep the margins completely white it is necessary to mask them physically, after inking, for each impression. This is done by using strips of wax paper (Figure 7-11). The wax paper also prevents the paper fibers from sticking to the slightly tacky gelatin where it is unprotected by ink.

Collotype Solutions

Plate Substratum

A. Gelatin		3 grams
Water		100 ml
B. Alum		1 gram
Water		100 ml

Soak the gelatin for 20-30 minutes, then heat it gently until it becomes liquid, but not past 55°C. Warm the Alum solution (B) to 50°C, and combine parts A and B. Add 20 ml Sodium Silicate. Filter with the Buchner funnel and store in a tightly stoppered bottle until needed.

Collotype Sensitizer

Ammonium Bichromate	3.5 grams
Water	120 ml

Potassium Bichromate may also be used. The negative exposure will be increased about 2x to produce the same image density. There are also differences in grain structure produced by the two bichromates.

Collotype Developing

Plain water is used.
The temperature is important.
Temperatures above 15°C cause coarse grain.

Collotype Defects

wave patterns in image
temperature variations in oven
blisters, airbells in emulsion
unclean plate, improper substratum, grease dust.
mottled image
gelatin too thick, plate unlevel during drying, temperature too low during drying, temperature uneven in oven
plate breaks down
inadequate exposure
overall greyness
too little ink rolled up, negative density range inadequate
muddy highlights, overall flatness
"continuing action" (characteristic of all dichromate sensitized emulsions) of gelatin caused by excessive delay between drying and exposure, or exposure and washout or both. This is reinforced by high temperature/humidity combinations in workroom. Also caused by low oven temperature during curing of gelatin.
scumming
insufficient etching time, or dry plate. A commercial lithographic "fountain" solution may be of assistance.

Calculating Emulsion Quantities

Plate Size (inches)	Plate Area (square inches)	Gelatin (grams)	Water (ml)	Sensitizer (ml)	Total Volume[1,2] (ml)
8 x 10	80	2	32	8	40
10 x 12	120	3	48	12	60
11 x 14	154	4	62	16	78
16 x 20	320	8	128	32	160

[1]add 4 ml of water to the volume of emulsion mixed to allow for loss in transferring and filtering.
[2]the general rules for calculating the emulsion needed are:
 (1) 0.0625 grams of gelatin for each milliliter of fluid
 (2) ratio of water to dissolve gelatin to sensitizer is 4:1
 (3) ½ml of sensitized emulsion is needed for each square inch of plate surface

A note on gelatin: The Bloom index has different correlations to viscosity and the reticulation characteristics of an emulsion depending on the source of the gelatin. Photographic gelatins are made from "limed" (i.e. bone or calfskin sources) gelatin. This gelatin has been largely supplanted in food gelatins by porkskin (acid) gelatins which have different physical properties. Sources for calfskin gelatin are KIND & KNOX, Suite 300, 900 Kings Highway, Cherry Hills, New Jersey 08034; and U.S. GELATIN, div. Peter-Cooper, Oak Creek, Wisconsin, as well as most scientific supply houses, but care must be taken to specify calfskin or neutral gelatin.

Figure 7-2: Collotype oven.

Figure 7-4: Masked separation negative.

Figure 7-3: Leveling the plate.

Figure 7-5: Measuring gelatin for 16 x 20 inch plate.

Figure 7-6: Spreading the gelatin on the warm plate.

Figure 7-9: Rolling ink on collotype plate.

Figure 7-7: Plate during development.

Figure 7-10: Pulling a proof.

Figure 7-8: Mixing ink with carbonate.

Figure 7-11: Masking white edges with wax paper.

Collotype, like gravure printing, is dependent on the precise repeatability of conditioning the gelatin reticulated surface (or etching resist, in the case of gravure), and this in turn means having constant humidity and temperature conditions. If these are not available, if there is neither humidity nor temperature controls for the room in which the collotype oven is operated, there will inevitably be variations in reticulation size, and in contrast and image printing characteristics from one plate-making session to the next.

Photogravure

Photogravure is a halftone printing process where the dot varies in depth as well as in width. A microscopic examination of a photogravure plate reveals interesting information about the etching of the plate and the character of the image.

Highlights: The dot varies both in size and depth and there is evidence of a "soft" dot effect, of a dot almost not etched, but visible.

Midtones: The dot varies mostly in depth; the "land" or unetched surface is constant and controlled by the rosin ground or a halftone exposure grid.

Shadows: The dot varies mostly in width; the etching depth is even, with textured bottom, and the lands are controlled by the rosin or by the halftone grid exposure.

There are two ways of making photogravure plates with copper. One is to use a random, mechanically deposited ground of powdered rosin or asphaltum which preserves the lands, or unetched areas. The other is to produce in the resist itself a pattern of dense exposed gelatin which is essentially impermeable to the etchant; these areas preserve lands in the copper.

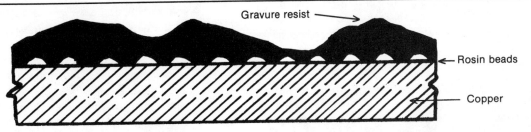

Figure 7-12: **The gravure resist, seen in cross section, not only varies in thickness as a function of the positive density, but must bridge the rosin resist and adhere smoothly around the melted droplets of rosin.**

The positive to which the resist is exposed is the principal control of tonal separation and density relationships in the picture. The etching process can be used to produce a wide range of contrasts, but for simplicity and uniformity of control it is best to treat the positive as a finished print, making all local controls there.

Bichromated colloids have a "straight-line" response to exposure to actinic light. This means, as noted in the graph below that doubling a given exposure will produce twice the thickness of gelatin after proper development. The resist emulsion does not alter the density relationships of the

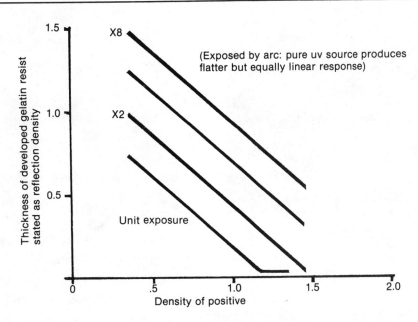

Figure 7-13: **Gelatin density is exactly proportional to exposure (graph after information from McGraw Colorgraph Corp.)**

positive, unlike the silver print emulsion which imposes a nonlinear, or s-shaped response curve on the negative image being printed.

The halftone screen pattern can be produced by the use of rosin or asphaltum dust, or ground, or by using a special halftone screen and exposing the resist to this separately. There are physical advantages to the latter system in that denser positives can be used with contemporary tissues without weakening the adhesion between copper and resist, ensuring greater etching latitude.

The actual etching is controlled by a photographic resist: a sheet of bichromate-sensitized gelatin. The gelatin is colored with iron oxide to make developing and etching action visible. The resist is sensitized, dried, exposed to a photographic positive, adhered to the copper plate, and then physically developed. The act of development removes unexposed gelatin, revealing a bas-relief that very accurately echoes the densities of the positive.

The plate is etched in a heavy iron salt which migrates slowly through the gelatin resist; acid etchants, having a much smaller molecule, do not perceive the gelatin as a differential resist but bite the metal immediately and uniformly. Varying the water content of the iron etchant will vary its penetration rate, and therefore vary the effective contrast for a given range of thickness of resist.

After etching, the plate is polished and prepared for the etching press. It is heated, a suitable ink is spread on the plate and the excess scrubbed off the surface. Prepared paper is then pressed against the plate in an etching press, transferring the ink to the paper. The imprint being completed, the paper is dried and whatever finishing processes that are desired used on the print.

Details of making the gravure positive are outlined in Chapter 5; the positive should appear to the eye as shown in the following illustrations.

For handling convenience the positive may be taped to a backing board, making it into a folder into which, for ease of handling, the sensitized resist may be slipped. If the resist is overdried, or the humidity below about 30%, the sensitized resist will curl and be relatively difficult to place neatly under the positive. Locating the resist correctly, aligning its edges with those of the masked edges of the positive, will make alignment of the resist on the copper plate simpler, and will make finishing of the plate after etching very simple. The edges of the positive must be made opaque to u.v. light. The easiest way to do this is tape them with 3M's No.

Figure 7-14: (A) **Gravure positive by transmitted light. Note the red taped "safe edge" around the picture area.**
(B) **Positive by reflected light, with resulting print.**

616 Ruby Red tape, made for stripping-in lithographic negatives. A quarter-inch strip around all sides is adequate. This area is referred to in the older literature as the "safe edge," and the very thin layer of gelatin that was under the tape and which survives washout development will keep heavily

Figure 7-15: **The positive is taped to a supporting card, producing a convenient folder into which the trimmed, sensitized resist can be placed prior to exposing it. Note white cotton gloves.**

exposed gelatin from loosening, or "frilling." The positive should be spotted as though it were a print. Spotone dyes work well, though the film emulsion absorbs them more readily than does paper emulsion, and spotting should be done with care.

The resist is McGraw Colorgraph's Type 37. It is sensitized in a 3½% solution of Potassium Bichromate, but no attempt is made to acid neutralize it. The chromate radical that produces the tanning action in the gelatin is used up rather rapidly; to avoid streaking, caused by irregularities in sensitivity and contrast, it is best to use the sensitizer on a one-shot basis. There is no easy way to determine exhaustion otherwise, as the liquid retains a characteristic yellow-orange color even after partial exhaustion.

The contrast of the sensitizer is inverse to its concentration. Older literature refers to a useful range of 2-5% with the stronger solution being the lowest contrast. This is borne out in experiments where the sensitizer is used until the contrast suddenly rises, producing irregular sensitization.

Figure 7-16: **Detail of a copper plate after etching, showing streaking caused by uneven sensitization created by partial exhaustion of sensitizer. Sensitizer contrast rises with exhaustion.**

The safest way to use the bichromate sensitizer is to sensitize two sheets of about 8 x 10 inches in each liter of solution, then throw that sensitizer away.

Safety Note : All the bichromates will sensitize the skin, producing an allergenic reaction called "chromate poisoning." To avoid this possibility, wear rubber gloves when mixing, pouring the liquid, or when sensitizing and drying the tissue. Gloves are not needed later, when the plate is being developed, as the bichromate is quickly washed out.

The gelatin tissue is packaged in a 40" roll, 12 feet long. It is easy to cut if a suitable length is pulled out and the free end held down with a straight-edge, while a second straight edge is used as a cutting guide. Use cotton gloves for handling the tissue — skin oils will cause blemishes in the finished resist.

Figure 7-17: (A) Cutting the resist from the roll. Two straightedges are used, to prevent cracking of emulsion.

(B) Cutting strip into standard smaller pieces.

The copper that is used should be of photoengraving quality, but cheaper stock may be used for preliminary work and for testing. Photoengraving copper is usually enameled on the reverse side so that no preparatory sealing of the back is necessary. The standard sheet size is 24 x 36 inches. Smaller sheets can be purchased, at a premium. If

there is access to a metal shear it is much more economical to purchase whole sheets and cut them to the size desired. Although 8 x 10 inches is a common photographic size and it is tempting to think of that as a norm, an 8 x 9 sheet is a more economical, modular cut, yielding 12 similar pieces from a standard sheet.

If the shear has left no burrs, the only preparatory work needed on the plate is a light filing to break any cutting edge on the plate. If the surface of the plate has been scratched, the scratches must be removed unless you want them as lines in the print. The copper photogravure image is a shallow etch of only about 5/1000ths of an inch; all surface imperfections will reproduce as part of the picture.

Scratches may be burnished out with a steel burnishing tool and a few drops of machine oil. The inevitable feathery scratches produced by handling and cutting the plate may be rubbed out using DuPont 202S followed by 606S Synthetic Lacquer Rubbing Compounds. The first is orange, the latter is white. They may be purchased at an automotive supply shop, and are normally used for smoothing auto bodies. The polishing with the 606S is desired in any case, to remove mill oils and finger grease from the plate.

Figure 7-18: (A) Polishing the copper plate with DuPont 606S: polish is rubbed in circular pattern until an even grey is achieved.

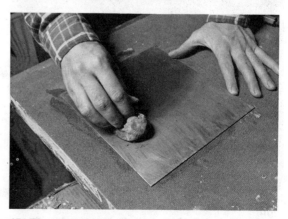

(B) Then it is lightly buffed with a larger soft cloth until a smooth even field is produced.

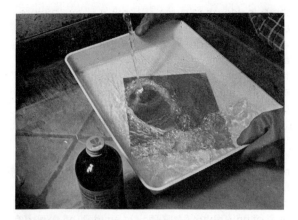

(C) The water-soluble polishing compound is flushed away with hot water.

(D) This leaves a clean, but still greasy surface.

When the plate has been polished evenly overall, it will have a faint circular pattern that has destroyed the almost perfect mirror finish the mill produced, but these minute scratches left by the rubbing compound are too fine to reproduce. The plate should be scrubbed gently in hot running water, and the rubbing compound wiped away with a soft wet cloth.

Figure 7-19: (A) Degreasing is done with Oakite, Tri-Sodium Phosphate, Sodium Hydroxide or Cascade. Pour a small quantity directly on the plate.

(B) Using a soft cloth, and very little water, make a paste and scrub the polished plate. Flush with hot water.

The plate is then chemically degreased. Use a 10% solution of Sodium Hydroxide, or pour Oakite (Tri Sodium Phosphate) directly onto the plate (as shown in the following illustration), or use Cascade automatic dishwashing detergent. They will all produce equal results. These are strong basic chemicals, and they will damage the skin unless protected by rubber gloves. Use a soft cloth and scrub the surface of the plate firmly, and thoroughly, left-to-right then up-and-down, but don't scratch it. Flush away the degreasing compound with running hot water; immediately wet the plate with a salt-acetic-water rinse.

Measuring by volume, mix 100ml non-iodized table salt, 100ml glacial acetic acid, and 1000ml hot water. Stir, and pour over the degreased plate in a smooth motion. This weak acid will etch the surface bright in 2-3 seconds, but not bite deeply enough to pit the plate and create tone during printing. This solution may be saved and resused until it takes 5-8 seconds to achieve brightening of the copper.

Figure 7-20: (A) Using a salt/acetic/water mixture, pour this weak acid over the plate immediately to neutralize the strong degreasing compound left.

(B) The salt/acetate may be saved and reused.

The copper should be plated immediately to prevent tarnish. If there is any iron or other mineralization of the tap water being used, rinse the plate after the acid with hot water, then pour a thin layer of 91% Isopropyl rubbing alcohol (purchased at a drugstore) on the plate. Tilt it back and forth until it is thoroughly wetted, then stand it on edge. The alcohol will dry the plate almost immediately and not allow corrosion to develop. Alternately, the plate may be rinsed and plated at once in this plating bath:

Solution A:

Silver Nitrate	2 grams
Distilled water	1 liter.

Solution B:

Potassium Cyanide*	2 grams
Distilled water	1 liter.

*This is a very dangerous poison. It is used only because there is no equivalent silver solvent. Measure, mix, combine, and use these solutions *only* in well ventilated rooms; wear rubber gloves at all times; wash the gloves afterward. If working in a photographic darkroom, flush the sink and then run enough water through the sink so the drain trap is free of any acid.

Pour B into A. there will be a temporary turbidity which will clear in a few minutes.

The freshly washed copper plate should be placed in a clean phototray and the plating solution poured over it in a smooth motion. If the plate is still warm from the last rinse, plating will take place in 10-15 seconds with fresh solution. The solution is reused until the time for plating to a smooth silver (sometimes with pinkish highlights, as exhaustion nears) approaches three minutes. After the copper is silver plated, rinse the plate again in hot water, and flow alcohol over the surface to dry it.

When the plating time exceeds three minutes, destroy the plating mixture in an ecologically safe way. DO NOT pour it down the drain! It is still an active cyanide solution.

The silver-coated copper may be used immediately, or it may be stored. If not being used at once, lift it by the edges and back and store it face up in an empty photographic paper box so surface corrosion is minimized. Before using it, cleanse it with the salt-acetic mixture, and then rinse well with hot water.

As noted earlier, there are two ways to produce a random pattern of dots in the gravure image. The first is by using a rosin dusting box, firing the rosin to partially melt it and adhere it to the plate, then adhering the exposed resist to the plate over the rosin (or asphaltum). The alternative system is to expose the resist twice, first to the continuous tone positive, then to a random pattern high contrast halftone with a density about 0.30. The first exposure produces the bas-relief that controls image density; the second exposure produces islands of impenetrable gelatin, which prevent etching the land of copper, just as the rosin does.

Rosin dusting boxes are usually available where there are etching presses. Asphaltum dusting boxes can be easily built. The asphaltum powder is so finely pulverized that it need not be blown to provide a fine dust. A tumbling box at least 4 inches larger each way than the plate size, and 30 inches tall is adequate. A drawer near the bottom will provide an access for the plate and for recharging the box. A few teaspoons of asphaltum, three or four inversions of the box, and two dusting periods of 1½ to 2 minutes each will adequately coat the plate. The asphaltum can be fired with a butane torch if piped-in gas is not available. It is almost impossible to overfire the asphaltum. The dust does not melt run, or varnish the plate as the rosin does. Fire the plate between successive dustings. A properly dusted plate is about 50% covered and 50% bare metal. Do not touch the surface of the plate after dusting.

Rosin is easier to melt but hard to melt properly. When the silver-coated plate is removed from the dusting box the rosin granules are white. Place the copper on a plate heated to 100-110° C, used for inking etching plates. After 1-1½ minutes the rosin will melt. The granules change from white to pale yellow, then to a corn-oil yellow. Heated further, they lose shape and flow together, varnishing the plate. If this happens, clean it in oil-free alcohol and redust it. Examined under an 8-10 power loupe the correctly fired rosin particle will be separate, hemispherical, and golden in color.

Rosin is equivalent to a 120-line halftone screen. Asphaltum is equivalent to a 300-line screen. The advantage of both powders is that the screen is random — the eye of the observer cannot sense the mechanicalness of the screen.

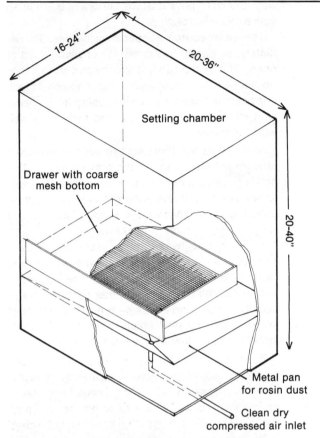

Figure 7-21: A rosin dusting box, shown in cutaway. The finely pulverized rosin (ground in a mortar) is placed in the tapered metal pan at the bottom. The air is blown for a second or two, creating a cloud of dust. The large particles will fall out in 15-30 seconds, after which the plate is inserted in the box, supported on the coarse mesh bottom of the drawer. After 1-2 minutes the plate is carefully withdrawn and fired.

Figure 7-22: (A) Collotype screen pattern, enlarged 15 diameters.

(B) Non-glare glass screen pattern, enlarged 10 diameters.

An alternative way to produce a random ground is by making a halftone pattern on ortho film. A moderately fine screen (similar to rosin) can be prepared using textured non-glare glass. A finer screen (similar to asphaltum) can be prepared using a reticulated gelatin collotype plate.

In the darkroom, expose an 11 x 14 inch sheet of ortho film by contact to a random pattern screen. The light source is the enlarger, set at f-16, to produce a point source. A sheet of textured non-glare framing glass is laid on the ortho film, and the enlarger turned on for 1-4 seconds. The film is then developed by the still development process described earlier, using Fine-Line developer. If properly exposed and developed, a halftone pattern with a density about 0.30 will be produced. Examined under a 10X magnifier, the pattern will be regular and about 50% of the area will be opaque. To prepare a collotype screen for producing a random halftone, clean a sheet of plate glass and

degrease it as described in Chapter 5 on preparing gelatin emulsions. Then coat the plate with Collotype emulsion, including bichromate; bake normally, expose to a u.v. source for a full normal exposure to harden the gelatin, wash out the bichromate in cold water, flood the plate with 91% Isopropyl alcohol, and stand on edge to dry.

This plate will inevitably have small variations of thickness of the gelatin which will affect the density pattern; they are neutralized by isolating the ortho film and the gelatin surface with a sheet of Kodak Diffusion Sheet. Place the ortho film on the enlarger baseboard face up, then a piece of Diffusion Sheet, then the dry collotype plate, gelatin down. The exposure and development is the same as for the textured glass screen.

The gelatin reticulation pattern is regular, random, and finer than the textured glass screen, and closely resembles the pattern formed by asphaltum dust.

Sensitize the tissue sheets by placing them face up in the Potassium Bichromate solution, cooled

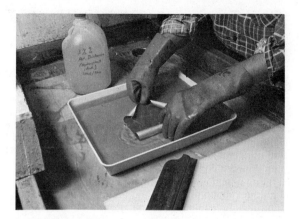

Figure 7-24: Sensitizing the tissue in 3½% Potassium Bichromate. Note the rubber gloves, which are absolutely necessary.

polished with a proprietary scratch-removing, buffing compound used for plexiglass and acrylic sheets, but must never be waxed. Waxing fills the scratches on the plexiglas, but is also transferred to the gelatin resist, and will leave white lines on the finished print.

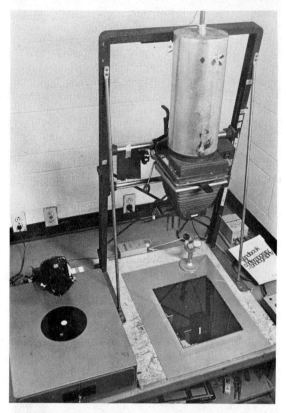

Figure 7-23: (A) Exposing a sheet of ortho film to a reticulated gelatin collotype screen to produce a halftone pattern for a random-dot second exposure gravure system.

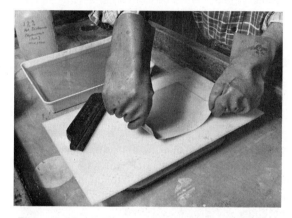

Figure 7-25: (A) The wet, sensitized tissue is placed face down on a pool of sensitizer, on a clean sheet of plexiglas.

(B) Isolating the ortho film from minor density waves in the gelatin by using a sheet of .003-inch Diffusion Sheet.

to 12-14° C. Use rubber golves; stroke the surface lightly, breaking any bubbles. When the first sheet is evenly wet, turn it face down and sensitize a second sheet. When the second sheet is wet, turn it face down. The total immersion time is 3 minutes per sheet.

The tissue is dried in contact with a plexiglas surface. This should be free of scratches. It may be

(B) The sheet is squeegeed from the center out.

When the tissue has been sensitized, lift it by one corner, let it drain onto the plexiglas sheet, lay the tissue in the puddle of sensitizer, then squeegee out from the center with a bar-squeegee.

(C) And excess liquid mopped up with paper towels. The tissue is air dried, using a fan.

After the excess sensitizer is squeegeed off, gently dry the back of the tissue with a paper towel. Set the tissue directly in the path of a fan to dry. Rotate it a quarter-turn every 10-15 minutes to avoid uneven drying. Depending on relative humidity, it will take from 30-90 minutes to dry. It is best to remove the tissue from the plexiglas just as it dries, when it will peel away easily but all at once. If it dries at one corner before another it will develop wave-patterns and not lie smoothly under the positive during exposure. As soon as the tissue is dry, store it flat and in the dark, under modest weight. A photographic paper storage envelope is ideal.

The paper immediately begins self-hardening. About 7-10% loss of total sensitivity is noted each 24 hours, but tissue used within 24 hours can be considered to be the same as fresh tissue. Self-hardening can be reduced by sealing tissue in a photographic storage envelope from a package of regular silver paper, and storing it in a refrigerator. Refrigerated tissue will store and be usable for 10 days to 2 weeks. Frozen tissue is usable indefinitely.

An exposure test should be made to determine the correct maximum exposure usable for the halftone system desired. Rosin or asphaltum grounds interrupt the surface of the resist so that it has less total adhesion capability than it does with the alternate system described below.

Using a typical positive — incorporating image densities that are normal for your pictures — expose a sheet of tissue to a standard u.v. light. Cover all but 2 inches of the tissue with a heavy piece of cardboard.

Typical Exposure Range Test Times

Sunlamp@18 inches	2-10 minutes
50 amp Nuarc @ 24 inches	1-5 minutes
Pulsed Xenon platemaking lamp	1/2-3 minutes

Expose each strip of the tissue at equal incre-

Figure 7-26: When the two exposure system is used, the first exposure is to the image:
(A) Exposing the resist to the positive.

(B) Transferring the exposed positive to the second master, the random halftone pattern litho film.

(C) Exposing the random screen pattern onto the resist.

ments, splitting the total exposure into five or six steps.

Immediately after exposure, immerse the tissue in 12-14° C water. Put it in face up, breaking any bubbles on the surface, then turn it face down. The tissue will curl inward until the gelatin begins to swell, causing it to flatten and then momentarily curl backward a bit. Just as it begins to reverse the curl, lift the paper and lay it face down on the prepared etching plate with a fired ground, or on

the silvered-copper plate if the second-exposure method is used.

Figure 7-27: (A) **The exposed resist is wetted in cold water (11-15°). It will soften slowly, as noted by the clock.**

(B) **After 30-50 seconds it will begin to curl backwards (note clock and detail indicated by finger). This is the time of maximum adhesion. Lift the tissue and squeegee it onto the plate.**

Squeegee the excess water from the tissue, moving outward from the center. The squeegee pressure is firm, but not violent; there must be no distortion of the tissue. Pat the backing paper dry with a paper towel, and set the plate aside, out of drafts for 10-20 minutes — until it feels cool-dry to the back of the hand.

Wet the plate with water at 26°C, raising the temperature smoothly to 43°C within a minute. Hold the temperature at 43-45°C during development.

Development consists of melting away the unhardened gelatin lying immediately beneath the paper support. The gelatin has been made insoluble to a depth which varies with the exposure. Too great an exposure will render the surface gelatin tough and incapable of swelling enough to become adhesive during the few seconds when the gelatin is swelling, and before it is completely swollen — at which point it loses adhesive power

altogether. It is desirable to have as much gelatin as possible for control in etching, consistent with correct adhesion. The second-exposure method will permit a greater exposure than will the rosin or asphaltum ground method.

If rosin has been used the adhered tissue must be wetted only with water. If asphaltum or the second-exposure method is used, the backing paper of the tissue should be prewetted with 91% Isopropyl alcohol after the tissue has been adhered and just before it is immersed in the developing water. The alcohol is poured in a pool on the plate, and spread with the hand. Allow 20 seconds for the alcohol to penetrate the paper and then immerse the plate. Alcohol encourages fast developing and retards the formation of pinpoint bubbles in heavily exposed areas, as well as assisting clearer developing in a short time.

Figure 7-28: **After the plate has dried for 10-20 minutes, prewet it with alcohol before physical development in hot water. (Two exposure system only!)**

Rock the tray while allowing water at 43-45°C to enter, and after two minutes it should be possible to grasp the paper backing at one corner and carefully peel away the paper.

Figure 7-29: (A) **Development begins in room-temperature water, which is raised to 43-45°C after about 30 seconds.**

(B) At the end of two minutes, it should be possible to peel back a corner of the paper.

(C) Pull steadily and slowly.

(D) The paper will release completely, and development can continue to completion.

Continue rocking the tray while supplying fresh hot water. Change the direction of tray motion every twenty seconds. At first there will be only a cloud of red gelatin to be seen. After about two minutes most of this will be gone, and the image will appear. By the end of four minutes all the gelatin should have washed free. Vigorous agitation is needed for the last minute to clear gelatin from the center of the plate.

If rosin has been used, dry the plate by flushing it with a gentle stream of water which is at 43-44°C at the start and cools to 15-17°C at the end, then stand the plate on edge to dry, supporting it on dowels or pencils to permit the water to run away from the plate edge. If asphaltum or a second exposure system is being used, chill the plate as described, then pour a bead of 91% Isopropyl alcohol along the upper edge of the plate, allowing the alcohol to flow across the plate in a smooth film. It will catch up loose water and also pick up a scum of gelatin as it passes over the plate. When the surface is wet in one direction, rotate the plate a quarter-turn and repeat; four alcohol pours are desirable, one for each edge. The plate may be stood on edge to dry.

If trouble develops with draining marks (irregular density wedging toward the lower edge), it may be necessary to build a drying turntable. A 1-2 RPM motor can be obtained from an electronic supply house and attached to a platform. Place the rinsed plate on the platform, and rotate it constantly while drying; accelerate drying by pointing an electric fan directly at the plate. This will drive the moisture out evenly in all directions and permit the plate to be etched within two hours.

The plate that bears the exposure test strips may be examined as soon as it is dry. The longest exposure that shows no sign of bubbling or edge frilling should be used as a standard exposure for the density of the positive used. Exposure is controlled by the minimum density of the positive, which is to say by the highlight areas. These will produce the thickest gelatin resist. An exact correlation can be established for other positives. For example,

Test Positive Density	Exposure
0.40 (textured highlight)	3.0 minutes

New Positive Density
d = 0.45 then the exposure = 0.45-0.40=0.05 expressed as an opacity of 1.12; multiply this times the test exposure to produce a new exposure of 3.56, which is 3'21".

The random pattern screen is exposed after the positive is exposed onto the gelatin resist. The exposure for the screen is 120% the correct positive exposure. For optimum control of the etching process it is desirable to use the densest gelatin practical consistent with good adhesion. If the correct positive exposure has been calculated, as in the example above, at 3'21", then the exposure for the random pattern will be approximately 4 minutes under the same lighting at the same distance.

The test plate may be cleaned and reused by immersing it in hot water, scrubbing off the gelatin

with a nylon scrubbing pad (found in kitchenwares in the grocery store), then removing the rosin ground with alcohol or the asphaltum ground with a tar solvent. The plate may be repolished with the DuPont 606S Rubbing Compound, cleaned and replated for use.

Using the test exposure information, a correct exposure may be calculated for a new piece of tissue. That is then exposed, wetted, adhered, dried and developed. When the plate is dry (four-six hours if air dried without a fan in a relative humidity of 30-50%; one to two hours if alcohol is used and the plate is dried under a fan in similar humidity range) it can be masked out and then etched.

The red photo-opaque tape used to create a "safe edge" on the positive produced a very thin layer of gelatin around the edge of the picture. The purpose of this unexposed strip is to keep heavily exposed gelatin from lifting during development; tanning during great exposure inhibits adhesion. Now that same strip of thin gelatin must be protected from the etchant, or it will etch to a dense black. Masking can be done with masking tape, or if a sharper edge is desired, with 3M's Magic Transparent Tape. The tape should be carefully pressed into place, and then gently buffed to insure adhesion and a clean edge.

Handles may be made from glass-fiber reinforced "Banding" tape. These permit the plate to be lifted from one etchant to another, and to provide controlled agitation of the etchant.

In the middle 1960's, McGraw Colorgraph Company, makers of gravure tissues, published a series of technical papers on single-bath etching of gravure plates. The investigations of their engineers indicated that the traditional etching procedures were not satisfactory and could be improved upon.

The traditional literature describes an etching procedure in which a series of etchants of decreasing specific gravity are used to produce contrast control, or alternatively a single etching solution is carefully diluted during the etching to produce the effect of a number of baths, adding water bit by bit.

Etching is accomplished by using de-acidified Ferric Chloride. The iron salt is dissolved in very little water, making a solution with a specific gravity of 46° Bé. At 20-21° C, this solution will penetrate the gelatin resist almost not at all, even in the very thin areas that will print maximum black when a correct etching is accomplished. Decreasing the specific gravity a little, to a 44° Bé, produces an etchant with enough water to penetrate the gelatin and begin removal of copper within 20-30 seconds. As more water is added, and the specific gravity falls, the penetration of the etchant through a given thickness of gelatin resist increases in velocity. At about 38° Bé, the etchant in effect sees no resist-

ance at all from the gelatin (in terms of the usable thicknesses that will adhere), and etches the entire plate at once.

The logic of the older etching procedures was to etch a resist by starting with a very dense etching bath, observing the etchant penetrate the thinnest layers of gelatin — and as soon as action seemed to stop, moving the plate to an etching bath containing a bit more water. The procedure requires a great deal of trial-and-error etching to develop a sense of materials, but what is worse is that the etching is not necessarily the best possible. The earlier etching procedure was predicated on the argument paraphrased in the McGraw Colorgraph bulletin that "equal density differences in the positive should be 'opened' at equal time intervals." This necessitated the use of a number of etching baths. The McGraw Colorgraph research indicated that by using an appropriate single-bath etchant, all the etching could be done in one solution. The equal density steps "do not open in equal time intervals — they open in logarithmic time intervals."

The use of single solution etchants has been thoroughly tested in conditions where professional control of humidity and temperature cannot be maintained, and within limits it has been proven that this etching process has great advantages for the photo-printmaker, relieving him of many decisions which require craft training that is difficult to attain, in part because there are few people qualified in gravure printmaking working outside the industry, where standardized procedures replace rational investigation of the theory of a process.

The random screen second-exposure process described to this point as an alternate to rosin ground gravure will be outlined in detail as a preferred process; the rosin ground information is appended, in a form unchanged from the Third Edition, for those who prefer to use it.

If a positive with highlight densities of 0.35-0.40 and deep shadow densities of 1.50-1.60 is given a correct exposure — exposed correctly on a sheet of Type 37 tissue, properly adhered, developed and dried with alcohol, the following etching relationships can be predicted:

First Etchant:
46° Bé Iron Chloride @ 20-21° C 2 minutes.
(constant agitation 1st minute; agitate each 15", second minute).

Second Etchant:

Contrast Desired (in equivalent silver paper grades, American numbers)	Specific Gravity of Etch: (at 20-21° C).
#1	40° Bé

#2	40.6° Bé
#3	41.2° Bé
#4	43.0° Bé
#6	44.0° Bé

As with other developing processes, time, temperature and agitation are the variables which must be controlled. Agitation is critical: if the plate is

pumped into the etching solution, there will be excess etching around the edge of the plate, producing a darkening of tone similar to an edge-burn in silver printing. For even tones, the plate must slide into the etch, slide out, be drained, and then slide back into the etching bath. A proper etching rate is to slide the plate out, drain and slide it back twice a minute, or once every 30 seconds.

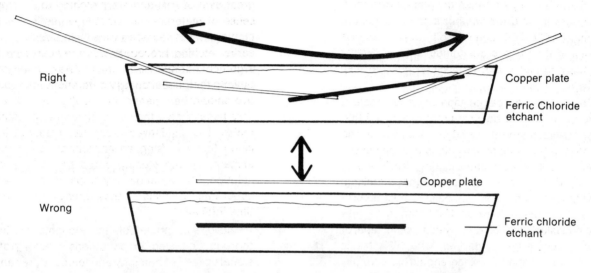

Figure 7-30: **Right and wrong agitation during etching. The upper drawing shows the correct sliding motion that will produce even etching over the entire plate. The lower drawing shows an agitation that will produce excessively deep etching around the borders of the plate and light etching in the middle.**

The 46° Bé solution is used for presoaking the plate, and yet is part of the total etching time. It must be applied evenly, without bubbles. The easiest way to do this is to place the copper plate face up in a clean, dry tray, and pour the 46° Bé solution over the plate, wetting it evenly and vigorously.

The iron solutions are quite messy; they cling and stain and they contaminate silver process chemicals. It is best to use a separate set of trays for gravure, with ridged bottoms, so the solutions will not damage other processes.

Temperature is also a critical variable and no contrast control plan is meaningful unless all etching temperatures are kept constant. A 3°C rise in temperature is approximately the same as 1-1½ paper grades loss in contrast. The etchant penetrates faster, and does not have time to work in the shadow areas to produce a proper depth of etch before penetration begins in the highlights.

The etching time, using the single-bath system, is direct and easy to determine. With a single etchant the image develops visually much as the silver print develops in a paper developer: the shadow areas change color and become visible first, appearing to darken and overcome the pale dull red of the gelatin resist covering the plate. The

darkest shadows appear in 15-30 seconds. As time continues and the plate is lifted, drained and gently returned to the etchant the darker middle tones, and then the middle tones will appear. Finally, the upper tones will change and become visible just as the greys of a silver print become visible and assume substance at about 2/3rd the complete developing time required to make a rich print. At the last, only small patches of pinkish gelatin are left, where the print will have delicately textured highlights. It is the penetration of the etching solution into these that determine the actual total etching time.

A properly made and exposed positive, etched in a 40.6° Bé etching bath will develop approximately like this:

Etching Time (by Description of Plate)	Elapsed Time
46° Bé Pre-soak	2'0"
40.6° Bé Etch	
Black lines	2'30"
Dark textured shadows	3'30"
Middle Greys	5'
Upper greys	7'
Textured highlights	11'

The etching is stopped by removing the plate from the iron and flushing it under a vigorous stream of cold water at 13'15" in this example. This is determined by noting the *first* sign of the color change (i.e. penetration) in the textured highlights. The total elapsed time the plate is in the etching bath is than multiplied by 1.20.

Total etching time = Highlight etching time x 1.20
e.g. 11' x 1.20 = 13'-15'.

The desired degree of contrast is chosen and an appropriate etching bath prepared. The plate is presoaked in the very dense 46° Bé bath to stabilize its gelatin resist water content, and then etched in the proper etching bath at a controlled temperature and with standard agitation.

With the higher specific gravity baths (42-44° Bé) the penetration of the thin gelatin in the shadows takes place at about the same rate as with the lower baths (40-42° Bé). So the longer the etching goes on, the deeper the holes in the copper in the shadows and the blacker the print will be there. But with the higher specific gravity etchants, the less water there is and the slower the penetration will be through the densely exposed highlight areas of the resist; therefore longer times will be needed to produce correct etching of highlight areas, and the more contrasty the resulting plate.

Etching times with the denser baths will run as long as 20-22 minutes; in the lower solutions, the etching times will be as short as 5-6 minutes. These times are all for standard density range positives. This means that standardized methods as described in Chapter 5 can be used to produce positives, and a final decision based on aesthetics can be made prior to etching, to determine the exact contrast desired.

The random screen second-exposure method using a collotype plate as the screen pattern produces an ink laydown which is indistinguishable from that generated by a fine rosin-ground or asphaltum ground.

Figure 7-31: (A) Photomicrograph of ink pattern produced by rosin-ground photogravure. Original negative is 250X. The rosin dust was very fine, and the support paper is Rives BFK.
(B) Photomicrograph of similar density image area produced by collotype-screen second exposure. All other details similar to part A. Note the great similarity of the ink distribution and shape of the ink dot.

In this illustration comparison, the ink patterns on Rives BFK are examined at 250X enlargement. In both cases, the pattern shown includes textured grey areas typical of highlighted skin. Note the relationship of the ink to the paper fibers themselves.

The following illustrations show (at 250X magnification) the results of etching of highlight and shadow areas with a random screen used to expose the resist and create non-etching lands.

The enlargements shown in these illustrations were taken from the plate used to print the photograph of the boy in the hat. The correct highlight detail is enlarged from the texture in the straw hat; the correct shadow etch from the dark background. Note that a portion of the unetched

Figure 7-32: **A good textured shadow area, with strong lands in the copper distinguishes this 250X detail from Figure 7-34.**

Figure 7-33: **Correctly textured highlight detail, from 7-34.**

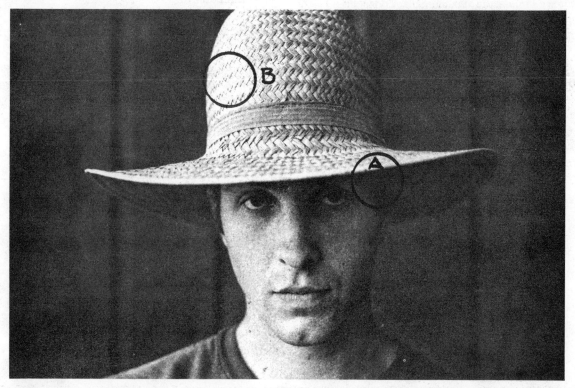

Figure 7-34: **Photogravure, reproduced in conventional halftone, with the shadows and highlights examined in earlier illustrations circled. The earlier figures were photographed from the original copper plate.**

edge of the plate is also shown, providing a visual reference for the way the surface of the copper may look. The fine scratches shown will hold some ink and cause the plate edge to print grey, unless they are polished out with DuPont 606S or with jeweler's rouge.

Shadow areas will not print correctly if the plate is etched for too short a time, or if the second-exposure is inadequate. The following illustrations show this.

Figure 7-35: **A shallow etch, resulting from etchant temperature being too high. Highlights were penetrated before shadows could achieve desired depths.**

In the first example, the maximum black possible is not great because the etch is so shallow. Shallow etches can be caused by high etchant temperatures or etchants with inappropriately low specific gravity. In either case, the highlights will be penetrated before the shadows have been adequately etched. Once the highlights are penetrated, etching must be stopped. Continuing the etch will merely make the entire plate gray, much as an overexposed silver print will turn grey, even at normal development times.

Figure 7-36: **A good, dark shadow, but one lacking separation due to the small lands. These are diminished because of an insufficient second exposure, producing an inadequately hardened gelatin control pattern.**

In the second illustration of improper shadow etching, there is a good deep etch but there will be no tone separation because the exposure of the random pattern screen was inadequate, and there was lateral etching between the lands. There is a great ink capacity in the grooves shown; the print will be dark but show little differentiation of shadow details. Increasing the exposure of the random screen pattern will increase the width of the lands, and improve shadow detail.

Figure 7-37: (A) **Failure to carry etching to conclusion. There is a mere hint of preliminary etching in what should be a detailed area.**

(B) **The plate from part *A*, showing how this kind of etch prints.**

The final illustration shows what happens when the etching is stopped early. The large blank area is not the perimeter of the plate, protected by tape, but what was supposed to be delicately modulated highlight skin tones. Unfortunately the etching was stopped before proper penetration took place; the metal has no pits to hold the ink and that part of the picture is paper-white, without texture of any sort.

The change of color that takes place with highlight penetration is slight, but definite: the gelatin loses opacity, and takes on a sense of the print. If local highlight densities do not show change after 14-15 minutes of etching in a normal contrast etchant, it may seem necessary to follow the traditional literature and move the plate to a lower specific gravity etchant. This will work; the print will also inevitably take on a flattened quality in the highlights. First, try letting the etching go on in the bath for which the calculations of density/contrast have been made. It is possible that the whole positive was thin, or the exposure of the resist accidentally long, and the resist is now overall thicker than need be. In this case the contrast will be acceptable, though the etching time is long, simply because it also took longer to penetrate the shadows. The **net** etching time remains constant.

When the etching is completed, lift the plate from the etching bath and place it under a vigorous stream of cold water. It is not sufficient to plunge it into a tray of water, because the etchant will continue to work for several seconds and produce muddy highlight tones, and there is also a possibility of streaks unless the iron salts are washed away at once.

After 20-30 seconds of rinsing, increase the water temperature to 50-55° C. The gelatin will soften and frill. Scrub off all traces of the gelatin with a nylon scrubbing pad. Remove the tape used to mask the edges, and the banding tape handles. Scrub away the gelatin under the taped edges. Dry the plate at once to avoid corrosion.

Finish the plate by filing the edges at about a 45° angle, as shown in the previous illustration.

Smooth the edge by polishing it with a series of silicon sandpapers (sold as wet-or-dry papers) moistened with light machine oil. Four sanding blocks prepared with increasing fineness of papers will make this operation simple and take only a minute or so. Start with 180 grit, then use 220, 340 and either 480 or 600 for the last. Finish the edge and the masked off strip around the image with crocus cloth, jeweler's rouge, or DuPont 606S, until the metal is very smooth and all the fine scratches on the surface and edge are polished out.

The plate is printed by heating it, wiping ink into the etched pits, scraping off the excess ink, buffing the copper surface clean, wiping the edge free of last traces, placing the inked plate on a press while it is still warm, putting paper on the plate, covering the paper with one or more felts to even the press pressure, passing the entire assembly through the press, and then removing and drying the print. The following illustrations on page 214-217 show each of these steps.

The ink used will affect the contrast of the image as well as the paper. Standard etching inks may be used, but they should not be considered inviolable. The stiffness of the ink can be increased by adding magnesium carbonate, or the ink made looser by adding plate oil or burnt linseed oil. A stiffer ink wipes harder, but is more contrasty because it is denser in the grooves and the lands can be buffed cleaner. A looser ink is less dense in the grooves, and smears onto the lands, lowering the contrast. Too stiff an ink will actually tear the surface of the printing paper. It is difficult to keep ink off the hands, but penetration can be avoided by using Ayerst Laboratories' Kerodex 51, a skin closing cream designed to be used for oily work. Apply as directed, using two coats, and printing inks will wash off easily, and reduce dermatitis. Two people are needed for edition printing of gravure prints: one to ink, wipe and handle the plate, and the other to handle the paper.

The paper used will affect the brilliance, contrast and detail of the image. All the heavier papers must be soaked, to soften the fibers enough so they will take the ink evenly. The time of soaking varies with the stiffness of the paper:

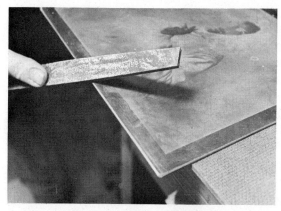

Figure 7-38: **The edge of the plate is filed to prevent cutting of the paper and felts in the press. If many plates are being prepared, a router can be arranged to mill the edges at 45°, then they can be polished swiftly.**

Paper	*Minimum Soak*
German Etching	2 minutes
Lennox 25	15-30 minutes
Rives BFK	24 hours.

Figure 7-39: Inking the plate. The plate is warmed. The ink may be rolled on, as shown, or daubed on with a leather dauber. Rolling damages fewer plates.

Figure 7-42: The tarleton is torn off.

Figure 7-40: Excess ink is drawn away with a small piece of cardboard.

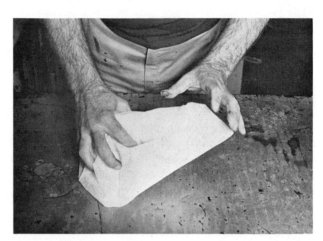

Figure 7-43: The tarleton is loosely folded into a wiping pad.

Figure 7-41: A piece of tarleton (coarse, sized cheesecloth) is chosen for making an ink-wiping pad.

Figure 7-44: The plate is cleaned with two tarletons: the first takes off the heaviest ink.

Figure 7-45: The second cleans the highlights. Brighter highlights can be produced by buffing them with slips of tissue paper.

Figure 7-48: Magnesium carbonate may be used to prevent any trace of ink. It is caught between finger and thumb.

Figure 7-46: The edges may be cleaned by wiping them with a small pad of paper.

Figure 7-49: Chalk or magnesium carbonate is stroked along the edge. Very oily inks will require this in addition to tissue wiping to avoid greyness.

Figure 7-47: A very clean edge is assured by a second wiping with a piece of tissue.

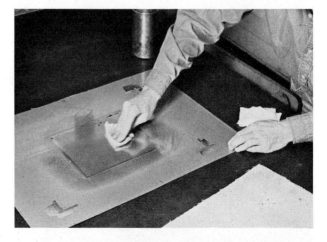

Figure 7-50: The press bed must be cleaned before placing the plate and paper. For this edition set, a template of zinc was prepared, with the plate location and corners of the paper marked with 3M No. 850 Silver Tape.

Figure 7-51: The plate is placed on the press, and the paper positioned over it.

Figure 7-54: The plate is driven through the press rollers.

Figure 7-52: An appropriate number of felts are placed over the paper.

Figure 7-55: The paper is carefully lifted from the plate.

Figure 7-53: The stack of felts will vary with presses. This is a typical array: outer felts of dense wool, and a central felt of loose wool.

Figure 7-56: The edition set prints are dried by interleaving with blotters.

Figure 7-57: **The damp print is protected with acid-free tissue, then a dry blotter, then another print, etc.**

If a great deal of printing is to be done (a number of proofs, or edition sets) the paper may be wetted all at once. Dissolve three or four Thymol crystals (a standard fungicide) in a tray of water about 50°C. Wearing rubber gloves, immerse the paper one sheet at a time, keeping all sheets in the same orientation, so that the water marked side is always either *up* or *down.* When all the sheets that will be needed within a 4-5 day period are in the water, they can be lifted all at once, drained, and placed in

a plastic bag. The Thymol will prevent mildew; the paper will be ready to use 24 hours later, and remain soft and constant in ink-receptivity for about a week. Paper that is soaked too short a time will print with the screening pattern of the paper visible. Paper that is too wet will accept the ink poorly. Presoaking, draining and storing in plastic will provide paper that does not need to be blotted and rolled in the traditional way, avoiding the problems of blotter lint that cling to the surface and cause imperfect prints.

Etching Rosin Grounds

Prepare two plastic photo trays. They must be clean and completely dry. Pour about one-half inch of 48 degree etchant into one. In the second place an equal amount of 44° Bé etching iron solution. Both solutions should be at 20-21°C.

The 48° Bé solution is very dense and must be watered for gravure etching. Solutions are needed in 2° intervals, from 38-44° Bé. One way to dilute the stock is by using a hydrometer and adding water to two liters of concentrated etchant. Add 30-50ml at a time, stir and measure the specific gravity with a FISHER (Cat. No. 11-571E) hydrometer. When the desired concentration is reached, store that solution and begin again for the next.

An alternate mixing method is to use the following table, however the solutions mixed should be verified with the hydrometer.

Figure 7-58: **(A) An essentially correct plate, marred by irregular sensitization (line from upper left edge of window to left of print).**
(B) Compare A to this: a short etching caused by residual water in the resist (which permitted rapid penetration), and marred both by watermarks caused during drying of the resist and an overall pebbled texture caused by improper soaking of the paper.

Figure 7-59: (A) Sensitizer exhaustion created a high-contrast resist; etching was stopped after 20 minutes with incomplete penetration of the highlights.

(B) and *(C)* are the same positive, and the same exposure, differing in the specific gravity of the etchant. *B* was etched in 40° Bé etchant, *C* in 42° Bé etchant. One is a little flat, the other a bit contrasty. Both were produced as validations of the system described.

Figure 7-60: The plexiglas support for the sensitized tissue was cleaned, then waxed. The wax fills the scratches in the plastic, but transfers to the tissue as a delicate and impervious resist. In this case, it is a nuisance, but it could easily be a useful tool for the creative printmaker.

Figure 7-62: Failure to rotate the plate frequently during the first half-hour of drying, producing wash marks in the resist.

Figure 7-61: The resist was unguarded during drying, and suffered water splashing that did not appear visible until the plate was etched.

Figure 7-63: A very high contrast etching, produced by using a 44 Bé etchant. The spotting is caused by drying water left on the plate following silver plating (avoidable by using alcohol). The residual minerals and tarnish interact with the gelatin.

["

penetrate everywhere. When moving the plate to 42° and 40° Bé solutions etching seems to "crawl" and colors flicker back and forth over the surface of the plate. Watch clear highlights closely for dark pinpoint penetrations. These are the first signs of penetration.

After etching is complete, clean the plate with water. This will destroy the gelatin resist. The rosin ground can be removed with alcohol.

The asphaltum particle is smaller and the gelatin conforms to it more tightly than with rosin. The resist for rosin ground can be more contrasty than for asphaltum, apparently because the looser conformation to the ground softens the image during etching.

Soak the plate in the 48° Bé density solution for two minutes. Transfer the plate to a 44° Bé bath. If the resist is of the right thickness (controlled by exposure) and the proper contrast (controlled by the positive), it will probably etch to completion, or nearly so, in this solution. If after 10 minutes the Zone VI values have not been penetrated, move the plate to a less dense solution.

A typical etching program using solutions of 2° Baume intervals is:

44Bé	(Zones 0-IV)	10 minutes
42Bé	(Zones V-VII)	6 minutes
40Bé	(if needed)	

Asphaltum ground melts at a high temperature. It is difficult to remove and may require some type of commercial tar-removing solution.

When the print has been removed from the press and dried by stretching, or dried on blotters, a final finishing gloss may be desired. Etching ink dries flat, without lustre. This can be compensated for and a controlled degree of depth restored to the print by spraying it with an ether-alcohol-cellulose lacquer. Acrylic lacquers are not satisfactory as they do not penetrate the ink adequately. Suitable lacquers have a specified table of contents that reads like this:

18-20% non-volatile (Cellulose Nitrate, Gums and Plasticizers)
80-82% volatile (Alcohol and Glycol Esters and Aromatic Hydrocarbons).

Spray the print with a pressure type spray gun. It will dry in 2-3 seconds. As soon as it is dry, buff it lightly with a smooth lintless cloth pad. These lacquers are poisonous, and should be sprayed only in appropriate conditions, preferably with an exhaust hood, and while wearing a filtering mask and safety goggles.

A modified gravure process for short-run printing using a zinc plate and a hard dot halftone resist that is etched with nitric acid is a practical alternative to copper photogravure printmaking. The collotype screen pattern can be used to create a halftone dot which varies in size as a function of negative density; the halftone image is used to harden a bichromated albumin or polyvinal alcohol, or a diazo resist — standards for the printing industry. Unhardened resist is washed away, leaving naked zinc where the resist was protected by the positive halftone dot. The plate is washed with acid, producing grooves between the resist-protected lands. The plate is then inked and wiped in the regular way, and a print pulled on an etching press.

There are disadvantages and advantages to this system. The image density is controlled mostly by the dot size, and the positive must be very carefully controlled; the zinc gravure plate requires a much flatter negative to produce a suitable positive than does the copper plate system. The zinc is much softer and wears quickly. The resolution of detail possible with the rigid area-controlled dot is less than with the area/depth controls of the copper. The metal plate is much less expensive, however, and for small editions of color prints made by gravure where a minimum of three plates are needed, the zinc system offers real advantages.

Three-color gravure prints require very flat separation negatives. Make a contrast mask with a maximum density of about 1.60, according to the procedure outlined in Chapter 5. This mask, combined with a typical Kodachrome transparency, will permit the making of a very flat separation with clear articulation of tones. The separation negative should have a density range of about 0.70, from perimeter density to clear areas in the sprocket holes. The separation negative may be enlarged to make a finished size halftone positive. The halftone positives may be measured with a densitometer. Important shadow areas should have a density between 0.60 and 0.70. Highlight areas must have a dot visible in all areas, except where there is an absolutely white light source in the picture (and this rarely happens: see Chapter 8, on color in photographic printmaking). It is better to presume that *all* areas of the photograph must have a visible dot in the positive.

The halftone positive is made by enlarging the separation negative onto Type 3 Ortho film, using a dyed collotype screen to create a random pattern and to usefully break the light into density variations suitable for the high-contrast characteristic curve of the film. See Chapter 5 for details of the contrast character of collotype screens used in this way.

Because such a flat positive is needed, it may be necessary to use flash exposure to guarantee a suitable dot in the highlights when a correct exposure has been given under the enlarger for the textured shadows. A Kodak safelight with a 40 watt lamp and an OC filter, at 24-30 inches, will produce a usable dot reinforcement of the latent image following enlargement of the negative through the collotype screen if the flash exposure is between 15-30 seconds.

Presensitized zinc printing plates are exposed by arc or pulsed xenon lamps to the halftones; they are then "developed" in the proprietary solvents recommended by the manufacturer. These are strong alkaline solutions, and rubber gloves must be worn to prevent skin damage. They are also volatile, and must be used only in well ventilated areas. As with other developments, temperature and agitation are important. Both bichromate and diazo presensitized resist-coated plates are available commercially. If the plate must be cut before being exposed and developed, it must be protected from u.v. light sources. Tape paper over the surface (to protect it from light and cutting and handling).

The time in the developer and the temperature are both specified by the maker of the plate used. Agitation is important because the development breaks down the unexposed resist, which then becomes a scum or sludge. Too much agitation can cause wave patterns to appear around the perimeter, caused by sludge being redeposited.

Agitate the plate the same way the copper gravure plate was agitated: every 30 seconds lift the plate and drain it from a corner, allowing the development wastes to slide off. Developer capacity is about 30 half-sheets of zinc per gallon. Standard precut zinc sheets are available in 24 x 36 inch size.

Wash the plate under a cold water spray immediately after development to remove sludge, and prevent emulsion from redepositing and blocking up dot detail, The image appears as a dull grey; the

Figure 7-65: (A) Development of the zinc gravure plate. The blue-on-grey image is barely visible. Note how the plate is lifted, not pumped.
(B) Detail of edge effect caused by pumping type of agitation (see Figure 7-30).

remaining resist is dark blue. A thin film of subbing remains on the zinc that must be removed in what is called "descumming." All the development and washout steps must be done with rubber gloves, to protect yourself from acid and the plate from finger oils.

Descumming is done in acid solutions. The first tray should have a 5% solution of Sulfuric Acid, and the second a 5% solution of Nitric Acid. Slide the plate into the Sulfuric Acid solution at 20-21°C for 15 seconds, drain, rinse with cold water, then slide it into the Nitric Acid for 15 seconds, and rinse with cold water. Repeat this cycle two or three times if necessary, until the image area is an even bright zinc, and the grey undercoating is gone.

Figure 7-66: Washing the plate under a vigorous spray, following development.

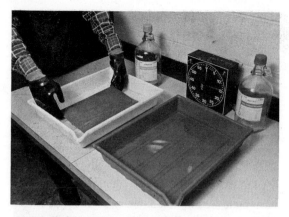

Figure 7-67: Descumming with nitric and sulfuric acid baths.

Etching must be done in a well ventilated space. The zinc-acid reaction releases quantities of Hydrogen. The etchant is Nitric Acid, diluted 1:12. Used at 23-24° C, the plate is gently immersed with a sliding motion (to prevent "pumping" of the etchant at the edges of the plate). The time of development will not be the same for all plates. When color printing is intended, the density differences of the inks require different depths of etch.

COLOR	ETCH TIME 24° C
Black*	2-3 minutes.
Cyan	60-70 seconds.
Magenta	40-50 seconds.
Yellow	25 seconds.

The edges of the zinc plate may be finished by filing and polishing, as the copper plate was prepared for the press, or the plate may be sheared off at the edge of the image, and the plate used in an edge mask to avoid cutting paper and felts.

There are three different ways of finishing the print produced on the etching press. One is to tape the print to a prepared wall with brown paper tape, after the print has been pulled from the plate. As the paper dries, it shrinks and stretches the paper tight, pulling the plate mark left by the thickness of the copper almost flat. A second way (illustrated in the section on copper gravure) is to cover the damp print with a piece of acid-free tissue, then put a blotter on top of the print, put the next print on the blotter, and so forth until the edition is complete. Every day or two the prints are removed and placed on dry blotters and stored under weights until they are bone dry. This method leaves a definite plate impression.

A third way, and one that offers advantages for multiple color printing, is to make a print with no plate impression. The standard four-ply photographic mounting and matting boards are very close to the thickness of the zinc (or copper) etching plate. A window is carefully cut into a piece of board, just the size of the plate. The perimeter of the paper on which the print is to be made is then carefully drawn around the plate, on the mattboard. Two processes are now combined in one: the print is supported evenly as it goes through the press, having equal thickness under it from the plate and the board, and a simple registration system for three- or four-color printing is established. The paper is laid on the empty mat, and the leading edge caught with a piece of masking tape. Each pass through the press is preceded by lifting the taped printing paper, putting the correct color plate into the hole in the matt, carefully replacing the paper, covering it with felts, and driving the assembly through the press.

Standard process color lithographic inks can be used by stiffening a little with magnesium carbonate. The stiffer the ink the higher the contrast of the picture, and the more vivid the color in the print.

Photosilkscreen

Silkscreen is a stencil process. Thick pigment in a viscous base-and-extender is supported by a fine mesh screen. Part of the screen is made opaque with glue, paper, tape or a photographic resist. The pigment is drawn across the screen by a flexible rubber or plastic bar. The bar literally pumps pigment through the screen. As long as the holes in the stencil are relatively large, the image produced on paper placed beneath the screen exactly reflects the stencil. When the holes become small, less than a millimeter in diameter, the image begins to change.

Very small holes in the stencil begin to look to the viscous pigment like venturis or small nozzles (see Figure 5-19). The first passage of pigment coats the walls of the opening, and each additional pass then encounters greater pressure, and deposits less pigment than would be expected. In effect, a small opening becomes smaller, but large openings stay effectively the same size.

Because of this problem, photosilkscreen requires a positive stencil image with a reduced range of dot sizes to produce a certain effective halftone scale, and it is also limited as to the absolute dot size which is reproducible. Although a screen will reproduce halftone information from a screen as small as 130 lines-per-inch, contrast control and screen controls required are so severe that a beginning printmaker is advised to limit the effective halftone dot to about a 70-80 line-per-inch image.

*(Not four-color process black, but when a single color (black) print is desired; four-color black requires a shallow etch of 40-60 seconds, from a special halftone, as described in Chapter 8)

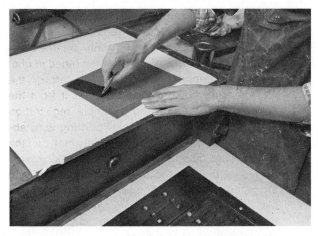

Figure 7-68: **The trimmed (but unbeveled) plate is inked on a low-temperature hotplate. Color inks are more oily than black inks, and require lower temperatures and stiffer wiping.**

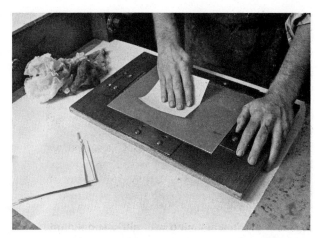

Figure 7-71: **Tissue wipe for clean highlights.**

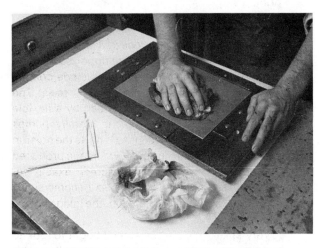

Figure 7-69: **The plate being wiped with the first tarleton. A wiping frame holds the plate so that it can be wiped to the very edge.**

Figure 7-72: **Inserting plate in register window.**

Figure 7-70: **Second wipe, with clean tarleton.**

Figure 7-73: **Completed print being removed from press.**

When screening color prints, the dot size changes in its effect, compared to a single color print. Transparent color inks create overlapping patterns which slightly confuse the eye, and what would be an objectionable dot in a monochromatic print disappears, or takes on a chromatic intensity in a three or four color print. In figures 5-23 (A) and (B), a print is shown hanging behind the women and dog, and then a "real size" detail from the process red separation positive is shown next to it. The dot is obviously very coarse, yet when combined with the other colors, and seen from a normal viewing distance, it is not significant. Photographic printmaking involves new aesthetic decisions not found in silver printing, and the concept of sharpness is one such decision. Photographers will often find themselves holding the silkscreen or gravure print up to their nose, to see if it is sharp. Of course it isn't sharp! It is a pattern of dots which make sense as an illusion only at a distance; the excitement is to have these dots also make sense for themselves, when seen closer.

Knowing this criterion it is easy to produce a halftone positive to specification.

A. Choose an image size (e.g. 14 inches long)

B. Choose a halftone dot for the print (80 lines-/inch)

C. Multiply A x B (80 x 14 = 1120)

D. Divide *C* by the screen pattern available to you in 4 x 5 film.*
(in this example, $\frac{1120}{300} = 3.72$

E. The result of *D* is the long dimension of the halftone needed for enlarging to make the final halftone positive with which the screen photoresist will be made.

The assumptions in this sample calculation are that a variety of screen sizes are available, and that the printmaker can make an enlarged halftone. The effective screen sizes in magenta or grey screens vary from 65-300 lines-per-inch, and in random pattern screens (described in Chapter 5) from about 100 to 300 lines. The textured glass is coarsest, the self-screening is finest, with collotype and diffusion sheet halftones somewhere between.

Given a halftone positive at the correct size and screen pattern for the picture you desire to make, the photosilkscreen process is then largely mechanical:

Expose a resist. Develop and adhere it to the screen.

Block out peripheral areas that should not print.

Mix pigments of a suitable color.

Mount the screen in supporting hinges and prepare registration marks or blocks.

Squeegee the pigment through the screen onto the paper; dry the print.

Clean the screen by removing pigment mechanically and with solvents.

Remove the resist mechanically and chemically from the screen.

If a color print is desired, more than one screen may be needed. If halftone color prints are planned, it is best to have three or four screens of the same size, stretched at the same time, so the image will maintain dimensional stability and be easy to register.

The screen size is controlled by the image size. To be safe, allow a minimum of three inches each dimension outside the maximum image area planned.

The screen may be finished by taping the edges, and then varnishing them, and this is a standard procedure suggested in many texts. However, the chemicals used with photoresists quickly destroy these finishes, and it is simpler to prepare the gutters of the screen freshly for each printing.

Brown paper butcher's tape will wash out with hot water when the screen is cleaned after the printing is done. Before taping, if the nylon or other synthetic screen material is new, degrease it and prepare it for photoresist by wetting the screen and scrubbing it with cloth pads. Fine carborundum (300-600 grit) can be used, or a commercial cleaning powder. If the cleaner is used, it is necessary to neutralize the screen by flooding it with a 1-2% acetic acid solution.

The photoresist can be one or two kinds:

1. Liquid, applied directly to the screen (direct resist)

2. A sheet, coated on mylar, exposed separately and developed separately, then adhered to the screen. (Indirect resist).

*The 4 x 5 film size is a practical limit, unless a 5 x 7 or 8 x 10 enlarger is available.

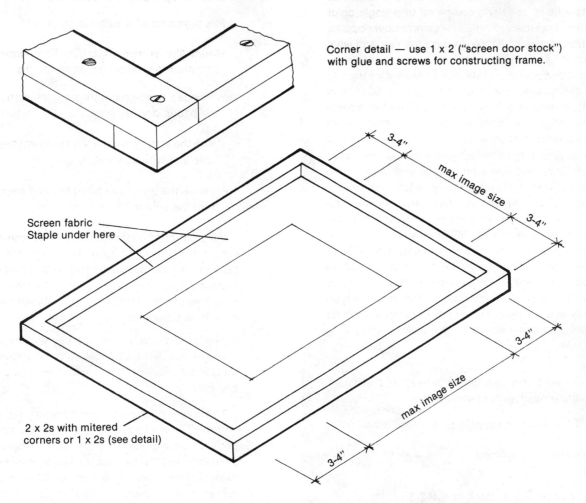

Corner detail — use 1 x 2 ("screen door stock") with glue and screws for constructing frame.

3-4"

max image size

3-4"

Screen fabric
Staple under here

3-4"

max image size

2 x 2s with mitered corners or 1 x 2s (see detail)

3-4"

Figure 7-74: Planning your screen: start with the expected image size, and work outward to determine the minimum screen size. The inset detail shows an alternate construction method that requires no clamps or special craftsmanship. Each side is constructed of two pieces the same length, offset at the ends to form the overlap.

Figure 7-75 (A) Cutting brown gummed paper tape ½-inch shorter than inside of screen.

(B) Wetting the tape in hot (43-40°C) water.

(C) Bending tape into edges.

(E) Cutting corner pieces half-way through.

(D) Using sponge to remove excess water and insure bond.

(F) Moistened corner piece in place.

Figure 7-76: (A) Characteristics of direct and indirect stencils.

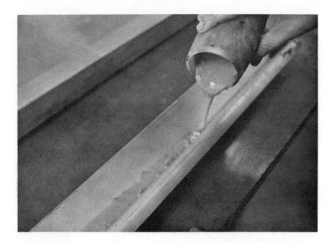

(B) **Pouring sensitized emulsion directly into the applicator.**

(C) **Securing a bead across screen.**

(D) **Spreading emulsion across screen.**

Figure 7-77: **The direct emulsion may be exposed to a battery of floodlamps as well as to a high-u.v. source. The image is less sharp, but the price is very low, and the material is most stable of all the photosensitive emulsions. Both bichromated and diazo emulsions are now available.**

The second type is now available in two different kinds of emulsion. One is a bichromate-based photosensitive system, essentially similar to the other bichromate sensitized colloid systems described earlier, developed by hot water. The other, newer system is a diazo chemistry, developed in cold water. The bichromate emulsion requires posthardening in a peroxide solution, following exposure to a u.v. source and before hot water washout-development.

The liquid emulsion is the most stable, as it is mixed with its sensitizer just before use. The indirect stencil has a higher degree of resolution possible, but allows only moderately long runs. The direct stencil has a lower degree of acuity and resolution, but has a very long run because of the greater adhesion of the stencil to the fabric.

The direct stencil process is usually limited in its resolution of fine detail in part because of the problems of holding the stencil in intimate contact with the screen (special vacuum frames are rarely available that will enclose the frame) and because the light source is often diffused, rather than being a point source.

Nevertheless, the direct stencil is much less expensive than the indirect stencil, and is perfectly adequate for halftone dots up to about 65-70 lines-per-inch. For the finest halftone dot resolution it will be necessary to use an indirect stencil, exposed by arc or xenon pulse light. Indirect stencil resist is sold under various trade names, most of them being bichromated gelatin coated on 2 or 3 mil mylar. The thinner base costs more, but per-

mits the positive to be closer to the gelatin, yielding a sharper dot from a fine-screened image. Ulano, for example, makes Poly Green, Poly Blue 3, Poly Blue 2, and Poly Red. The differences are that the green is a thicker resist material designed for long-run industrial applications, and has a textured mylar supporting sheet that further diminishes sharpness. Poly Blue 3 and 2 are essentially the same, being thinner gelatin resists than the Green, supported on 3 and 2 mil clear mylar supports; they are designed for normal halftone work. Poly Red is a very soft gelatin, supported on a 2 mil base, and is designed for the finest detail reproduction with halftones. It requires very careful handling during cutting, exposing and developing to avoid scarring and dirt pickup.

An English firm, Autotype Ltd., London, makes Autotype Superb; the resist is a polyvinalalcohol, diazo-sensitized emulsion coated on a 2 mil support. It has advantages over the bichromated materials in ease of handling and cold water developing; it is about the same speed as the bichromated emulsions. It is unique in that the emulsion may be exposed, developed, dried and stored on the support; when convenient it can be rewetted and then adhered to the screen.

The positive is trimmed so that only an image is left. Any black or opaque areas will print on the screen. The positive is placed in a print frame (pressure or vacuum), the emulsion in contact with the back, or support side of the resist material. Exposure is made by a standard u.v. light. Sunlamp, arc or xenon lamps may be used. Initial exposures must be determined by using a positive with the finest halftone desired, then making step-exposures exactly as gravure tissue was tested, at 1', 1'30", etc., to about 4'0" for a 50 amp arc at 24 inches.

Immediately following exposure, the bichromate presensitized tissue is placed in a dry tray and the peroxide post-hardening solution poured over the resist in a single smooth motion. A liter of this developer (compounded from A & B powders supplied by the manufacturer) will process three 11 x 14 sheets of tissue with no change in effectivity. Since the solution generated is about 2% Hydrogen Peroxide, gas is constantly being given off. Light will break it down, and between developments it should be covered. It must not be stored in a tightly closed jar, however, or the increasing gas pressure may burst the container. The tray is rocked vigorously for the total developing time, wetting all the resist constantly. At the end of the time recommended by the manufacturer of the resist, transfer the resist to a piece of double-strength glass or quarter-inch plexiglas large enough to support it completely. Wash off the unhardened resist with a spray of water at 43-44°C (110-115°F). The pressure should be moderate at

first, and may be increased slightly when the image is mostly clear. Continue washout for about two minutes, moving steadily over all parts of the image. Any gelatin left unwashed will become impenetrable resist, once adhered to the screen.

When the image is clear, the resist should look sharp and precise. What is left are islands of gelatin, adhering to the mylar support. Place the supporting sheet on a smooth surface; wipe the face of the clean screen with a dampened sponge, both to evenly moisten the nylon and to brush away any dust that might prevent total adhesion. Position the screen above the resist, then lower it smoothly onto the gelatin resist. Lay a pad of four or five sheets of clean newsprint on top of the

Figure 7-78: (A) **Indirect stencil being cut. There should be a safe area outside the image to allow for handling. Both Ulano (bichromated) and Autotype diazo materials are shown in foreground. They are exposed the same way, with the light coming through the plastic support into the emulsion.**

(B) **After exposure, the Ulano material is posthardened in an Hydrogen Peroxide bath. The diazo material does not need this. Either material is then developed out by washing. The Bichromated sheets develop at 43°C ±2 degress. The diazo materials wash out best between 21-25°C, as shown here.**

Figure 7-78: (C) After 30" to a minute of washing, the full image should appear. Continue washing for at least a minute to remove all scumming resist. In the case of Bichromated materials, gradually cool the water to room temperature and continue washout another minute to prevent scumming.

(C) Place a pad of 5 sheets of clean newsprint over the adhered resist.

Figure 7-79: (A) Dampen the screen with a clean sponge. This also permits removal of any airborne dust that would cause pinholes.

(D) Pat lightly with a folded towel, just compressing the towel.

(B) Place the developed resist face up on a glass or plastic support, and position the clean screen over it. Lower the screen until it touches the resist.

(E) Remove the bottom, wet, sheet of paper and repeat.

screen material. Using a towel folded into a pad, press lightly everywhere, assuring that the resist is in intimate contact with the screen. **Do not** use a roller, or squeegee, or press heavily; this **will** adhere the resist more firmly, mashing it into the weave of the fabric, but it will also crush halftone detail finer than about 50-line dots.

Lift off the newsprint, throw away the bottom sheet that had been in contact with the screen, and repeat the patting. Do this for four or five sheets of paper. As soon as there is clean paper, without wetness or resist color, stop. Lift and tilt the screen frame, pulling the resist and its support away from the plexiglas.

The screen can be opaqued, or blocked-out around the image resist by spreading a ribbon of fast-drying blockout solution around the frame. and spreading it with a cardboard scrap until it is

(C) **Be certain it overlaps the opaque surround of the image. Spread it evenly, scooping off any excess, and set the screen in front of a fan to dry. If the blackout is too thick, it may dry with lumps, making screening difficult.**

Figure 7-80: (A) **Pour a thin stream of rapid-drying blockout (sold in various colors, e.g. red, green, blue) around the image.**

smooth. The screen should then stand on edge in a quiet place for 10-15 minutes, and then be placed directly in front of a fan, to dry the resist. When the resist is dry, the supporting mylar sheet can be peeled away by lifting a corner and pulling back, parallel to the screen, across the image.

Examine the screen for pinholes, and use the blockout as needed. When the spotting of pinholes is dry, place the screen on a printing table. The hinges supporting the screen frame should keep the frame about a quarter-inch off the table. Additional blocks should be made up of scraps of cardboard taped together and placed under the corners of the frame away from the hinge. These keep the screen from being in contact with the paper until the squeegee presses the screen down. This is called "off contact" printing, and produces the sharpest dot for fine halftone reproduction.

The pigments used for silkscreen are available in two grades, poster and process. Poster colors are coarsely ground, and when used in fast drying **poster** or **sheet base** tend to clog halftone images, increasing contrast and reducing quality. Process colors are more finely ground pigments, and are best used in **halftone,** or **process** base. This diluent is a jelly or a heavy syrup compared to the more fragile and semi-liquid sheet base. It need not be thinned. A cautionary note: the squeegeeing technique is different with each base material used, and will require different pressure and stroke.

Offset inks can be used with halftone base, and produce color effects that are more clear and brilliant than the process screen printing inks.

(B) **Spread it in a thin even layer over a piece of cardboard.**

Figure 7-81: Stretched screen, using in "off contact" printing; this produces the sharpest halftone reproduction.

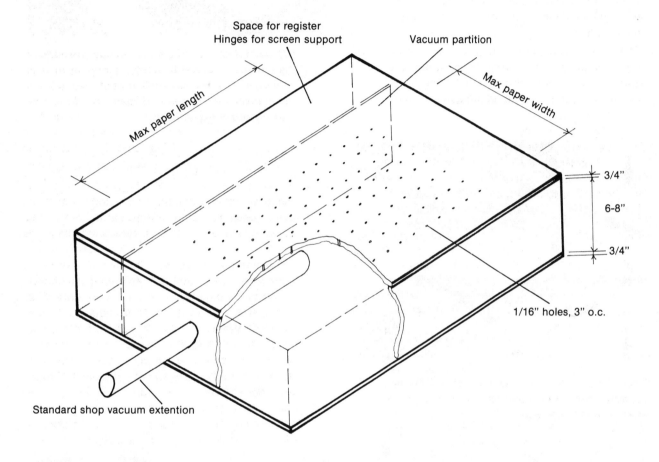

Space for register
Hinges for screen support
Vacuum partition
Max paper length
Max paper width
3/4"
6-8"
3/4"
1/16" holes, 3" o.c.
Standard shop vacuum extention

Figure 7-82: Cutaway drawing of an inexpensive vacuum table. This can be built of standard materials, e.g. the frame of nominal 1 x 6, etc. There should be no more vacuum holes than shown: larger holes, or greater numbers simply reduce the vacuum pressure at each contact point. This system will accomodate a 30 x 40 inch print.

Halftone color separations are made and printed in the same way single images are produced. Three or four screens are used, to avoid registration changes caused by humidity variations that are inevitable if one screen were used over and over. Papers change size with humidity. Some standard papers will increase a quarter of an inch in 20 inches with a 25% rise in relative humidity. Paper fresh from the package must be spread on drying racks to season before starting critical registration printing.

A vacuum table will produce sharper halftones and more critical registration of colors. A table is simple to build, and requires the pressure of only a standard small shop vacuum.

The vacuum holds the paper still during the vertical movement of the frame, and keeps the paper from sticking to the underside of the screen as the ink is

squeegeed through the fabric. This means that when the squeegee has passed the width of the picture, there is no contact between the screen and the print. Without the suction of the vacuum table, the print clings to the screen because of the ink, and because of static electricity. Pulling the print away often smears it. If a vacuum table is unavailable, discharge the screen's static electricity every other pass by holding a metal bar between the hands and drawing it across the underside of the screen, not quite touching the fabric. The electricity will discharge into the bar, and through you into the floor. The charge will not shock you if done this way, and the paper will cling much less.

Sequential registration may be done by using registration hinges that permit the screen to be positioned over the previous imprint, or by using an overlay matrix. If only a few prints of an edition are required, the overlay is cheap and quite accurate, though not as speedy as using hinges. But good hinges cost about a hundred dollars, unless you make a set yourself, and many artists are not motivated to do that. An overlay matrix is a sheet of 2 or 3 mil acetate, larger than the paper on which the print is being screened. Tape the acetate along the left edge. Screen the first impression of each color on the acetate. Then slip each succeeding

print into register with the acetate image before tipping it out of the way. The acetate can be wiped clean after each run, using a standard solvent.

A safety note: photosilkscreen printing requires the use of highly volatile solvents, both in the pigment support and in the thinners and cleaning agents used to remove the pigment from the screen. None of these are especially good for the lungs and liver, and they all must be used with caution. Kerodex 51 may be used to prevent penetration into the skin of the hands, as noted in the section on gravure printing. A ventilation system is necessary if much printing is going to be done. The fumes are heavier than air, and the exhaust fan should be located close to the vacuum table and no higher than it. An ideal system will provide fresh air from one side and exhaust solvent-laden air from the other side of the screen. The following illustration shows a home system with a vacuum table driven by a small shop vacuum. Both the exhaust from the vacuum and the fumes from the screen are picked up by the large exhaust fan and pushed outdoors.

Lithography derives its name from stone; the photographic image was adapted to lithographic printing within two years after photography was perfected in 1839. The first attempts were pure line reproduction, copies of engravings, rare books, etc., and it wasn't until 1855 that Alphonse Poitevin developed a new system based on bichromated colloids. The exposed gelatin, albumin, gum or glue that has been bichromate sensitized loses to a large degree its ability to absorb water. The areas surrounding an exposed patch, being absorbent by nature, do absorb water. The result is that a negative halftone exposed onto such a surface will produce patches that are effectively ink-resistant, and other patches that are effectively water resist-

Figure 7-83: **Vacuum table and exhaust system. The large-volume kitchen exhaust fan, located slightly below printing level, draws fumes directly outdoors.**

Figure 7-84: **(A) The metal lithographic plate comes in large standard sizes; cut the plate to size by scoring it with a mat knife (avoiding direct finger contact, for skin oils will form a resist).**

(B) Bend the plate along the scoring and break it.

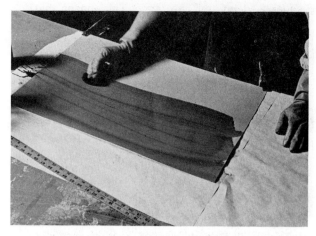

(C) Spread the emulsion left to right.

Figure 7-85: (A) Clamp the plate to a clean work-surface.

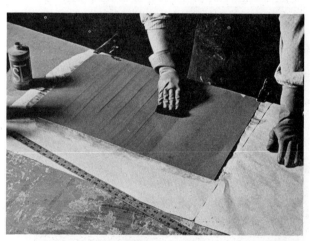

(D) And then crossways, to assure even distribution. Fan it dry. The emulsion should not be spread under fluorescents.

(B) Spread a pool of emulsion. The plate's tooth will offer some resistance to spreading, which is why the clamp is needed.

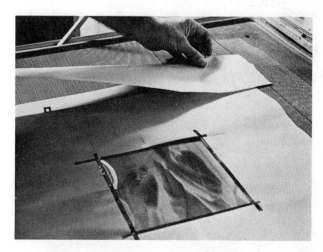

Figure 7-86:(A) Place the dry plate on the exposing table, and mask off the perimeter of the negative halftone so nothing but image is exposed.

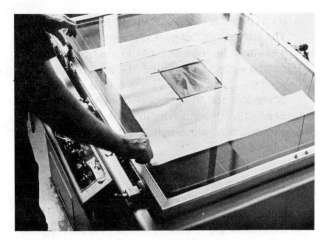

(B) The masked-off plate ready to be exposed.

(B) The developer is worked into the tooth of the entire plate.

(C) Under full vacuum pressure, the table is rotated for exposing to pulsed xenon lamp.

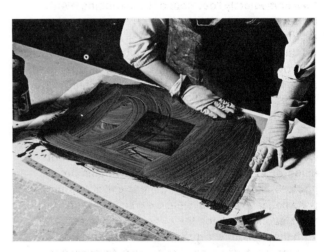

(C) Until the full image is completely developed.

Figure 7-87: (A) After exposure there is a faint print-out image. The plate is returned to the work-table and developed with a lacquer/developer. This "brings up" the exposed image.

(D) Then the plate is washed (some workers prefer to spray with water, but a sponge and bucket of clean water seems to work just as well and eliminates physical transfer of the plate.)

ant. By keeping the surface moistened and rolling it with an inked roller, a planographic printing surface is created. This was done on stone until this century, when mechanically textured thin metal plates became popular.

Made of metal alloys and resembling zinc in color, the plates are "grained" on one side. The tooth produced by the graining machine resembles the pattern on a properly ground lithographic stone. The chemically clean plate is sensitized with a polyvinalalcohol + bichromate mixture. As soon as it is dry, it is exposed by contact to a standard u.v. source. A halftone negative is used to make the image on the plate. Where light penetrates through low density areas in the negative, the pva is made insoluble; elsewhere it remains soluble.

The exposed plate reveals a weak image due to the photomechanical changes in the emulsion. It is then immediately "developed" by scrubbing it with a "lacquer-developing-ink" which is usually a liquid mixture of greasy substances dissolved in a volatile solvent. This has three functions, which are to provide a greasy foundation for the image, to make the exposed resist image clearly visible, and to protect the image from the lithographic etching solution.

The developing fluid is washed away with clear water, and the plate is "etched." There are different kinds of etching processes used in commercial photo-offset printing — but the zinc and aluminum plate negative image system is the simplest and the most economical for the expressive printmaker. With these plates the gum etch is a modern substitute for the gum arabic + nitric acid desensitizing solution used in stone printing since the days of Alois Senefelder, the inventor of lithography. Lithographic gum is made from purified wood fibers, or cotton, and is referred to as cellulose gum or "C gum." The principal purpose of the gum etch on

metal plates is to desensitize the bare metal to ink. The etch consists of gum, phosphates, nitrates and weak acid. As soon as the plate has been etched, it can be wetted and printed. If it is not desirable to print it immediately, the plate can be treated like a stone and stored for a time. When the plate has been printed, it may be inked and "closed" in a standard way, with a pure gum etch wiped, buffed, and fanned dry.

The plate may be printed on a press made for photo-offset printing, in which case the orientation of the negative should be such that the image on the plate is "right reading" because the ink impression will be transferred to a "blanket" and then transferred to a piece of paper. This is the meaning of the work *offset* in this context: the image is offset from the plate to a blanket to the paper. This permits a press to transport paper at high speed and accept an image from an essentially frail original source. Or the plate may be printed on a lithographer's press, as shown in the following illustration in which case the plate image should be reversed, left-to-right.

A conventional lithographic stone may be used to support the metal plate. The stone need not be as large as the plate, only larger than the image area itself. The plate is temporarily adhered to the stone by a thin film of lithographic gum.

The plate will have a relatively short life printed on the sliding bar press, in direct contact with the paper, compared to the life expectancy of the same plate on a regular press where its only contact is with the fine rubber of the blanket. But a short life here means a few hundred impressions, compared to hundreds of thousands, and for the photographic printmaker working a hand press that is surely long enough.

Figure 7-88: (A) **The clean, developed plate is then desensitized with a gum etch.**

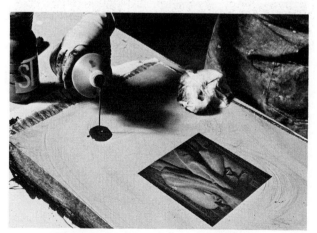

(B) Some workers prefer to use two etches. The second etch is wiped dry, and the plate is ready for printing.

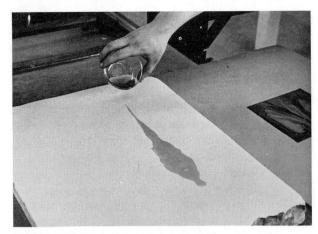

Figure 7-89: The plate can be adhered to a stone by puddling lithographic gum on the stone, then sliding the plate across, as shown.

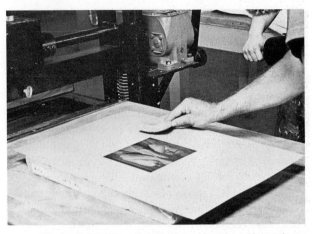

Figure 7-92: The plate is dampened and kept damp between rollings with water, or with a proprietary "fountain solution." Most fountain solutions are weak acids, combining phosphoric acid, gum arabic and zinc nitrate. The purpose is to keep the bare metal desensitized, accepting water and rejecting ink.

Figure 7-90: Lithographic ink is spread in a standard way, in stripes or bands, on a glass or stone rolling surface. The viscosity of the ink can be modified with magnesium carbonate.

Figure 7-93: The roller inking the plate on the diagonal.

Figure 7-91: The ink is rolled out and evened. Note that a *composition* roller, rather than a sewn leather roller is used for the metal plate.

Figure 7-94: Rolling up at right angles to the image. The first rollup should be very thorough, to assure complete inking of the image. Subsequent imprints can be adjusted to the ink density desired.

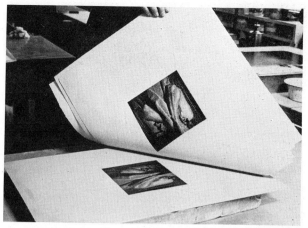

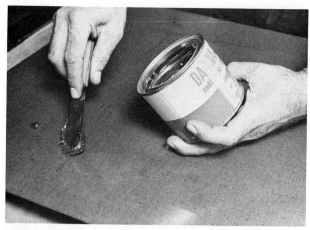

Figure 7-95: The tympanum (the hard slick sheet between the pressure bar and the paper) must be protected by grease.

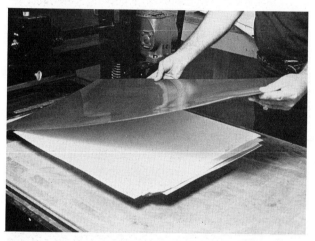

Figure 7-96: The tympanum is positioned over the stone, and the plate moved into correct printing position.

Figure 7-97: The pressure bar is lowered into printing position, and the image cranked through in a continuous smooth motion.

Figure 7-98: After the impression has been made, the tympanum and packing layers are removed, and the print lifted from the plate. Multiple color registration may be accomplished by edge marks or other traditional lithographic registration systems, e.g. needle registration.

There are many different manufacturers of offset printing plates and chemistries; each has their own proprietary products. The illustrations show how the process works with one set of chemicals, those produced by the Pittman Company, under the ST label. The emulsion is called *Process Base Solution,* and must be handled with rubber gloves or the bichromate will create an allergenic skin reaction. The image is exposed and then developed in *Super D Developer,* then washed off with water. The etchant for this process is called *Age.* As soon as the plate has been etched, it may be put on the press, wetted, inked and printed.

CHAPTER EIGHT
Color Notes

Color Notes

Contemporary color photography is essentially a process which uses three black and white filtered photographs and somehow combines them with appropriate primary colors to produce an image which is perceived as a full color photograph resembling the original subject. All contemporary processes are dependent on the argument presented by James Clerk Maxwell in a lecture in 1861, in London, in which he argued that all colors may be matched by mixing primary colors in varying proportions, and that the primary colors of light were red, green, and deep blue. His lecture demonstrated this by projecting three photographs together. One was made through a red filter, the second through a green and the last through a blue filter. The negatives from each of these exposures were then printed into positives which were projected with correctly colored light. When brought together on a screen, with the light intensities balanced, the result was an image which seemed to have all the colors we see.

Variations of this idea were worked out in Philadelphia by F. E. Ives, who did research in halftone reproduction as well, by Miethe in Berlin, and by Gaumont, in France. Gaumont's process used movie film: three similar pictures were exposed on adjacent frames, identical except for the color filters in the light path. The processed film was then played back as a movie, with three projector lenses showing colored positive prints combined on the screen into a single full color moving picture. In 1869, L. Ducos du Hauron, a prolific inventor in photography, suggested breaking up the surface of the negative into spots of color, created by using tiny color filters. The negative and positive would have complementary uses of the filters on the plate, and the film could be reversal processed to make a color image which when seen at a distance would blur the separations of the color dots. This idea was made practical in 1904 by the Lumiere Company, in France. They coated a glass plate with dyed starch grains. The spheres of rice starch were dyed red, green and blue, mixed in equal quantities, distributed at random, covering

the plate, then squashed into flat discs. This *reseau* of starch was varnished, then the emulsion put on the plate. The plate was exposed, processed by reversal to make a positive, and one had a color photograph, called an *Autochrome.* In a few years Agfa produced a similar effect on flexible film. These systems were all additive, relying on the addition of primary light sources affecting the sensory mechanism of the eye.

A positive image in which the colors were created by the superposition of prints, each absorbing color, was desired and became a photographic goal. This depended on using the complements of the red, green, and blue primaries suggested by Maxwell. These are blue-green, red-blue, and yellow, respectively. These hypenated names are awkward, and the names cyan, magenta and yellow were accepted instead. In the printing trade these were renamed again, for the dominant color in each mixture, as *process blue, process red* and *yellow.*

Different color printing systems were developed to use the possibilities of these subtractive color relations, where the natural color of the objects appears because the dyes used absorb some components of white light. Separation negatives would be made of the subject, each exposed through an appropriate primary — red, green or blue. From these, separation prints were made on pigmented gelatin tissue sensitized in Potassium Bichromate, and developed by washing away unhardened gelatin. The three colored positives, with cyan, magenta and yellow pigments in the gelatin relief, were brought together in register on a white support, creating a positive, subtractive color print, called a carbon color print. The prints could be made by exposing the tissue to a negative, or by a chemical interaction with a positive, a process called Carbro color printing.

Gelatin relief images on film could be produced from the same separation negatives, and then dyed and imprinted onto a chemically prepared piece of paper to create a full color image. This was known

as the dye-imbibition process, and then standardized by Kodak as the Dye Transfer print.

In Dye Transfer printing, the separation negative is printed onto a thick gelatin emulsion with a standard photosensitive silver suspension. The exposure is made through the base, so the image will vary in density from the base out, rather than from the top of the emulsion down. The film is developed in a tanning developer, a silver reduction developer of very high energy and little sulphite which produces both a silver image and a polymerization or tanning of the gelatin. The film image is washed in hot water, dissolving away the unhardened gelatin and leaving a bas-relief of gelatin which varies in thickness as the negative varied in density. This piece of film is called a matrix. A matrix is made for each primary color, dyed in an appropriate dyebath, and then rolled into contact with gelatin covered paper that has been soaked in a *mordant.* The low *ph* mordant causes the water-soluble dyes to precipitate out in the print as they migrate from the matrix. When each color has been transferred, the result is a full color print.

Separation negatives required special cameras,

and in essence usually required unmoving subjects. (A notable exception was the Technicolor movie process, in which three rolls of film were exposed in a special camera; these were used to expose film matrices which were then developed in tanning developers and printed by the dye-imbibition process onto a film positive. This print was for years the standard for all color movies).

A number of experimenters worked with ways to make separation negatives all at once, on a single piece of film. R. Fischer suggested in 1912 that it ought to be possible to coat three emulsions on a clear film, the top being sensitive to blue, the middle to green and the bottom to red light. Further, he suggested that these emulsions should incorporate chemicals which would interact with the developer to *make* dyes. He was unable to solve the problems, but the idea was sound. The problems were solved by Leopold Mannes and Leo Godowsky, both known as musicians to the world at large — their process was perfected by the Kodak laboratories. Their mutual research into technical problems led to the introduction, in 1935, of Kodachrome film, an *integral tripack emulsion* with color produced by dye-coupling developers.[1]

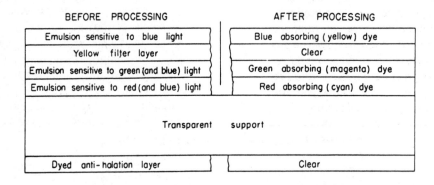

Figure 8-1: **Diagram of film layers in Kodachrome before and after processing.**

In Germany, Fischer's ideas were made usable by the Agfa company and in 1936 they introduced a film with the dye-couplers in the film, not in the developing solutions. The implications of this were that the photographer himself was enabled to process the film. Kodachrome chemistry and processing (each layer of emulsion was re-exposed and redeveloped separately in expensive automated equipment) was too difficult for a private person; Agfachrome chemistry was complicated, but practicable for the individual or the small lab. Under the Alien Properties Act, Agfa patents were made available to the American photographic industry during the Second World War. Ansco, a photographic manufacturer in Binghamton, New York, the American partner of Agfa, found itself in

the position of being suddenly run by Kodak engineers and making film for the military. Within a short time Anscochrome, the American color film derived from the Agfa patents, was supplemented by Ektachrome, Kodak's equivalent process. The Binghamton company, originally known as Anthony & Scovill, shortened to Ansco, then renamed as Agfa-Ansco, remained a trustee of the American government for almost 15 years after the War was over, until it was returned finally to private control under the name GAF, for General Aniline and Film.

In 1942, Kodak made a trial introduction of a color negative material which they called Kodacolor. Because the colors available in the dye-coupling process have certain limits, it was found that an orange dye could be incorporated which

would prevent the degradation of color due to improper absorption of light by imperfect dyes. Such a control would be impossible in a print, but in the negative it simply means that the proportional exposures for the three primaries are affected, because the final result is a balanced color print. The Kodak integral tripack negative was withdrawn from the market for a time, and reintroduced with stable dyes and a dependable chemical system in the late 1950's. Kodak renamed the whole printing process and called it **Type C,** a name which clings as a generic term for the chemically produced color print, though the actual negative and printing papers have long since been given different company names — Kodacolor, Vericolor, Ektacolor, etc.

In the negative-positive color printing system, the silver negative image layers are sensitized to primary colors, and protected from other colors of light by filters. After exposure the film is developed to produce a silver image and a dye-density wherever there is silver. The silver is bleached out with an acid, leaving a negative dye image (i.e. red, green, blur).

The color negative is used to expose an integral tripack color printing paper. The process here is exactly the same: the three layers are exposed to colored light, and respond according to the emulsion's sensitivities and the filters that guard them. During development both silver and dye images are formed. After development the silver is removed with acid, leaving cyan, magenta and yellow images superimposed on a white support. The result is a chemically produced color print.

The virtue of this system is in its mechanical simplicity: only one negative and one piece of paper need by handled. The image is sharp, clear, with excellent color possible.

The Kodachrome, Ektachrome, Agfachrome, Fujichrome, or other color transparency is a single piece of film which is exposed, developed, redeveloped in a dye coupling developer, bleached, and which yields a full color positive. The chemistries of all these systems are quite similar now. So close in fact that for years various "universal chemistries" have been available which would produce **adequate** results with any of them. Now, Sprint Chemicals of Providence, Rhode Island, manufactures a "modular" chemistry for universal color processing, a set of concentrated reducing agents in solution, and of buffered accelerators and inhibitors. One can produce an excellent "standard" developer for any one of the proprietary color systems, without having to stock them all.

The color transparency can be considered an end in itself, and many photographers think of it only in this way: a visual statement to be projected, or perhaps to be sold for reproduction. Exposure, development, filters and special lights are all arranged to produce the slide as a finished object. If it isn't right there, for this kind of photographer it isn't there at all.

Another kind of photographer views the transparency, or the entire chemical-color process, as a means to an end — and the end is the production of a personal statement in color. A printmaker in photography put it this way: "A lab may turn out excellent color prints, but it's the standard machin-

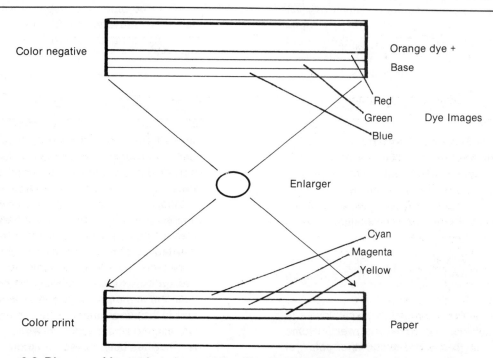

Figure 8-2: **Diagram of layers in color negative film and the American chemical color print.**

ery of Kodak — not the expressive prints of a photographer; and the color photographer who goes that route signs an aesthetic contract. He must play within bounds of the conventional look of a 'color photograph'."[2] As was noted in the first two chapters, once you have achieved a print, then the possibilities of making the print subject to your intention becomes a possible new goal.

The commercial process can be modified to produce nonstandard color; the color transparency can be altered to reinforce or restructure color possibilities; the transparency can be considered as a means to a color print, utilizing many of the printing methods described earlier. In all of these cases, if the photographer's intention is to produce a "window on the world" picture, he should hesitate. The standard chemistries and processes do the best job possible at this time, producing color slides and prints which we find consensually acceptable for the task of "reproducing reality." Any discussion of color becomes a description of the photographer's act of selection. The photographer working with Kodacolor, Ektacolor, Kodachrome, Agfachrome and the other color negative and print systems chooses color from the world and permits the chemistry of a proprietary system to translate that color into a print or slide. When this is done, he can accept or reject, and use the knowledge of his successes or failures in planning how he will photograph a possible subject sometime in the future. This is a kind of control of color, an attitude characteristic of photographers.

An alternative tradition is to make use of the characteristic qualities of color sensitivity of silver emulsions and separate color into primaries, translate those separations into complementary primaries and recombine them to make prints which satisfy the photographic printmaker's formal, coloristic and emotional intentions.

Color has many meanings. In art, color has been used as a code, to express esoteric meaning as well as to describe emotional states. Religious art, for example, has used color thus:[3]

1. Black: mourning, sickness, death. In conjunction with white, humility and purity of life; used for robes of religious orders (Augustinians, Dominicans).

2. Brown: spiritual death, renunciation of the world: the color of Franciscan robes.

3. Red: color of blood, emotions, love and hate. The color of power in Rome before Christianity, the color of power now, and of martyred saints.

4. Yellow: if used as golden, the color of sun, divinity; backgrounds are golden in early paintings symbolizing sacredness; it also means degradation, jealousy, deceit — Judas is shown in a yellow robe, and heretics were clothed in yellow.

5. Green: spring, and therefore triumph over death; St. John the Evangelist's mantle; the color for Epiphany.

6. Blue: color of Heaven; Christ when in earthly ministry, the Virgin when holding the Child.

7. Violet: passion and suffering; the Virgin is shown in violet after the Crucifixion

This use of color assists schematic concepts in art, permitting picturemaking and moralism to stand comfortably hand-in-hand. And in our day color continues to have ambivalent meanings, referring both to pictorial and to schematic intentions. In a brief survey, during the last century of art, color was used by the great Romantic painters as symbolism and as a dramatic and emotional trigger, linking public political meaning of color to intuitive responses to red, blue, heavy yellows. The great revolution of the Impressionists replaced symbolic romantic color with prismatic color, generated according to rigid theory and painstaking observation of the way colors actually look, rather than how things ought to look. Green trees were found to be blue, red, green, brown and yellow. Skin was discovered to reflect the entire spectrum. Physics and optical theory dominated emotions for a time.

Schematic structure found the Impressionist's prismatic color unsuited to further expressive development, and Paul Cezanne, born in the year photography was made practical by Daguerre, severed color from mere reflectances. Color became a means of describing masses, creating relationships, producing illusions of projection and recession. It was divorced from simple representation. In the next generation of art, during the Cubist explosion concurrent with the First World War, color was almost rejected because of the inevitability of emotional associations for a vastly middle-class world. Later, color became decorative again, luxurious, without religious or moralistic intent in the paintings and collages of Matisse; and in the period after the Second World War color was used to create geometry without associations, in what has been called an amoral objectivity in art.[4]

But the camera-made picture is almost always concerned both with pictorial reality as well as a moralistic view of reality. So long as the image is an attempt at an illusion, at making a-window-on-the-world, color is a bother. Black and white photography is simpler because the "suspension of disbelief" so well known in the theater can be more easily produced. Color depends on comparative references and on experience — what seems naturalistic to one eye is garish, or worse is inaccurate to another.

In fact, we rarely have a consensual view of what the color of an object really is. The "thinking eye" is always with us. In the nineteenth century, Ruskin argued that we saw nothing but flat color, and only by experience did we discover that changes in value or color meant changes in direction, mass, density. *If* we had an innocent eye, this would be true, but the mental image we all experience and accumulate affects both retinal and memory information. We ascribe to color all the lifetime implications our particular societal and personal education provides.

Yet we believe in an unalterable color being inherent in an object. We speak of a "red" apple, or "white" snow. The camera does, in fact, have an innocent eye in this sense, and lays down on film a schematic of what color actually existed in the reflected light captured by the lens — *actually,* in this sentence, means within the limits of the chemistry and filters and dyes of the particular color system being used. For if you make photographs of identical landscapes with Agfa and Kodak films, different color pictures will be the result.

Which colors are right? It is easier to ask which colors are acceptable? And the answer is what in effect, it always has been — those are most acceptable which are most pleasing to the thinking eye that observes them. If color is isolated from shape, it changes. If color is isolated from comparison with other colors, or if compared with the same color in a different value, it is changed. Color can be seen as being part of pictorial documentation; it can be seen as being scientific, when the exact color-temperature of the illuminating source is specified as well as the technical ambience in which the color is being viewed; it also can be seen as a complex modulator which acts intuitively as well as rationally on the viewer's nervous system and evokes a certain energy of response in him.

The term used in this book, the "thinking eye" is derived from the title of Paul Klee's notebooks on his work as a teacher and artist.[5] His concern was for an investigation of the world from within, an effort to become aware of his own way of working, the sources of his own vision. In a footnote Klee commented that there have been many color theories. "We have Goethe's theory of colors, which

he probably worked out to refute Newton's assumptions. We find earlier traces of a color theory in Leonardo, Dürer and others. Today still other color theories have been devised. But we are neither a paint industry nor a chemical dye house. We must be free and have access to all the possibilities."[4]

For the artist, he offers a very simple and moving modification of the traditional color wheel. Instead of neatly and precisely breaking it into three (or, with complements, six) pie wedges, he visualizes it as what almost becomes a galactic spiral in which the primaries are dominant at points, but sweep one into the next:

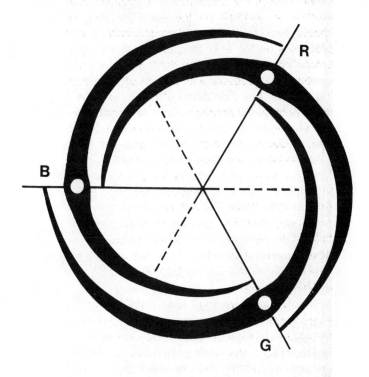

Figure 8-3: **The canon of the color wheel (after Klee).**

He describes this color chart in musical terms as well: "The colors on this circle do not sound in unison as (one might suppose), but in a kind of three-part counterpoint. This combined diagram permits us to follow the three-part movement. The voices come in successively as in a canon. At each of the three main points one voice reaches its climax, another voice softly begins, and a third dies away. One might call this new figure the canon of totality."[6] Later he describes it another way, when he writes that color is "not in unison; in several voices."[7] What he is making visible is the fact that for the thinking eye, color is not a spectrum beginning with red and ending with blue, but a complex living relationship that is cyclical in effect.

]244[

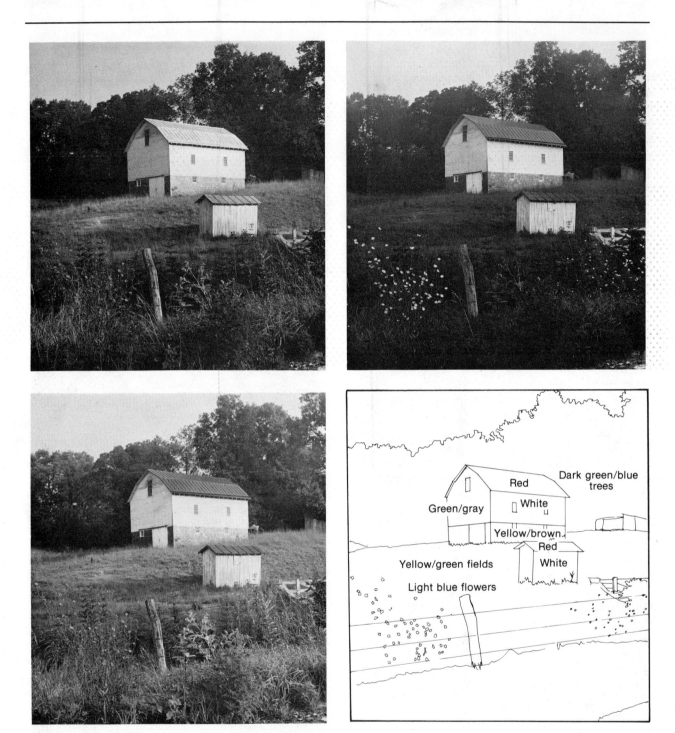

Figure 8-4: (A) Landscape with buildings, photographed through a primary red (Wratten 29) filter. Note the darkening of the skies, the tree shadows, and the increased contrast between the foreground green grasses lit by early morning sunlight (red-yellow) and the shadowed glass in the middle ground. Note the lightening of the red roofs.

(B) With the primary green (Wratten 61) filter, the trees and grasses are much lighter. The contrast definitions in the foreground are lost, because the film sees more nearly equal brightnesses, regardless of color of the sunlight. The roofs are dark. The shadowed sides of the white barns are light, because they are reflecting greenish light from the ground and trees.

(C) With the primary blue (Wratten 47B) filter, the dark greens of the trees are heavily absorbed. The red roof is dark, as well as the green grasses. The blue chicory blossoms are almost white, however. The atmospheric light destroys all roundness in the trees.

(D) A simplified drawing of the photograph, showing the colors of the original scene.

The question often posed for the photographic printmaker by the young photographer, on examining a color gravure, silkscreen or gum print, is "how close is that to the original". Which is an important question to the photo-technician and the advertiser, but of second importance to the photographer making an expressive print. His burden of decision relates to the color which he is willing to have his print compared to — from painting, etching and lithography, or by a poetic extension, from music, where we commonly speak of color of a melody or an instrumentation or a chord. This is the problem for the photographer: to solve for himself the equation of pictorial, schematic, associative and historical meaning present in any color print. Many photographers prefer to ignore it and deal only with the photomechanical problems of sharpness and of narrow accuracy to the sensitometric design limits of the particular process being used.

To begin with, if the photographer wishes to use color in printmaking, unless he is making chemical-color prints by a standard process, he is wise to acquaint himself with the photographic subtractive color primaries: cyan, magenta and yellow, and with their negatives, red green and blue.

The film itself is not equally sensitive to these. Nor does an emulsion produce equal degrees of contrast for these primaries, even with balanced exposures. Contemporary panchromatic film, normally equally sensitive to all colors, produces pictures like Figure 8-4 when exposed through three intense primary colored filters.

The light energy available from the sun is continuous across the visible spectrum, which is merely a narrow bit of the whole spectrum of energy we use, one way or another.

Figure 8-5 shows the relationship of the light to the ability of the filters to transmit colors.

The filters have "sharp-cutting" characteristics, meaning that a small change in color (or frequency, for light is simply a special part of the electro-magnetic radiation spectrum) will produce a big change in the amount of energy they pass, or absorb. The sharper the rejection of unwanted frequency, the purer the translation of colored light into primaries recorded on the negative. The

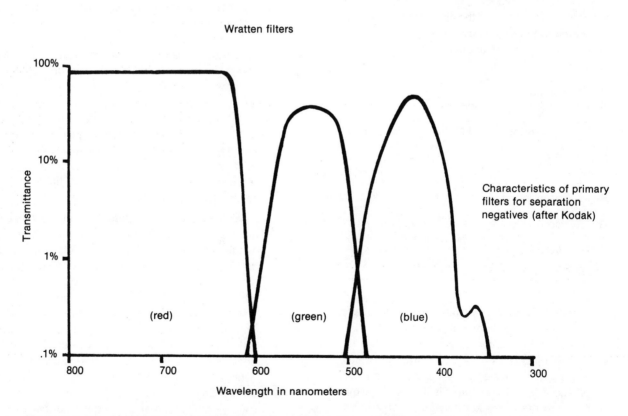

Wratten filters

Characteristics of primary filters for separation negatives (after Kodak)

Figure 8-5: **The band-pass characteristics of the primary filters used in the previous figure. The fact that these color characteristics do not overlap (except below the 1% line) will "exaggerate" the color rendition if used with very pure pigments or dyes. The other primaries suggested for separation work (25, 58 and 47) do overlap a bit.**

filters that are used for isolating primaries in color separation work are now named in a standard numbering, called the Wratten numbers. Kodak makes filters in gelatin sheets, sold in 2, 3, 4 and 5 inch squares. The sheets are very thin (0.1mm), and will not affect the sharpness of the image framed by the lens. They may be held in front of the lens by hand, or mounted in metal filter frames and clipped to the lens.

The Wratten numbers used for making separations are of two different series.

Separation Conditions	Filter Number	Color	Old Filter Name
direct, from the	25	red	A
subject before	58	green	B
the camera:	47	blue	C5
from	29	deep red	F
transparencies:	61	deep green	N
	47B	deep blue	—

The "old" filter names are the alphabetical nomenclature given to filters in the early part of the century. Few filters were then used, and they were named in a comfortable and homely fashion — process filters used in color separation being called A, B, C for red, green, blue, and other filters being assigned letters of the alphabet more or less according to the frequency of use. Other common filter names that occur in older literature, and their Wratten equivalents are: [8]

Old Filter Name	Color	Wratten Number	Use
K1	light yellow	6	slight darkening of blues
K2	yellow	8	"correct" values of sky with panchromatic film
K3	deep yellow	9	dramatic darkening of sky
G	deep yellow	15	stronger than K3
X1	yellow-green	11	lightens greens
X2	yellow-green	13	lightens greens, stronger than X1.

Color becomes value, when filtered. Panchromatic film "sees" all visible light more or less equally, but not in exactly the same way the human eye responds to light. The thinking eye interprets color, translating it in terms of value and also in terms of associations; sky, for example is darker to the eye than it is to the photosensitive emulsion and the print. To make panchromatic film "see" sky the way we do, a K2 filter is used. To make film "see" trees the way we do, with our associations of light, airy, gracious qualities we often ascribe to the forest, an X-2 filter provides a correction of sensitivity so that the print will look right, the greens lighter and the sky darker than the unfiltered film would record the scene.

Color is descriptive, used to describe the object in a way often impossible for value change alone to do it. Color is pictorial, used to define areas and figure-ground relationships in a way that tone or value alone cannot do. Color is of course scientific, and is defined according to a given color-temperature of illumination. Color is schematic, as described briefly in the beginning of this chapter, and is imbued with ritual iconological implications.

A subject can be seen by the photographic artist either as a color statement or as a monochromatic composition. Frequently the same subject will work for both color and black and white film, but often the real meaning of the picture is in the color relationships, and then the meaning of the picture is lost in the monochromatic translation. Often, when one has been working with color film for a time, a photographic subject will be exposed in monochrome, and the picture almost disappears in a blur of greys, because the values of the colors are nearly identical, seen in monochrome.

Working with color with the intention of making color prints by photomechanical methods imposes new disciplines. First, the negatives that result from color separation have to be evaluated differently than negatives meant for monochromatic printing. Evaluation of color separation negatives and the subsequent halftone positives (or negatives) is made easier if the photographer remembers that there is almost never a pure white in a photographic subject. What is called white almost always has color. Only specular highlights (reflections of light sources seen in mirror-like surfaces) are white, i.e. **have no density** in the halftone positive. All other areas of the image have density, and therefore must have a halftone dot — otherwise they would have no color.

White in the color separation halftone has a dot that is a function of the color of that white. "The white light a piece of paper reflects when turned toward the window is a multiple of what it reflects when turned away. We are not conscious of the objective degree of all these changes unless we use a 'reduction screen,' in essence a peephole that makes us see a speck of color but masks off its relationships. Those who have used this magic instrument report the most striking discoveries. A white handkerchief in the shade may be objectively darker than a lump of coal in the sunshine. We rarely confuse the one with the other because the coal will on the whole be the blackest patch in our field of vision, the handkerchief the whitest, and it is relative brightness that matter and that we are aware of."[9]

The color of a nominally white object in the

photograph can be used as a control. It is possible to transform that white, and consequently modulate the entire color range of the photograph, by a number of controls available to the photographic printmaker.

Color Controls

Exposure and development of transparency.
Dyeing the transparency.
Contrast control of the separation negatives.
Rebalancing of separations.
Contrast and density control of halftones.
Local control of halftone dot.
Control of saturation and brilliance of colors used in printing.
Balancing of primaries in printing.

Taking these in order, the transparency can be exposed and developed in various ways to create color modulations that will be of aesthetic use. Exposure can be seen as a control in two different ways, first simply to place the color higher or lower on the brightness scale, by overexposing or underexposing the film. Since the color transparency has a useful density range from 0.10 to almost 3.0, the possibilities of exposure control are reasonably large compared to a black-and-white negative. If the transparency is not the end product, but a means to the print, overexposure yields both lightening of detail and reduction of contrast. Underexposure yields both darkening of the picture and increasing color saturation.

The transparency is processed by reversal to produce a positive. This means that the exposure is in effect controlled by the highlight details needing density, rather than by the shadow areas — provided standard recommended development is used. For the color transparency one meters the highlights to determine the exposure, placing the highest textured grey-white at Zone VII-VIII (i.e. by metering this value and then exposing 2-3 stops more than the meter says). But this is not an unalterable rule. Exposing more will wash out colors, producing an image with low color saturation, but will not destroy all detail, because of the curved shoulder part of the characteristic curve and the fact that increasing the exposure does not increase the negative density linearly. Unlike making an overexposed negative and then a print from that, there is detail in the whites, even with relatively large overexposure. It will no longer be naturalistic detail.

For the majority of color films now available, the processing can be done by the photographer. The manufacturer's recommended processing produces a standard, useful result. It is not the only way the film can be processed. For example, Sprint chemistry can be used to process Ektachrome film to produce a slightly different color statement than

that produced by the standard Kodak chemistry. The maximum density areas are more neutral grey-black, and the color saturation a little more intense. The cost of processing is significantly less than the standard Kodak chemistry:

Modified Sprint Chemistry for E-6 Ektachrome Processing
First Developer: Sprint Quicksilver, 1:9, with 22½ml of Quicksilver Reversing Converter #1 per liter.
Stop Bath: Sprint Block 1:9.
Color Developer: Kodak E-4 Color Developer with 4ml Sprint Quicksilver Redeveloping Converter #2 per liter.
Bleach/Fix/Hardener: Sprint Record Fix 1:9 with 15ml Big Al Hardener + 30 grams Potassium Ferricyanide per liter stirred in immediately before use. (**Do not** discard down drain after use).
Stabilizer: 3 drops Photoflo 600 + 5ml Formaldehyde per liter.

Processing E-6 with Sprint Modified Chemistry:
(All solutions are to be maintained at 30° C (86° F).

Step	Time	Process	General Notes
1	2 min	**presoak**—agitate 15 sec.	water at 30° C
2	11½	**negative development:** agitate constantly first minute, then 10 seconds each minute	discard after use
3	3	**stop bath**—agitate 30 sec. then 10 second each	save bath
4	3	**wash:** FILL tank, dump & shake. Repeat 15 times.	
5	16	**color developer**—modified E-4. Agitate as for first developer.	discard after use.
6	3	**stop bath:** as above	reuse from Step 3, then discard.
7	3	**wash:** as before.	discard in ecologically sound way after use.
8	7	**bleach/fix/hardener: agitate continually.**	
9	3	**wash:** as before.	
10	2	**stabilize:** agitate 15 seconds only.	
11	-	**squeegee** with rubber blade scissors squeegee	absolutely necessary.
12	-	**dry**	

Once the transparency is achieved, it must be separated into primary colors for use by the printmaker if he wishes to produce a color print reflecting the original color relationships. This is not required, of course, but the procedures for nonstandard color interpretations are essentially the same as for a representational color interpretation. Once the tools are learned, one is limited only by creative imagination. The mechanism of color separation, and the appropriate exposure and developing conditions are described in Chapter 5.

There is no reason why separations may not be done directly from a color negative. The disadvan-

tage of working from a color negative rather than from a transparency is that there is no easily verifiable visual reference to which to return, from time to time, when attempting to coordinate the details of a new process, or when modifying color relationships away from a standard result. But, by using an unexposed but processed piece of color negative material in order to obtain the orange masking color inherent in the process, and sandwiching this with a negative density step tablet, one can experimentally produce balanced continuous tone positives and then make halftone negatives — or by using a grey contact screen or diffusion sheet material and Kodak Pan Litho film (2586) directly produce halftone positives suitable for enlargement. The Pan Litho film must be processed in total darkness.

If the transparency as processed is lacking the color balance desired, one may modify the color in two ways. One is to add color to the transparency. The second is to rebalance the separation negatives, making deliberately unbalanced separations that will produce a desired color effect.

Color may be added to the transparency during the exposure or after it has been processed. Putting aside local manipulations, i.e. painting and drawing on it, the transparency may be dyed or it may be colored by the light passing through the lens (filtering it) or it may be colored by the use of filters at the time separation negatives are made. To color the light at the time of exposure, Wratten CC filters may be used. These are marked in density increments and color names, e.g. CC 30 M = color correction, density 0.30, color magenta. The effect of adding this would be to add red + blue light to the picture, and to decrease the total amount of light passing through the lens. The exposure correction would be about half the CC number, or in this example 0.15, which is one-half stop. The density numbers add arithmetically. If you were to use a CC 30M and a CC 30B, the effect would be to add more blue than red, and the exposure correction would be 60 over 2 =0.30 which is a full stop more exposure. The effect of such filters *can* be estimated with some luck by closing one eye, looking quietly at the scene, and moving the filters swiftly before the other eye, and trying to *see* the change that takes place. The problem is that the eye accommodates so quickly to color changes and "rebalances" the scene, that it is hard to see objectively what actually is going to change. The principal effect will be on the highlights. The same filters may be laid over the transparency during separation negative production, producing similar results.

Starer Chemical Company, Box 15536, Durham, N.C. 17794, sells dyes for modifying transparency and resin coated paper chemical color prints. The

dyes are sold in sets of magenta, cyan and yellow dyes. Instructions are provided for their use. The dyes are diluted in distilled water; the transparency is prepared by soaking in water containing a wetting agent. A 10 second immersion in any given primary will add a 0.085 color density to the transparency and a 0.025 neutral density. Excess color may be removed if the transparency is washed immediately, but drying fixes the color. Local color alterations may also be done by painting, or swabbing the color, either on the print or the transparency.

Presume that you make a photograph under conditions which created an overall color cast — for example after sundown, when the light may be heavily blue from the ambient skylight. The transparency is not ruined for reproduction, in fact it may have hidden virtues. A painter knows that one way to harmonize a complex color palette is to add a bit of a given color to *all* the colors on the palette. Individually, they look funny: add a trace of blue to all the other colors and the orange gets a bit dirty, the green becomes more nearly cyan, etc. But paint a picture with these colors and the effect is startling; all the colors look like they should except they are linked by the underlying blue. "While form is absolute, color is wholly *relative.* Every hue throughout your work is altered by every touch that you add in other places."[10]

The photographer can take advantage of this effect, and often does. Photographs made by warm afternoon light, for example, are unified in just this way. But the problem here is how to use this effect, and minimize its obviousness. Examine the blue-grey transparency exposed after sundown, by reflected skylight. Find a neutral subject in it, one which is large enough to meter with a color densitometer. (Each densitometer has a probe with a definite minimum size area which can be safely metered. The Kodak Model 1 Color Densitometer, for example, has a metering circle about 1mm in diameter.) Using the color filters for the densitometer, meter the proportions of each primary. Now take a transparency with a similar neutral subject, photographed in a "normal" light, so that the color as seen on the transparency resembles the color you would wish that subject to be recorded in on the print. Meter the densities of the primaries on the "normal" transparency.

Example: a transparency photographed in blue light yields these densities for a dirty-white painted wall:

Red	Green	Blue
0.70	0.75	0.35

and the densities from a similar surface in "normal" light:

0.40 0.45 0.35

the *differences* between these would be:

0.30 0.30

The separation negatives from the blue-light transparency can be changed by increasing the red and green exposures (but not changing the development plan for them, as produced by the experiments in Chapter 5), and keeping the blue exposure standard. This will increase the density of the red and green separations, proportional to the blue, and when positives are made and printed, decrease the amount of cyan and magenta pigment laid down, while maintaining the normal amount of yellow. The effect will be to remove the excess blue from the neutral color; but since there is an effect of this color implicit in the whole brightness range of the picture, it will slightly grey all the colors, and in a quiet way make them interrelate in a way not possible otherwise.

The pigments themselves will modify the sensation of color produced by the halftone color print. Again, it is not necessary to balance the pigments in the way described below, but if they are balanced then controlled or experimental imbalance can create results which relate both to description and to expressive intent. The process of balancing pigments is described for photosilkscreen because it is quickest and easiest to accomplish, but the same method will work with any of the halftone printing methods.

Make a halftone resist and adhere it to a clean screen. The image used should have a definite dot in all areas, and the darkest areas should have some opening in the dot for the most sensitive results. When the resist is dry, the support peeled away, and the perimeter filled with blockout, mix a trial quantity of process blue. Mix by weight, for precise control. A triple-beam balance with a flat pan (see Advanced Controls) is best; measure pigment onto a piece of wax paper; measure halftone base by determining the weight of a convenient standard volume. For example, a squat glass jar, easily filled, with straight sides that permit scraping out, may hold 500 grams of base when it is filled and the excess struck off with a blade. This container then becomes your standard unit, and you can calculate pigment ratios against the weight of the base it will hold. For 300 grams of base, try 30 grams of a standard process blue silkscreen pigment. Mix the pigment and base thoroughly and then squeegee the color onto 10 sheets of paper. Dry them. Clean the screen and mix a process red and base color. If you use regular

process red, use twice the amount of red as you used of blue to 300 grams; if you use permanent process red, use triple that amount of pigment. Regular red would be 60 grams, then, or permanent process red would be 90 grams. Registering the image carefully, squeegee red pigment onto five of the prints. Dry them, clean the screen, and mix a process yellow. Use 1/3 the weight of yellow that you did of blue, or in this example, 10 grams. Squeegee the yellow carefully over the red + blue image, being certain to register the image as exactly as possible.

When the yellow pigment is dry, examine the finished result in various lighting conditions—by daylight, windowlight, tungsten light, fluorescent light. Note how the color of the image changes slightly in each, but look always for the sense of greyness. If your pigments were exactly in balance, if the squeegee pressures were exactly even, the stroke across the screen identical, and the images exactly in register, you would have made a perfectly even grey image, varying from a pale grey in textured white areas to a deep grey-black in the deepest shadows.

None of the variables described will be identical. The image will have some color variations—there will be some washing of colors due to squeegee pressure and stroke variables, and registration changes. But the overall sense of greyness should be there. If it isn't then the pigment balance must be changed.

The color logic of subtractive pigment printing is direct and easily learned.

Red= process red + some yellow. The yellow cancels the blue in the process pigment, leaving red + neutral density.

Green = process blue + yellow. The yellow combines with the blue making green.

Blue = process blue + process red; the green in the cyan cancels the red in the process red, leaving blue from each + neutral density.

The shades in between (orange, etc.), are created by shifts in balance.

If the print seems reddish, then either the process red is excessive, or the process red **and** the yellow are in excess, or there is a deficient amount of process blue. The next test would be to reduce the strength of the process red mixture, print the last five prints, add the yellow and compare results. Make all changes in pigment balance by weight, or your information is useless. Once calibrated, you will find that a 3-5% change in pigment weight is visible to a discerning eye.

If the print seems greenish, there may be an excess yellow, or an excess process blue, or a

deficiency of process red. Increase the strength of the process red, and screen the last five prints.

If the prints seem blue, there may be a deficiency in yellow or too little process red, or an excess in process blue. For this test, increase the concentration of the process blue and screen the last five prints and compare them with the first group.

Carry this test to completion, and note the results. A balanced set of pigments can then be proportionately increased or decreased in saturation to change contrast without seriously affecting color balance.

For example, the following table suggests approximate ranges of concentration for specific effects:

Contrast	Process Blue	Process Red	Perm Yellow
Low	30	90	12
Medium	40	120	16
High	60	180	24

After the pigments have been brought into balance, and a trial print made there are still control possibilities other than major manipulation of the image. Colors may be screened over the three color image to modify the total balance, or glazes may be added, or the entire print may be varnished to increase brilliance.

If the completed print has a definite color cast in the darker tones which is unpleasing, it may be neutralized or modified by using a complimentary color, or a neutral brown + a complimentary color screened onto the print with an appropriate screen. For example, if the overall tone of the shadow areas is greenish, the process blue screen may be used, and a very dilute brown + red screened. This in effect lays down pigment only where the cyan (process blue) was placed the first printing, adding both a neutral density (brown) plus a complimentary color (red), neutralizing and enriching the darker tones. It will have little effect on the upper tones. The amount of pigment to use, for a trial, is 5-10% of the amount of pigment originally used in the color being overprinted, in a similar quantity of halftone base.

The order of screening colors in printing has traditionally been yellow, red, blue, the idea being to protect the yellow from u.v. destruction. The yellow is difficult to register to because of its great transparency, compounded by the fact that most synthetic screen materials are yellow-to-orange. A compromise can be struck by screening the magenta (process red) first, then the yellow, and finally the cyan (process blue). This provides a protective overprint and easy registration.

Other pigments may be used, and perhaps the best alternative both in terms of purity of color and permanence and suitability of pigment to paper is lithographic ink. Process colors may be purchased from a local printer by the pound, or from a printing supply house. The purity of these colors exceeds that of the silkscreen colors, and they are of ideal transparency for printing halftones. The balancing of the pigments should be done in the same way as outlined with the silkscreen pigments.*

All the work described has been in terms of three-color printing, which most of the time is adequate. Sometimes the traditional fourth color (black) is desired. The separation negative may be made with white light, or with a salmon (Wratten 85B) filter. The separation negative for the black print may be produced to the *same* density range as the other separation negatives, and then the halftone positives exposed and developed (with constant agitation, rather than still development) so as to produce a visible dot only up to a Zone V equivalent density. Or, the separation negative may be made significantly more contrasty (the maximum density rising about 0.30 above that of the other separations, and the minimum density being the same), and the halftone positives produced by the same exposure and development as the other positives. The results are similar, but not exactly the same, and the effect of one versus the other must be tried for personal taste. In either case, the important thing is to make the black print rather subtle, if "naturalistic" renderings are desired. As with all other process suggestions, transforming the black print into something more vigorous can be a creative tool, especially combined with dot-etching as detailed in Chapter 5.

* Standard Process color lithographic inks will be approximately in balance with a Blue/Red/Yellow ratio of 3/3/1 by weight. There will be some variation, one brand to the next.

[1]S. Labrot, letter to author, June 1977.

[2]C. E. Kenneth Mees, *From Dry Plates to Ektachrome,* Ziff-Davis, New York, 1961.

[3]George Ferguson, *Signs and Symbols in Christian Art,* Oxford, New York, 1954, pp. 271-275.

[4]William Fleming, *Arts and Ideas,* Holt, Rinehart & Winston, New York, 1974, pp. 314, 342, 402, 412, 419.

[5]Paul Klee, *The Thinking Eye,* ed. Jurg. Spiller, George Wittenborn, New York, 1961, p. 521.

[6]Ibid., p. 489.

[7]Ibid., p. 491.

[8]Kodak Filters, Eastman Kodak Company bulletin B-3, Rochester, 1973.

[9]E. H. Gombrich, *Art and Illusion,* Bollingen, Princeton University Press, 1972, pp. 50-52.

[10]Ibid., p. 308.

Bibliography

The task of assembling a bibliography for a workbook of photography grows steadily more difficult. Several hundred new titles have been added each year during the last decade, titles that include both photographic texts, technical theses and collections of new and rediscovered photographers. The sources listed in this bibliography are therefore limited to books which are pertinent and are reasonably available. Unfortunately, many excellent technical books published in the past have been printed by small publishers, are out of print, and the originals are rare. It is equally unfortunate that for the average photographer the older books are rapidly becoming unreadable because of the great renaming of chemicals that took place during the first half of this century.

The bibliography has been divided into three sections: I: Silver Processes; II: Alternate processes; III: History and Aesthetics. The books named sometimes have information in all three areas, and sometimes are for the advanced photographer and sometimes more relevant to the beginner. And no separate listing has been made of monographs; these have been published with such rapidity the last ten years that it is best to refer to the Light Impressions, Visual Studies Workshop, Aperture, IMP at Eastman House, and Arno reprint catalogs.

Section I: Silver Processes.

Adams, Ansel, *Basic Photo Series,* Morgan & Morgan: Hastings-on-Hudson, N.Y.
 —Camera and Lens, 1970
 —The Negative, 1968
 —The Print, 1968
 —Natural Light Photography, 1965
 —Artificial Light Photography, 1968
Black-and-White Processing for Permanence, Kodak Publication J19 Rochester, N.Y., 1968
Craven, George, *Object and Image,* Prentice-Hall, N.Y., 1975.
Davis, Phil *Photography,* Little Brown, Boston, 1975.

Dixon, Dwight R. *Photography: Experiments and Projects*, Macmillan, N.Y. 1976.
Eaton, George T., *Photo Chemistry In Black-and-White and Color Photography,* Kodak, Rochester, N.Y. 1957
 —*Photographic Chemistry,* Morgan & Morgan, Hastings-on-Hudson, N.Y. 1965.
Encyclopedia of Colour Photography, Fountain Press, London, 1962.
Feininger, Andreas, *Successful Color Photography,* Prentice-Hall, N.J., 1969.
The Focal Encyclopedia of Photography, McGraw-Hill, N.Y. 1969.
The Focal Dictionary of Photographic Technologies, Prentice-Hall, N.Y. 1973.
Geraci, Phillip, *Photojournalism, Making Pictures for Publication,* Kendall-Hunt, Dubuque, Ia., 1976.
Hedgecoe, John, *The Book of Photography,* Knopf, N.Y., 1976.
Hedgecoe, J. and Michael Langford, *Photography: Materials and Methods,* Oxford U. Press, London, 1971.
Horenstein, Henry, *Black and White Photography,* Little Brown, Boston, 1974.
Jacobs, Lou, *Photography Today,* Goodyear, Santa Monica, Ca., 1976.
James, Thomas H. and George C. Higgins, *Fundamentals of Photographic Theory,* Morgan & Morgan, Hastings-on-Hudson, N.Y., 1968.
Kemp, Weston D. *Photography for Visual Communicators,* Prentice-Hall, N.J. 1973.
Kodak, *Index to Information* L-5, (annual) Kodak, Rochester, N.Y.
Langford, Michael J. *Basic Photography,* Amphoto, N.Y., 1965.
 —*Advanced Photography*, Amphoto, New York, 1972.
Larmore, Lewis, *Introduction to Photographic Principles,* Dover, N.Y., 1965.
Lothrup, Eaton S., Jr., *A Century of Cameras,* Morgan and Morgan, Hastings-on-Hudson, N.Y. 1973
Mees, C.E. Kenneth, *From Dry Plates to Ektachrome Film,* Ziff-Davis, N.Y. 1961.

—and T.H. James, *The Theory of Photographic Process,* Macmillan, N.Y., 1966.

Neblette, Carrol B. *Photography; Its Materials and Processes* (editions 1-6, 1932-1962) Van Nostrand Reinhold, N.Y.

Pittaro, Ernest M., ed. *Photo-Lab Index,* Morgan & Morgan, Hastings-on-Hudson, N.Y., 1975 (also see earlier editions).

Procedures for Processing and Storage of Black-and-White Photographs for Maximum Possible Permanence, East Street Gallery, Grinnell, Iowa, 1970.

Sussman, Aaron, *The Amateur Photographer's Handbook,* T.Y. Crowell, N.Y., 1973.

Swedlund, Charles, *Photography, A Handbook of History, Materials and Processes,* Holt, Rinehart and Winston, N.Y., 1974.

Tollis, Hollis N. and Richard D. Zakia, *Photographic Sensitometry,* Morgan and Morgan, Hastings-on-Hudson, N.Y., 1969.

Towler, J., *The Silver Sunbeam,* Morgan and Morgan, Hastings-on-Hudson N.Y., 1969.

Upton, J. and B. Upton, *Photography, adapted from the Life Library of Photography,* Little Brown, Boston, 1976.

White, M. and Richard Zakia and Peter Lorenz, *The New Zone System Manual,* Morgan and Morgan, Hastings-on-Hudson, N.Y., 1975.

Zakia, Richard D., and Hollis N. Todd, *101 Experiments in Photography,* Morgan and Morgan, Hastings-on-Hudson, New York, 1969.

Section II: Alternate Processes.

Anderson, Paul L. "Hand Sensitized Palladium Paper", *American Photography* Vol. XXXII, Boston, July 1938, pp. 437-439.

—*The Technique of Pictorial Photography,* Lippincot, Phila, 1938.

Bingham, Robert J., *Photogenic Manipulation,* Arno Press, N.Y., 1972

Bunnell, Pter C., *Nonsilver Printing Processes,* Arno Press, N.Y., 1973.

Cartwright, H. Mills, *Photogravure,* American Photographic Publishing, Boston, 1939.

Color: see periodical bibliography appended to this section.

Cox, R.J. *Non-silver Photographic Processes,* Academic Press, N.Y., 1975.

Denison, Herbert *A Treatise on Photogravure,* Visual Studies Workshop, Rochester, N.Y., 1974.

Gelatin, Gelatin Manufacturers Institute of America, 516 Fifth Ave., N.Y., 1973.

Hunt, Robert (ed. James Tong) *A Manual of Photography,* O.U. Press: Athens, O., 1975.

Johnson, Pauline, *Creative Bookbinding,* U. of Washington Press, Seattle, 1963.

Kirby, Kent, "The Collotype Printing Process: A Proposal for Its Revival", *Leonardo,* Vol. 9, London, pp. 183-186.

Kodak: *Photofabrication Methods with Kodak Photosensitive Resists,* Kodak, Rochester, p-246.

—*Contact Screens, Types and Applications,* Q-21.

Kwik-Print Newsletter, pub. Direct Reproduction Corp., 835 Union Street, Brooklyn, N.Y. 1976.

Lietze, Ernst, *Modern Heliographic Processes,* Visual Studies Workshop, Rochester, N.Y. 1974.

McGraw Colorgraph Systems for Gravure Etching, McGraw Colorgraph Corp. 175 W. Verdugo, Burbank, Ca., 1966.

Mertle, J.S., and Gordon L. Monsen, *Photomechanics and Printing,* Mertle Publishing, Chicago, 1957.

Rexroth, Nancy, *The Platinotype 1977,* Violet Press, Arlington, Va., (dist. Light Impressions), 1977.

Southworth, Miles, *Color Separation Techniques,* North American Publishing, Phila., 1974.

Wilson, Thomas A. *The Practice of Collotype,* American Photographic Publishing, Boston, 1935.

Color Bibliography:

Adams, Ansel "Color Photography as a Creative Medium," *Image,* Nov. 1957

Archibald, James H. "Color in PHotography," *American Photography,* June 1947, P38

Boje, Dr. Walter "Essays in Colour," *Camera,* Oct. 1966, p. 52

Bone, Stephan "Is Your Color Really Necessary," *Photograms of the Year,* 1957, pp. 26-29

Brasseur, C.A. "Notes Relating to Color Photography," *Camera Work,* Oct. 1907, pp. 35-36

"Cavalcade of Color," 1940, U.S. Camera, Oct. 1940, p. 36

Camera. July 1960, p. 12 (Introduction to Ernest Haas' work)

"Colour Photography," *Camera Work,* April 1908 (Three autochromes by Steichen reproduced)

"Colour Photography," *Photography* (London), July 23, 1907, p. 65

Davis, Douglas "New Frontiers in Color Photography," *Newsweek,* April 19, 1976 pp. 56-61

"First Public Lantern Exhibition of Autochromes," *Photography* (London) pp. 259-60

Hahn, Betty "Henry Homes Smith, Speaking with a Genuine Voice" *Image,* Dec. 1973.

Herschel, John "On the Action of the Rays of the Solar Spectrum on Vegetable Colours and Some New Photographic Processes," *Philosophic Transactions of the Royal Society of London,* Vol. 132, 1842.

Holme, Charles (ed). "Colour Photography and Other Recent Developments of the Art and Camera," *The Studio* (London), 1908

"Interview with Mr. Edouard J. Steichen," Photography (London), July 16, 1907 pp. 45-47

Kodak. "Printing Color Slides," E-96

Kodak. "Applied Infrared Photography," M-28

Kodak. "Printing Color Negatives," E-66

Kodak. "Color Dataguide," Cat. 156 9136

Kodak. "Applied Color Photography Indoors," E-76

Kodak. "Kodak Vericolor II Professional Films," E-36

Kodak. "Reciprocity Data: Kodak Color Films," E-1

Kodak. "Filter Data for Kodak Color Films," E-23

Kodak. "Color News and Documentary Photography with Fluorescent Lighting," H-9

Kodak. "Black and White Prints from Kodak Color Films," AE-21

Jones, Pirkle. "Short Run Color," *Image,* March 1957

Laurvik, Nilseen J. "The New Color Photography, *The International Studio,* March 1908

Levitt, Helen "New York City," *Aperture,* vol. 19, no. 4, 1975

"New Color Photography-A Bit of History," *Camera Work,* Oct. 1907, pp. 20-25

Newhall, Beaumont "An 1877 Color Photograph," *Image,* May 1954, pp. 33-34

Newhall, Beaumont "The Search for Color-A History," *Color Photography Annual* 1956 pp. 19-25

Newhall, Nancy "Painter or Color Photographer," *U.S. Camera,* Feb. 1941, p. 42

Porter, Allan "The Choice Between Color and Black and White:, *Camera,* Nov. 1970, p. 5, 21

Ross, Roger J. "The Advent of Color," *American Photography,* Oct. 1947 p. 38

Scully, Julia "Seeing Pictures," *Modern Photography,* Aug. 1976, p. 26.

Section III: History and Aesthetics.

Arnheim, Robert, *Art and Visual Perception,* U. of Calif., Berkeley, 1954.

Akeret, Robert U., *Photoanalysis,* PocketBooks, N.Y., 1975.

Burnham, Jack, *The Structure of Art,* Braziller, N.Y., 1973.

Bachelard, Gaston, *The Poetics of Space,* Beacon, Boston, 1968.

Caffin, Charles F. Photography as A Fine Art, Morgan and Morgan, Hastings-on-Hudson, N.Y. 1971.

Clark, Kenneth, *The Nude,* Murray, London, 1960.

Coke, F. Van Deren, *One Hundred Years of Photographic History,* University of New Mexico, Albuquerque, 1975.

—*The Painter and the Photograph,* U.N.M., Albuquerque, 1970

Coleman, A.D. "Because It Feels So Good When I Stop," *Camera 35* N.Y., October, 1975, p. 29.

Cavell, Stanley, *The World Viewed,* Oxford, N.Y., 1971.

Collingwood, *The Principles of Art,* Oxford, Galaxy Books, N.Y., 1958.

Cordasco, Francesco, *Jacob Riis Revisited,* Anchor, Doubleday, N.Y. 1968

Doty, Robert, *Photo-Secession, Photography as a Fine Art,* Eastman House, Rochester, N.Y. 1960.

Ferguson, George, *Signs and Symbols in Christian Art,* Oxford, N.Y., 1955.

Fleming, William, *Arts and Ideas,* Holt, Rinehart & Winston, N.Y., 1974.

Emerson, *Naturalistic Photography for Students of the Art,* and *The Death of Naturalistic Photography,* Arno, N.Y., 1973.

Focillon, Henri, *Life of Forms in Art,* Dover, N.Y. 1970.

Frank, Waldo, *America and Alfred Stieglitz,* Literary Guild, N.Y., 1934.

Fry, Roger, *Last Lectures,* Beacon, Boston, 1962.

French Primitive Photography, (Intro. Minor White) Aperture, Millerton, N.Y. 1970.

Gernsheim, Helmut, *Creative Photography, Aesthetic Trends, 1839-1960,* McGraw-Hill, N.Y. 1970.

—*History of Photography,* Oxford, London, 1955.

—*The History of Photography,* McGraw-Hill, N.Y., 1970.

Green, Jonathan, *Camerawork: A Critical Anthology,* Aperture, N.Y., 1973.

Gregory, R.L. *Eye and Brain,* World University Library, McGraw-Hill, N.Y., 1966.

Gombrich, E. H. *Art and Illusion,* Bollingen. Princeton, N.J., 1972.

Hauser, Arnold, *The Social History of Art* (4 vol.) Vintage. Random House, N.Y.

Herbert, Robert L. *Modern Artists on Art,* Prentice-Hall, N.J. 1964.

Ivins, William M., Jr., *Prints and Visual Communications, M.I.T., Cambridge, 1953.*

Jussim, Estelle, *Visual Communications and the Graphic Arts,* Bowker, N.Y., 1974.

Kahler, Erich, *The Disintegration of Form in the Arts,* Braziller, N.Y., 1968.

Kandinsky, W., *Concerning the Spiritual in Art,* Wittenborn, N.Y. 1966.

Klee, Paul, *The Thinking Eye,* Wittenborn, N.Y., 1961.

Kramer, Hilton, *The Age of the Avant-Garde,* Farrar, Strauss and Giroux, N.Y. 1973.

Kostelanetz, Richard, *Moholy-Nagy,* Praeger, N.Y.. 1970.

Kubie, L., *Neurotic Distortion of the Creative Process,* Yale, New Haven, 1968.

Kubler, George, *The Shape of Time,* Yale, New Haven, 1962.

Lyons, Nathan, *Photographers on Photography,* Prentice-Hall, N.J., 1966.

Margolis, Joseph, *The Language of Art and Art Criticism,* Wayne State U. Press, Detroit, 1965.

Newhall, Beaumont, *The History of Photography from 1839 to the Present Day,* Museum of Modern Art, N.Y. 1964.

—*Latent Image: The Discovery of Photography,* Doubleday, N.Y. 1967.

Panofsky, Erwin, *Meaning in the Visual Arts,* Anchor, Doubleday, N.Y. 1955.

Peckham, Morse, *Man's Rage for Chaos,* Schocken, N.Y. 1973.

Pollack, Peter, *The Picture History of Photography,* Abrahms, N.Y. 1970.

Ornstein, Robert E. *The Psychology of Consciousness,* Penguin, N.Y. 1975.

—*The Nature of Human Consciousness,* Viking, N.Y. 1973.

Read, Herbert, *The Grass Roots of Art,* Meridian, N.Y. 1966.

Rosenberg, Harold, *The Tradition of the New,* McGraw-Hill, N.Y. 1965.

Rudisill, Richard C. *Mirror Image: The Influence of the Daguerreotype on American Society,* U. of New Mexico Press, Albuquerque, 1971.

Scharf, Aaron, *Art and Photography,* Penguin, Baltimore, 1969

Schafer, Elwood L. Jr., and James Mietz, *It Seems Possible to Quantify Scenic Beauty in Photographs,* U.S.D.A. Forest Service Research Paper NE-162, 1970.

Shahn, Ben, *The Shape of Content,* Vintage, Random House, N.Y. 1957.

Simpson, Louis, *Three on the Tower,* William Morrow, N.Y., 1975.

Sontag, Susan, "Photography In Search of Itself," *The New York Review of Books,* January 20, 1977.

Stott, William, *Documentary Expression and Thirties America,* Oxford, N.Y., 1973.

Szarkowski, John, *Looking at Photographs,* Museum of Modern Art, N.Y., 1973.

—*The Photographer's Eye,* Museum of Modern Art, N.Y. 1966.

Sypher, Willie, *Rococo to Cubism in Art and Literature,* Random House, N.Y., 1960.

Taft, Robert, *Photography and the American Scene: A Social History,* Dover, N.Y. 1964.

Tucker, Kay, *The Educated Innocent Eye,* The Image Circle, Berkeley, 1972.

Whyte, Lancelot Law, ed. *Aspects of Form,* Indiana U. Press, Bloomington Indiana, 1966.

Winters, Yvor, *In Defense of Reason,* Swallow, Chicago, 1947.

Zakia, Richard D., *Perception and Photography,* Prentice-Hall, N.J., 1975.

Additional resources for the photographer concerned with problems of the changing values of photographic aesthetics are to be found in *Aperture,* (originally a quarterly, now published irregularly as a series of monographs), in *Creative Camera* (distributed by Light Impressions), and in *Artforum;* the last named are monthly magazines.

Creative Camera has three periods of publication. It was known as *Camera Owner* until July 1967, when it changed to *Creative Camera Owner,* through January, 1968, when it assumed its present title. Each issue presents portfolios of contemporary work plus historical texts culled from the hundred-odd years of writing available to the editors.

Artforum is the first major magazine of art criticism to deal frequently with photography as an art form. The following short bibliography lists the principal essays that have appeared in the last few years, since this editorial policy became apparent: The articles are listed by author, title, issue date, and page.

Boice, Bruce "Jan Dibbets: The Photograph and the Photographed" 4/73.45.

Coleman, A.D. "The Indigenous Vision of Manuel Alvarez Bravo" 4/76-60.

— "The Directorial Mode; Notes Toward a Definition" 9/72-43.

Davis, Douglas, "What is Content? Toward an Answer" 10/73-59.

Foote, Nancy, "The Anti-Photographers" 9/76-46.

Frampton, Hollis, "Digressions on the Photographic Agony" 11/72-43.

—"Edweard Muybridge: Fragments of a Tesseract" 3/73-43.

Hoelterhoff, Manuela, "Art of the Third Reich: Documents of Oppression" 12/75-55.

—"Hearthfield's Contempt" 11/76-58.

Hopkins, Budd, "A Note on Composite Imagery: The Photographs of Barbara Jo Revelle" 4/76-64.

Horvitz, Robert Joseph "A Talk with George Kubler" 10/73-32.

Kozloff, Max "Atget's Trees" 11/72-62.

—"The Uncanny Portrait: Sander, Arbus, Samaras" 6/73-58

—"New Japanese Photography" 6/74-42.

—"The Territory of Photographs" 11/74-64.

—"Meatyard" 11/74-68.

—"Photography: The Coming to Age of Color" 1/75-30.

—"The Box in the Wilderness" 10/75-54.

—"Photographs Within Photographs" 2/76-34.

—"Nadar and the Republic of the Mind" 9/76-28.

—"How to Mystify Color Photography" 11/76-50.

Novak, Barbara "Landscape Permuted: From

Acknowledgements

Assistance in technical research was given by John Carson Graves, who developed the zinc gravure process outlined in the text, while completing graduate work at Ohio University; Graves also produced the dye-modified gelatin halftone screens in cooperation with the author, as well as making tests on films and developers for the parametric graphs (Figures 4-31, 4-35). Carl Sesto and Syl Labrot were of great help in providing basic information on the "self-screening" halftone system described in chapter 5. Nancy Rexroth's detailed exploration of platinum printing possibilities must be noted as well as the process demonstrations given by Cynthia Hoden, Kwik-Print; Steve Brown, photolithography; D. James Dee, collotype.

Illustrations were supplied as follows: Light Impressions Corp., Figures 2-23, 2-24, 4-61, 4-62, 4-66. Kimberley Burleigh 1-37A and B, with the print for 1-37B being made by Frederick Schreiber, who also provided the original prints for 3-6A, 3-6B, 3-7, 3-8, 3-9A, 3-12A, 3-12C, 3-15A, 3-15B. Richard Ross provided the original color silkscreen print for Figure 5-6. The original photosilkscreen prints used to illustrate Figure 5-5 were provided by the student art collection, Center of the Eye, Inc., Aspen, 1968 (Figure 5-5E), and Shawna Reilly (5-5A, 5-5D), and Cynthia Hoden (Figures 5-5F and 5-5H).

The process sequence illustrations were produced by Ron Rusnak and Carla Leonardi; the balance of photographs in the text are by the author. Figure 2-15 is by permission of Kodak; Figures 3-4 and 3-5 are redrawn after Arnheim, and Figure 8-3 is redrawn after Klee. All the graphs and interpretations of Figures 3-1, 3-3, 3-4, 3-9, 3-10, 3-12, 3-14, 4-25, 4-26, 4-27, 8-4 are drawn by the author.